UNCLE SCROOGE McDUCK
HIS LIFE & TIMES

WALT DISNEY'S

UNCLE $CROOGE McDUCK

HIS LIFE & TIMES

Written and Drawn by
Carl Barks

Edited by
Edward Summer

Recolored by
Peter Ledger

CELESTIAL ARTS
Berkeley, California

*The first trade edition is published in honor of
the 40th Anniversary of the creation of Uncle Scrooge McDuck
in the story "Christmas on Bear Mountain" which appeared
in the DELL Donald Duck 4-Color comic of December 1947.*

Conceived and Edited by	Edward Summer
Publisher (Limited Edition)	Gary Kurtz
Publisher (Trade Edition)	Phil Wood
Coloring	Peter Ledger
Coloring Assistants	Michael Ambrose Hope London
Copy Editor	Danelle McCafferty
Art Editor	Christy Marx
Proofreader	David Chasanow
Design and Graphics	Barry Larit Michaelis/Carpelis Design Associates
Color Separation Technician	Arnold Kirshner
Checklist Compilation	David Kaler John Nichols
End Paper Art	Walter Simonson
Cover (Trade Edition)	Ken Scott
Color Consulting (Trade Edition)	David Charlsen

Photo Credits:
Pages 61, 89, 117, 215, 270, 291, 345, 364, 366, 373, 375:
Edward Summer; 149, 175, 239, 317: Michael Sullivan
(from "The Men Who Made the Comics," a film supported by
a grant from the National Endowment for the Arts,
a federal agency in Washington, D.C., photographs © 1975
Edward Summer, used by permission); 20, 64: E. B. Boatner;
376: B.A. Skiff, Lowell Observatory

Printed and bound in Singapore

Library of Congress Number 81-66953
ISBN 0-89087-510-3 (paper), 0-89087-511-1 (cloth)

First Limited Edition 1981
First Trade Edition 1987

To Walt Disney,
whose aggressive promotion of theatrical
cartooning built a great industry and a mighty
stage upon which lesser playwrights, such as
I, could produce plays that would otherwise
have died somewhere in a wastebasket.

To comic fans in general
and duck fans in particular.

To Garé,
who postponed her art career to letter the
quackings of my herd of ducks.

To the children of 1942–1943,
who bought the first comic books that
contained my work.

Acknowledgements

During the quarter of a century in which I produced comic book stories, I came close to being a one-man operation, but although I wrote and drew most of my stories in isolation, I am sure that, looking over my shoulder, there was always a host of invisible helpers, whose promptings helped make those stories memorable.

For my apprenticeship in the crisp timing of gags and buildup of situations, I owe much to my former associates at the Disney studio, Harry Reeves, Chuck Couch, Jack Hannah, Homer Brightman, Nick George; the list could go on and on.

For pictorial clarity in the art work, the great men of the comic strips deserve a bow. Hal Foster, Floyd Gottfredson, Roy Crane are three among several whose mastery of lines and forms made black and white drawings swing like beautiful music.

For plot forms and far-out ideas, I absorbed much from Elzie Segar, the genius who created Popeye.

And for critics whose constructive comments helped keep my stories and artwork at high levels, I must bow toward the staff at Western Publishing, where worked such sage editors as Chase Craig, Alice Cobb, Don MacLaughlin, and the brothers McKimson. My wife, Garé, was a constructive critic, too. She perused the stories more carefully than anyone, since it was she who did the lettering and background inking for a staggering number of years.

C.B.

The editor gratefully acknowledges the help of Garé Barks, Michael Barrier, Kim Weston, Wendall Mohler, Wally Green, David Smith, David Kaler, Walter Simonson, Bunny Alsup, Trudy Herrell, Jean Danch, Nancy Cipes, Christy Marx, Kathleen Hallberg, Bill Chleboun, Debbie Speed, Rudy Montana, Bruce Hamilton, Robyn Tynan, Malcolm Willetts, my parents (for buying me my first Disney comics), my grandmother (for allowing me to hide the comics in her closet), Gary Kurtz (who made it possible to read these stories in their proper form for the first time), Carl Barks (who has been a bottomless source of endless enjoyment and inspiration), and everyone else who got this book finished against impossible odds.

First Trade Edition

The editor would like to extend special thanks to Donald Ault who supplied the missing pages from "Back to the Klondike," Ken Scott who did a remarkable cover, Connie Mersel for extremely adept editorial aid, Donald Aslan who has made more things possible than he will ever know, Wayne Morris, Peter Thomas, Edward Bowell, B.A. Skiff, the Lowell Observatory, and the late Sheldon Scheps who first made the editor aware of the unpublished pages.

David Hinds, George Young, Phil Wood, Hal Hershey and Sylvia Chevrier deserve a line of their own for getting this book ready well after the eleventh hour.

E.S.

TABLE OF CONTENTS

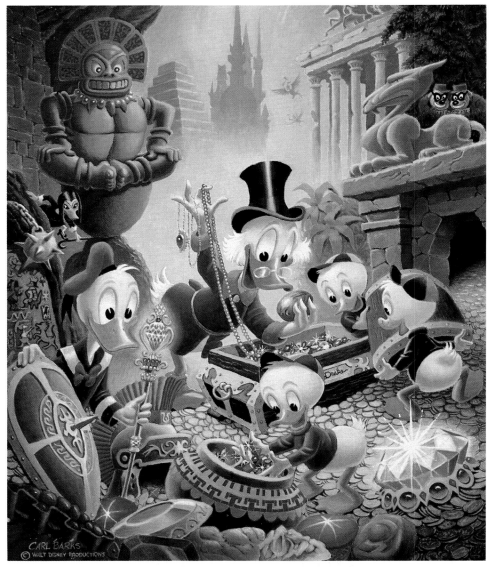

WANDERERS OF WONDERLANDS (1980) CARL BARKS

Published in honor of Carl Barks's 80th birthday (March 27, 1981), the extremely rare 5,000 copy limited edition of UNCLE SCROOGE McDUCK: HIS LIFE AND TIMES included a separate hand-signed and numbered lithograph entitled "WANDERERS OF WONDERLANDS".

It is rumored that the hieroglyphs on the shield behind Donald Duck contain a clue to the secret of Scrooge's immense wealth. It is certain, however, that the painting itself immortalizes the spirit of high adventure, discovery, and eternal wonder.

AN APPRECIATION

By George Lucas

I grew up in a time when television was just beginning to present itself in the American living room. Prior to that, comics were my main form of home entertainment. Some of the very first comics I obtained were written by Carl Barks. I had a subscription to *Walt Disney's Comics and Stories* and liked the Scrooge character so much that I immediately went out and bought all the *Uncle Scrooge* comics I could find on the newsstand.

My greatest source of enjoyment in Carl Barks's comics is in the imagination of his stories. They're so full of crazy ideas—unique and special and bizarre—not in the contemporary sense of bizarre but in the sense that, to a child during the fifties, they were extremely exotic.

The stories are also very cinematic. They have a clear beginning, middle, and end, and operate in scenes, unlike many comic strips and books. Barks's stories don't just move from panel to panel, but flow in sequences—sometimes several pages long—that lead to new sequences.

Carl Barks's world view involves poking fun at the materialistic tendencies that all people have and praising their more sociable, brotherly aspects. Donald Duck and Huey, Dewey, and Louie (especially as Junior Woodchucks) are all other-oriented, generous, and charitable. While Scrooge is an individualistic miser, the others participate more in the family relationship. Scrooge uses Donald and the nephews for help, but he is really separate—yet never really opposed to them. (There is the example of the Beagle Boys as *real* thieves for contrast.) The lure of material things is clearly a main theme throughout all of the Scrooge stories.

I think the reason Carl Barks's stories have endured and have had such international appeal is primarily their strength as *good stories*. Yet on a deeper level, they display American characteristics that are readily recognizable to the reader: ingenuity, integrity, determination, a kind of benign avarice, boldness, a love of adventure, and a sense of humor. Even the foreign reader is given a certain perspective on American culture.

Sociologists have studied comics as reflections of the society of their times. In addition to the artistic pleasure given by comic stories and drawings such as Carl Barks's, comic art has something to say about the culture that produces it.

What I think I enjoy most about Uncle Scrooge is that he is so American in his attitude. These comics are one of the few things you can point to that say: like it or not, this is what America is. And it is for just this reason that they are a priceless part of our literary heritage.

Marin County, California

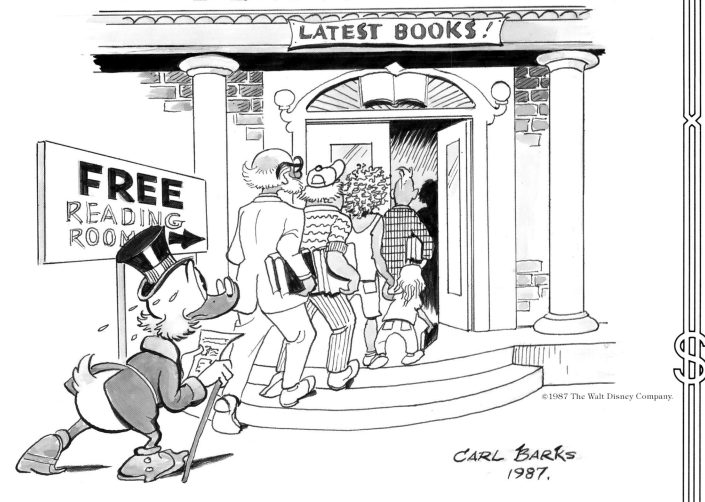

CARL BARKS
1987.

"A new book about *me*! I'm dying to see what it says!"

Mr. McDuck earnestly requested that Mr. Barks do a special drawing for the first trade edition of his book. Mr. Barks complied, but Mr. McDuck left for the library before anyone could discuss a fee for doing the drawing. Mr. Barks does not expect to get paid. E.S.

INTRODUCKTION

by Carl Barks

Since some people who peruse these pages may be seeing Uncle Scrooge McDuck for the first time, he may need a bit of introduction. Uncle Scrooge was never a movie star like his noisy nephew Donald. He was a creature of the printed page. He is by any measurements the richest character ever to live in the realm of fiction. He is also the stingiest. He roams the earth and even outer space in search of additional riches to store in his vast money bin. He was a sourdough in the Klondike gold rush, he helped dig the first diamond pits at Kimberley, he found the treasures that escaped Pizarro, Coronado, and Cortez, he cleaned out King Solomon's mines, and he scaled the heights of Asia to find the haunts of the Abominable Snowman.

To list all of his adventures and feather-rattling battles would take many pages of space. Let it be known that he accomplished his staggering successes without the help of magic or special powers that might have been derived from spider bites or steel corpuscles. He is a web-footed duck who wears spats and a silk hat, which, when you think about it, makes him quite an extraordinary creature, and certainly one blessed with a mystique that transcends human limitations.

He came into being in long-ago 1947 when I happened to need a rich old uncle as a foil for Donald in a Christmas story.

In that first appearance he was only a bit player who forced Donald into a test of courage. His wealth had a very minor role in shaping the action. I might never have used him again, except that about a year later I wanted to write a story about an old Scottish castle on a spooky moor, and Uncle Scrooge's wealth furnished an excuse for Donald and the kids to go there, accompanied, of course, by Uncle Scrooge.

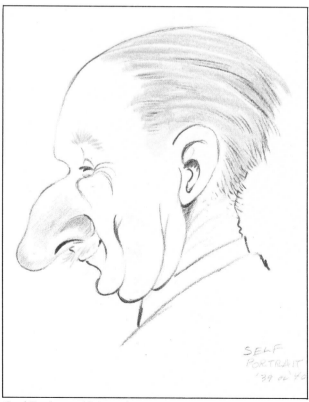

Carl Barks, a self-portrait, c 1939.

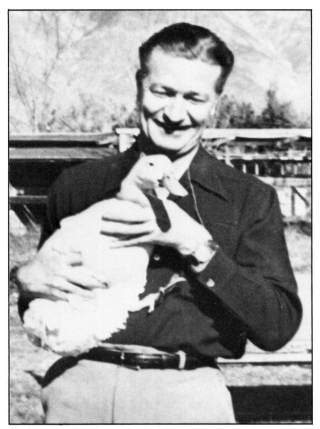

Carl Barks with a pet, Quacky Ducky, in San Jacinto, 1945.

He went on from that spooky tale into other supporting roles, and each new story added more facets to his personality and bulk to the size of his money hoard. In 1952 he was given his own comic, which, under the title of *Uncle Scrooge*, soon rose to the top of all newsstand comic-book sales.

A major reason for his rapid rise to stardom was his globe-trotting story roles. I sent him on location to many romantic areas of the world, and I've learned since that kids really liked the geography lessons they absorbed along with the derring-do. Needless to say, in the writing of those tales, I got myself some pleasant hours of armchair trekking, too. Always I tried to make his adventures believable. If Uncle Scrooge voyaged up the Yukon River, the background scenery and the menaces had to be endemic to the Yukon.

In this book the eminent Australian colorist, Peter Ledger, has upgraded all eleven of the reprinted stories with colors attuned to each locale. Even the mood of the characters is reflected in the hues of their surroundings. In the one story that is completely new, "Go Slowly, Sands of Time," the original watercolor illustrations are my own.

Several books have been published that reprint stories from the great comics of the "golden years." This book, however, is the first definitive book of Uncle Scrooge's adventures. Its editors have carefully chosen a spectrum of stories covering a wide range of his characteristics, adversaries, and fields of action. It should acquaint anyone who reads it with the motivations that made Uncle Scrooge tick.

It is my hope that those who read these twelve stories will feel that Uncle Scrooge's three cubic acres of money have bought them cruise tickets on twelve tall ships of dreams.

Carl Barks

Riverside County, California

ON WINGS OF DUCKS

A biographical essay by Michael Barrier

In the early 1940s, comic book publishers discovered that the characters in animated cartoons could command a large audience when they appeared in print, not just when they appeared on the screen. Comic books based on the Walt Disney cartoons, the Warner Brothers cartoons, and the cartoons of other studios began to sprout, followed by a multitude of imitations. "Funny animals" were a comic-book staple for many years.

The publishers needed artists and writers to fill their four-color pages, and they turned to the logical source, the people already working at the animation studios. Dozens of animators and story men (as cartoon writers are called) tried their hands at comic books, some leaving animation for good, others restricting their comics work to nights and weekends.

Of the companies publishing comic books with characters that had originally been animated, easily the most important was Whitman Publishing Company, since it was licensed to publish comic books with the characters from the major Hollywood studios—Disney in particular. Late in 1942, the search for writers and artists for the Disney comic books led Whitman to a former story man for that studio, Carl Barks.

If there was any character Barks knew well, it was Donald Duck. He had gotten into story work at Disney's in 1936 by submitting a gag for one of the first Donald Duck cartoons, and he had worked on almost every Donald Duck cartoon made after that—three dozen in all. He had even illustrated half of one of the first Donald Duck comic books—a 1942 "one-shot" titled *Donald Duck Finds Pirate Gold*—while he was still on the Disney staff.

Barks had left Disney's in November 1942; he was forty-one years old at the time. He left less to go into comic-book work than to get away from the studio. Barks had never liked the studio very much in his seven years there, since he was by nature a solitary worker and the Disney studio—like any cartoon studio—was a place where everyone worked in teams. Barks was also somewhat isolated

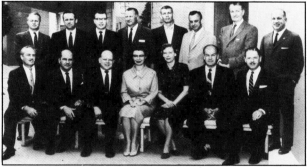

The staff of the Hollywood, California office of Western publishing as shown in a 1957 Annual Report. SEATED, L. to R.: Michael H. Arens, Carl Buettner, J. Alfred Riley, Jane Werner Watson, Alice N. Cobb (Barks's editor), Alfred L. Stoffell, Thomas McKimson. STANDING, L. to R.: Ralph Heimdahl, Chase Craig (Barks's other editor), Francis J. Hoffman, A. L. Zerbe, John N. Carey, Guy Erne, Carl Barks, R. S. Callender.

from his colleagues by the partial deafness that had afflicted him since his youth; as one fellow story man has said, "He just bent over his board, and when you talked to him you figured maybe it was easier not doing it, for him as well as for you."

When the United States entered World War II, and almost everyone at the studio started working on war-related films, Barks decided it was time to quit. He moved to a chicken farm near San Jacinto, east of Los Angeles, and began casting about for free-lance work as a cartoonist. That led to someone—evidently a member of the Disney studio's staff—sending him a script for

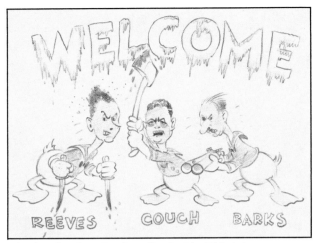

The doorsign from Barks's office in The Third Annex at the Walt Disney Studio on Hyperion Avenue circa 1938. It shows caricatures of Harry Reeves, Chuck Couch, and Carl Barks who were storymen on the Donald Duck motion picture cartoons.

a ten-page story about Donald Duck and his nephews. Barks was hired to illustrate the story, which would be published in the monthly Disney comic book, *Walt Disney's Comics & Stories.*

When the script was sent to Barks, he was invited to make changes if he saw any room for improvement, and he revised the script before illustrating it. For the next issue of *Walt Disney's Comics,* Barks wrote as well as illustrated another ten-page story about Donald; and then another, and another—hundreds of ten-page stories in all, the last of which was published in the September, 1966 issue of *Walt Disney's Comics.* There were longer stories, too—dozens of them, first in the *Donald Duck* comic book and then in *Uncle Scrooge.* The last appeared in mid-1967, about a year after Barks retired. Even in retirement, at his publisher's urging, he continued to write stories for other artists to illustrate, until he finally left comic books behind in 1973.

Before he retired, Barks joined his third wife, Garé, a highly regarded landscape

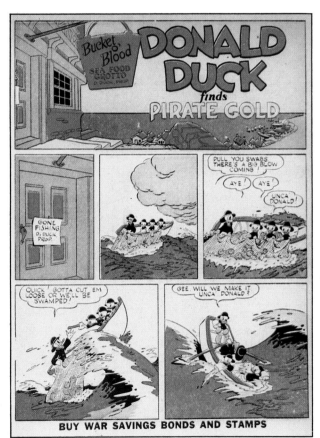

Drawn from an unproduced movie script by Bob Karp, the work on PIRATE'S GOLD (1942)—one of the longest Donald Duck comic books—was divided between Jack Hannah (indoor scenes) and Carl Barks (outdoor scenes). This is page one of the story.

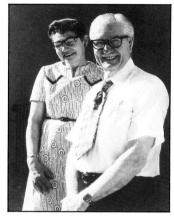

Carl and Garé Barks in front of their Goleta, California home in 1971.

painter, at the easel, and now he is a painter exclusively. For one five-year period (1971–1976), he was permitted by the Disney studio to sell oil paintings of the ducks; in a small but pleasurable irony, these paintings, based on Barks's comic-book work, commanded prices that dwarfed the page-rates Barks was paid for his stories. The most he was ever paid was $45.50 per page of script and drawings; the last of his duck paintings sold at a 1976 auction for $6,400. One painting was recently reauctioned for over $30,000.00. That his paintings of the ducks should command such prices is only one measure of the impact his stories had on his readers over the years.

For a quarter of a century, Barks wrote and drew stories about the Disney ducks, an association that would be notable for its duration alone, since few comic book men had the opportunity (or the desire) to stick with one small group of characters that long. Barks's stories were notable for much more than the long marriage of their author and his characters. Alone among all the alumni of the cartoon studios, Barks took his comic book stories

seriously, lavishing on them tremendous effort and painstaking attention to detail. He spent days polishing the scripts for his stories before he began drawing, and sometimes he made major changes, discarding or reworking pages, after a story was drawn and inked and ready to send to the publisher. He accumulated a large morgue of photos and drawings that he used as source material, so that no matter where the stories took place, the settings would look authentic

There were no other "funny-animal" cartoonists who cared that much about their work. For the other cartoonists, comic books were an inconsequential sideline or, at best, a pleasant, undemanding way to make a modest living. Most of these cartoonists were not allowed to sign their stories, and this anonymity no doubt encouraged a relaxed attitude toward the work. Anyone with ambitions as a cartoonist stayed in animation or perhaps tried for a syndicated comic strip.

L. to R.: An unidentified Italian publisher, Garé Barks, George Sherman, Tom Goldberg, Chase Craig, Carl Barks. Behind them is the house at 152 Washburn Avenue, San Jacinto, California where Barks drew most of the Duck comic books.

For Barks, comic books were different: they were, for him, the perfect medium for artistic expression. Not that he thought about them that way (and certainly he did not *talk* about them that way), but to know that this was so, it is necessary only to compare Barks's work before 1942 with the incomparable stories of comedy, fantasy, and adventure that flowed from his Estabrook pen in later years.

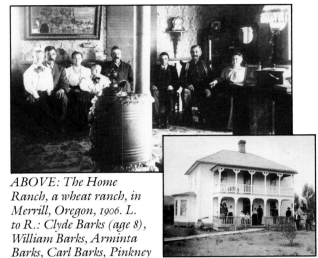

ABOVE: The Home Ranch, a wheat ranch, in Merrill, Oregon, 1906. L. to R.: Clyde Barks (age 8), William Barks, Arminta Barks, Carl Barks, Pinkney Barks (Carl's father's cousin), Miles Roberts (father's nephew), Paul Wright (an Indian War veteran who was a friend of the family), Jenny Wright (Paul's wife). RIGHT: The exterior of the Home Ranch, 1906.

Barks had been making his living as a cartoonist for about eleven years—since he was thirty years old—before he

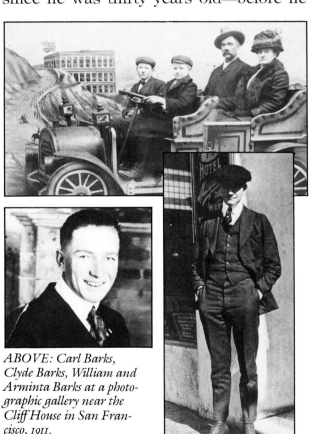

ABOVE: Carl Barks, Clyde Barks, William and Arminta Barks at a photographic gallery near the Cliff House in San Francisco, 1911.
BELOW LEFT: Carl Barks in his 20's.
BELOW RIGHT: Carl Barks, age 19, 1920, working as an apprentice in a job printing company in San Francisco. He is wearing two-tone high top shoes.

started working regularly for Whitman. Nothing in Barks's first thirty years had particularly prepared him to make his living as a humorist; if his experiences in those years had taught him anything, it must have been that life is a gray and disappointing business, in which most people struggle doggedly for meager rewards.

Certainly that was true of his parents. As a boy Barks's father William, who was an orphan, had traveled west not long after the Civil War, riding on top of boxcars to California. His wife-to-be, Arminta Johnson remained in Missouri nursing her invalid parents until they died. Then she came to Oregon—where William Barks had moved as a homesteader—and they were married, late in the 1890's. By this time they were both in their forties, and they had not seen one another in the intervening years. Carl Barks was born the second of two sons, on March 27, 1901, near Merrill, Oregon.

Barks was born on what he calls a "wheat ranch." During the next dozen years or so, Barks's father tried other busi-

Barks drew the cover of the first issue of a one-shot humor magazine COO COO in 1932. It was published in Minneapolis by the Bob Edwards Publishing Company which also put out CALGARY EYE-OPENER.

nesses—a feedlot in Oregon, a prune orchard in California—with little success, finally winding up on the ranch again. After shepherding the family through one crisis after another, Barks's mother died on the ranch when Barks was fifteen. His parents as he describes them, were stoic undemonstrative people, and certainly did not stimulate any interest in art or literature in him. "My dad was never much of a fellow to talk," Barks has said. "He was a silent sort of guy. He would read his Bible—that was about the extent of his life."

Even Barks's brushes with superficially more colorful people did not provide much food for the imagination. When his father owned the feedlot, cowboys would bring cattle in from eastern Oregon, but they did not bring any stories of life on the trail with them. "Their talk about the cattle drives was mostly concerned with when they got past the outer fringes of civilization and had to drive down fenced roads with their cattle, and the cattle breaking down farmers' fences and getting into their yards, and so on," Barks has said. "That was what concerned them most, and that was about all we ever got out of their conversations."

As his family moved from place to place when he was a boy, Barks went from one small-town schoolroom to another, finally leaving school at the age of fifteen, when he had finished the eighth grade. He spent

the next year or so working on his father's ranch and other nearby spreads; help was scarce because of World War I. The war over, Barks moved to San Francisco, living there intermittently for a couple of years until, jobless, his money gone, he returned to the ranch. He shared the family's bad luck at agriculture—"As soon as I tried to raise wheat and potatoes and things there on the ranch, the rains stopped"—and in 1923, he and his new wife left for a logging camp. That was followed by more than six years repairing railroad cars at Roseville, California—swinging a sledgehammer, heating rivets, and getting steadily sicker of the work.

The saving grace in these years was an interest in cartooning that had been kindled when Barks was in school in California; he was impressed by a schoolmate's caricatures of public figures like Woodrow Wilson and Theodore Roosevelt. Barks began a correspondence course in cartooning but never finished; it was too difficult to keep up with it in a rural setting because, as he has said, "Maybe, if there was snow on the ground, it'd be two or three weeks between trips to the post office." In

Labrador Mountie: "Do you know any new steps?"
Cutie: "None that you haven't taken already."

A panel from "McFuzzy is Safe" which appeared in the September 1931 CALGARY EYE-OPENER. It exemplifies the kinds of jokes that Barks contributed to the magazine from 1930-1935.

"I knew they were going to do Snow White. I just drew this picture and others and sent them to Disney's for examples of my penmanship....they wrote back and said, 'Come out and go to work.' Just on the basis of those drawings." C. B.

San Francisco, he tried to find work as a cartoonist but had to settle for a job with a printing company. But Barks stuck with cartooning, and finally, late in the 1920s, he began to sell gag cartoons to humor magazines—a couple to the venerable *Judge* and many more than that to the *Calgary Eye-Opener*, a Minneapolis-based magazine that specialized in slightly off-color prose and gag cartoons.

Barks's dedication to cartooning, the only escape route open to him, caused the breakup of his first marriage. His wife, he said, "resented the long evenings and weekends I spent at trying to draw cartoons and would have preferred that I lived like the other less ambitious husbands around us." Their quarrels led to a separation in 1930 and a divorce a few years later. Barks returned to Oregon and went to work for a box factory, but the Depression soon cost him that job. Thus pushed, Barks finally made his break: "I thought, well, hell, I'm just gonna put in all my time on cartooning." When, late in 1931, the owner of the *Eye-Opener* asked Barks to join the magazine's staff in Minneapolis, "I had enough money to send a telegram

saying I didn't have enough money to get back there. He sent me money to come back there on, and I closed up my affairs very rapidly and gave away the big stack of joke magazines I had. What I could carry in a valise, I carried with me." Barks remained with the *Eye-Opener* for four years, contributing hundreds of gag cartoons under his own name and pseudonyms.

In 1935, apprehensive about the *Eye-Opener*'s future, Barks returned west, to work for the Disney studio. He spent a few weeks as an "in-betweener"—the lowliest kind of apprentice animator—before moving into story work and beginning his long career as the most important biographer of Donald Duck and his family.

For all their differences, there is a thread that connects Barks's drawings for the *Eye-Opener*, the gags that he contributed to the Donald Duck animated cartoons, and the first few stories that he wrote and illustrated for *Walt Disney's Comics & Stories*. The similarity is not in the subject matter, of course, but in the way it is handled. In every case, the comedy owes quite a bit to accepted ideas

To earn extra money, Barks contributed this gag idea for the "Sorceror's Apprentice" sequence of FANTASIA. The Disney studio paid between $2.50 and $10.00 for gags which were accepted.

of what is "funny." Great humorists rely on their own experiences and observations, and in the thirties and early forties Barks was not yet doing that. Not that he ever thought of his life as too gloomy to be good raw material for comedy—he is not a sour, brooding man, and self-pity is the last emotion that could ever be associated with him. He had simply not yet found a way to put his knowledge of life to work in fresh, unconventional gags and stories.

And, actually, only a few of his many hundreds of comic book stories were ever autobiographical in the way that, say, Mark Twain's novels were. But Barks, in his years as rancher and laborer, had learned a lot about the fickleness of animals, machines, and the weather, and that knowledge shone through in some wonderful gags. Likewise, he sometimes used settings that he was familiar with, particularly southern California, and his stories with the inventor Gyro Gearloose were a reflection of Barks's own frustrated desire

to be an inventor. However, it remained relatively rare for him to draw so directly on his own experiences.

Barks discovered how to give of himself in his stories on a much deeper level. This discovery came as he began writing and drawing longer stories with the ducks, starting with a story called "The Mummy's Ring" for a 1943 issue of *Donald Duck*. The longer form lent itself to a different kind of story than the ten-page episodes in *Walt Disney's Comics & Stories* did; there was room to stretch out, to introduce complications and perils that wouldn't fit comfortably within ten pages. The longer stories quite naturally became adventures, as well as comedies. In some of the longer stories, comedy disappeared altogether for pages at a time.

There were precedents for this mingling of comedy and adventure in such silent films as Chaplin's *The Gold Rush* and Keaton's *The General*, and particularly in the Mickey Mouse comic strip of the

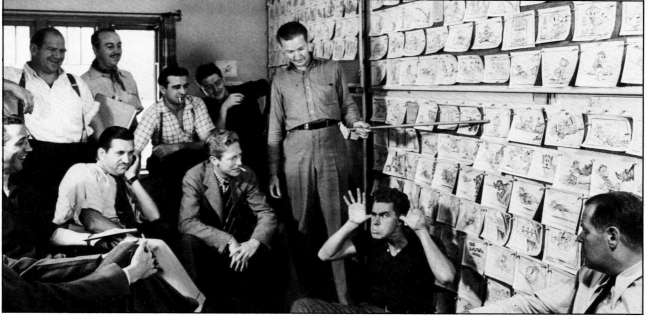

A 1938 publicity photo taken in front of the storyboards for GOOD SCOUTS, a Donald Duck short. Barks, with pointer, is surrounded by Joseph Sabo, Roy Williams (standing L.), T. Hee, Erdman Penner, Peter O'Crotty (seated in front of Penner) and others. Harry Reeves is on the floor making faces.

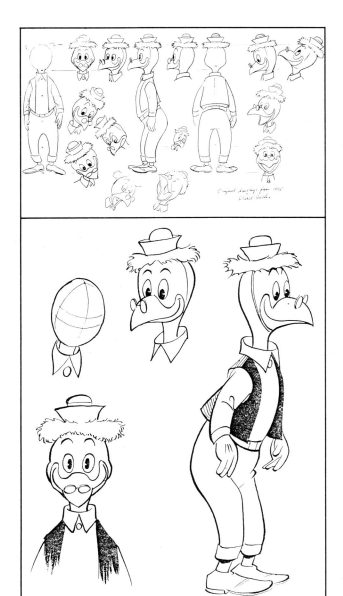

Two model sheets for Gyro Gearloose drawn by Barks in 1955. A model sheet helps to keep the "look" of a character consistent. Gyro, whom Barks invented, became popular enough to be included in other artist's stories.

Carl Barks, in 1974, puttering in his garage workshop at the Goleta, California home.

1930s as plotted and drawn by Floyd Gottfredson. But there was a big difference between Mickey's adventures in the Gottfredson strip and Donald's adventures in Barks's stories. Mickey was not a naturally funny character; Donald was.

The basic ingredients of Donald's personality—his short temper, his pugnacity, his enormous capacity for indignation—were well established when Donald was just a supporting character in the Mickey Mouse animated cartoons, even before Barks began writing for the cartoons in which Donald starred. In his comic book stories, Barks greatly enriched the character, but Donald's core was not altered; he remained Donald Duck, and this meant that he was an inescapably comic figure, no matter what he was doing.

As a result, Barks in his longer stories could harmonize—for the first time in his career as a cartoonist—his desire to be funny with the lessons his life had taught him about what a demanding place the world is. In these stories, there was no division between the serious and the comic; they were united in the person of Donald Duck. Donald in his comically weak moments created difficulties for himself that he could resolve only through heroic action, grumbling and stumbling all the while. Furious with his cousin Gladstone Gander because of Gladstone's insufferable good luck, Donald sent him on a wild-goose chase to the far north—and then,

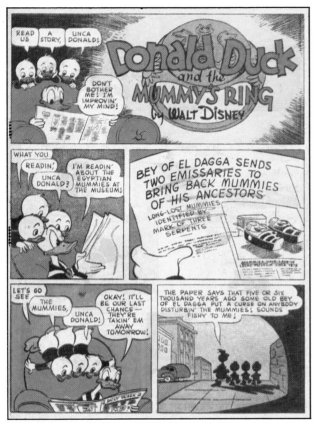

The title page of THE MUMMY'S RING (1943). In this book Barks undertook his first full-length Donald Duck story which he both wrote and drew.

conscience-stricken, made an arduous trek across the ice and snow to rescue his unworthy relative.

However heroic the action, Donald made it funny. When Donald pursued a snarling villain, in a story called "Sheriff of Bullet Valley," he was unmistakably riding into deadly danger—but as he rode, he was suspended in the air behind his horse, clinging imperturbably to the reins as he contemplated similar moments in his favorite western movies: "Reminds me of the chase sequence in 'Powderburns on the Powderhorn.'"

This interaction between the serious and the comic worked in the other direction, too: the unequivocally comic stories—particularly those in *Walt Disney's Comics*—got funnier as Barks transformed Donald into a much more complex and sympathetic character than he was in the screen incarnation. Donald still had a short fuse, but his explosions of temper were more amusing than before because they were now just the underside of real courage.

By the late forties, Barks's stories were securely anchored in both comedy and drama, in both fantasy and reality. As no one else ever had, or ever would, he had found the way to give comic book stories the richness—of character, language, incident, plot, and description—associated with real literature.

His work even seemed to prosper under new pressures at home; some of his best stories, in the late 1940s and early 1950s, were written and drawn as his second marriage disintegrated because of his wife's love of 80-proof bourbon. During moments when missiles weren't flying, Barks has said, the creative juices would begin to flow.

Not only did Donald blossom in Barks's stories, but Barks gave him a superb supporting cast. Donald's three nephews,

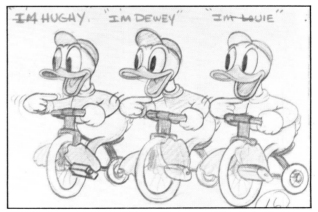

The first appearance of Huey, Dewey and Louie in the storyboards for the Donald Duck motion picture short Donald's Nephews (1938). They were probably drawn by Chuck Couch or Harry Reeves. Carl Barks contributed gags and story material.

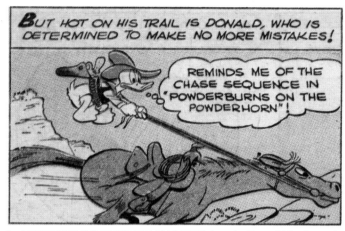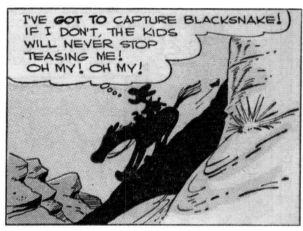

In SHERIFF OF BULLET VALLEY (1948), Donald is obsessed with cowboy movies and pictures himself as "Stumpalong Hoppity" or "Trigger Trueshot." Blacksnake McQuirt, however, is a real-life villain who proves too much for Donald until the Nephews come to the rescue.

never more than little devils on the screen, were presented as bright, resourceful children. Sometimes they were Donald's rivals, sometimes his invaluable partners in adventure, but they were never the boring hellions of the animated cartoons.

Barks introduced a host of other characters that had never appeared in the cartoons, most of them with *shticks* on which plots could be hung. There was Gyro Gearloose, the fabulous inventor; the incredibly lucky Gladstone Gander; and most important of all, Donald's uncle, Scrooge McDuck, who was so wealthy that his money was measured in cubic acres. Scrooge, in turn, spawned such supporting characters

as the Beagle Boys, comic villains who coveted his fortune.

Scrooge first appeared in 1947, in a *Donald Duck* story titled "Christmas on Bear Mountain." After that, he shared Donald's role at the center of many of Barks's adventure stories, until, finally, in 1952, Barks surrendered the *Donald Duck* comic book to other cartoonists and devoted most of his time to the new *Uncle Scrooge* comic book. No one else wrote or drew the principal story in any issue of *Uncle Scrooge* until 1967, and Scrooge is the character with whom Barks is most closely identified.

Scrooge had one great advantage over

Barks drew this storyboard sequence for Donald's Nephews. *In animation much detail is shown, especially in storyboards. In a comic strip, Barks explains, "you have just one drawing: the climactic moment. That's the secret of action."*

Donald as the star of an adventure series: his wealth was a ready-made excuse for sending the ducks all over the globe. Barks had begun to use Scrooge in this way shortly after he first appeared in *Donald Duck*, by having Donald and the nephews accompany Scrooge to Scotland, and Scrooge's money continued to be a passport to dozens of countries (and even to outer space) for almost twenty years.

As a personality, Scrooge in his supporting roles was a fanatic old miser, funny because his avarice was carried to such ludicrous extremes. Scrooge loved his money with a physical passion—"I love to dive around in it like a porpoise! And burrow through it like a gopher! And toss it up and let it hit me on the head!"—and guarded it with a jealous beau's fury, even begrudging Donald and the nephews the token salaries that he paid them when they were helping him to fight off the Beagle Boys or other predators.

When Scrooge became the star of his own comic book, Barks reshaped him so that, like Donald, he was simultaneously comic and heroic. He remained comic because his passion for his money was undiminished; he was also heroic because, as Barks made clear in the first issue of the *Uncle Scrooge* comic book, Scrooge had worked like a Trojan for every dime he owned. Thus, he could be forgiven his ferocious determination to *keep* every dime he owned. Barks has spoken of Scrooge in these terms: "I never thought of Scrooge as I would think of some of the millionaires we have around, who have made their money by exploiting other people to a certain extent. I purposely tried to make it look as if Uncle Scrooge made most of his money back in the days before the world got so crowded, back in the days when you could go out in the hills and find riches."

What mattered most about Scrooge was not his money, but the way he had earned it; his wealth was the symbol of a life built on honesty and hard work. When the Bea-

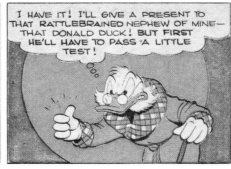

These four panels, from pages one and two of CHRISTMAS ON BEAR MOUNTAIN (1947), are the very first appearance of Scrooge McDuck. His Dickensian and Scottish origins are apparent in his demeanor and costume. Scrooge gradually evolved into a less stereotypical and more complex character.

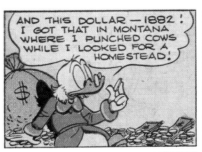

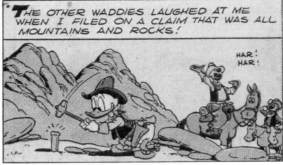

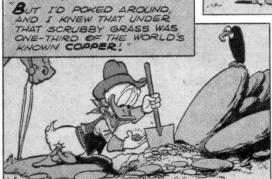

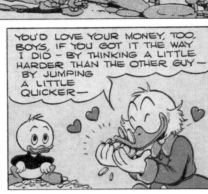

In ONLY A POOR OLD MAN (1952), Scrooge made his first appearance in his own comic book. He recounts his experiences as a young duck in gathering his fortune: "I froze my fingers to the bone digging nuggets out of the creeks! And I brought a fortune out, instead of spending it in the honkeytonks!"

gle Boys tried to raid Scrooge's money bin, their target was not just his cash but his integrity, and that was why he fought back so fiercely.

Barks always preserved a certain distance between himself and his characters; he liked some better than others (he never had much use for Gladstone Gander, for example), but it would be a mistake to think of any one of them—even Uncle Scrooge—as his alter ego. And yet there is something about Scrooge that suggests comparisons with Barks himself; perhaps that is because in Scrooge—even more than in Donald—it is clear what a thin line separates the heroic from the ridiculous.

In Barks's case, it might seem ridiculous that a man of obvious ability as a writer and an artist should have spent his days writing and drawing stories for children, stories that were published on the cheapest of paper in comic books, the most widely scorned of all magazines, the magazines least likely to be preserved in libraries or to receive any attention from educated adult readers. Not only did Barks write and draw stories for comic books, he put into those stories all the passion, intelligence, and hard work that mainstream writers and artists put into their finest work for much slicker and more prestigious publications; and after investing so much effort in his stories, Barks cheerfully accepted payment for them at page rates that many writers and artists would have denounced as insultingly low.

It really does sound ridiculous—until you read the stories.

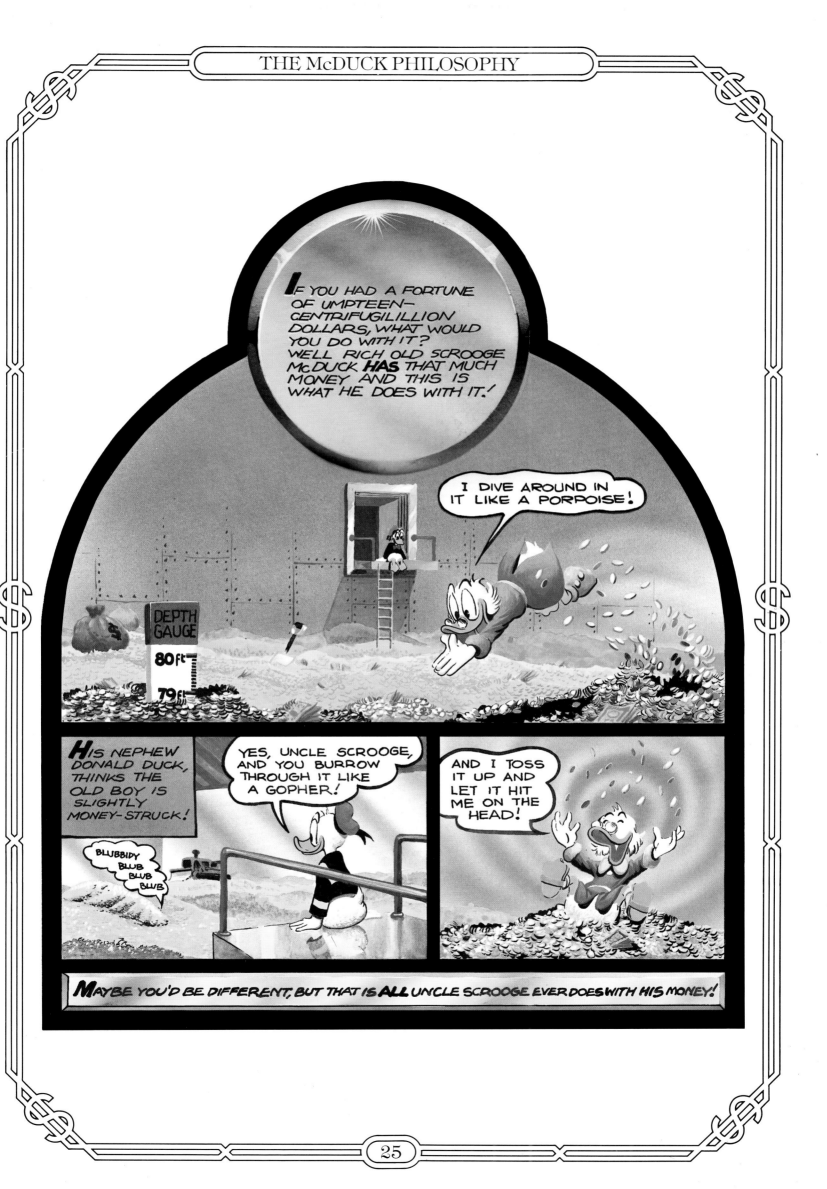

BACK TO THE
KLONDIKE

Back to the Klondike
Uncle Scrooge #2 (Four Color 456)
March 1952

The fortune that fills Uncle Scrooge's vast money bin didn't come easy. He had his early hardships, just like the rest of us. In 1898 he was in Alaska mining the frozen creeks for gold. He found lots of the stuff, but he lost some of it to crooks. Then he got some of it back, hid some of it, and forgot where.

In this tale of a sourdough's return to scenes of long-ago triumphs and troubles, Uncle Scrooge reveals a tiny soft spot in his flinty old heart. As originally written and drawn in 1952, this robust adventure was deemed too robust by the publisher's editors. They scissored five pages.

Now for the first time "Back to the Klondike" is being published unabridged. The sequence in which Uncle Scrooge was robbed of his "Goose Egg Nugget" has been restored to its meaningful place in the plot. The rough business of his getting it back is here, and also for the first time, the real role played by the gaudy dance hall girl, Glittering Goldie, is presented uncut. Four panels, alas, are still missing. I have redrawn the original panels to the best of my recollection. Rest assured that no details of consequence have been lost. *C.B. 1981*

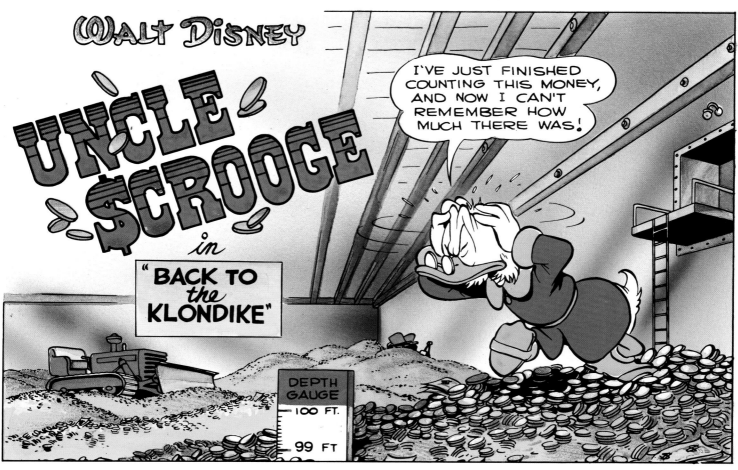

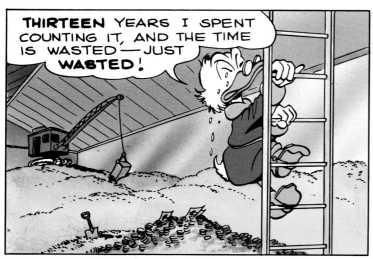

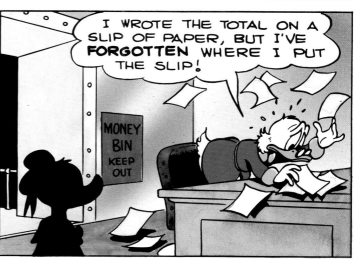

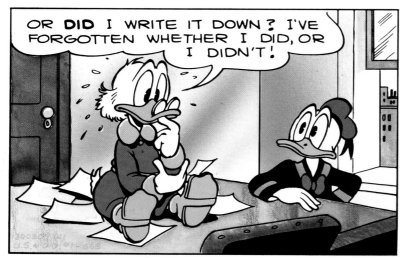

LET'S SEE NOW— **WHAT IS MY NEPHEW'S NAME?** I'VE **FORGOTTEN!**

DONALD DUCK!

THAT'S RIGHT! SAY, MAYBE YOU REMEMBER HIS PHONE NUMBER, TOO!

I SURE DO!

BUT WHY PHONE? **I'M HIM!**

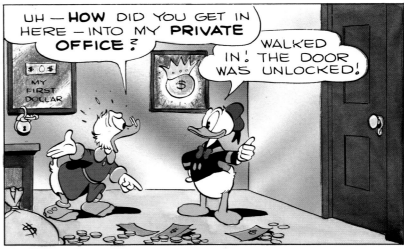

SO YOU ARE! SAY, THAT'S RIGHT! **YOU ARE DONALD DUCK!**

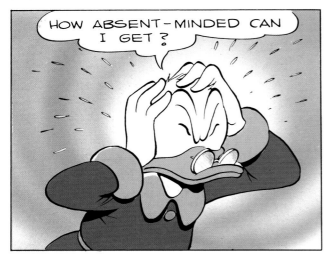

HOW ABSENT-MINDED CAN I GET?

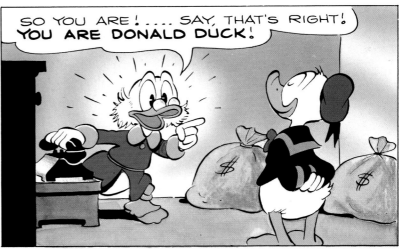

UH — **HOW** DID YOU GET IN HERE — INTO MY **PRIVATE OFFICE?**

WALKED IN! THE DOOR WAS UNLOCKED!

0 MY FIRST DOLLAR

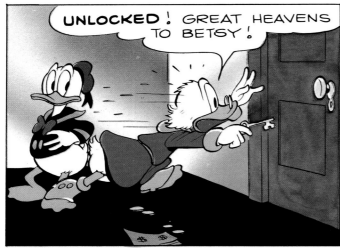

UNLOCKED! GREAT HEAVENS TO BETSY!

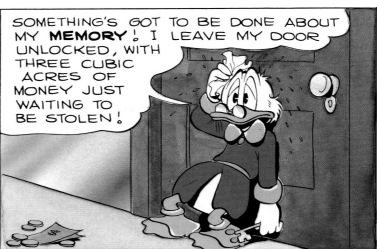

SOMETHING'S GOT TO BE DONE ABOUT MY **MEMORY!** I LEAVE MY DOOR UNLOCKED, WITH THREE CUBIC ACRES OF MONEY JUST WAITING TO BE STOLEN!

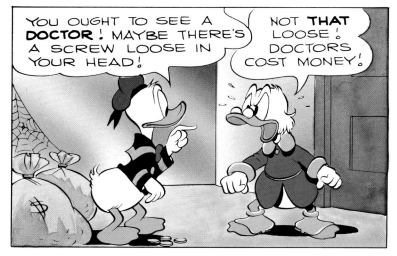

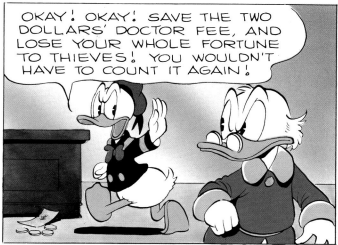

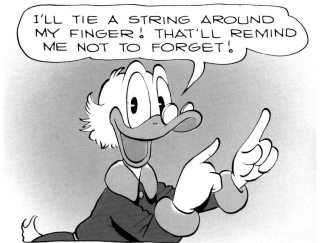

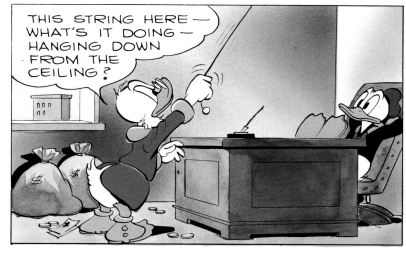

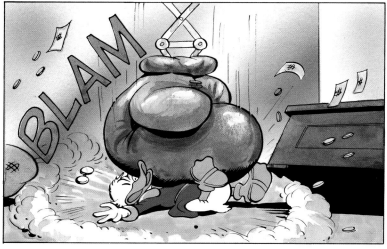

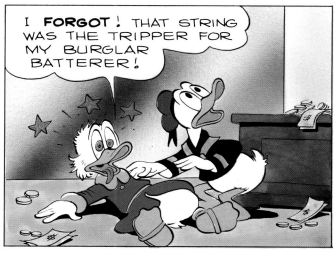

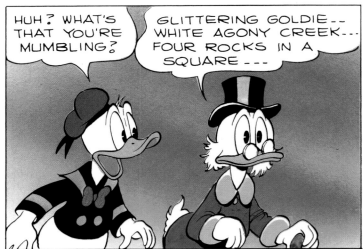

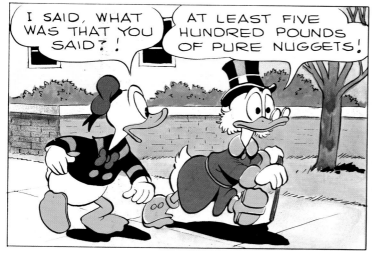

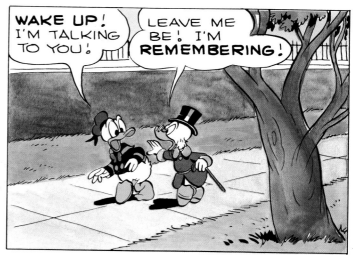

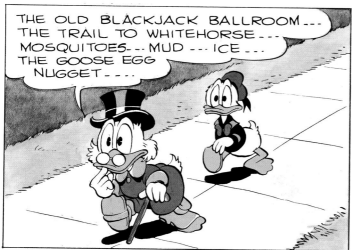

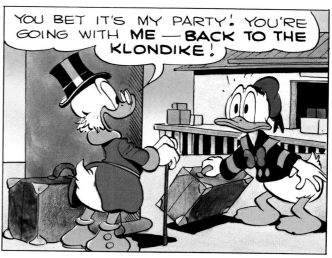

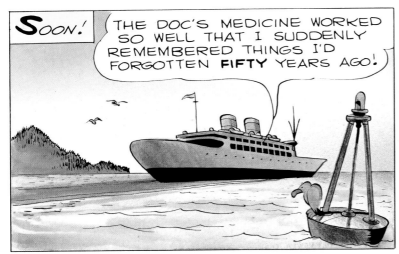

SOON! THE DOC'S MEDICINE WORKED SO WELL THAT I SUDDENLY REMEMBERED THINGS I'D FORGOTTEN **FIFTY** YEARS AGO!

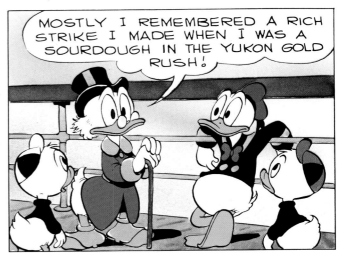

MOSTLY I REMEMBERED A RICH STRIKE I MADE WHEN I WAS A SOURDOUGH IN THE YUKON GOLD RUSH!

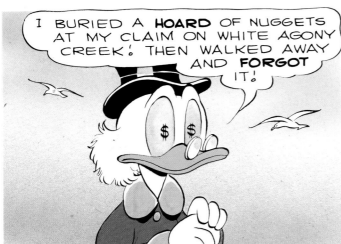

I BURIED A **HOARD** OF NUGGETS AT MY CLAIM ON WHITE AGONY CREEK! THEN WALKED AWAY AND **FORGOT** IT!

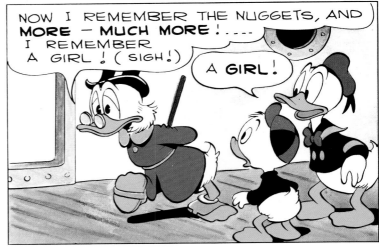

NOW I REMEMBER THE NUGGETS, AND **MORE — MUCH MORE!** I REMEMBER A GIRL! (SIGH!)

A GIRL!

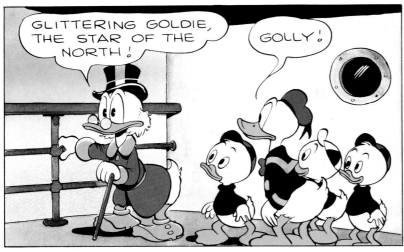

GLITTERING GOLDIE, THE STAR OF THE NORTH!

GOLLY!

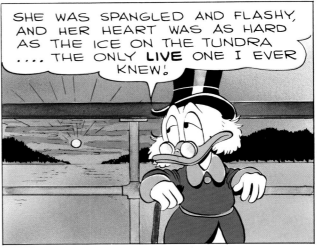

SHE WAS SPANGLED AND FLASHY, AND HER HEART WAS AS HARD AS THE ICE ON THE TUNDRA THE ONLY **LIVE** ONE I EVER KNEW!

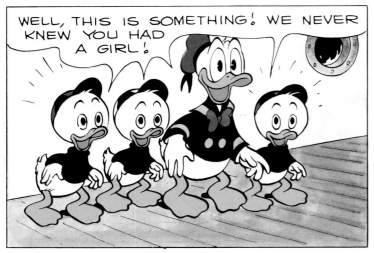

WELL, THIS IS SOMETHING! WE NEVER KNEW YOU HAD A GIRL!

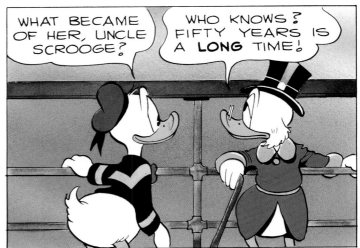

WHAT BECAME OF HER, UNCLE SCROOGE?

WHO KNOWS? FIFTY YEARS IS A **LONG** TIME!

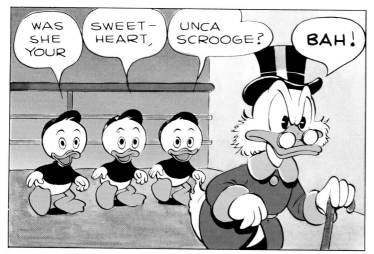

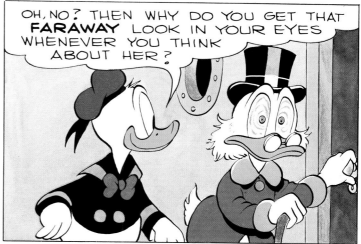

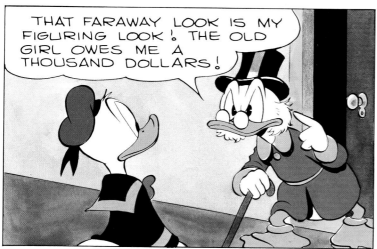

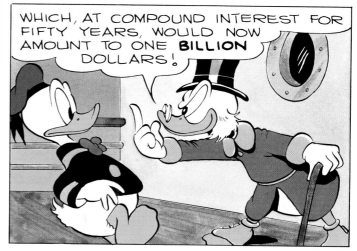

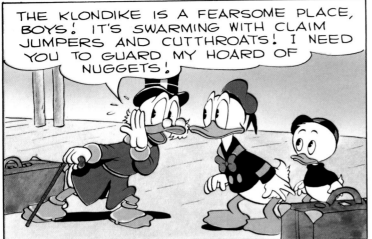

THE KLONDIKE IS A FEARSOME PLACE, BOYS! IT'S SWARMING WITH CLAIM JUMPERS AND CUTTHROATS! I NEED YOU TO GUARD MY HOARD OF NUGGETS!

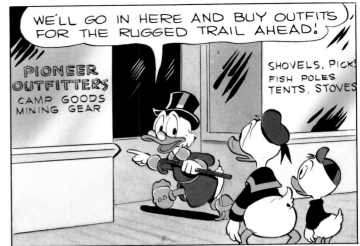

WE'LL GO IN HERE AND BUY OUTFITS FOR THE RUGGED TRAIL AHEAD!

PIONEER OUTFITTERS
CAMP GOODS
MINING GEAR

SHOVELS, PICKS
FISH POLES
TENTS, STOVES

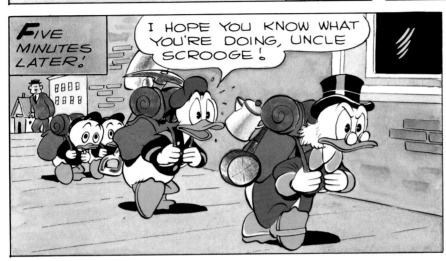

FIVE MINUTES LATER!

I HOPE YOU KNOW WHAT YOU'RE DOING, UNCLE SCROOGE!

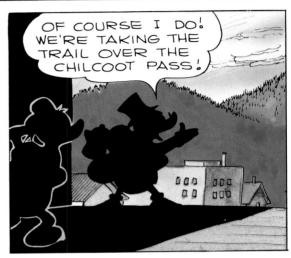

OF COURSE I DO! WE'RE TAKING THE TRAIL OVER THE CHILCOOT PASS!

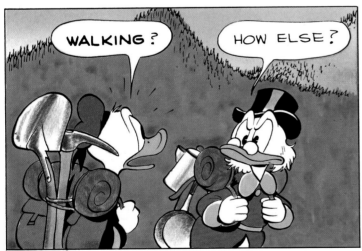

WALKING?

HOW ELSE?

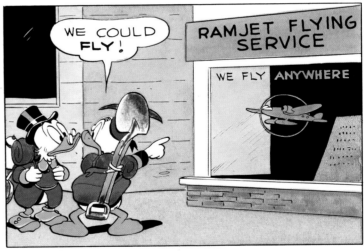

WE COULD FLY!

RAMJET FLYING SERVICE

WE FLY ANYWHERE

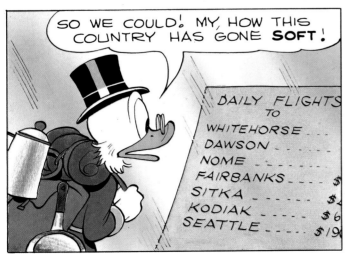

SO WE COULD! MY, HOW THIS COUNTRY HAS GONE SOFT!

DAILY FLIGHTS
TO
WHITEHORSE
DAWSON
NOME
FAIRBANKS ____ $
SITKA ____ $
KODIAK ____ $6
SEATTLE ____ $19

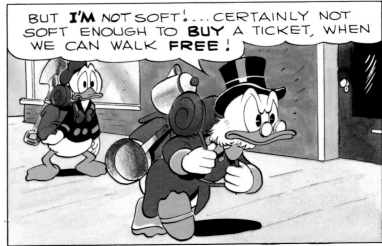

BUT I'M NOT SOFT! ... CERTAINLY NOT SOFT ENOUGH TO BUY A TICKET, WHEN WE CAN WALK FREE!

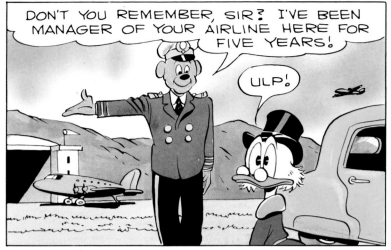

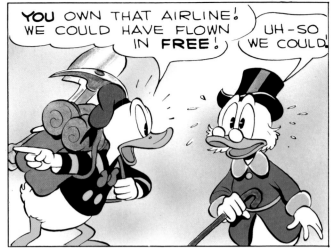

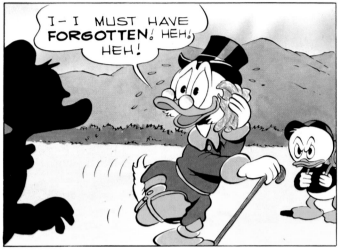

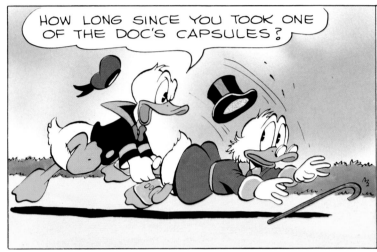

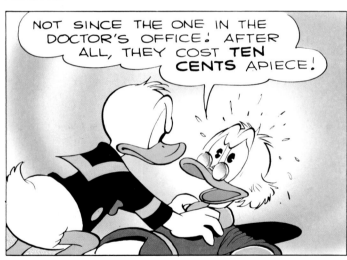

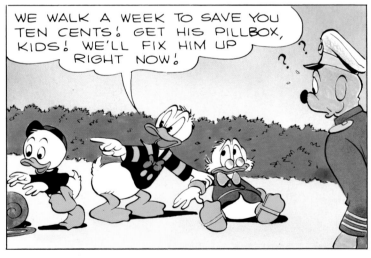

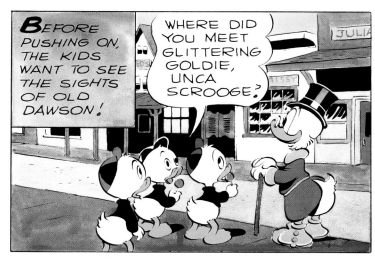

BEFORE PUSHING ON, THE KIDS WANT TO SEE THE SIGHTS OF OLD DAWSON!

WHERE DID YOU MEET GLITTERING GOLDIE, UNCA SCROOGE?

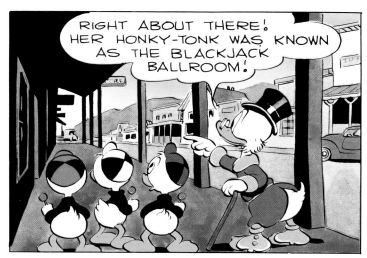

RIGHT ABOUT THERE! HER HONKY-TONK WAS KNOWN AS THE BLACKJACK BALLROOM!

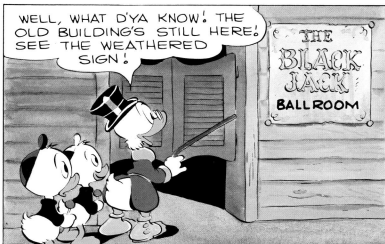

WELL, WHAT D'YA KNOW! THE OLD BUILDING'S STILL HERE! SEE THE WEATHERED SIGN!

THE BLACK JACK BALLROOM

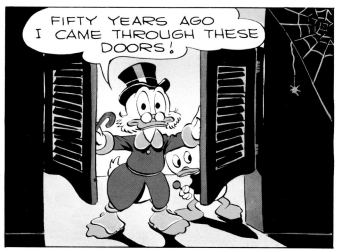

FIFTY YEARS AGO I CAME THROUGH THESE DOORS!

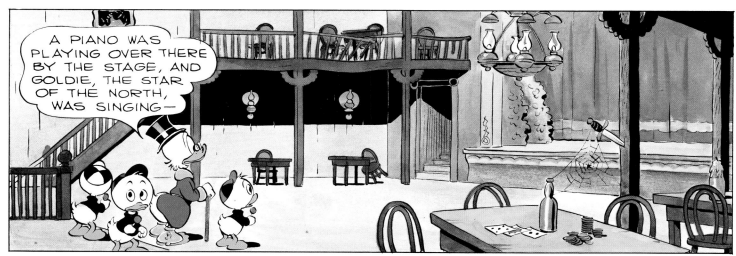

A PIANO WAS PLAYING OVER THERE BY THE STAGE, AND GOLDIE, THE STAR OF THE NORTH, WAS SINGING—

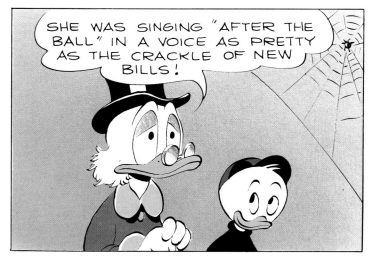

SHE WAS SINGING "AFTER THE BALL" IN A VOICE AS PRETTY AS THE CRACKLE OF NEW BILLS!

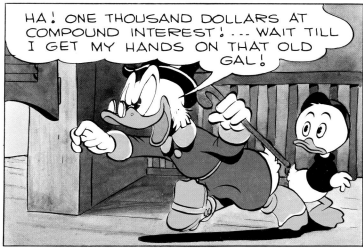

HA! ONE THOUSAND DOLLARS AT COMPOUND INTEREST! ... WAIT TILL I GET MY HANDS ON THAT OLD GAL!

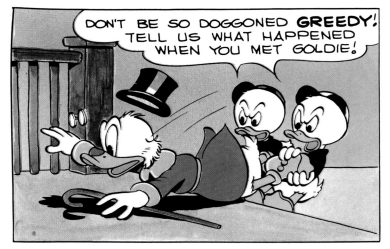

DON'T BE SO DOGGONED **GREEDY!** TELL US WHAT HAPPENED WHEN YOU MET GOLDIE!

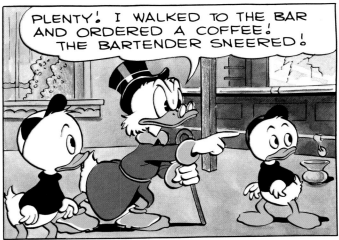

PLENTY! I WALKED TO THE BAR AND ORDERED A COFFEE! THE BARTENDER SNEERED!

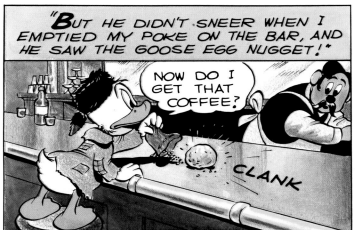

"BUT HE DIDN'T SNEER WHEN I EMPTIED MY POKE ON THE BAR, AND HE SAW THE GOOSE EGG NUGGET!"

NOW DO I GET THAT COFFEE?

CLANK

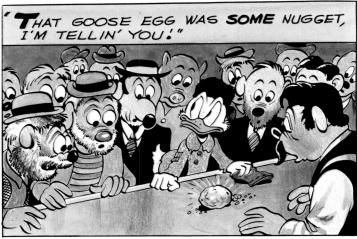

"THAT GOOSE EGG WAS **SOME** NUGGET, I'M TELLIN' YOU!"

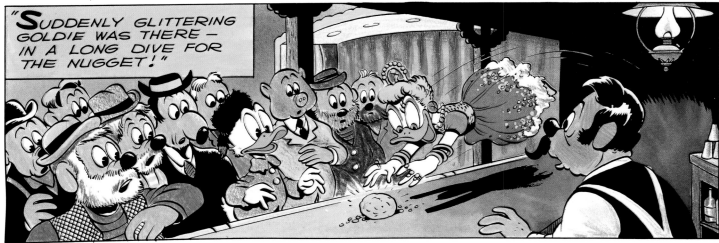

"SUDDENLY GLITTERING GOLDIE WAS THERE — IN A LONG DIVE FOR THE NUGGET!"

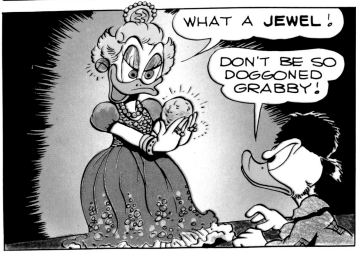

WHAT A **JEWEL!**

DON'T BE SO DOGGONED GRABBY!

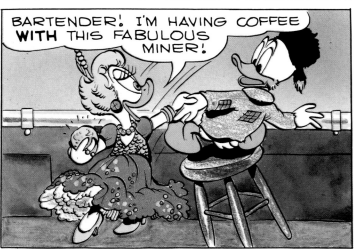

BARTENDER! I'M HAVING COFFEE **WITH** THIS FABULOUS MINER!

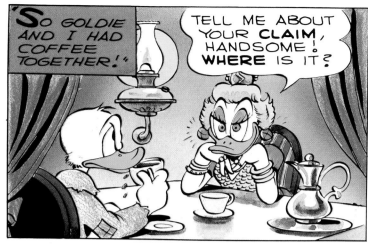

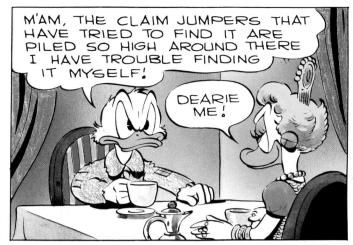

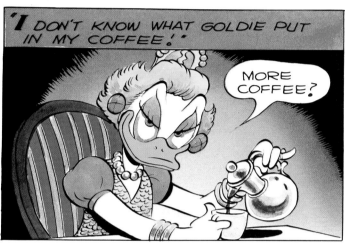

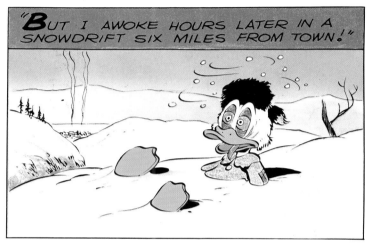

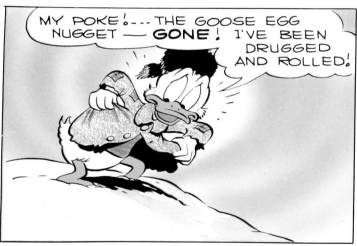

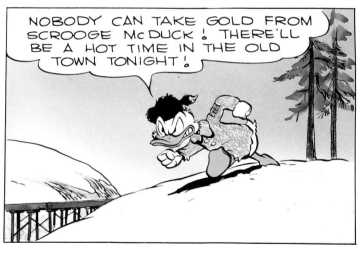

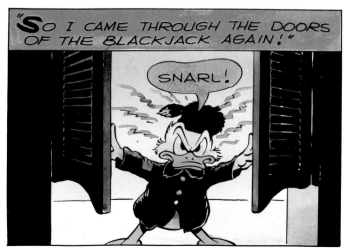

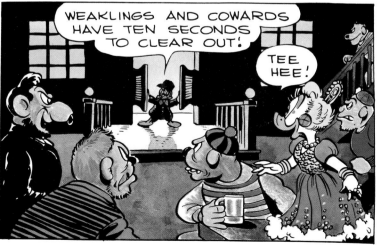

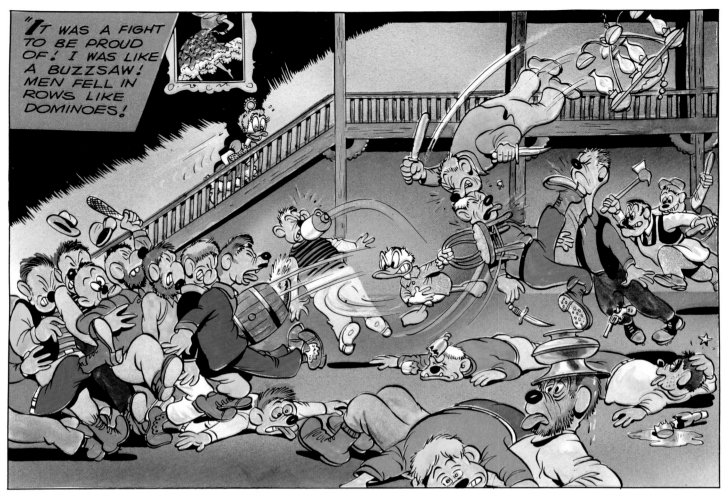

"IT WAS A FIGHT TO BE PROUD OF! I WAS LIKE A BUZZSAW! MEN FELL IN ROWS LIKE DOMINOES!"

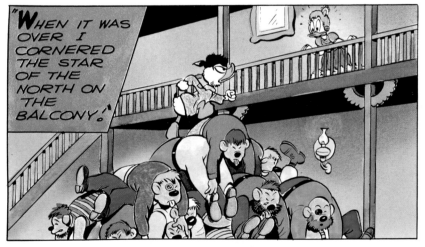

"WHEN IT WAS OVER I CORNERED THE STAR OF THE NORTH ON THE BALCONY!"

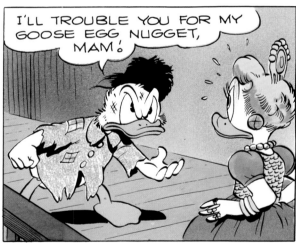

I'LL TROUBLE YOU FOR MY GOOSE EGG NUGGET, MAM!

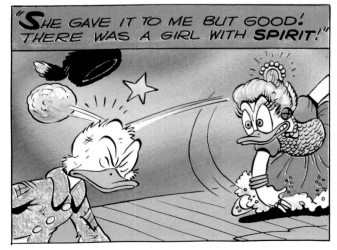

"SHE GAVE IT TO ME BUT GOOD! THERE WAS A GIRL WITH **SPIRIT!**"

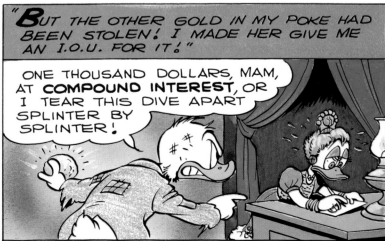

"BUT THE OTHER GOLD IN MY POKE HAD BEEN STOLEN! I MADE HER GIVE ME AN I.O.U. FOR IT!"

ONE THOUSAND DOLLARS, MAM, AT **COMPOUND INTEREST**, OR I TEAR THIS DIVE APART SPLINTER BY SPLINTER!

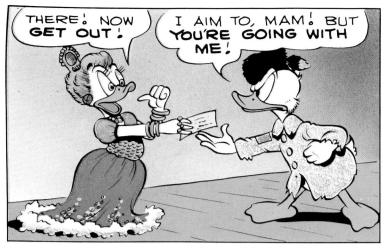

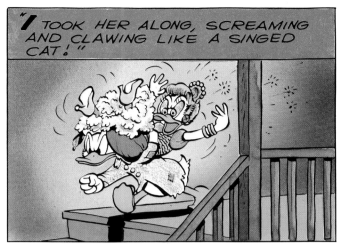

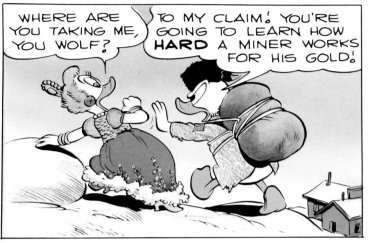

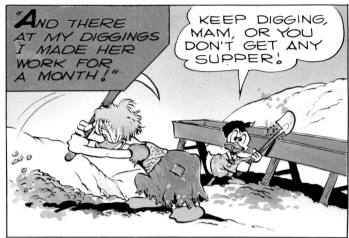

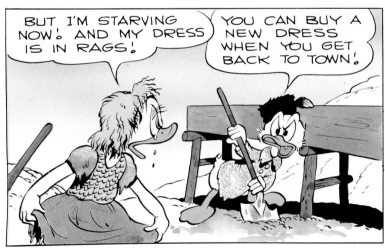

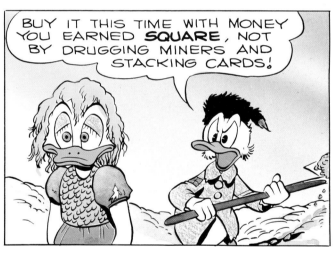

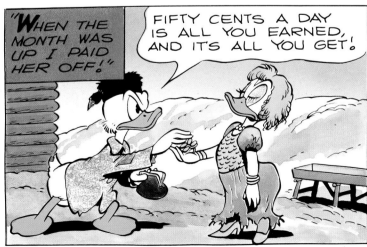

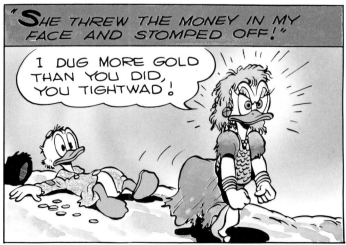

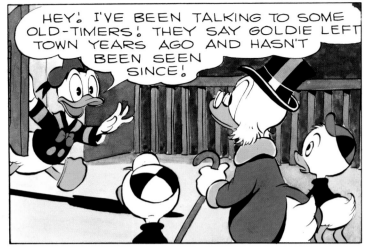

HEY! I'VE BEEN TALKING TO SOME OLD-TIMERS! THEY SAY GOLDIE LEFT TOWN YEARS AGO AND HASN'T BEEN SEEN SINCE!

WOULDN'T YOU KNOW IT! SOMEBODY OWES YOU A **BILLION** DOLLARS, AND THEY SKIP TOWN **EVERY** TIME!

WELL, THE TRIP WON'T BE A FAILURE! I CAN STILL GO AFTER MY GOLD CACHE!

SURE! IF YOU CAN *REMEMBER* WHERE IT IS!

BLACK JACK BALLROOM

DON'T WORRY, BOYS! I HAVEN'T SKIPPED MY MEMORY MEDICINE!

LET US COUNT THE CAPSULES JUST TO BE SURE!

YEP! YOU'VE BEEN OBEYING DOC'S ORDERS!

I COULD FIND MY WAY TO WHITE AGONY CREEK IN THE DARK!

NOT TONIGHT, YOU WON'T!

WE DUCKS WILL SAVE THAT AGONY FOR TOMORROW!

GOODNIGHT, UNCA' SCROOGE!

HOTEL

NEXT DAY!

WE'RE NEARLY THERE, BOYS! THIS IS WHITE AGONY CREEK!

IS THAT YOUR CABIN, UNCA SCROOGE?

YEAH! JUST LIKE I LEFT IT, EXCEPT— **SOMEBODY'S LIVING IN IT!**

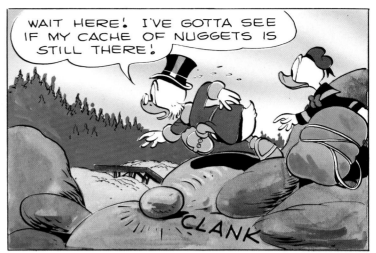

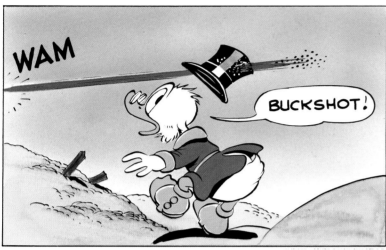

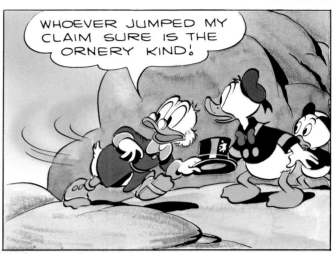

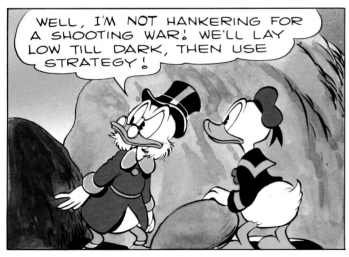

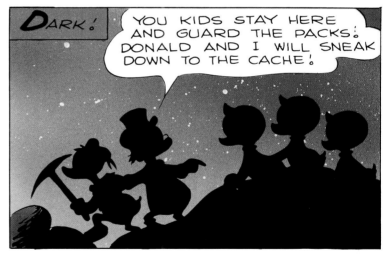

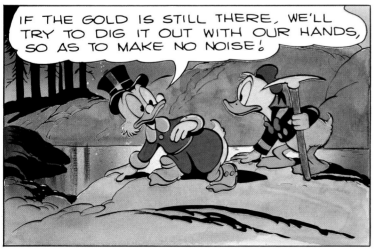

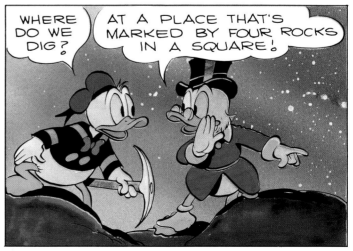

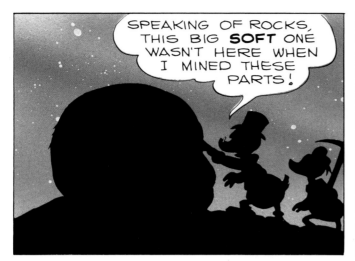

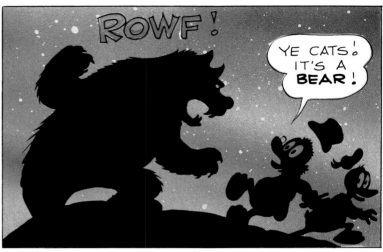

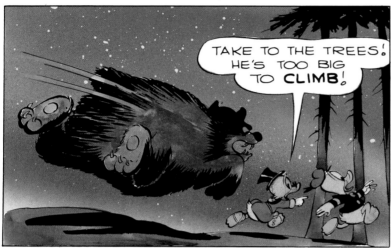

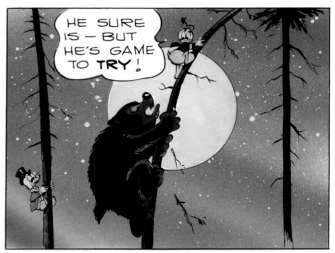

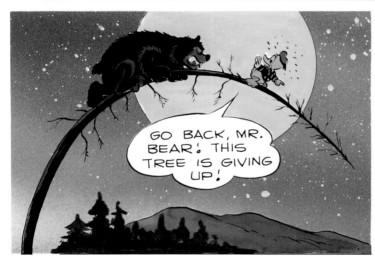

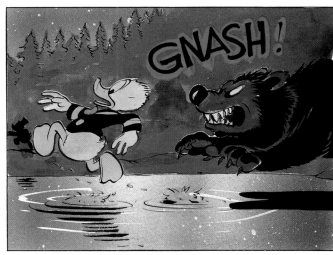

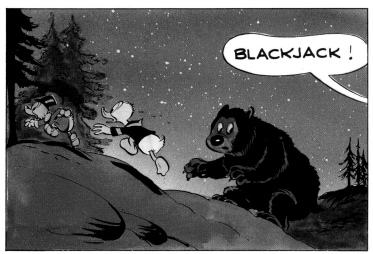

BLACKJACK!

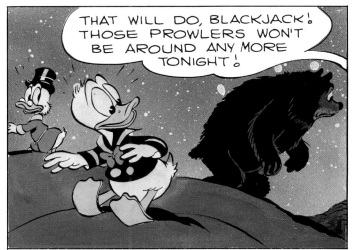

THAT WILL DO, BLACKJACK! THOSE PROWLERS WON'T BE AROUND ANY MORE TONIGHT!

UNCA DONALD! UNCA SCROOGE! DO YOU SEE WHAT WE SEE?

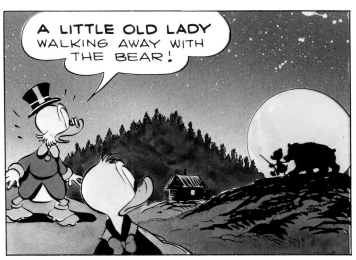

A LITTLE OLD LADY WALKING AWAY WITH THE BEAR!

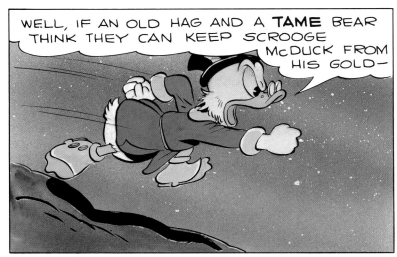

WELL, IF AN OLD HAG AND A TAME BEAR THINK THEY CAN KEEP SCROOGE McDUCK FROM HIS GOLD—

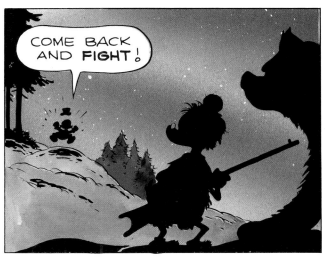

COME BACK AND FIGHT!

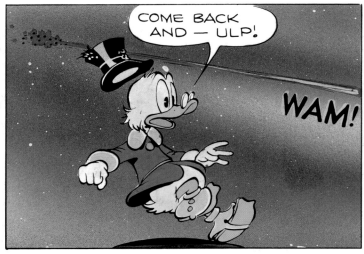

COME BACK AND — ULP!

WAM!

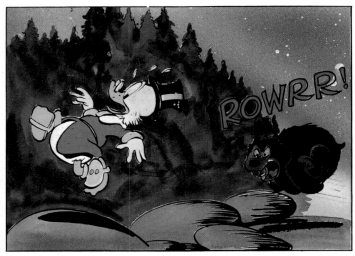

ROWRR!

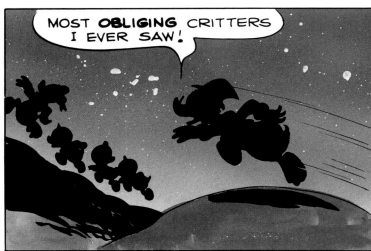

MOST **OBLIGING** CRITTERS I EVER SAW!

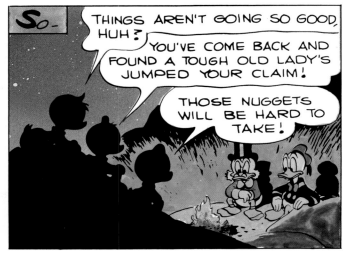

So—

THINGS AREN'T GOING SO GOOD, HUH?

YOU'VE COME BACK AND FOUND A TOUGH OLD LADY'S JUMPED YOUR CLAIM!

THOSE NUGGETS WILL BE HARD TO TAKE!

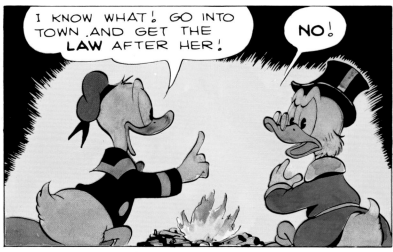

I KNOW WHAT! GO INTO TOWN AND GET THE **LAW** AFTER HER!

NO!

I — AHEM!' COFF! COFF! — KINDA HOPE TO KEEP THE LAW OUT OF THIS!

Y'SEE, I NEVER KEPT UP THE TAXES ON THAT CLAIM! IT DOESN'T BELONG TO **ME** ANYMORE THAN TO **HER**!

OHO! SO YOU'RE CLAIM-JUMPING YOUR OWN CLAIM!

WELL, IT AMOUNTS TO THAT!

MORNING! WE DAREN'T GET **ROUGH** WITH AN OLD WOMAN! LET'S SEE IF WE CAN COOK UP SOME RAZZLE-DAZZLE!

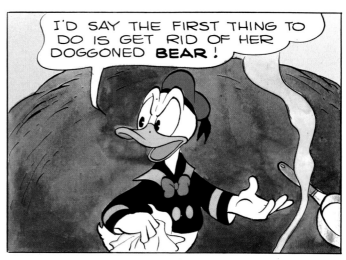

I'D SAY THE FIRST THING TO DO IS GET RID OF HER DOGGONED **BEAR**!

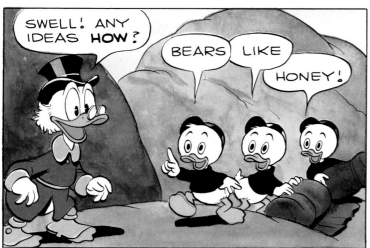

SWELL! ANY IDEAS **HOW**?

BEARS LIKE HONEY!

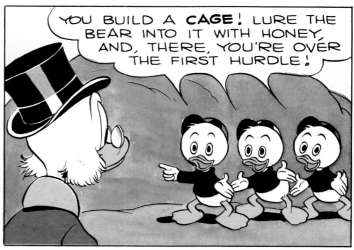

YOU BUILD A **CAGE**! LURE THE BEAR INTO IT WITH HONEY, AND, THERE, YOU'RE OVER THE FIRST HURDLE!

BOYS, I THINK I'LL RAISE YOUR WAGES TO **TWENTY-TWO** CENTS AN HOUR!

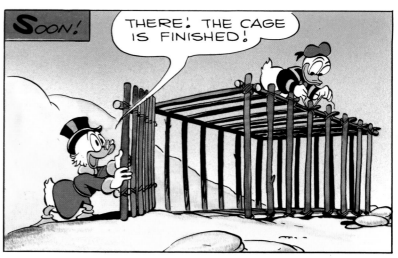

SOON! THERE! THE CAGE IS FINISHED!

HERE'S A JAR OF HONEY, UNCA SCROOGE!

DON'T HAND IT TO ME! I WON'T WAVE HONEY UNDER ANY BEAR'S NOSE!

ME, NEITHER!

NOR WILL **WE**! NOT FOR TWENTY-TWO CENTS AN HOUR!

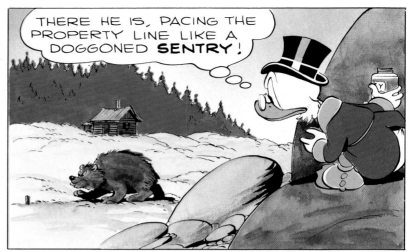

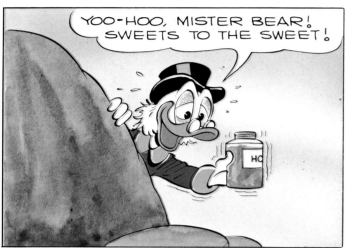

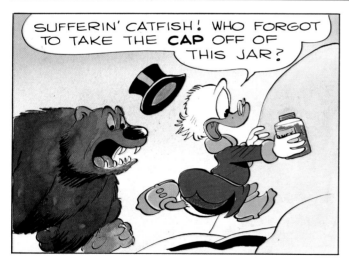

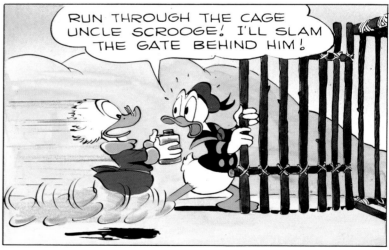

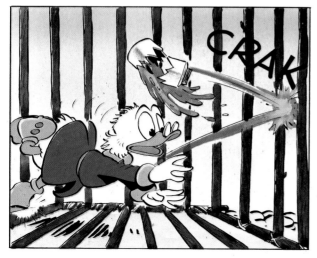

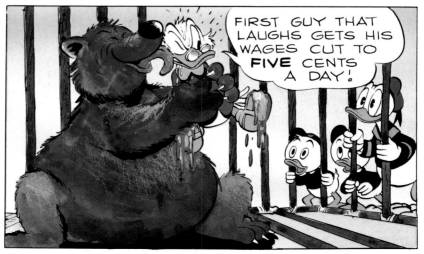

LATER! NOW LET'S PLAN THE NEXT MOVE!

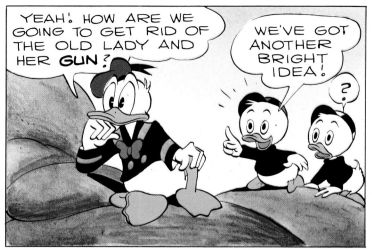

YEAH! HOW ARE WE GOING TO GET RID OF THE OLD LADY AND HER GUN?

WE'VE GOT ANOTHER BRIGHT IDEA!

?

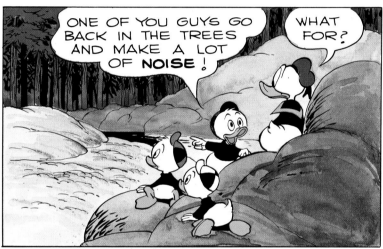

ONE OF YOU GUYS GO BACK IN THE TREES AND MAKE A LOT OF NOISE!

WHAT FOR?

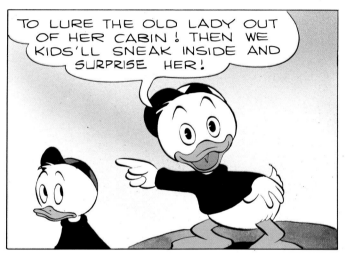

TO LURE THE OLD LADY OUT OF HER CABIN! THEN WE KIDS'LL SNEAK INSIDE AND SURPRISE HER!

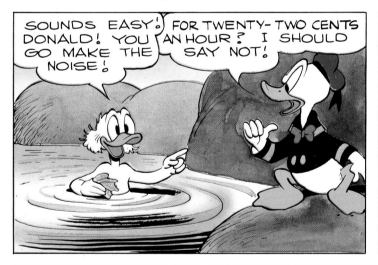

SOUNDS EASY! DONALD! YOU GO MAKE THE NOISE!

FOR TWENTY-TWO CENTS AN HOUR? I SHOULD SAY NOT!

OKAY! TWENTY-THREE CENTS! GET GOIN'!

HOW COME YOU SUGGESTED WE BREAK INTO THAT CABIN?

BECAUSE I'D KINDA LIKE TO MEET THAT OLD LADY! WOULDN'T YOU?

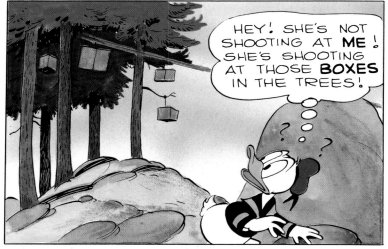

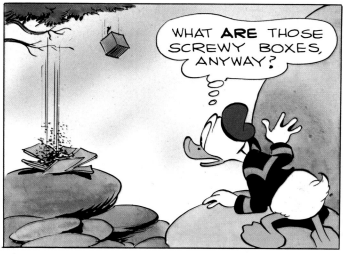

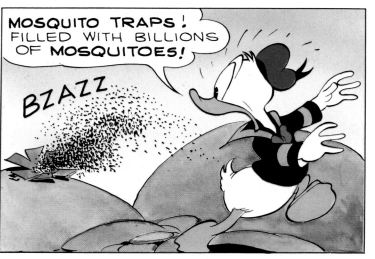

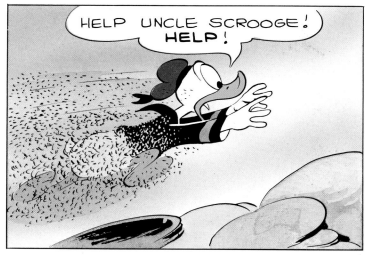

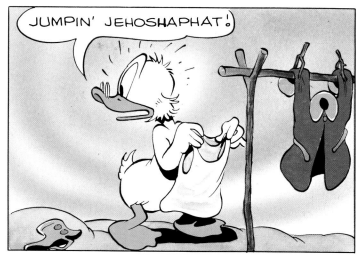

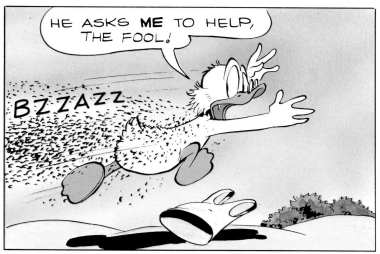

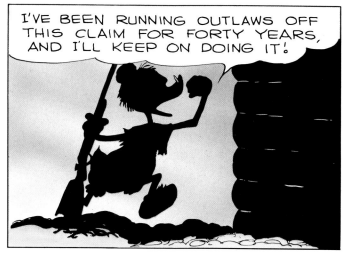

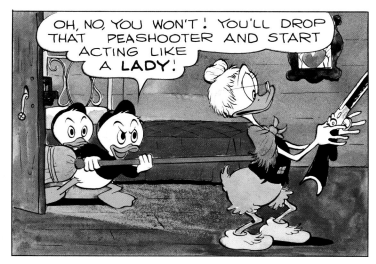

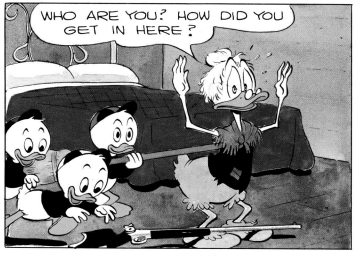

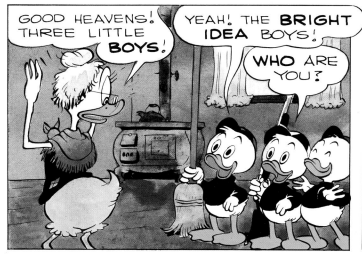

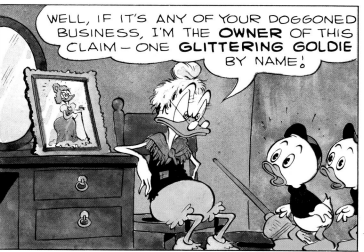

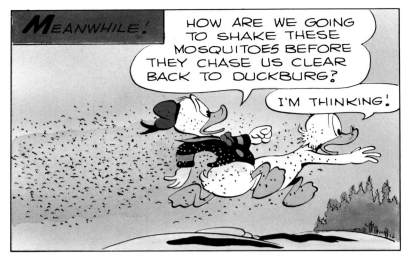

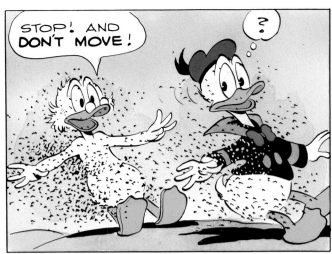

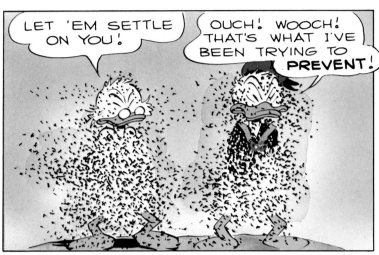

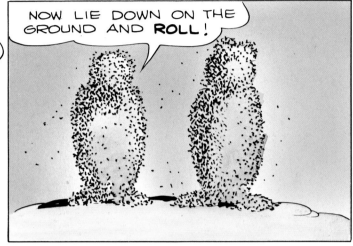

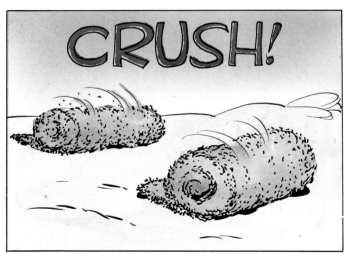

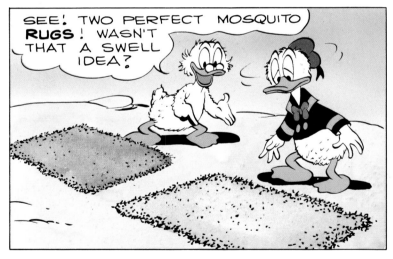

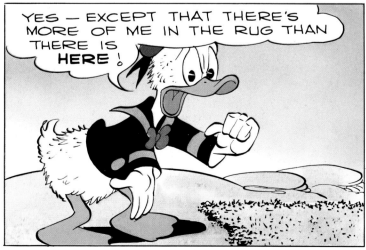

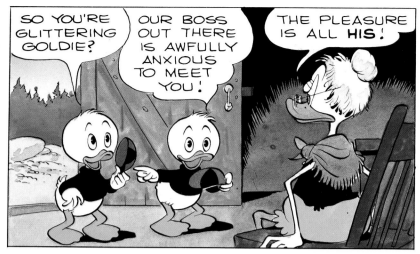

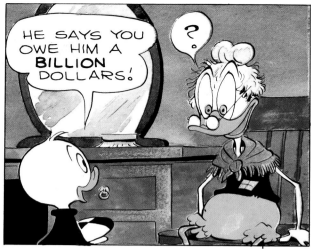

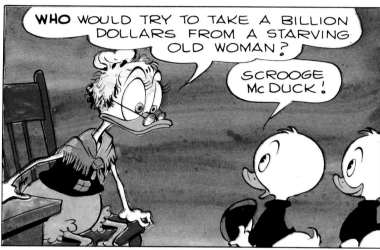

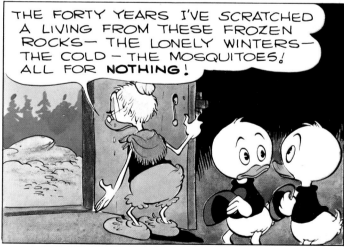

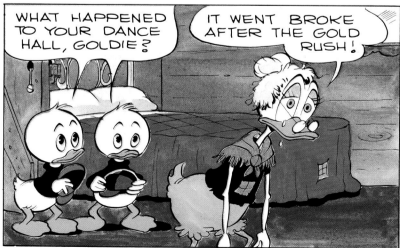

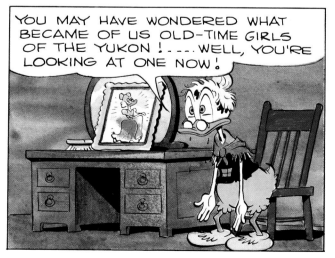

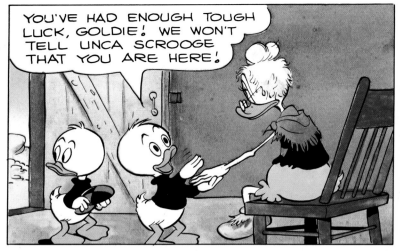

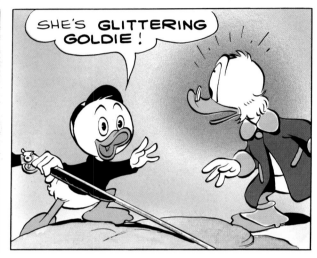

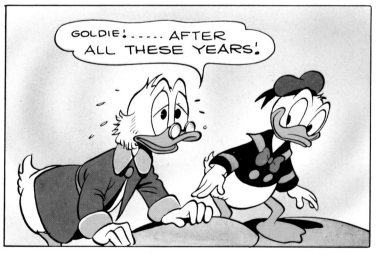

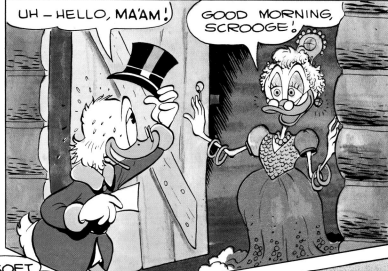

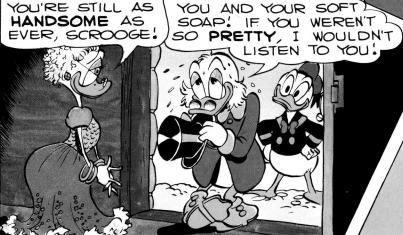

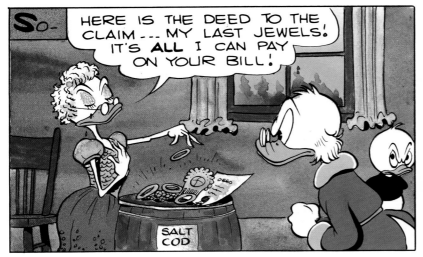

So— HERE IS THE DEED TO THE CLAIM--- MY LAST JEWELS! IT'S **ALL** I CAN PAY ON YOUR BILL!

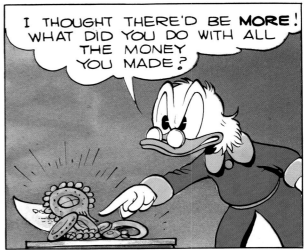

I THOUGHT THERE'D BE **MORE**! WHAT DID YOU DO WITH ALL THE MONEY YOU MADE?

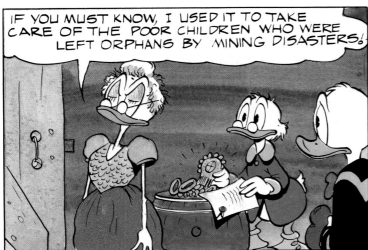

IF YOU MUST KNOW, I USED IT TO TAKE CARE OF THE POOR CHILDREN WHO WERE LEFT ORPHANS BY MINING DISASTERS!

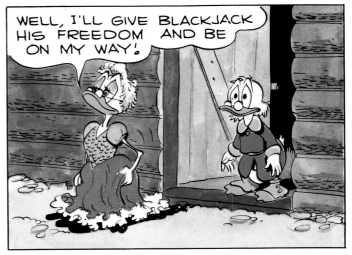

WELL, I'LL GIVE BLACKJACK HIS FREEDOM AND BE ON MY WAY!

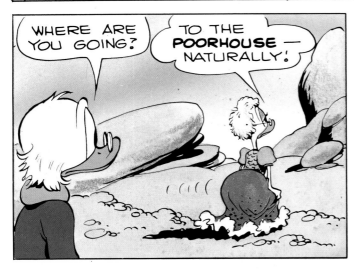

WHERE ARE YOU GOING? TO THE **POORHOUSE** — NATURALLY!

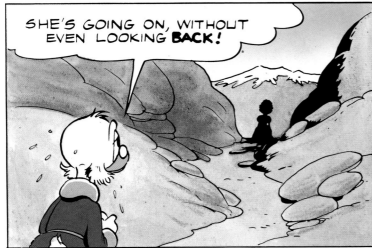

SHE'S GOING ON, WITHOUT EVEN LOOKING **BACK**!

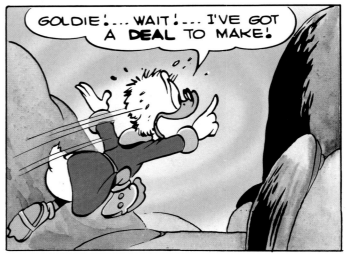

GOLDIE!.... WAIT!.... I'VE GOT A **DEAL** TO MAKE!

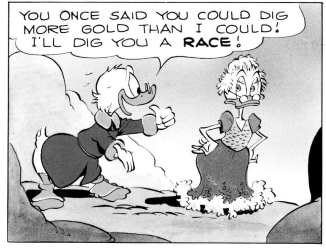

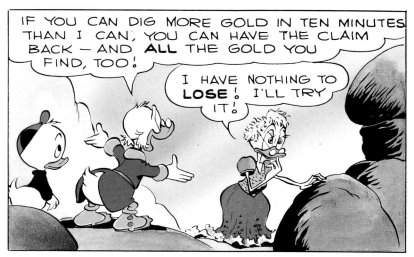

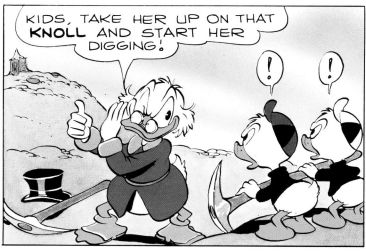

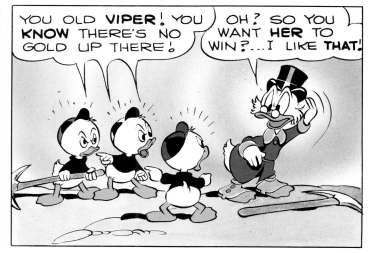

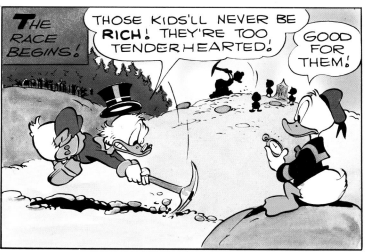

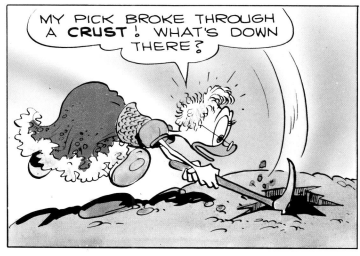

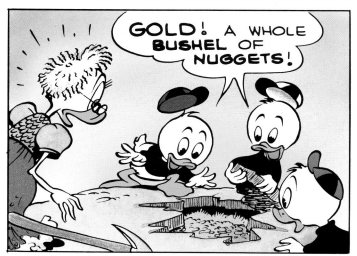

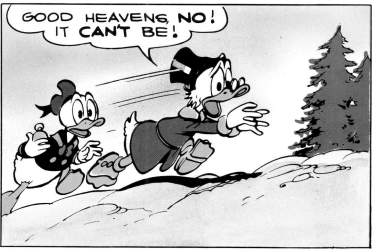

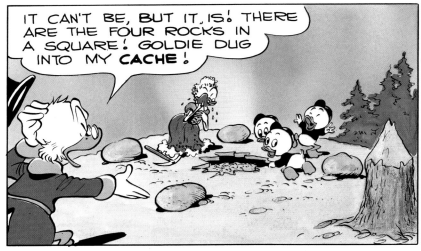

IT CAN'T BE, BUT IT IS! THERE ARE THE FOUR ROCKS IN A SQUARE! GOLDIE DUG INTO MY **CACHE**!

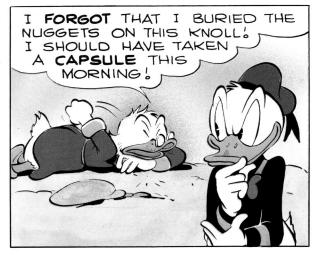

I **FORGOT** THAT I BURIED THE NUGGETS ON THIS KNOLL! I SHOULD HAVE TAKEN A **CAPSULE** THIS MORNING!

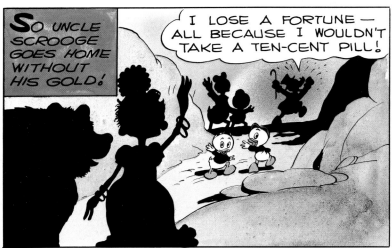

SO UNCLE SCROOGE GOES HOME WITHOUT HIS GOLD!

I LOSE A FORTUNE — ALL BECAUSE I WOULDN'T TAKE A TEN-CENT PILL!

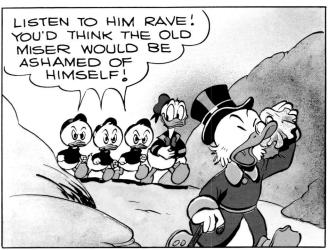

LISTEN TO HIM RAVE! YOU'D THINK THE OLD MISER WOULD BE ASHAMED OF HIMSELF!

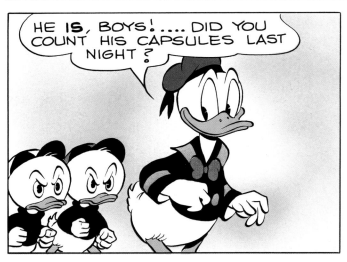

HE **IS**, BOYS! DID YOU COUNT HIS CAPSULES LAST NIGHT?

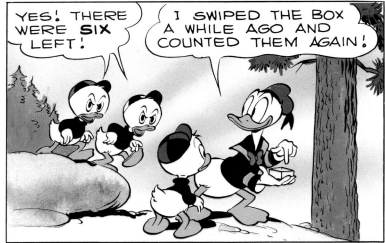

YES! THERE WERE **SIX** LEFT!

I SWIPED THE BOX A WHILE AGO AND COUNTED THEM **AGAIN**!

SEE — **FIVE**! HE **RIGGED** THAT RACE SO GOLDIE WOULD FIND HIS CACHE!

WELL, WHADDAYA KNOW! GOOD OLD UNCA SCROOGE!

During January, 1979, Carl Barks was interviewed
at his studio in southern California by Edward Summer.
Mr. Barks recalled the genesis of the stories in this volume,
recounted some of the problems of writing and drawing stories
in general, and reflected on his life and philosophy.
The appropriate sections of these anecdotal remarks follow
respectively each of the twelve stories.

The first Uncle Scrooge comic-book had been "Only a Poor Old Man." Dell Publishing decided they were going to make the book a steady feature, as Scrooge had only been a supporting character before. So "Back to the Klondike" was the second of Scrooge's own books. In the first issue Scrooge said he had made much of his fortune in the Klondike, so I did a little further buildup on his past to make a whole story about the Klondike years of his life. I used the gimmick of his losing his memory to get him back to the Klondike, where he reviewed some of his former associates and the way he made his money.

I wasn't sure just how I wanted to make Scrooge—just how much of an old tightwad, how cranky. I was afraid if I got him to be too softhearted, then he would be wishy-washy. So it was difficult to make

him do what he did in this story and still keep that whole tightwad personality. In the transition from the old guy in "Christmas on Bear Mountain"—the very first appearance of Scrooge McDuck, where he was just an invalid and a cranky old guy—to the broadening out of his character, I had to keep an awful lot of that original personality he had, greediness, crankiness, and all. Still, it seemed to me that he had to have some little bit of humanity about him. I was able to do that in "Back to the Klondike," to put both elements there, but it really was a story in which I was feeling my way along in every panel.

Now Uncle Scrooge himself was based on Gould and Harriman and Rockefeller. All those guys made their fortunes in railroads and mines and so on by being just a little bit unscrupulous with the way they eliminated the competition. That's why

they were called "Robber Barons." Scrooge had to be in that mold, or he couldn't have made it in an era when he was up against all those plutocrats. Since the Klondike era was right at the turn of the century, 1897 through about 1902, the "Robber Barons" would have been Scrooge's rivals.

So when Scrooge lets Goldie win, I had to struggle hard to make that look right. But he did it and was able to make himself believe that he had fooled the other ducks into believing he was still the old hardhearted guy, that he hadn't let his dignity down by letting her win, that it *had* been an accident, and that because of his memory pills he had been swindled. He went around pretending that he was breaking his own heart. I don't know at what stage that ending suggested itself, but somewhere in the panel-by-panel breakdown I came to it.

It's really the very first story in which I made Scrooge softhearted. After all, it's a more interesting story to have him be like that than if he was a oneline type of character, cranky and stingy all the way through, who would let this old lady duck get the worst end of the stick in the finale. I don't think it would have been as popular a story. But the fact that I did let him crack his armor just a little bit made it a better story.

I didn't write a full script, but I wrote a fairly detailed synopsis. And then I broke that down into panel-by-panel stuff. I started it when I was still living in San Jacinto. I had just been divorced from my second wife at that time, and I was kind of at loose ends. I thought I would like to go up to Seattle and spend the summer up there away from the heat. So I took my drawings and drawing board and drove north. I drew most of the story in motels: some in Grants Pass, Oregon, and some

in Seattle. I was working on the story for at least a month, but not steadily. It was in Seattle that I got the idea of going down to one of the bookstores and finding some books on the Klondike. I found an old book that was practically an eye-witness account. Reading this is how I got off on this wild beat of having Scrooge have the big fight in the saloon, kidnap this gal, and take her out to the hills and make her work out her debt. (This is the scene that has been restored in this book.)

After having worked in the story and storyboard department at Disney's for seven years, I sometimes felt that somebody was looking over my shoulder and keeping the story in a certain line, even though there was nobody really there. In moving picture cartoons, because the action is actually going to move on the screen, there is a certain kind of timing involved, which is in real time. That time element was not so important in comic-book work because I could explain if there was any gap in time with a little box up in the corner saying "Later" or "Next Day." Otherwise, the drawings moved from one situation to another, and the dialogue indicated the time sequence in which the various events took place. For instance, where Scrooge goes up the river looking for his old mining claim, the passage of time is all indicated by where they are in a given panel. There are about four panels still missing from this sequence. I've redrawn them to the best of my recollection, but haven't inked or colored them since they aren't the originals. They restore the time sequence and page layouts to the proper order for the very first time.

When I laid the stories out, I was trying to get some gimmick down on the end of each page that would make people turn the page over. A little climax of some sort. I

tried to get such a climax in every four panels if possible, but just a small one because when you're working on a story that has a whole lot of ramifications, you can't always do it without cheating on something. It is for this reason, in fact, that the previously missing pages and panels threw the story off so much. Climaxes that were meant to be at the end of a page were in the middle and vice versa. If you compare this book with the previously published ver-

sion it will be very clear.

I was always looking for sight gags if I could use one, especially a good, funny action one that would advance the story. I certainly preferred that to just a dialogue gag: for example, where Scrooge finds a string hanging from the ceiling, can't remember what it's for, pulls it, and a gigantic fist comes down and knocks him into the floor. It's the same kind of gag, a visual gag, that we used in the movie cartoons.

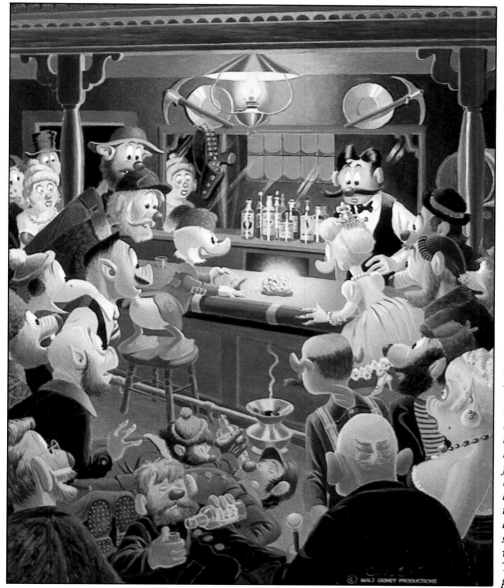

"The Goose Egg Nugget," oils, 20" x 16", 1973. Between 1971 and 1976, Carl Barks did approximately 120 paintings, which, like this one, expanded upon or duplicated scenes and covers from his best-loved stories. At first, the paintings were done to order at the rate of about one per month. Eventually, however, the demand and the waiting list became so huge that the paintings were sold at public auction. This painting is Mrs. Barks's personal favorite.

Donald is a little quieter and more passive in this story. After all, Scrooge is the hero. Scrooge is such a colorful character that Donald has to take a backseat and be upstaged in nearly all the panels.

Since I had to have a comic menace, I thought a bear would be good. The ducks can fight with the bear and have a lot of rough stuff, whereas with an old lady, they couldn't bang her around and knock her down. The bear furnished something for the old lady to fight with; she could use the bear to do her fighting for her.

Often I was pleasantly surprised by an opportunity that would develop by getting a character into a certain situation. Something would pop into my head that would tell me that it would be funny if Scrooge could say thus-and-so right here. A good dialogue gag would just pop into my head, but it grew out of knowing where I was going to end up. The building of the cage, for example, suggested the situation where Uncle Scrooge tries to lead the bear into the cage and gets stuck in it himself. It was actually only after I started breaking the story down page by page that this gag was built with a pencil and paper and just longhand writing. I rarely let myself come to a dead end where I'd throw away three or four panels after I had actually drawn them.

The mosquito scene came out of a situation where Gertie had to have the help of nature to battle those darn ducks. The gag of the ducks unrolling themselves and squeezing the mosquitos—that's a sight gag that grew out of the situation. I didn't even think of it until I was this far along in the writing.

I very seldom used oddshaped panels like those where Scrooge and Goldie meet again by her cabin because they seemed to make a botch whenever we started cutting

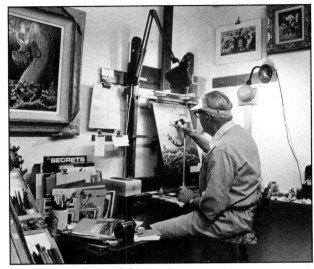

Carl Barks at his easel, late 1970's.

panels out: It messed up the panels around them. I sometimes stretched panels out of shape to put in a lot of dialogue or because I was just getting tired of always using square panels.

There is one other curious thing about a painting I did many years later of the scene where old Uncle Scrooge bangs his "Goose Egg Nugget" down on the bar and all these dance hall girls are around. Nostalgia about the gold rush country and the old dance hall girls had a lot to do with my thinking on that story. There were still some dance hall girls alive and around and they'd get a write-up in the paper once in a while. I had tried to make Goldie a believable person because I thought that people were interested in what became of these girls. Anyway, shortly after I did this painting, the *National Geographic* did an article about the city of Dawson during the gold rush and told about the dance halls. In my painting one of the girls has a pig face, and another one a big glittering tooth. The *Geographic* said there were two famous belles of the Klondike named Nellie the Pig and Diamond-toothed Gertie! But I never knew it until after I did the painting.

TROUBLE FROM LONG AGO

(The Horseradish Story)

Trouble From Long Ago
(*The Horseradish Story* or
The Month of the Golden Goose)
Uncle Scrooge #3 (Four Color 495)
September 1953

In many stories starring Uncle Scrooge, the old miser is depicted as short on mercy and about as mean as a bilious banker, but if you think *he* is mean, you should meet some of the villains he deals with.

Chisel McSue, the villain of this piece, is the scion of a long line of swindlers that goes back to the days of wooden ships and iron men. He matches mettle with Uncle Scrooge in the stormy waters of the Bermuda Triangle and makes the old duck seem like a soft-hearted saint. *C.B. 1981*

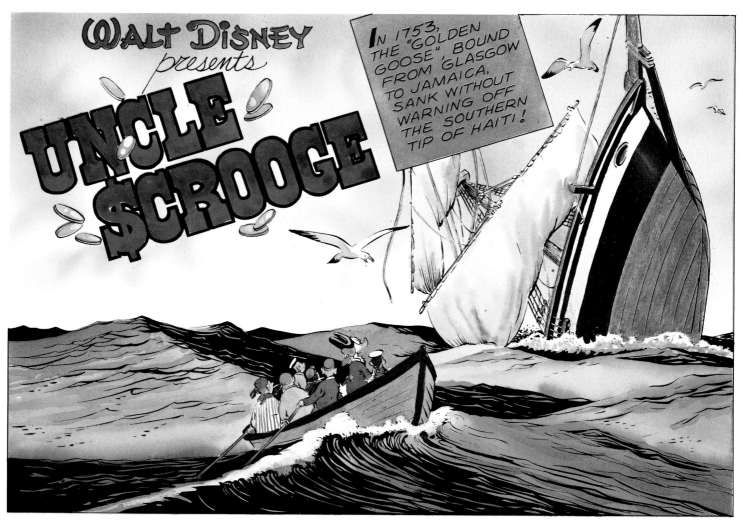

WALT DISNEY presents UNCLE $CROOGE

IN 1753, THE "GOLDEN GOOSE" BOUND FROM GLASGOW TO JAMAICA, SANK WITHOUT WARNING OFF THE SOUTHERN TIP OF HAITI!

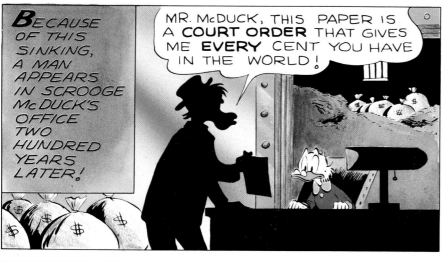

BECAUSE OF THIS SINKING, A MAN APPEARS IN SCROOGE McDUCK'S OFFICE TWO HUNDRED YEARS LATER!

MR. McDUCK, THIS PAPER IS A **COURT ORDER** THAT GIVES ME **EVERY** CENT YOU HAVE IN THE WORLD!

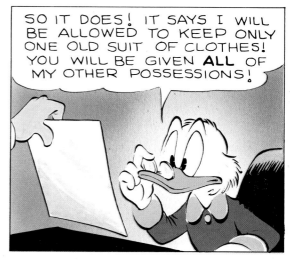

SO IT DOES! IT SAYS I WILL BE ALLOWED TO KEEP ONLY ONE OLD SUIT OF CLOTHES! YOU WILL BE GIVEN **ALL** OF MY OTHER POSSESSIONS!

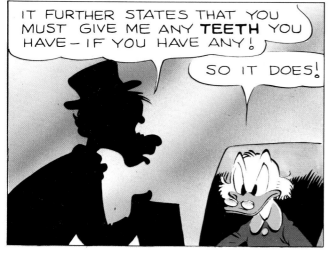

IT FURTHER STATES THAT YOU MUST GIVE ME ANY **TEETH** YOU HAVE — IF YOU HAVE ANY!

SO IT DOES!

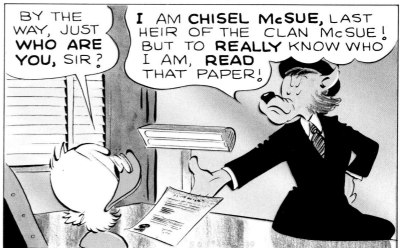

BY THE WAY, JUST **WHO ARE YOU**, SIR?

I AM **CHISEL McSUE**, LAST HEIR OF THE CLAN McSUE! BUT TO **REALLY** KNOW WHO I AM, **READ** THAT PAPER!

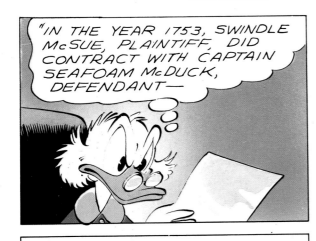

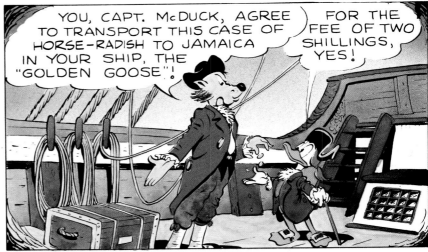

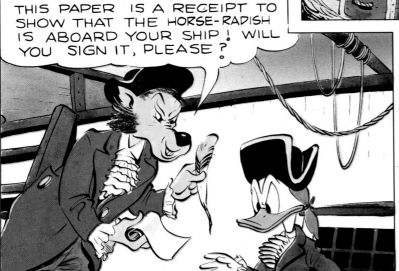

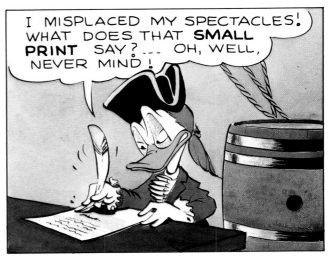

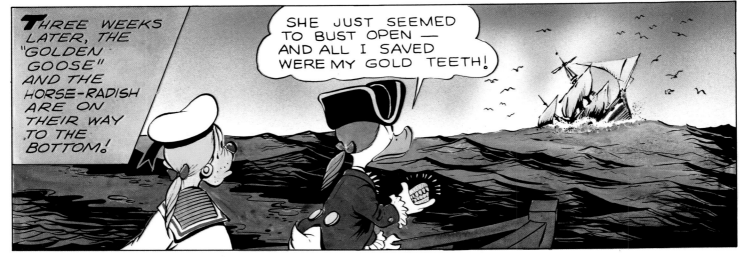

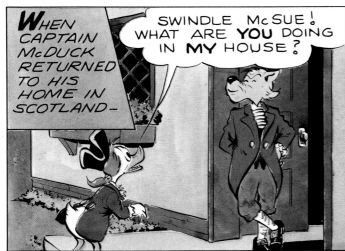

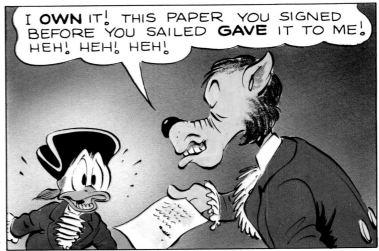

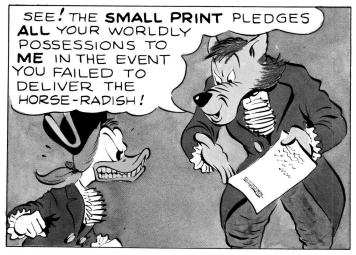

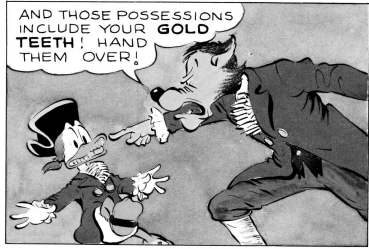

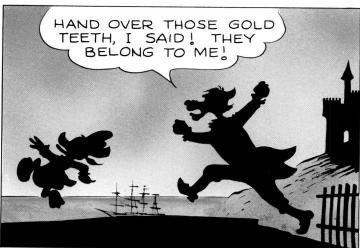

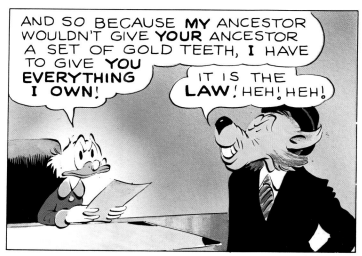

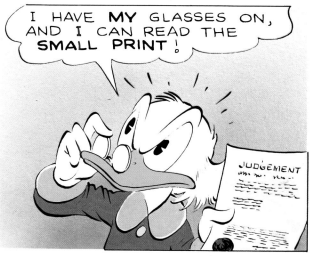

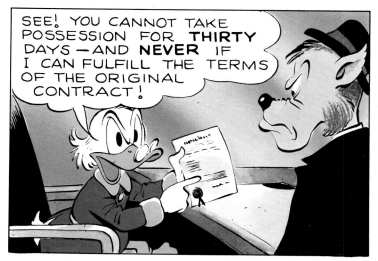

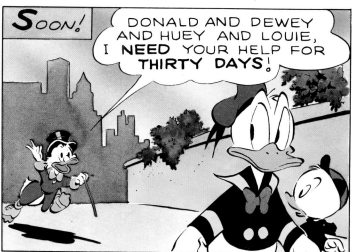

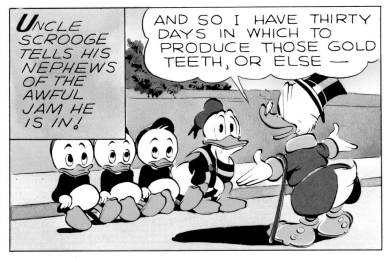

UNCLE SCROOGE TELLS HIS NEPHEWS OF THE AWFUL JAM HE IS IN!

AND SO I HAVE THIRTY DAYS IN WHICH TO PRODUCE THOSE GOLD TEETH, OR ELSE —

HAVE YOU ANY IDEA WHAT BECAME OF THEM?

YES! I USED THEM TO START MY FORTUNE! THAT'S WHERE HE HAS ME BY THE LEGAL NOSE!

THEY WERE THE ONLY HEIRLOOM HANDED DOWN TO ME BY MY FOREFATHERS! I SOLD THE GOLD FOR ENOUGH MONEY TO BUY A PROSPECTOR'S OUTFIT!

AND BECAUSE I CAN'T NOW PRODUCE THOSE TEETH, I HAVE TO DO THE OTHER THING!

THE OTHER THING?

YES! I HAVE TO DELIVER THE ORIGINAL CASE OF HORSE-RADISH TO JAMAICA!

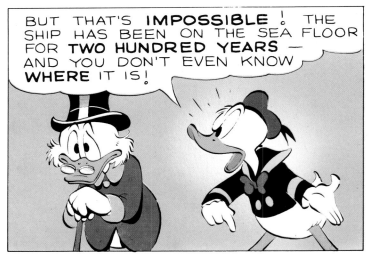

BUT THAT'S IMPOSSIBLE! THE SHIP HAS BEEN ON THE SEA FLOOR FOR TWO HUNDRED YEARS — AND YOU DON'T EVEN KNOW WHERE IT IS!

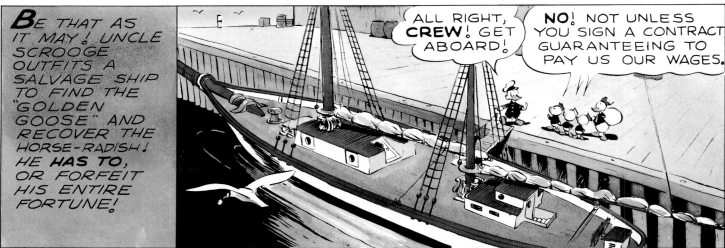

BE THAT AS IT MAY! UNCLE SCROOGE OUTFITS A SALVAGE SHIP TO FIND THE "GOLDEN GOOSE" AND RECOVER THE HORSE-RADISH! HE HAS TO, OR FORFEIT HIS ENTIRE FORTUNE!

ALL RIGHT, CREW! GET ABOARD!

NO! NOT UNLESS YOU SIGN A CONTRACT GUARANTEEING TO PAY US OUR WAGES.

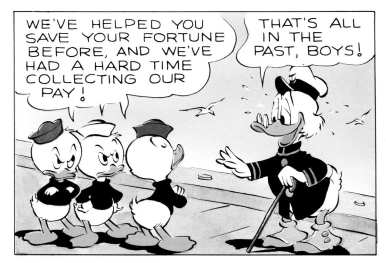

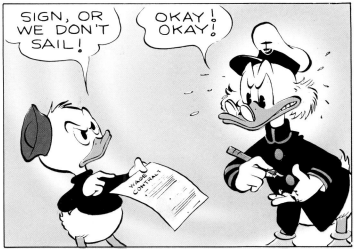

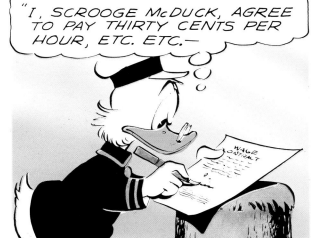

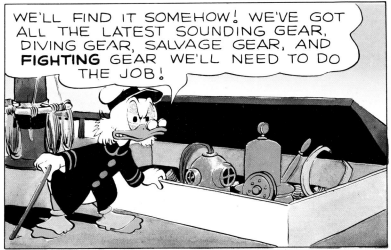

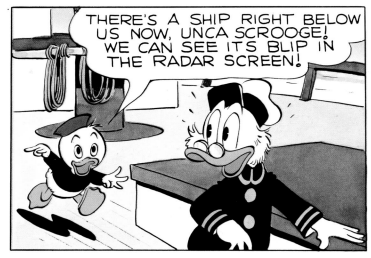

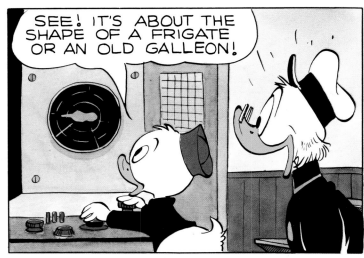

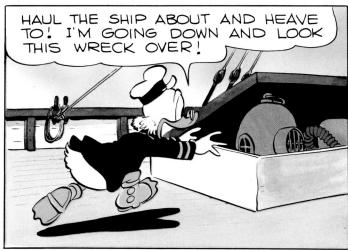

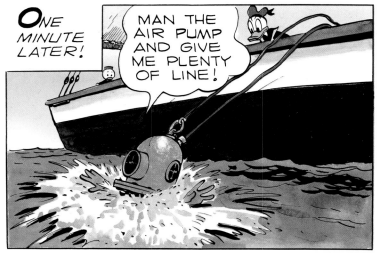

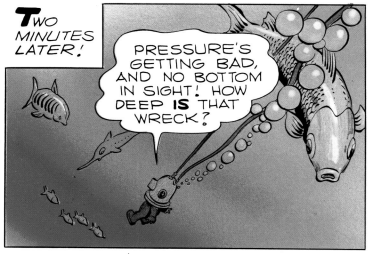

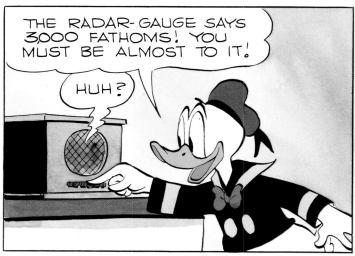

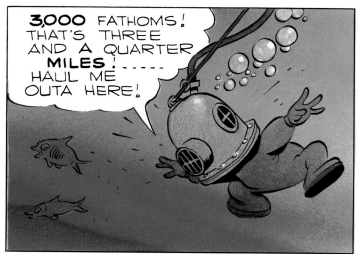

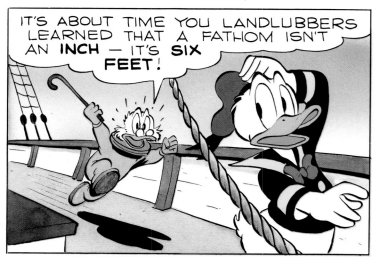

LATER...OUTFITTED FOR SHARK-FIGHTING, DONALD DANGLES ALONG ABOVE THE OCEAN FLOOR!

THE SEA BOTTOM IS AN INTERESTING PLACE! HERE'S A TANKER THAT WAS SUNK DURING THE WAR!

AND THERE'S AN OLD ENGLISH SHIP OF THE LINE WITH BARNACLES IN HER CANNONS!

MORE KINDS OF FISH THAN YOU CAN SHAKE A STICK AT!

HEY, DO YOU WANT A **BLUE** FISH FOR DINNER, OR A YELLOW ONE WITH POLKA DOTS?

YOU LOOK FOR THAT **SHIP**, OR THERE WON'T BE ANY DINNER FOR ANYBODY!

HUH! THIS IS FUNNY!... VERY ODD!

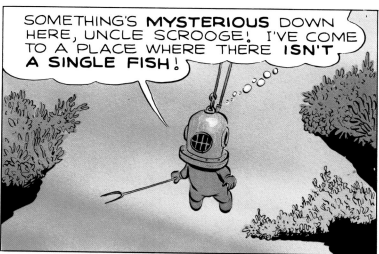

SOMETHING'S **MYSTERIOUS** DOWN HERE, UNCLE SCROOGE! I'VE COME TO A PLACE WHERE THERE **ISN'T A SINGLE FISH!**

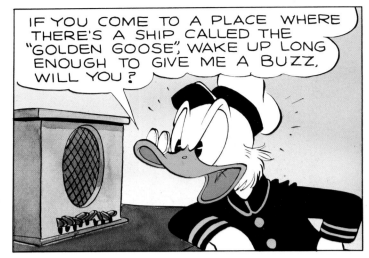

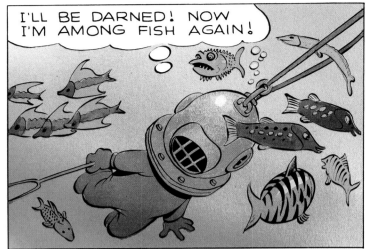

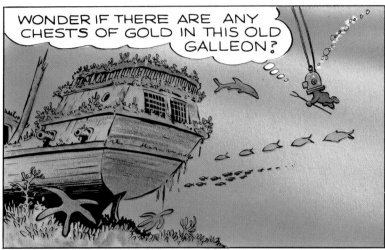

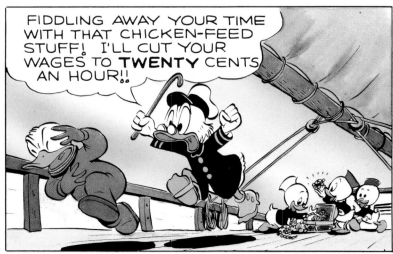

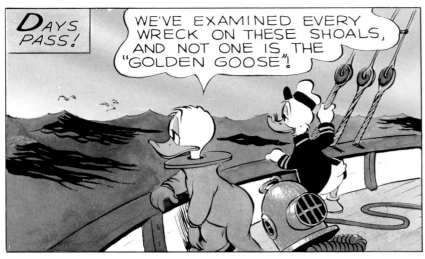

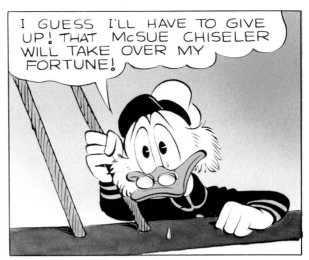

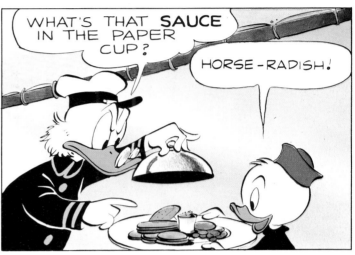

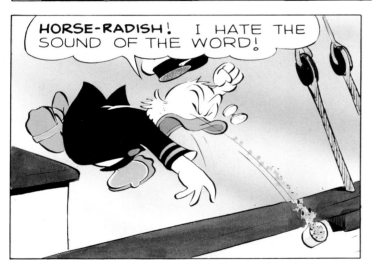

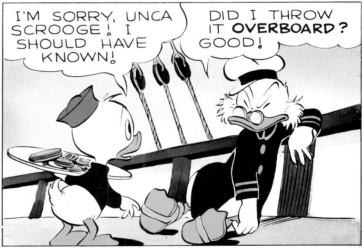

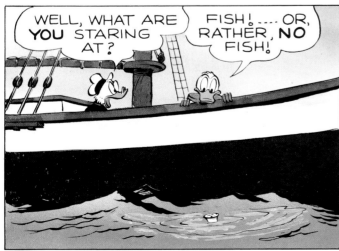

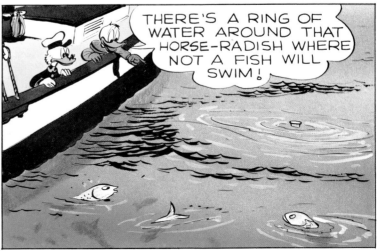

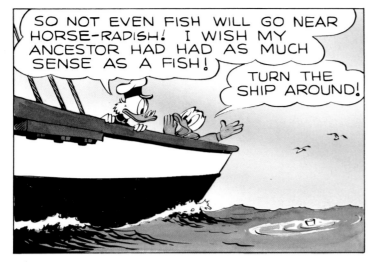

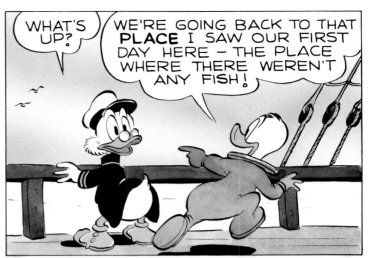

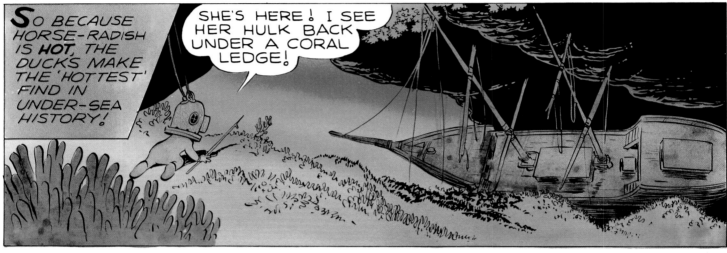

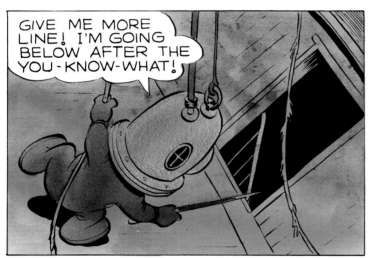

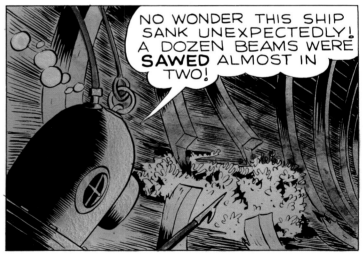

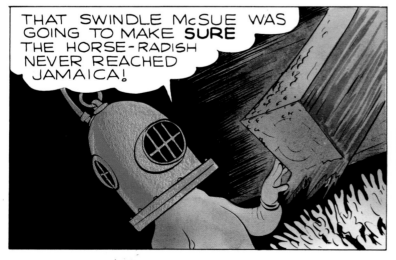

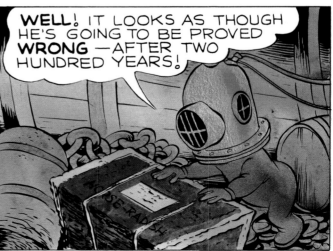

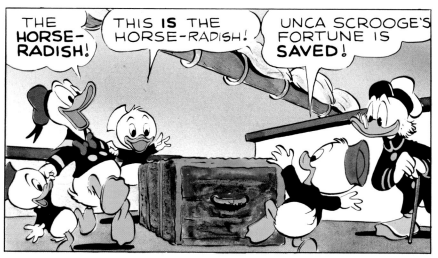

THE HORSE-RADISH!

THIS **IS** THE HORSE-RADISH!

UNCA SCROOGE'S FORTUNE IS **SAVED**!

FOR NOW, YES! BUT MY WORRIES AREN'T OVER **YET**!

I STILL HAVE TO DELIVER THAT CASE TO THE CUSTOMS HOUSE IN JAMAICA — AND **TIME IS RUNNING SHORT**!

HOIST THE SAILS! BATTEN THE HATCHES, AND SPIN OUT THE SPINNAKERS!

A RACE ISN'T WON TILL THE LAST LAP IS RUN!

HOW MUCH TIME IS LEFT OF YOUR THIRTY DAYS?

THREE DAYS!

AND JAMAICA IS HOW MANY DAYS SAIL?

TWO — WITH A FAIR WIND!

BY THE WAY, **WHAT BECAME** OF OUR WIND?

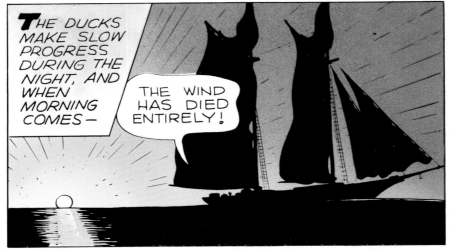

THE DUCKS MAKE SLOW PROGRESS DURING THE NIGHT, AND WHEN MORNING COMES—

THE WIND HAS DIED ENTIRELY!

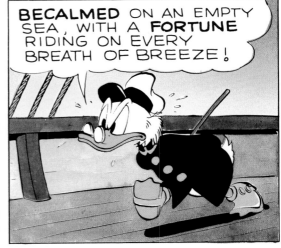

BECALMED ON AN EMPTY SEA, WITH A FORTUNE RIDING ON EVERY BREATH OF BREEZE!

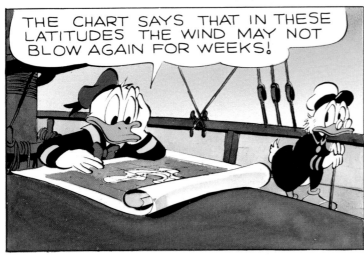

THE CHART SAYS THAT IN THESE LATITUDES THE WIND MAY NOT BLOW AGAIN FOR WEEKS!

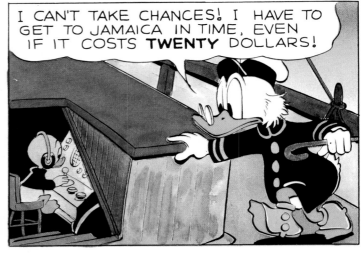

I CAN'T TAKE CHANCES! I HAVE TO GET TO JAMAICA IN TIME, EVEN IF IT COSTS TWENTY DOLLARS!

DEWEY, RADIO THE NEAREST PORT FOR A TUG TO TOW US TO JAMAICA!

AYE, AYE, SIR!

AND TELL 'EM TO HURRY! I DON'T LIKE THE LOOKS OF THINGS!

LATER!

THE PORT OFFICERS CAN'T PROMISE A TUG, UNCA SCROOGE! THEY SAY NO BOAT WILL LEAVE THE HARBOR NOW!

THERE'S A HURRICANE COMING!

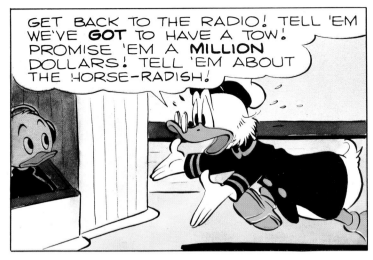

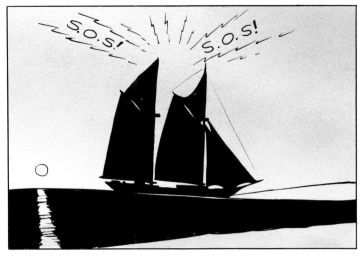

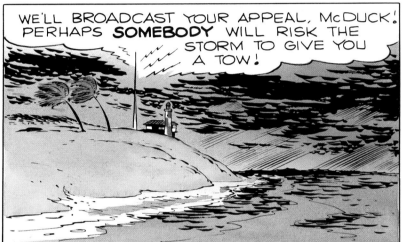

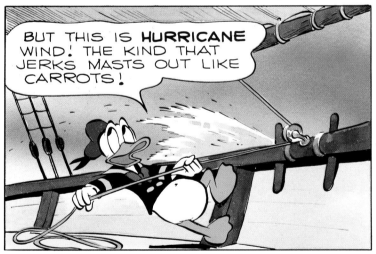

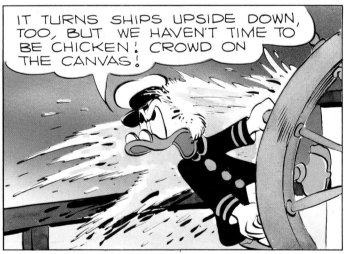

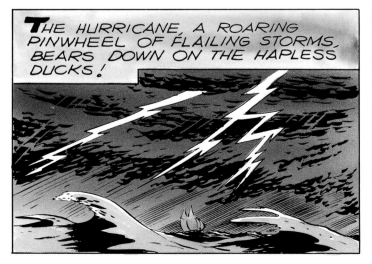

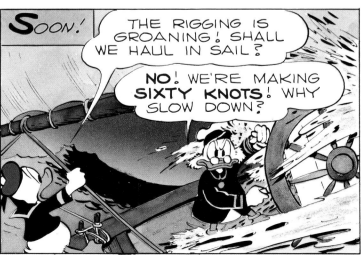

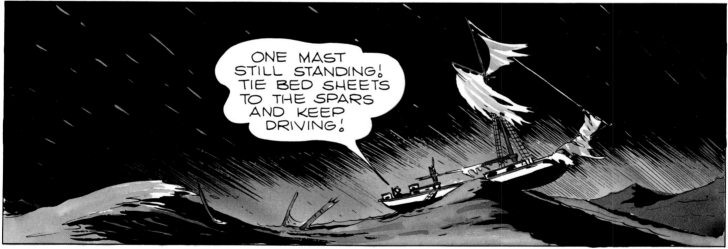

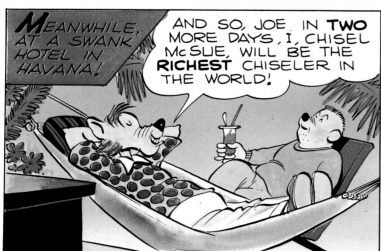

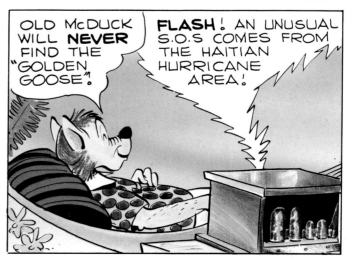

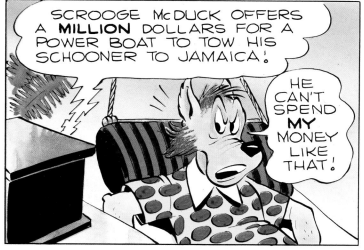

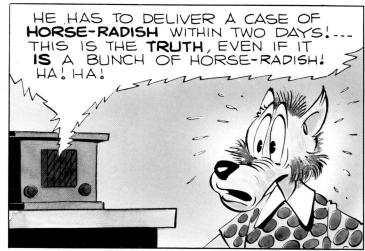

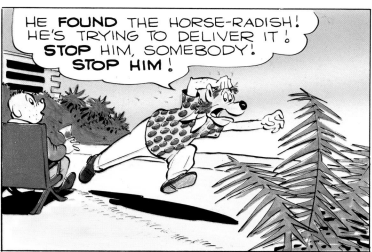

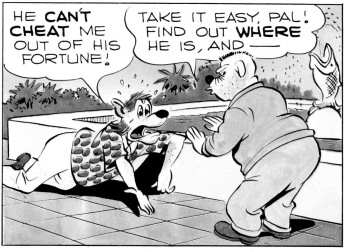

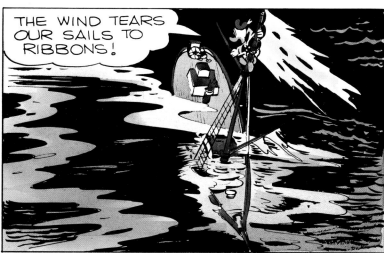

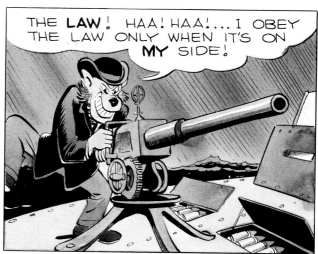

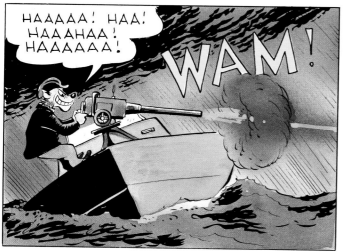

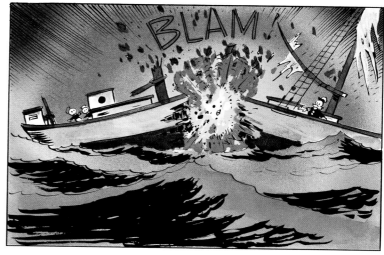

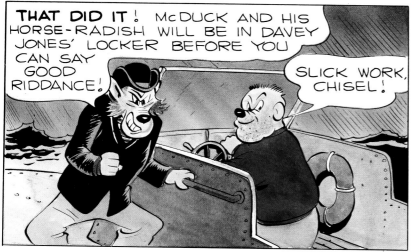

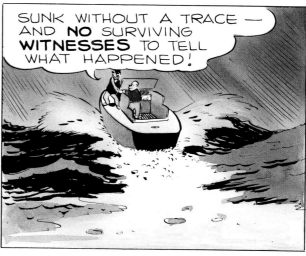

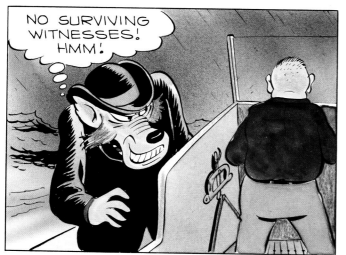

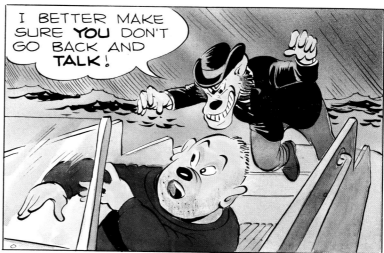

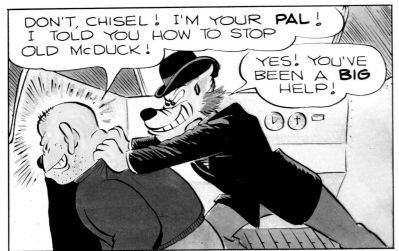

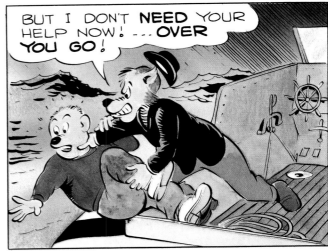

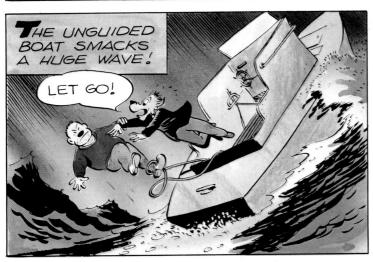

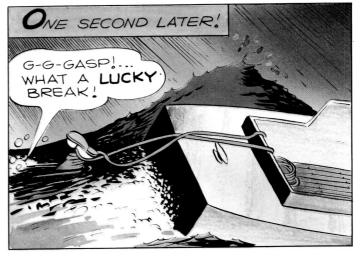

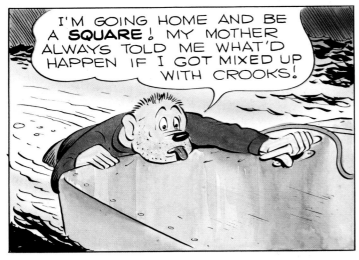

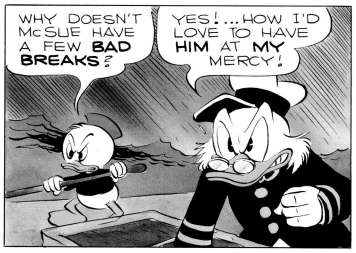

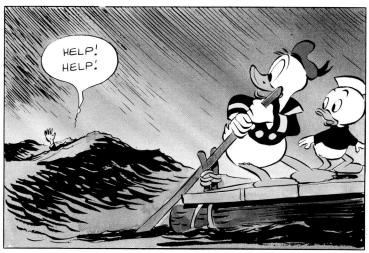

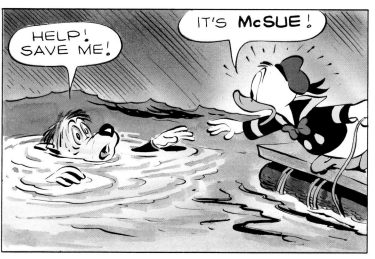

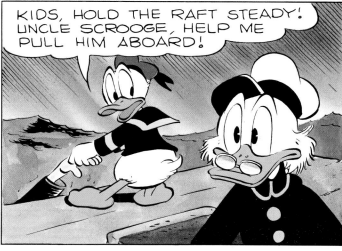

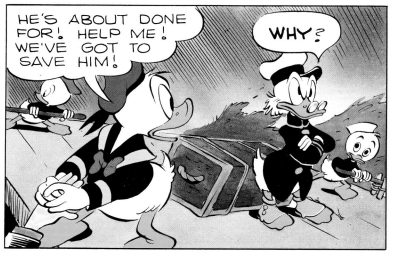

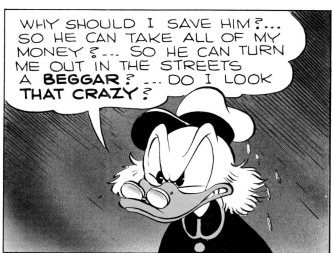

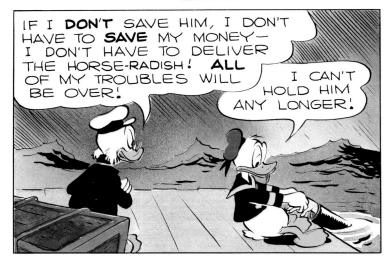

IF I **DON'T** SAVE HIM, I DON'T HAVE TO **SAVE** MY MONEY— I DON'T HAVE TO DELIVER THE HORSE-RADISH! **ALL** OF MY TROUBLES WILL BE OVER!

I CAN'T HOLD HIM ANY LONGER!

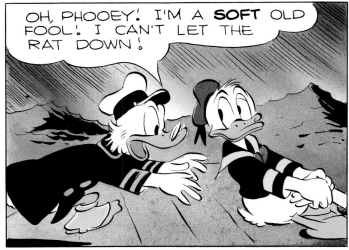

OH, **PHOOEY!** I'M A **SOFT** OLD FOOL! I CAN'T LET THE RAT DOWN!

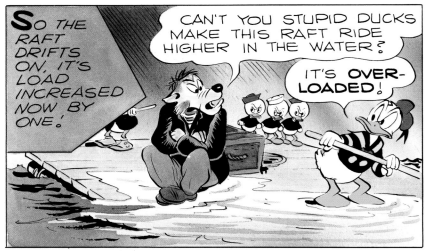

So THE RAFT DRIFTS ON, ITS LOAD INCREASED NOW BY ONE!

CAN'T YOU STUPID DUCKS MAKE THIS RAFT RIDE HIGHER IN THE WATER?

IT'S **OVER-LOADED!**

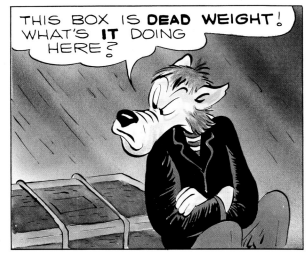

THIS BOX IS **DEAD WEIGHT!** WHAT'S **IT** DOING HERE?

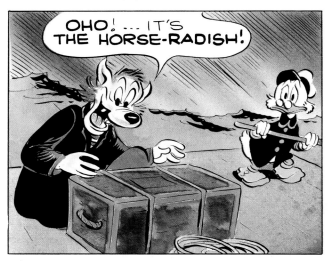

OHO! ...IT'S THE **HORSE-RADISH!**

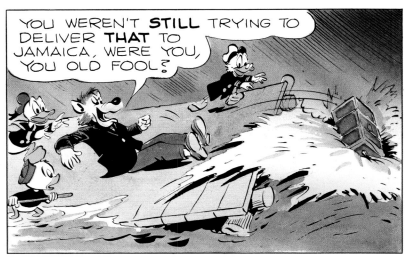

YOU WEREN'T **STILL** TRYING TO DELIVER **THAT** TO JAMAICA, WERE YOU, YOU OLD FOOL?

IT'S **MY** FAULT, DONALD! I SAVED HIM!

THIS MISERABLE RAFT IS **STILL OVERLOADED** — BY FIVE DUCKS!

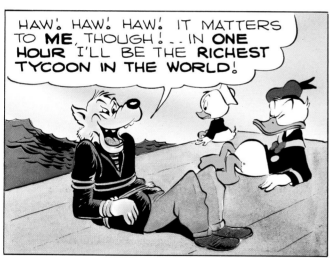

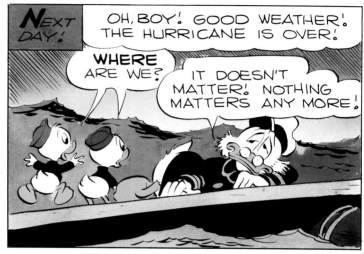

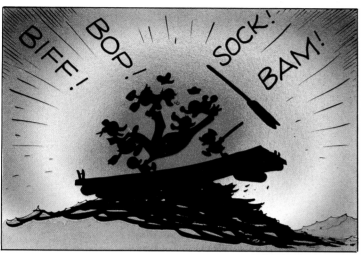

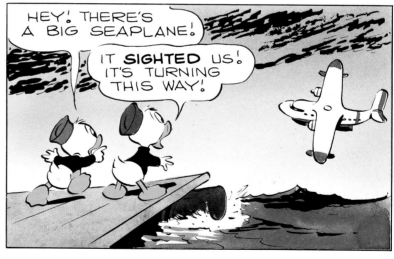

WHY SHOULD I WANT TO GO TO JAMAICA?

TO DELIVER THIS HORSE-RADISH!

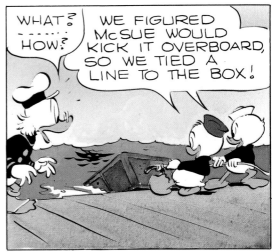

WHAT?......HOW?

WE FIGURED McSUE WOULD KICK IT OVERBOARD, SO WE TIED A LINE TO THE BOX!

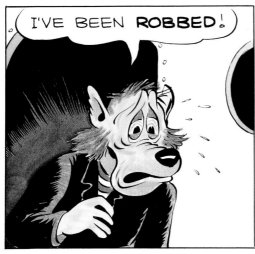

I'VE BEEN ROBBED!

So UNCLE SCROOGE'S FORTUNE IS SAVED, AND HIS DOUGHTY CREWMEN APPLY FOR THEIR WAGES!

CUSTOMS HOUSE

YOU OWE US TWO HUNDRED AND TWENTY-SIX DOLLARS!

$226.00! THAT'S A FORTUNE! YOU CAN'T MEAN IT!

PAY UP, OR WE ENFORCE THIS CONTRACT!

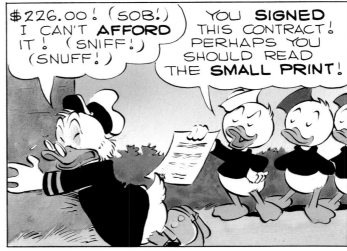

$226.00! (SOB!) I CAN'T AFFORD IT! (SNIFF!) (SNUFF!)

YOU SIGNED THIS CONTRACT! PERHAPS YOU SHOULD READ THE SMALL PRINT!

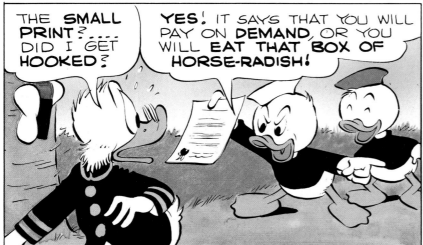

THE SMALL PRINT?.... DID I GET HOOKED?

YES! IT SAYS THAT YOU WILL PAY ON DEMAND, OR YOU WILL EAT THAT BOX OF HORSE-RADISH!

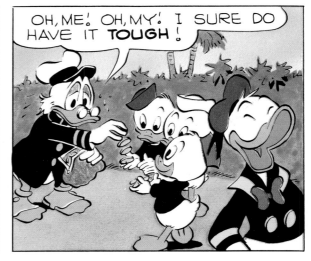

OH, ME! OH, MY! I SURE DO HAVE IT TOUGH!

> **"It wasn't genius or even unusual talent that made the stories good, it was patience and a large wastebasket."**

"The Horseradish Story" never really had a title, though "Trouble from Long Ago" seems to me like a good one. The actual cover of the comic-book had nothing to do with the inside and was probably drawn weeks or months later.

The story is different from other Scrooge stories in that it is a straight-out adventure story. It makes Scrooge the victim: He is the sympathetic character who's being put down and trampled on. Scrooge is fighting for his life and fortune. An unscrupulous son of a gun has taken very unfair advantage of him. The nephews just manage to save Scrooge's hide.

Instead of coming up with the climax of the story first, I came up with the middle. The very basic kernal is that I wanted to have Scrooge finding an old lost ship under the ocean, but I had to find a reason to be salvaging this ship, something more than just treasure hunting, which anyone can do. The special reason was Chisel McSue and his lawsuit against Scrooge because of something one of Scrooge's ancestors had done. What he had to find was the most comical thing I could come up with: this crazy horseradish. To have him look for a ring or some piece of paper sealed in a waterproof carton was a little too ordinary.

It would have to be something that would repel the fishes from the ship all of those years. Believe me, that must have been some pretty potent horseradish!

This story has some of Scrooge's family history. I think his ancestors were tightwads, too. I felt during those early years of Scrooge stories that it was good to give him a kind of family lineage to establish a reason for his present behavior: He came from a very tightwad family, and his tightwad ways were just part of his nature.

I'm not sure of ever committing myself to an absolute formula for writing stories, but basically I always wanted to get a good gag situation and then deal with that. First, I had to think of a good, funny climax gag. Then I would just go back and figure where I could use that climax gag—in a locale in Alaska or wherever—and then from the climax gag I could build an ending. But a formula for a climax gag would really start from a desire in my system to draw some particular type of scenery, a type of background. If I felt that I could do something with a shipboard story, whether it was a steamer or a sailboat, the desire to paint a sea story would develop. I would start working on gags for a sea story and then come up with something that would make

a good, big, powerful gag. Then I'd go back to the beginning and figure out how I would get the ducks into that sea story situation.

One of the guys who worked down at Western Publishing said, "Why don't you write your stories the right way? You just start out, and Donald goes out of the house, across the street. Then when you've got him across the street, you say, What can he do when he's over there? So he does something that leads him into going into a grocery store. He meets somebody, and he talks of something, and pretty soon they're out on the desert looking for treasure. You just go from one thing to another, and pretty soon you come up to something big and use that to end the story." It was a whole different way of working.

I liked stories that gave me a chance to draw water and ships sailing into storms and big pictorial panels. It helped take the monotony away from drawing just round-headed ducks all the time. I'd look at pictures of boats or whatever when I was working. While I never copied the layout of any boat, I would always develop one that was so simple I could use it from one scene to another. The reader could always refer to a long-shot view and check it against the close-ups and see where the characters were in relationship to some spot on the boat. In this story, there's a whole page in which I have a ship wallowing around in the waves. A hurricane is tearing the ship apart, and the villain, who is a real dirty skunk, turns on his own helper. It was a hard-boiled story! I think that might have been one of its charms. If my stuff had charm, it could have been that you didn't know when you picked up a story whether you were going to read a hard-boiled one or one that had a bunch of dripping sentiment. I tried to have a wide range of subjects and methods of handling them.

I did that for several reasons. One is that I couldn't see myself typing each one just alike. I knew that the public liked variety, so I would think back over what I had already done and see if I couldn't come up with something different. That was always one of the first thoughts I had in dreaming up a story: I always looked for plots or formulas that were different, tried to find a different way of doing it, and searched for a different place to stage the business. It is so hard to come up with something new all the time that by the sixties I used some of the old plots again. But I soon found that it was just as hard to do that as it was to think of a whole new plot. I inevitably had to change the locale, the situation, and the gags along a story pattern that originally fitted very nicely in some other location or situation. It involved so much rewriting it was almost as bad as thinking up a whole new plot.

My plots had so many angles in them that once a person read one of them he recognized it when he read it again, even if it was a little different. This story, for example, has an angle that would be hard to reuse exactly. Scrooge saves the villain, even though that scamp is totally worthless. It made Scrooge much more likable. If I had had the nephews tie Scrooge down so that they could rescue the crook, you wouldn't have had much sympathy for Scrooge, but the fact that he helped to rescue the darn guy and then got kicked in the face again made him sweet.

My tastes in literature ran to anything that kept moving fast: action

"My taste in movies was very low class," said Barks.
"I was reputed to attend only horse operas." Sketch by
Jack Hannah, 1939.

a couple of Jack London's stories, but his stuff didn't move fast enough for me. I guess that is one of the reasons why I go in for the comic-book style more than stories that are told in type—the action moves so much faster. A fault I found with Zane Grey's writing was that you would have a couple of paragraphs of action, then he would go into two or three pages of describing purple skies and sagebrush and rocks and the way streams trickled down the sides of mountains. I would just glance through that stuff—doing some speed reading. When I came to the end where some action started up again, I would start reading it again. I imagine that in most of Zane Grey's books, I read only about half of the words.

This 1939 sketch shows Barks hard at work "writing" gags in the Disney story department. "Cecil Beard probably did the drawing," recalls Barks. "He used to like to kid me about stealing gags from the other guy's storyboards."

gags, adventure, and especially anything that had humor. I loved the P.G. Wodehouse stories that appeared in the *Saturday Evening Post* or *Colliers.* I always bought them on the newsstand. You always got a nice, crisp copy: When you got it by mail, the pages were torn or crumpled up.

And I read western pulps and *Argosy.* If they had stories that had good action in them, I read them. They didn't have to be on pretty, slick paper to please me. There were quite a bunch of real good writers that specialized in western stories: Max Brand, Ernest Haycox. In western or sea stories there was always more action, something I could get more involved in. Now, I liked

SCROOGE McDUCK

(DONALD'S UNCLE)
HE HAS THREE
CUBIC ACRES
OF MONEY!

(AND KNOWS THE DATE
ON EVERY DIME!)

HAT POSITION MATCHES
HIS MOOD

UNCLE SCROOGE
IS DONALD
EXCEPT FOR
SIDEBURNS,
PINCE-NEZ
GLASSES, ETC.

TILTS HEAD
DOWN TO SEE
OVER
GLASSES - - - - -

UP TO SEE
THROUGH
GLASSES

HIS COSTUME IS TOP HAT,
CANE, SPATS, AND AN
OLD-FASHIONED BELTED
COAT WITH MOLESKIN
COLLAR AND CUFFS.

GLASSES
VERY
SIMPLE.

SPATS.

← CANE

A model sheet done by Barks for Western Publishing in the mid-1950's.

TRALLA LA

Tralla La
Uncle Scrooge #6 June 1954

The title of this story is deceptive. Tralla La is not a musical operetta, it is a place. It is a far-off land, where cares are unknown. It is a land without riches of any kind, especially of gold, silver, or diamonds. It is hardly a land that Uncle Scrooge would ever want to visit, but it has a lack of other things, too, that makes it seem suddenly attractive to the busy old money grubber. It is a land without greed or selfishness or envy.

What happens to this lyrical land and to Uncle Scrooge as a result of his visit shouldn't happen to dogs, to say nothing of ducks. *C.B. 1981*

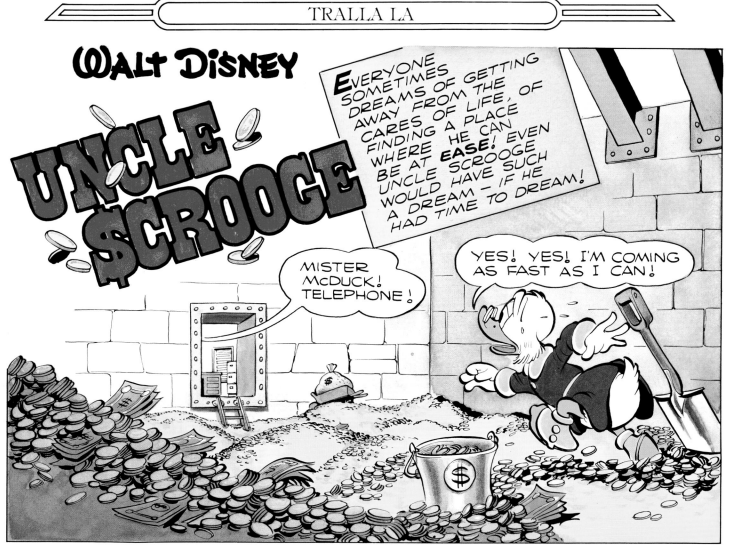

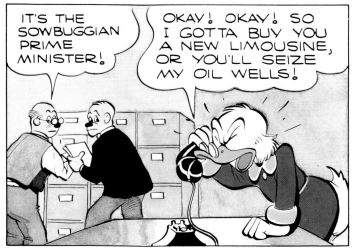

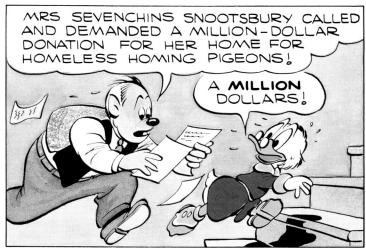

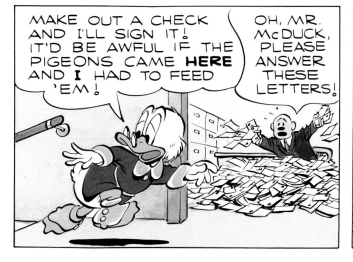

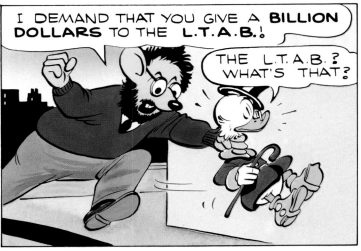

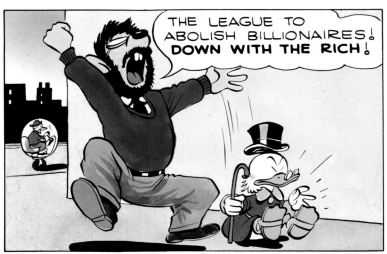

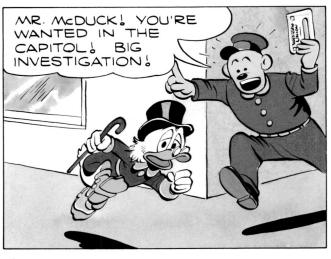

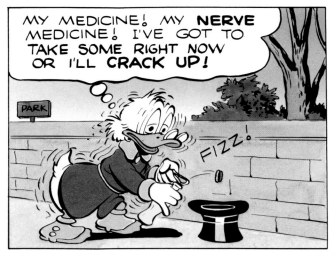

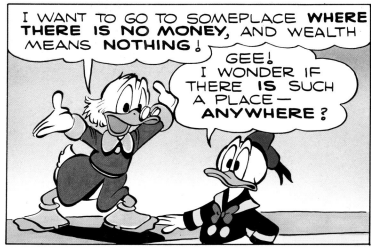

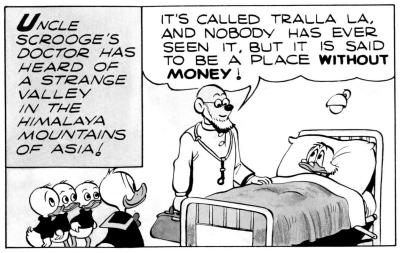

UNCLE SCROOGE'S DOCTOR HAS HEARD OF A STRANGE VALLEY IN THE HIMALAYA MOUNTAINS OF ASIA!

IT'S CALLED TRALLA LA, AND NOBODY HAS EVER SEEN IT, BUT IT IS SAID TO BE A PLACE **WITHOUT** MONEY!

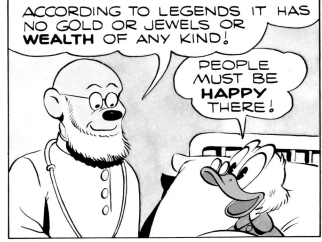

ACCORDING TO LEGENDS IT HAS NO GOLD OR JEWELS OR **WEALTH** OF ANY KIND!

PEOPLE MUST BE **HAPPY** THERE!

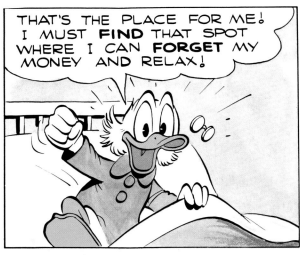

THAT'S THE PLACE FOR ME! I MUST **FIND** THAT SPOT WHERE I CAN **FORGET** MY MONEY AND RELAX!

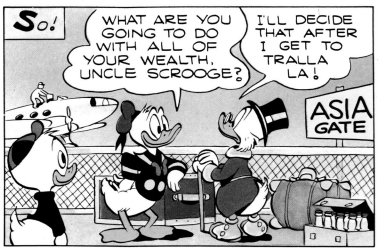

GET ME PLANE TICKETS TO INDIA! I'M GOING TO TRALLA LA, WHERE NOBODY WILL PESTER ME FOR MY RICHES!

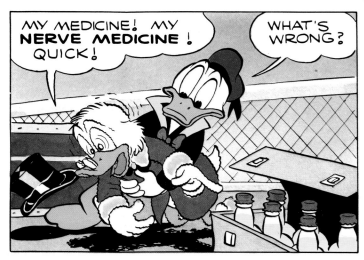

SO! WHAT ARE YOU GOING TO DO WITH ALL OF YOUR WEALTH, UNCLE SCROOGE?

I'LL DECIDE THAT AFTER I GET TO TRALLA LA!

ASIA GATE

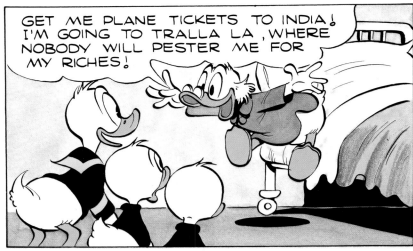

WELL, IF YOU DECIDE TO **GIVE IT AWAY**, I'LL GLADLY TAKE IT OFF YOUR HANDS!

EEP!

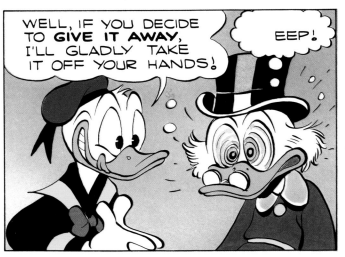

MY MEDICINE! MY **NERVE MEDICINE**! QUICK!

WHAT'S WRONG?

I'VE GOTTEN SO I GO **ALL TO PIECES** WHEN ANYBODY MENTIONS MY WEALTH!

YOU SURE DO!

FIZZ

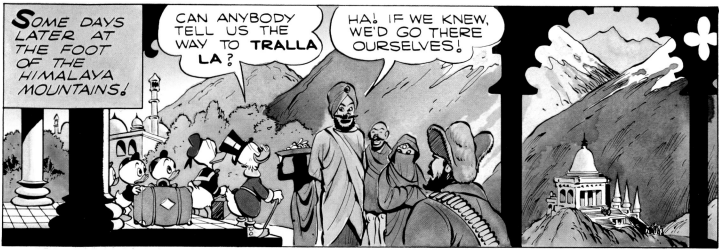

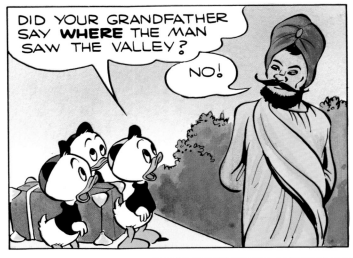

DID YOUR GRANDFATHER SAY **WHERE** THE MAN SAW THE VALLEY?

NO!

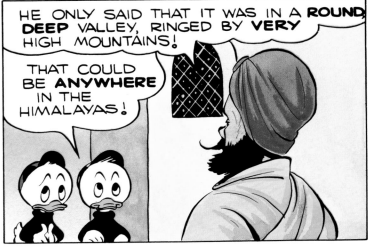

HE ONLY SAID THAT IT WAS IN A **ROUND, DEEP** VALLEY, RINGED BY **VERY** HIGH MOUNTAINS!

THAT COULD BE **ANYWHERE** IN THE HIMALAYAS!

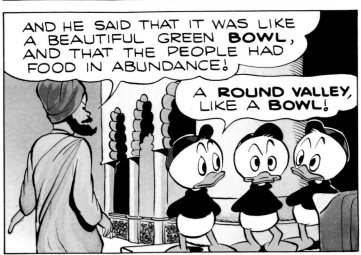

AND HE SAID THAT IT WAS LIKE A BEAUTIFUL GREEN **BOWL**, AND THAT THE PEOPLE HAD FOOD IN ABUNDANCE!

A **ROUND** VALLEY, LIKE A **BOWL**!

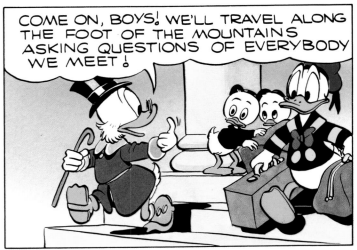

COME ON, BOYS! WE'LL TRAVEL ALONG THE FOOT OF THE MOUNTAINS ASKING QUESTIONS OF EVERYBODY WE MEET!

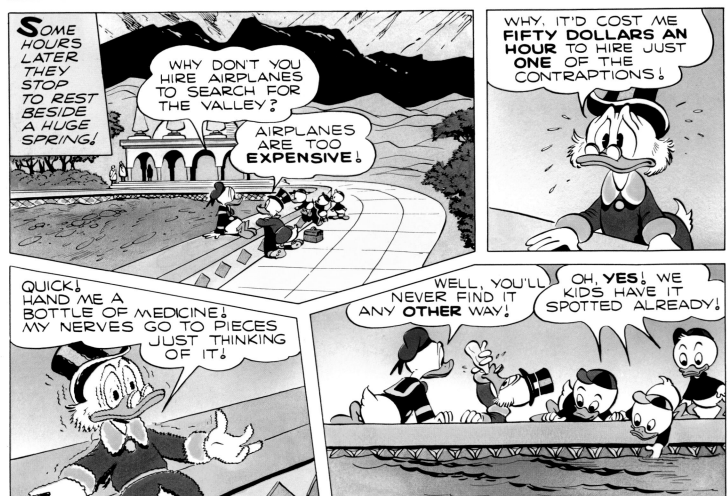

SOME HOURS LATER THEY STOP TO REST BESIDE A HUGE SPRING!

WHY DON'T YOU HIRE AIRPLANES TO SEARCH FOR THE VALLEY?

AIRPLANES ARE TOO **EXPENSIVE**!

WHY, IT'D COST ME **FIFTY DOLLARS AN HOUR** TO HIRE JUST **ONE** OF THE CONTRAPTIONS!

QUICK! HAND ME A BOTTLE OF MEDICINE! MY NERVES GO TO PIECES JUST THINKING OF IT!

WELL, YOU'LL NEVER FIND IT ANY **OTHER** WAY!

OH, **YES**! WE KIDS HAVE IT SPOTTED ALREADY!

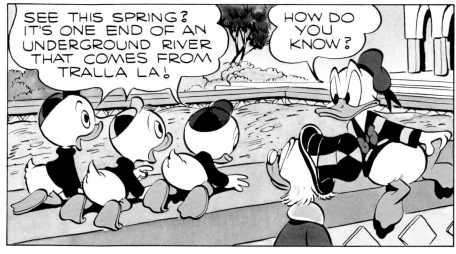

SEE THIS SPRING? IT'S ONE END OF AN UNDERGROUND RIVER THAT COMES FROM TRALLA LA!

HOW DO YOU KNOW?

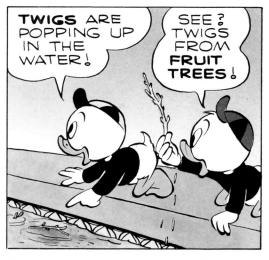

TWIGS ARE POPPING UP IN THE WATER!

SEE? TWIGS FROM FRUIT TREES!

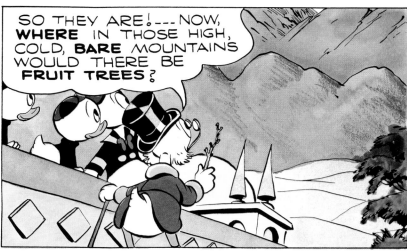

SO THEY ARE!---NOW, **WHERE** IN THOSE HIGH, COLD, **BARE** MOUNTAINS WOULD THERE BE **FRUIT TREES**?

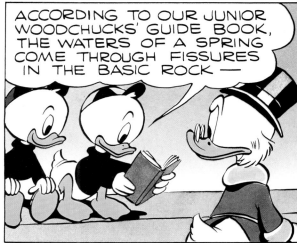

ACCORDING TO OUR JUNIOR WOODCHUCKS' GUIDE BOOK, THE WATERS OF A SPRING COME THROUGH FISSURES IN THE BASIC ROCK —

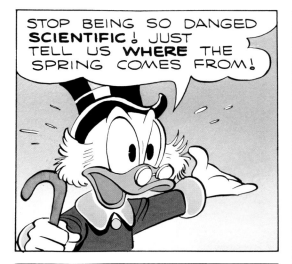

STOP BEING SO DANGED **SCIENTIFIC**! JUST TELL US **WHERE** THE SPRING COMES FROM!

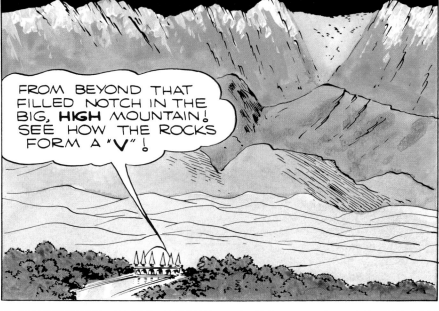

FROM BEYOND THAT FILLED NOTCH IN THE BIG, **HIGH** MOUNTAIN! SEE HOW THE ROCKS FORM A "V"!

THAT COULD BE THE PLACE! THE VALLEY COULD HAVE BEEN **HIDDEN** ALL THESE CENTURIES BY THOSE MOUNTAINS, BECAUSE THEY'RE OVER **FIVE MILES** HIGH!

IF ANY OF YOU **HEROES** FEEL LIKE TAKING A FIVE-MILE HIKE **STRAIGHT UP**, COME ON! WE'LL START WADDLING!

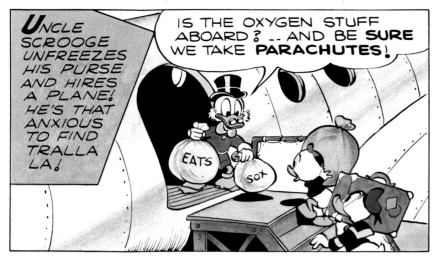

UNCLE SCROOGE UNFREEZES HIS PURSE AND HIRES A PLANE! HE'S THAT ANXIOUS TO FIND TRALLA LA!

IS THE OXYGEN STUFF ABOARD? -- AND BE **SURE** WE TAKE **PARACHUTES**!

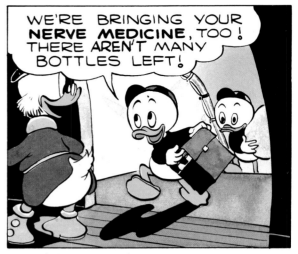

WE'RE BRINGING YOUR **NERVE MEDICINE**, TOO! THERE AREN'T MANY BOTTLES LEFT!

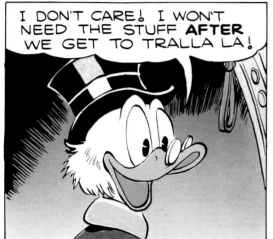

I DON'T CARE! I WON'T NEED THE STUFF **AFTER** WE GET TO TRALLA LA!

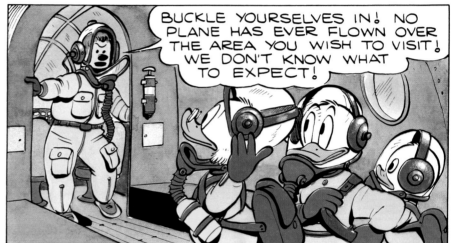

BUCKLE YOURSELVES IN! NO PLANE HAS EVER FLOWN OVER THE AREA YOU WISH TO VISIT! WE DON'T KNOW WHAT TO EXPECT!

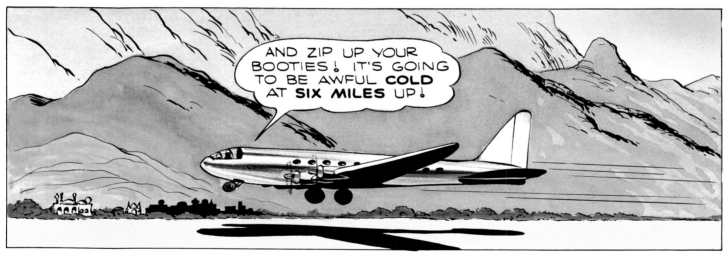

AND ZIP UP YOUR BOOTIES! IT'S GOING TO BE AWFUL **COLD** AT **SIX MILES** UP!

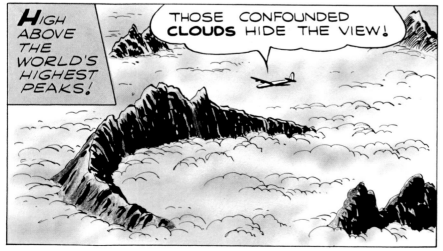

HIGH ABOVE THE WORLD'S HIGHEST PEAKS!

THOSE CONFOUNDED **CLOUDS** HIDE THE VIEW!

I'M SCANNING THE GROUND WITH **RADAR**, MR. McDUCK! THERE'S A DEEP VALLEY BELOW US RIGHT NOW!

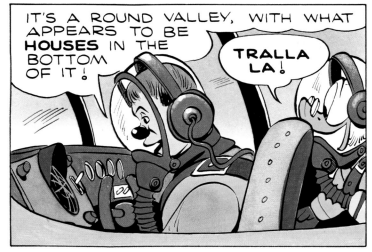

IT'S A ROUND VALLEY, WITH WHAT APPEARS TO BE **HOUSES** IN THE BOTTOM OF IT!

TRALLA LA!

GET DOWN BELOW THE CLOUDS SO I CAN HAVE A LOOK AT IT!

NOT BY A JUGFUL!

THIS PLANE COST A **MILLION** DOLLARS! I WON'T RISK IT IN SUCH A TIGHT PLACE!

QUICK, DEWEY! HAND ME A BOTTLE OF MY MEDICINE!

I'VE GOT TO BUILD UP MY **COURAGE**!

FINN!

GLUG! GLUG!

OKAY! HERE'S **TWO** MILLION DOLLARS! NOW FIND A HOLE IN THOSE CLOUDS!

YESSIREE!

IF THERE'S A FIELD DOWN THERE BIG ENOUGH, WE'LL LAND! ----- OTHERWISE —

OTHERWISE, WE DUCKS WILL **JUMP** AND TAKE OUR CHANCES!

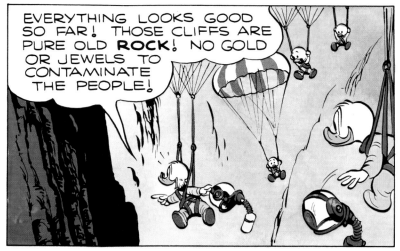

EVERYTHING LOOKS GOOD SO FAR! THOSE CLIFFS ARE PURE OLD **ROCK**! NO GOLD OR JEWELS TO CONTAMINATE THE PEOPLE!

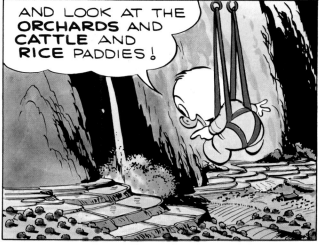

AND LOOK AT THE **ORCHARDS** AND **CATTLE** AND **RICE** PADDIES!

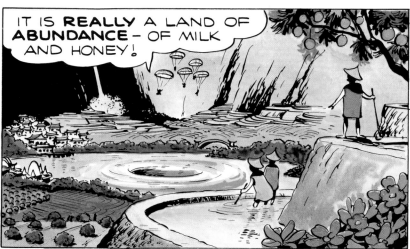

IT IS **REALLY** A LAND OF **ABUNDANCE** — OF MILK AND HONEY!

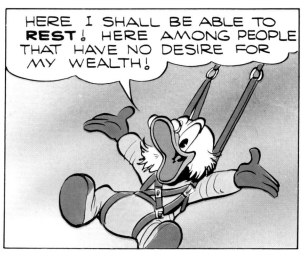

HERE I SHALL BE ABLE TO **REST**! HERE AMONG PEOPLE THAT HAVE NO DESIRE FOR MY WEALTH!

HERE'S WHERE YOUR TROUBLES **END**, ALL RIGHT! LOOK WHAT WE'RE FALLING INTO!

A LAKE! — AND A GIANT **WHIRLPOOL**!

YES! ALL THAT SNOW WATER WOULD **FILL** THIS VALLEY IF IT WEREN'T FOR THAT **OUTLET**!

THE WATER GOES DOWN HERE AND COMES OUT AT THE BIG SPRING WE SAW BEYOND THE MOUNTAINS!

HOW CAN YOU KIDS BE SCIENTIFIC AT A TIME LIKE THIS? --- HELP! HELP!

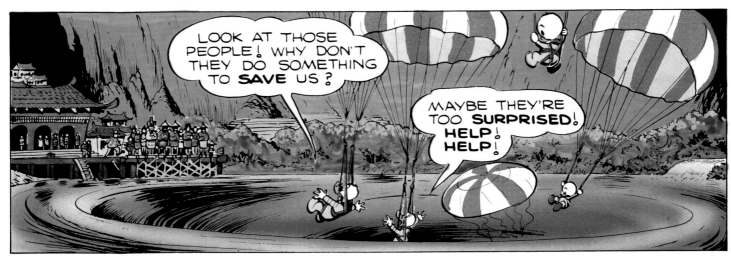

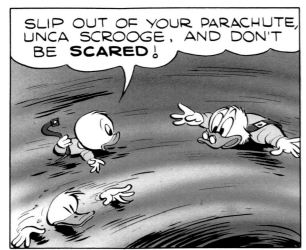

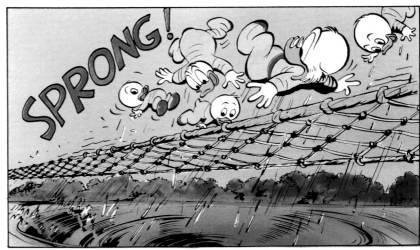

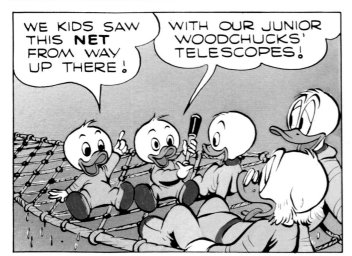

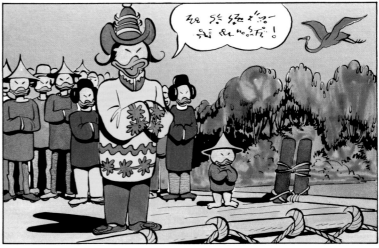

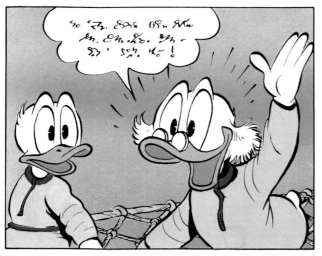

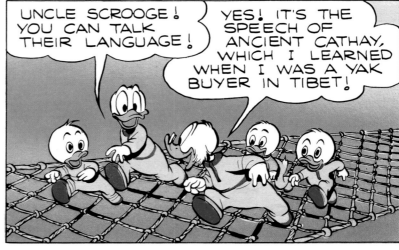

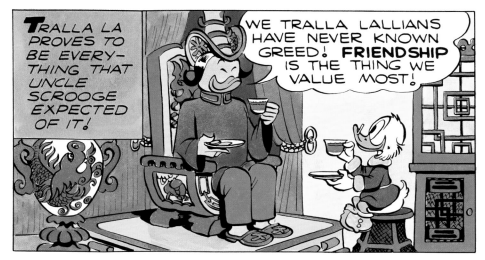

TRALLA LA PROVES TO BE EVERYTHING THAT UNCLE SCROOGE EXPECTED OF IT!

WE TRALLA LALLIANS HAVE NEVER KNOWN GREED! **FRIENDSHIP** IS THE THING WE VALUE MOST!

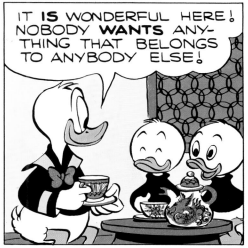

IT **IS** WONDERFUL HERE! NOBODY **WANTS** ANYTHING THAT BELONGS TO ANYBODY ELSE!

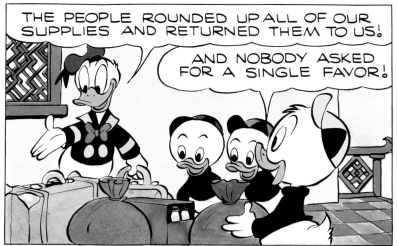

THE PEOPLE ROUNDED UP ALL OF OUR SUPPLIES AND RETURNED THEM TO US!

AND NOBODY ASKED FOR A SINGLE FAVOR!

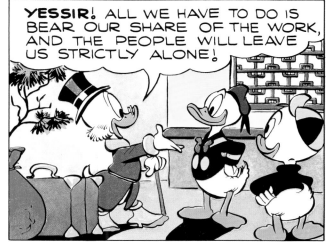

YESSIR! ALL WE HAVE TO DO IS BEAR OUR SHARE OF THE WORK, AND THE PEOPLE WILL LEAVE US STRICTLY ALONE!

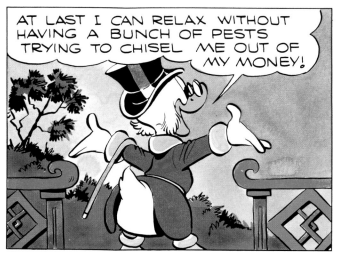

AT LAST I CAN RELAX WITHOUT HAVING A BUNCH OF PESTS TRYING TO CHISEL ME OUT OF MY MONEY!

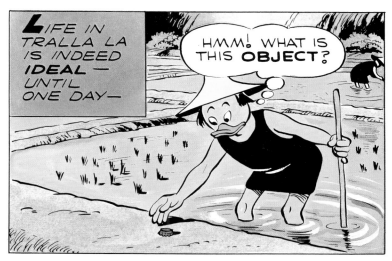

LIFE IN TRALLA LA IS INDEED **IDEAL** — UNTIL ONE DAY—

HMM! WHAT IS THIS **OBJECT**?

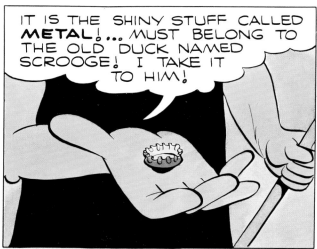

IT IS THE SHINY STUFF CALLED **METAL**! ... MUST BELONG TO THE OLD DUCK NAMED SCROOGE! I TAKE IT TO HIM!

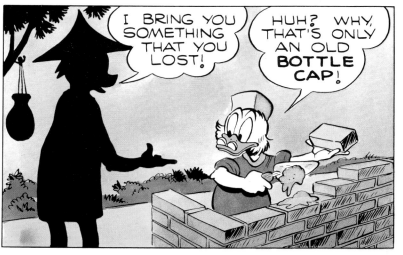

I BRING YOU SOMETHING THAT YOU LOST!

HUH? WHY, THAT'S ONLY AN OLD **BOTTLE CAP**!

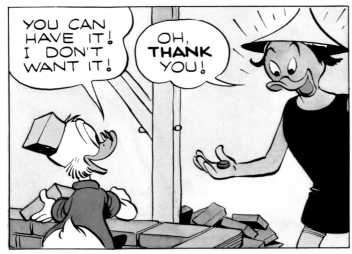

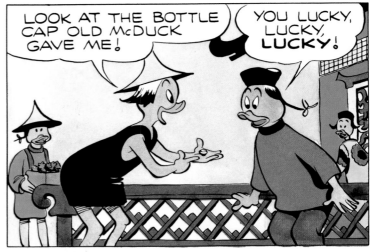

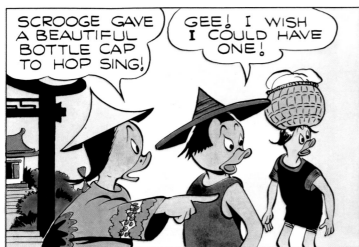

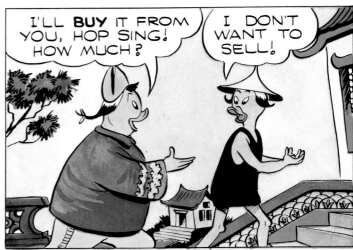

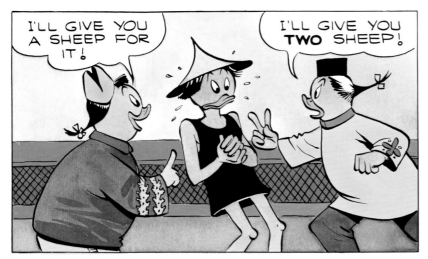

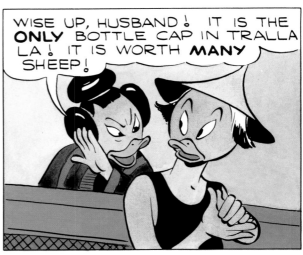

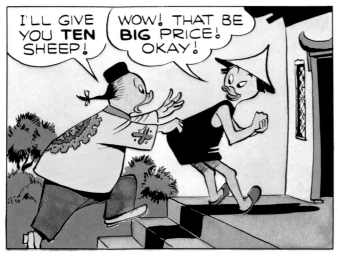

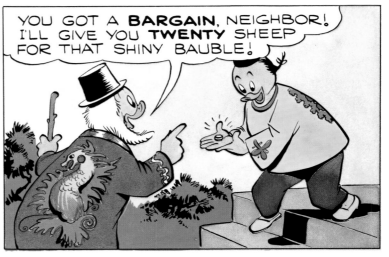

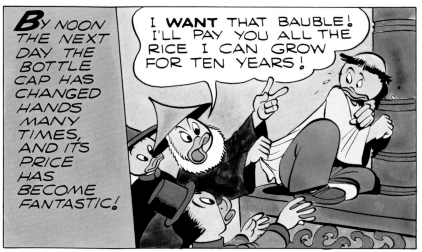

By noon the next day the bottle cap has changed hands many times, and its price has become fantastic!

I **WANT** THAT BAUBLE! I'LL PAY YOU ALL THE RICE I CAN GROW FOR TEN YEARS!

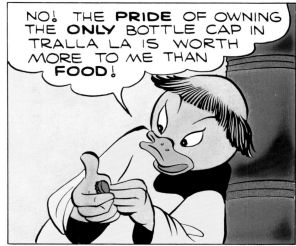

NO! THE **PRIDE** OF OWNING THE **ONLY** BOTTLE CAP IN TRALLA LA IS WORTH MORE TO ME THAN **FOOD!**

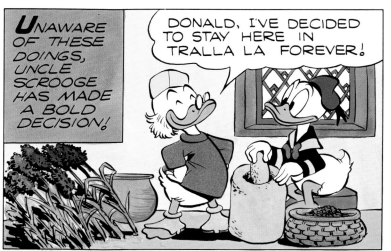

Unaware of these doings, Uncle Scrooge has made a bold decision!

DONALD, I'VE DECIDED TO STAY HERE IN TRALLA LA FOREVER!

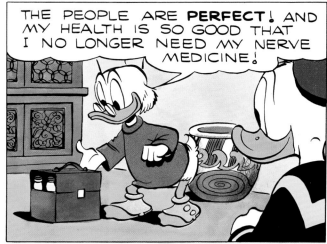

THE PEOPLE ARE **PERFECT!** AND MY HEALTH IS SO GOOD THAT I NO LONGER NEED MY NERVE MEDICINE!

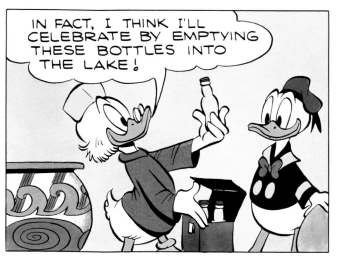

IN FACT, I THINK I'LL CELEBRATE BY EMPTYING THESE BOTTLES INTO THE LAKE!

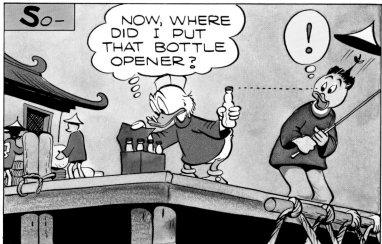

SO—

NOW, WHERE DID I PUT THAT BOTTLE OPENER?

!

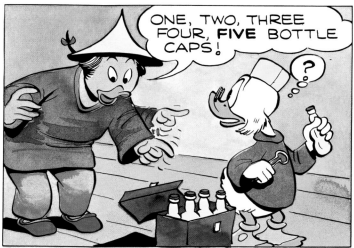

ONE, TWO, THREE FOUR, **FIVE** BOTTLE CAPS!

?

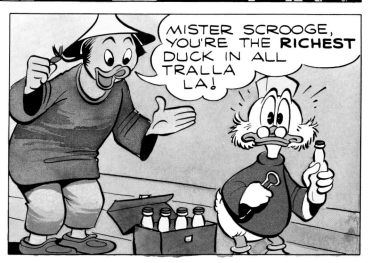

MISTER SCROOGE, YOU'RE THE **RICHEST** DUCK IN ALL TRALLA LA!

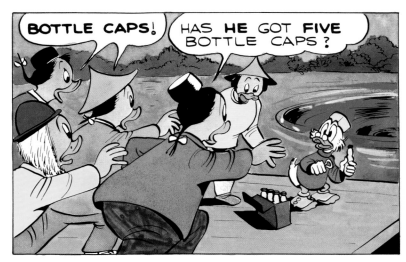

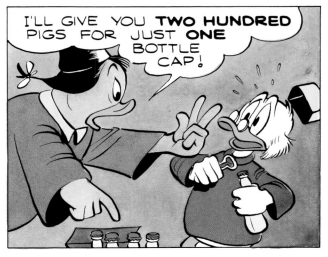

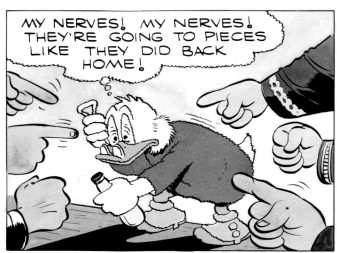

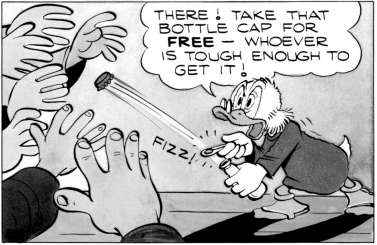

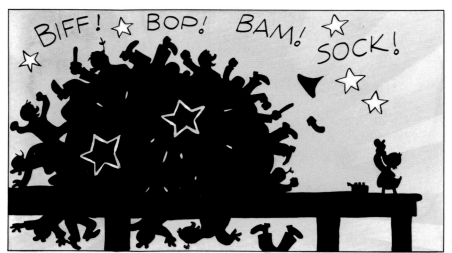

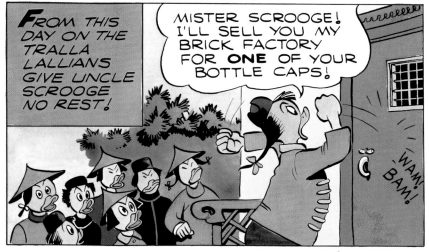

FROM THIS DAY ON THE TRALLA LALLIANS GIVE UNCLE SCROOGE NO REST!

MISTER SCROOGE! I'LL SELL YOU MY BRICK FACTORY FOR **ONE** OF YOUR BOTTLE CAPS!

WAM! BAM!

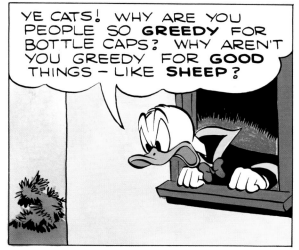

YE CATS! WHY ARE YOU PEOPLE SO **GREEDY** FOR BOTTLE CAPS? WHY AREN'T YOU GREEDY FOR **GOOD** THINGS — LIKE **SHEEP**?

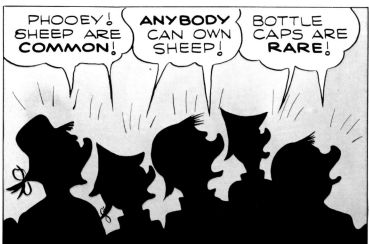

PHOOEY! SHEEP ARE **COMMON**!

ANYBODY CAN OWN SHEEP!

BOTTLE CAPS ARE **RARE**!

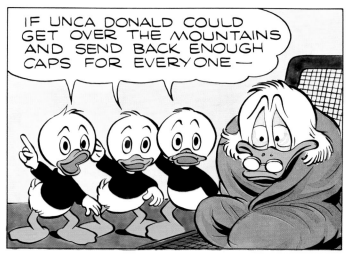

IF UNCA DONALD COULD GET OVER THE MOUNTAINS AND SEND BACK ENOUGH CAPS FOR EVERYONE —

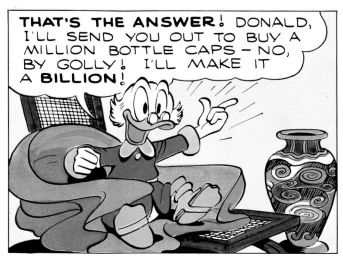

THAT'S THE ANSWER! DONALD, I'LL SEND YOU OUT TO BUY A MILLION BOTTLE CAPS — NO, BY GOLLY! I'LL MAKE IT A **BILLION**!

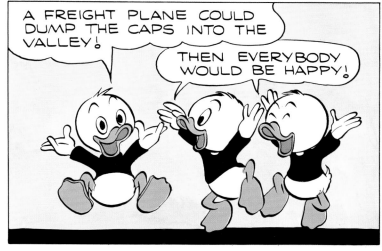

A FREIGHT PLANE COULD DUMP THE CAPS INTO THE VALLEY!

THEN EVERYBODY WOULD BE HAPPY!

WITH ONE OF HIS FEW REMAINING BOTTLE CAPS, UNCLE SCROOGE HIRES AN ARMY OF GUIDES TO ASSIST DONALD OVER THE MOUNTAIN WALL!

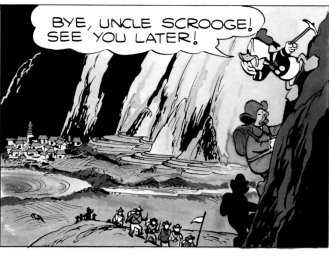

BYE, UNCLE SCROOGE! SEE YOU LATER!

NOW, IN A FEW DAYS THIS PLACE WILL BE **PERFECT** AGAIN!

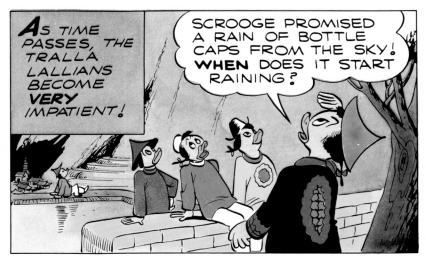

As time passes, the Tralla Lallians become **VERY** impatient!

SCROOGE PROMISED A RAIN OF BOTTLE CAPS FROM THE SKY! **WHEN** DOES IT START RAINING?

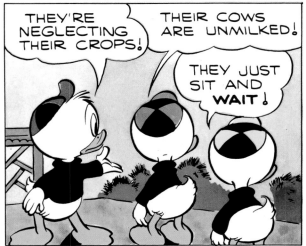

THEY'RE NEGLECTING THEIR CROPS!

THEIR COWS ARE UNMILKED!

THEY JUST SIT AND **WAIT!**

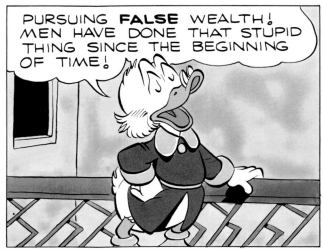

PURSUING **FALSE** WEALTH! MEN HAVE DONE THAT STUPID THING SINCE THE BEGINNING OF TIME!

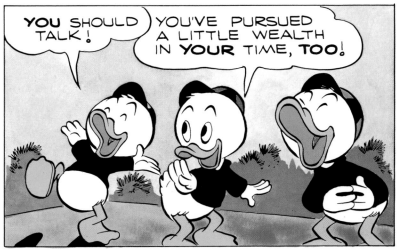

YOU SHOULD TALK!

YOU'VE PURSUED A LITTLE WEALTH IN **YOUR** TIME, **TOO!**

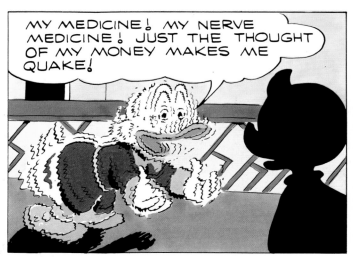

MY MEDICINE! MY NERVE MEDICINE! JUST THE THOUGHT OF MY MONEY MAKES ME QUAKE!

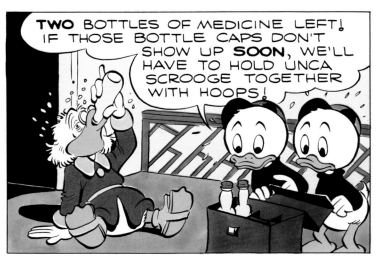

TWO BOTTLES OF MEDICINE LEFT! IF THOSE BOTTLE CAPS DON'T SHOW UP **SOON**, WE'LL HAVE TO HOLD UNCA SCROOGE TOGETHER WITH HOOPS!

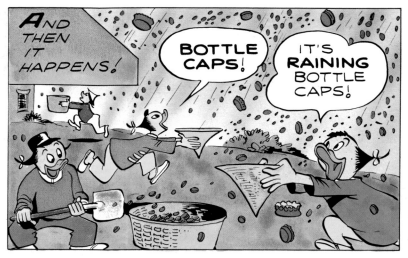

And then it happens!

BOTTLE CAPS!

IT'S **RAINING** BOTTLE CAPS!

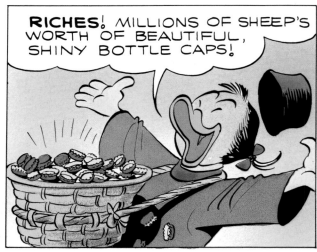

RICHES! MILLIONS OF SHEEP'S WORTH OF BEAUTIFUL, SHINY BOTTLE CAPS!

WELL, THAT SHOULD MAKE EVERYBODY HAPPY — INCLUDING UNCLE SCROOGE!

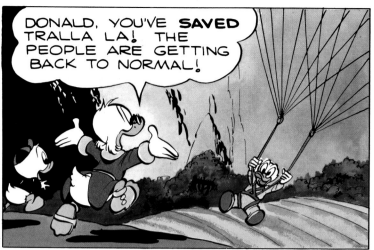

DONALD, YOU'VE **SAVED** TRALLA LA! THE PEOPLE ARE GETTING BACK TO NORMAL!

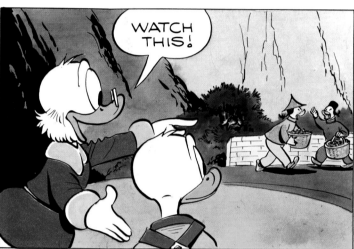

WATCH THIS!

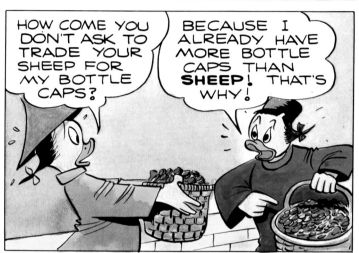

HOW COME YOU DON'T ASK TO TRADE YOUR SHEEP FOR MY BOTTLE CAPS?

BECAUSE I ALREADY HAVE MORE BOTTLE CAPS THAN **SHEEP**! THAT'S WHY!

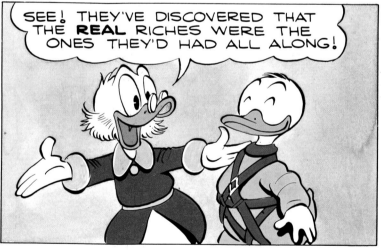

SEE! THEY'VE DISCOVERED THAT THE **REAL** RICHES WERE THE ONES THEY'D HAD ALL ALONG!

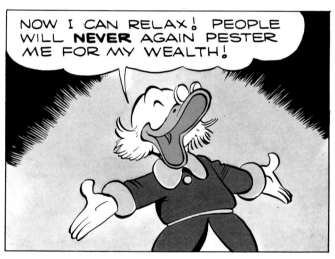

NOW I CAN RELAX! PEOPLE WILL **NEVER** AGAIN PESTER ME FOR MY WEALTH!

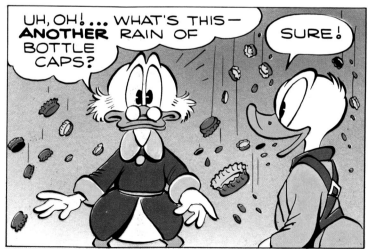

UH, OH! ... WHAT'S THIS — **ANOTHER** RAIN OF BOTTLE CAPS?

SURE!

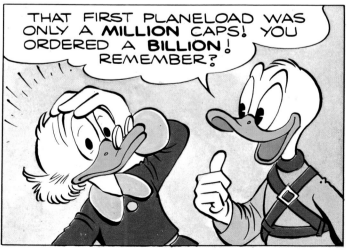

THAT FIRST PLANELOAD WAS ONLY A **MILLION** CAPS! YOU ORDERED A **BILLION**! REMEMBER?

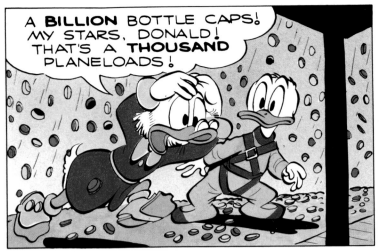

A **BILLION** BOTTLE CAPS! MY STARS, DONALD! THAT'S A **THOUSAND** PLANELOADS!

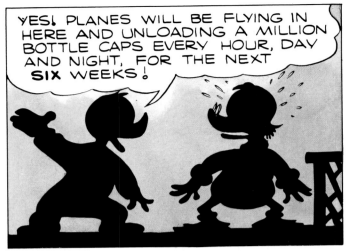

YES! PLANES WILL BE FLYING IN HERE AND UNLOADING A MILLION BOTTLE CAPS EVERY HOUR, DAY AND NIGHT, FOR THE NEXT **SIX** WEEKS!

DON'T EVEN WAIT AROUND TO **EXPLAIN**! TAKE TO THE HILLS WHILE WE'VE STILL GOT A CHANCE!

SOON!

THOSE BOTTLE CAPS HAVE KNOCKED DOWN HALF OF MY RICE PLANTS! THAT RICH OLD SCROOGE SHALL **PAY** FOR THE DAMAGE!

MY PASTURE IS SO FULL OF BOTTLE CAPS, MY SHEEP CAN'T EAT THEIR GRASS!

AND HERE'S **ANOTHER** RAIN OF THE TERRIBLE THINGS! OH, BROTHER! IS OLD SCROOGE EVER GOING TO **REGRET** THIS!

UNCA SCROOGE, THERE'S A **MOB** ROAMING THE VALLEY! AND THEY'RE LOOKING FOR **YOU**!

IF THEY FIND ME, THEY'LL MAKE ME PAY DAMAGES! **WHAT** COULD I USE FOR MONEY?

BOTTLE CAPS! NO — THEY'RE OUT —

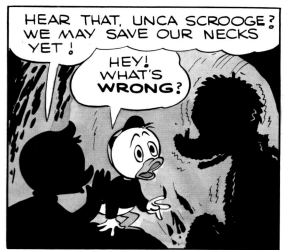

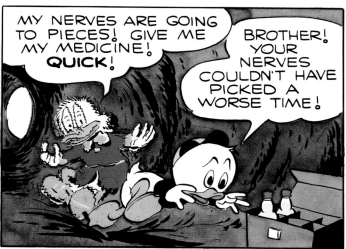

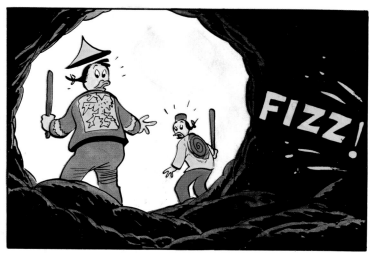

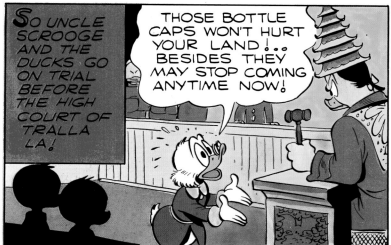

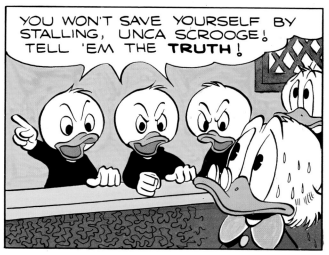

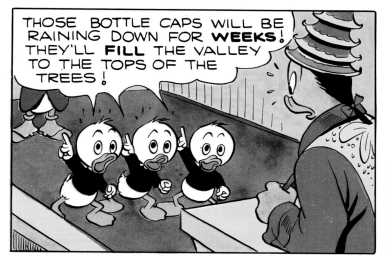

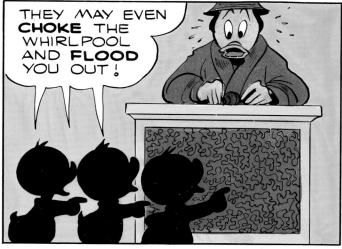

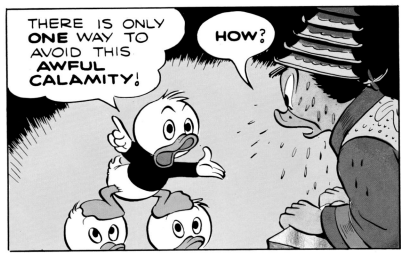

THERE IS ONLY **ONE** WAY TO AVOID THIS **AWFUL CALAMITY!**

HOW?

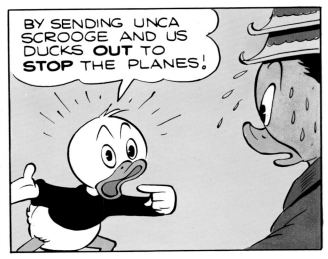

BY SENDING UNCA SCROOGE AND US DUCKS **OUT** TO **STOP** THE PLANES!

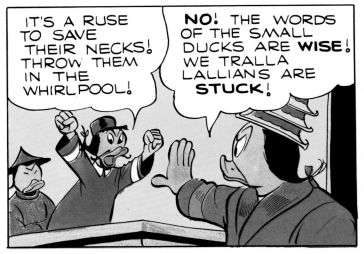

IT'S A RUSE TO SAVE THEIR NECKS! THROW THEM IN THE WHIRLPOOL!

NO! THE WORDS OF THE SMALL DUCKS ARE **WISE!** WE TRALLA LALLIANS ARE **STUCK!**

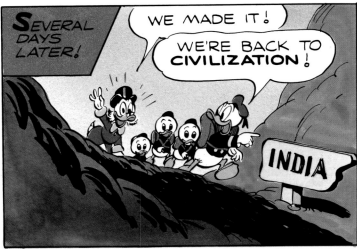

SEVERAL DAYS LATER!

WE MADE IT!

WE'RE BACK TO **CIVILIZATION!**

INDIA

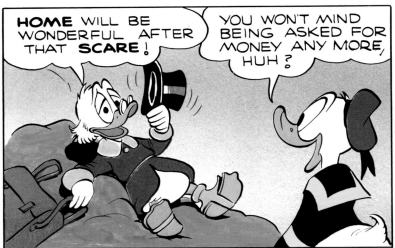

HOME WILL BE WONDERFUL AFTER THAT **SCARE!**

YOU WON'T MIND BEING ASKED FOR MONEY ANY MORE, HUH?

HEAVENS, **NO!** IN FACT, I'LL **NEVER** NEED THIS LAST BOTTLE OF MEDICINE NOW!

WE'RE GLAD TO HEAR THAT, UNCA SCROOGE! WE WERE JUST GOING TO ASK YOU FOR OUR THIRTY CENTS AN HOUR WAGES!

OH, MY GOODNESS GRACIOUS ME! HERE I GO AGAIN!

> **"Errors and boo boos bother me years after I've forgotten every other feature of a story."**

It's obvious that "Tralla La" is a parody on *Lost Horizon.* At the time I wrote it, *Lost Horizon,* with its land of Shangri-La, was very popular. I saw the movie. I never read the book, but I read so many reviews of the book I felt I knew it. Anyway, I felt it wouldn't matter if my version of Shangri-La was a parody of the book or not. I'd just make a fantasy in which the people were so pure that nobody wanted to take anything from his neighbor, and see how far I could carry it.

I also wanted to do a story that had a billion of something in it. I read about the appropriations that Congress makes of a billion for this, ten billion for that. I got to thinking of how much of something a billion really amounts to. You can visualize a million because you can think of a thousand thousands of bottle caps or whatever. But when you multiply that pile by another thousand, then you are into numbers that are beyond the ability of the mind to visualize. I hoped to find a story that could put that point over. So, I dreamed up this bottle cap business that disrupted the people's way of life. They had always been satisfied with what they had, and suddenly one of them got one little piece of metal

that no one else had. The man who found the bottle cap tried to return it to Uncle Scrooge, but Scrooge said, "You can have that." *That* started it! This guy now had something that nobody else had. It really tested these people to see if they were all they were cracked up to be. Human nature wouldn't allow them to be quite that good when they got up against the real nitty-gritty. Instead of the guy putting it in a museum for everybody, his wife urged him to sell it for the highest price he could get. The guy who bought it wanted a profit. Very quickly the profit system was working in Tralla La.

I think this is inevitable in the present world. Ideally, if civilization could keep softening people up, we might have people around who would be so unselfish and kindly that they would never try to take advantage of anyone else. But that's far away in the future.

I've always wanted to promote a broader understanding of life as well as entertaining. As the world becomes overpopulated, hatreds intensify. People have got to learn to be more patient and liberal about each other's views.

The nerve medicine was a running gag

to help pull parts of the story together. I had learned about running gags before I ever worked at Disney. It was a kind of thread or connecting link in stories, such as Wodehouse's stories, and in the movies: Chaplin and Laurel and Hardy had running gags. I liked those movies more than romantic ones or shoot-'em-up westerns. The running gags were a necessary part of the stories, like a period at the end of a sentence.

I was never temperamental in any way that I can remember. If you were a *prima donna* down at the Disney studio, if you went in thinking that you were a genius and then you had to work with a bunch of geniuses, why you soon got the ego knocked out of you. We served an apprenticeship at the Disney story department. You'd come out of there with humility, so you didn't feel that you had to have a grand opera band playing background music before you could get ideas!

I had very little editorial supervision. I guess they felt that it was better to leave me alone. In the very beginning—on "The Mummy's Ring" (1943)—I turned in a script to Eleanor Parker, the editor. She thought that I should change the climax around. I sketched up her changes and sent in the script. Soon she wrote back and said that my original script was better. From that time on they never monkeyed with my scripts much. If I turned in one that was a turkey, they just paid me for it and put it on the shelf.

Any time that I wrote a script, when I got through with it, I'd lay it aside, pick it up the next morning, and read it. If it didn't read with a lot of rhythm going right on through, I'd work on it another day or so until I got it to where it sounded good, then start drawing. With the drawing, too, I would pick up sheets that I had done two or three days before and look at them. If the business didn't look right, I didn't mind doing it over. I was after a certain quality. I wasn't thinking of getting a fast buck, and anyway, the bucks in this business were so small that I wasn't throwing much away.

I worked hard at trying to make something as good as I could possibly make it. When I took the finished art into the office and turned it over to the editor, I was satisfied that I had done the very best I possibly could, and I just dared anybody to see if they could improve on it. I had a sourpuss temperament, so when somebody would find some fault with a script, I would blow my marbles in all directions. It actually happened very seldom. If it had happened very many times, I would have gone into another occupation. Once those editors started telling me how to do something, why, I would rather have gone down to the shipyards and gotten a job on a riveting gang.

I always tried to write a story that I wouldn't mind buying myself. Maybe that's what distinguishes it from the writing of those who only try to get the story past the editors. I was always thinking that other people valued their dimes as much as I did: if I wrote a story that was good enough so that I would want to buy it, then probably a lot of other people would. I wasn't thinking so much of getting it by the editor as I was of getting it by my own critical analysis of value. I think writers should be their own editors and really polish stuff and not fall completely in love with their stuff at first draft.

THE
SEVEN CITIES
OF CIBOLA

The Seven Cities of Cibola
Uncle Scrooge #7 September 1954

This story of a simple desert outing that turned into a dangerous search for fabulous treasures is sprinkled with real settings and dubious historical ones.

The Indian trail where the ducks find arrowheads is real. The "Lost Ship of the Desert" is questionable, although many old-timers claimed to have seen it. Histories of the period report the disappearance of a Spanish ship in the Gulf of Lower California around 1539. A great tidal wave is reported, too, and an earthquake that sloshed the Colorado River out of its banks. The past and present events that make up this story's fictional doings could have happened in real life.

The story's villains, however, may seem a little preposterous. To those who haven't followed Uncle Scrooge's many troubles in the comics, the Beagle Boys should be explained as an overprivileged gang of paroled jailbirds, who continually try to separate Uncle Scrooge from his fortune and to horn in on any new boodles he might find. *C.B. 1981*

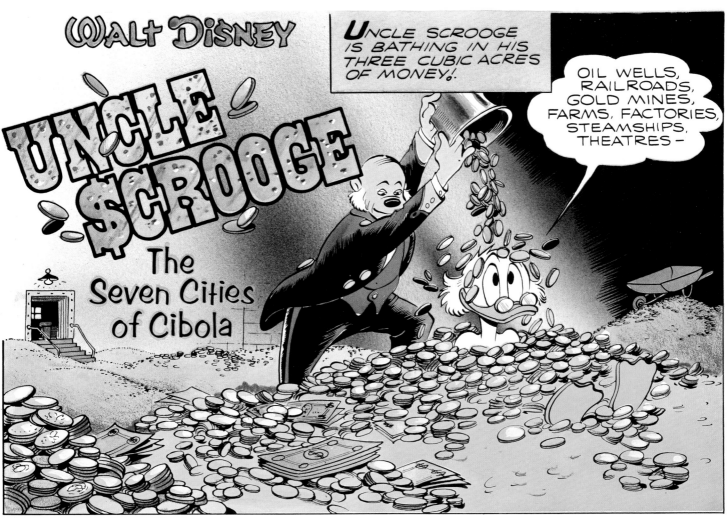

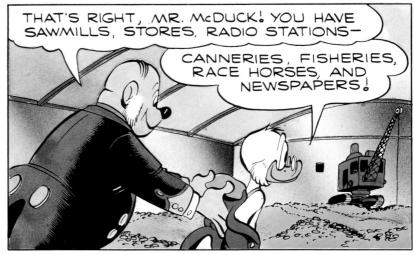

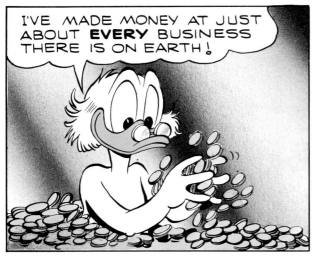

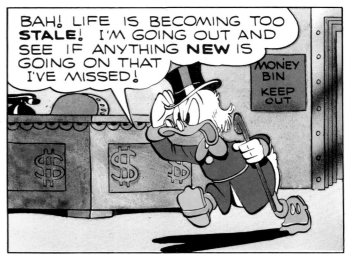

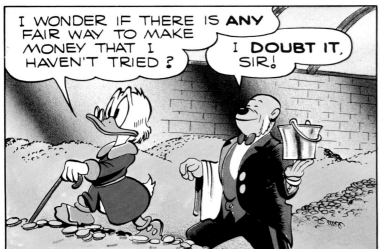

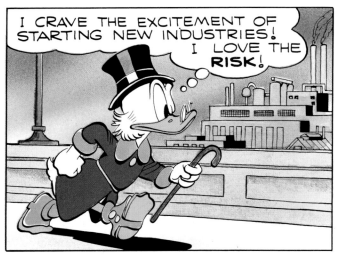

I CRAVE THE EXCITEMENT OF STARTING NEW INDUSTRIES! I LOVE THE **RISK**!

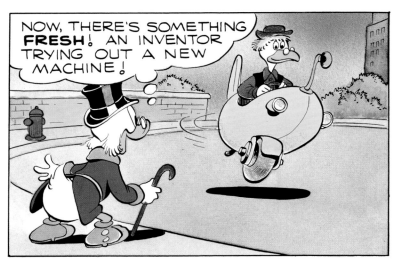

NOW, THERE'S SOMETHING **FRESH**! AN INVENTOR TRYING OUT A NEW MACHINE!

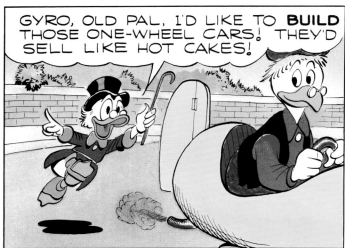

GYRO, OLD PAL, I'D LIKE TO **BUILD** THOSE ONE-WHEEL CARS! THEY'D SELL LIKE HOT CAKES!

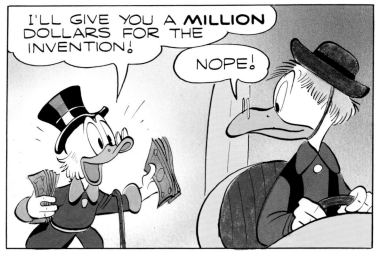

I'LL GIVE YOU A **MILLION** DOLLARS FOR THE INVENTION!

NOPE!

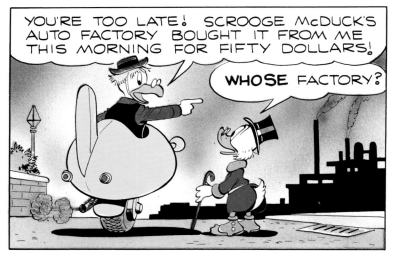

YOU'RE TOO LATE! SCROOGE McDUCK'S AUTO FACTORY BOUGHT IT FROM ME THIS MORNING FOR FIFTY DOLLARS!

WHOSE FACTORY?

SCROOGE McDUCK'S! SAY— AREN'T **YOU** SCROOGE McDUCK?

NEVER MIND! NEVER MIND!

I OWN SO MANY BUSINESSES I DON'T KNOW WHAT **ANY** OF THEM IS DOING!

I NEED TO GET INTO SOME **SIMPLE** BUSINESS THAT I CAN RUN WITH MY **OWN** HANDS!

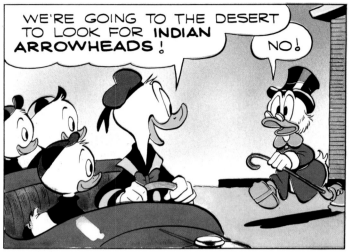

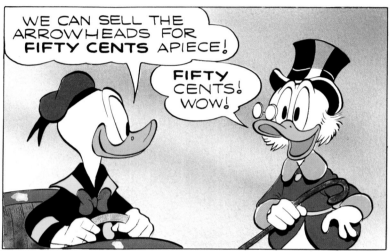

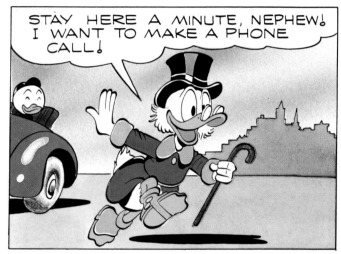

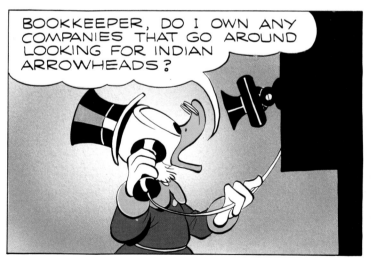

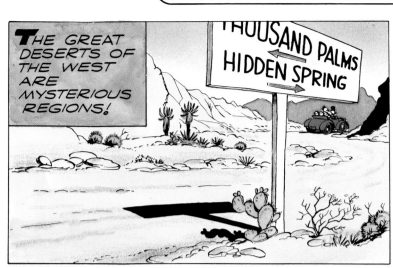

THE GREAT DESERTS OF THE WEST ARE MYSTERIOUS REGIONS!

THOUSAND PALMS
← HIDDEN SPRING →

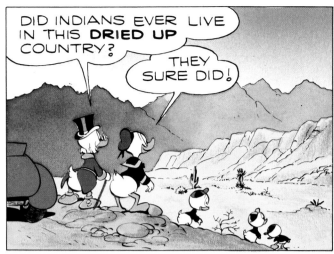

DID INDIANS EVER LIVE IN THIS **DRIED UP** COUNTRY?

THEY SURE DID!

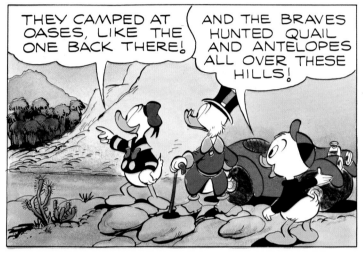

THEY CAMPED AT OASES, LIKE THE ONE BACK THERE!

AND THE BRAVES HUNTED QUAIL AND ANTELOPES ALL OVER THESE HILLS!

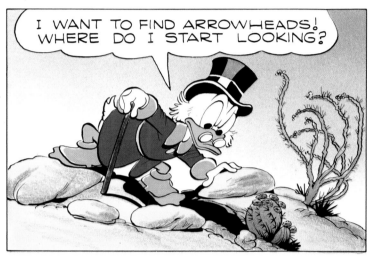

I WANT TO FIND ARROWHEADS! WHERE DO I START LOOKING?

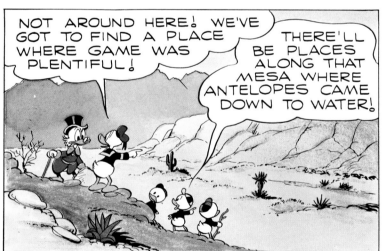

NOT AROUND HERE! WE'VE GOT TO FIND A PLACE WHERE GAME WAS PLENTIFUL!

THERE'LL BE PLACES ALONG THAT MESA WHERE ANTELOPES CAME DOWN TO WATER!

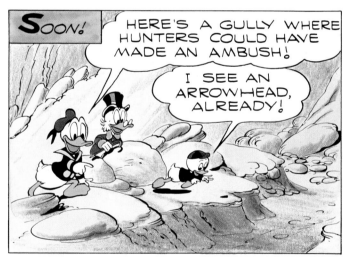

SOON!

HERE'S A GULLY WHERE HUNTERS COULD HAVE MADE AN AMBUSH!

I SEE AN ARROWHEAD, ALREADY!

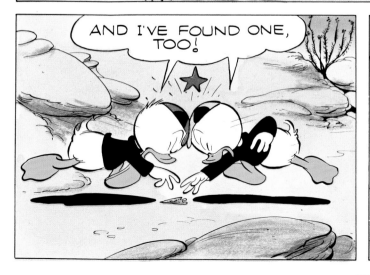

AND I'VE FOUND ONE, TOO!

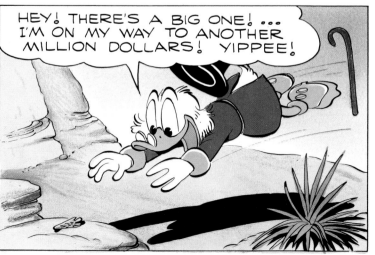

HEY! THERE'S A BIG ONE! ... I'M ON MY WAY TO ANOTHER MILLION DOLLARS! YIPPEE!

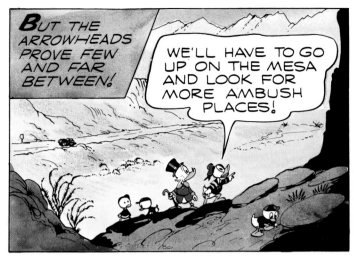

BUT THE ARROWHEADS PROVE FEW AND FAR BETWEEN!

WE'LL HAVE TO GO UP ON THE MESA AND LOOK FOR MORE AMBUSH PLACES!

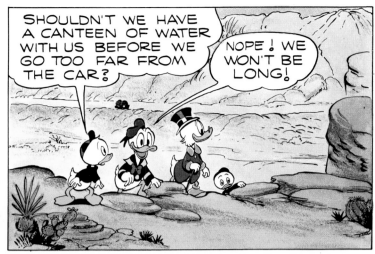

SHOULDN'T WE HAVE A CANTEEN OF WATER WITH US BEFORE WE GO TOO FAR FROM THE CAR?

NOPE! WE WON'T BE LONG!

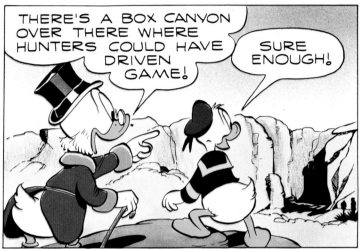

THERE'S A BOX CANYON OVER THERE WHERE HUNTERS COULD HAVE DRIVEN GAME!

SURE ENOUGH!

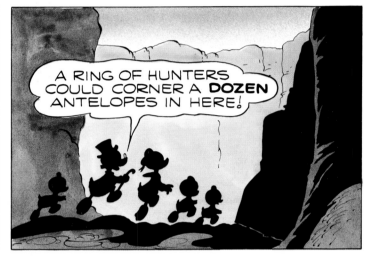

A RING OF HUNTERS COULD CORNER A **DOZEN** ANTELOPES IN HERE!

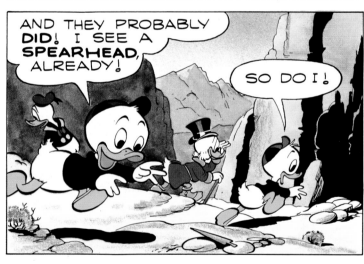

AND THEY PROBABLY **DID**! I SEE A **SPEARHEAD**, ALREADY!

SO DO I!

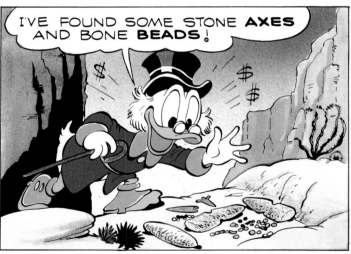

I'VE FOUND SOME STONE **AXES** AND BONE **BEADS**!

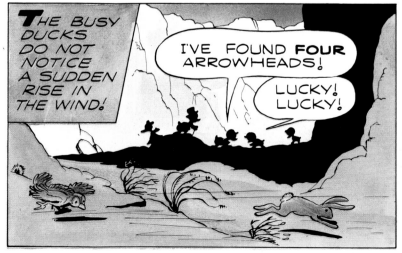

THE BUSY DUCKS DO NOT NOTICE A SUDDEN RISE IN THE WIND!

I'VE FOUND **FOUR** ARROWHEADS!

LUCKY! LUCKY!

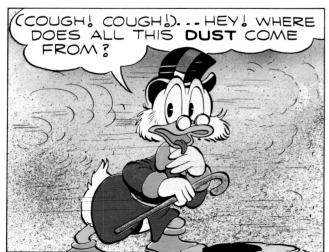

(COUGH! COUGH!)... HEY! WHERE DOES ALL THIS **DUST** COME FROM?

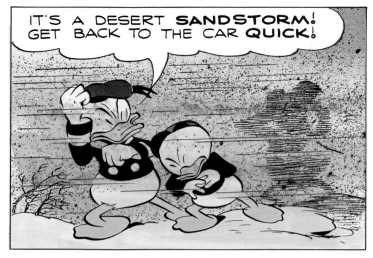

IT'S A DESERT **SANDSTORM**! GET BACK TO THE CAR **QUICK**!

THESE THINGS CAN BLOW FOR DAYS! COME ON, UNCA SCROOGE!

HOLD ONTO EACH OTHER'S HANDS SO WE WON'T GET SEPARATED!

DRAT! AND I WAS ABOUT TO FIND ANOTHER ARROWHEAD!

SOO-WOOO!

THIS IS **BAD**! THE WIND IS BLOWING US **AWAY** FROM THE CAR!

(COUGH! CHOKE!) I CAN'T **SEE**!

WHO **CAN**?

Later!

WE'RE **LOST**!

AND **THIRSTY**, TOO! HOW I WISH WE HAD THAT CANTEEN OF **WATER**! ... (GASP!)

HEY! IS THIS A **TRAIL** WE'RE FOLLOWING?

I CAN'T SAY! IT LOOKS LIKE A **GROOVE** IN THE GROUND!

I BELIEVE IT **IS** A TRAIL! WONDER WHERE IT'S TAKING US?

TO A **SODA POP STAND**, NO DOUBT!

WOULDN'T YOU BE SURPRISED IF IT DID?

SPLAT!

HEY! WE'RE IN AN **OASIS** — ANOTHER GROVE OF THOSE DESERT PALMS!

WATER! HOW COULD ANYTHING SO **MUDDY** TASTE SO GOOD?

YOU KNOW SOMETHING? THAT TRAIL WE FOUND SAVED US FROM A **BAD** TIME!

SOLID WORDS, UNCA SCROOGE!

*L*ATER!

THE WIND IS DYING! LET'S HAVE A **LOOK** AT THAT MYSTERIOUS FOOTPATH!

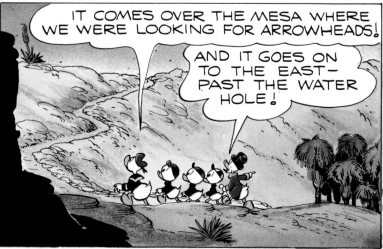

IT COMES OVER THE MESA WHERE WE WERE LOOKING FOR ARROWHEADS!

AND IT GOES ON TO THE EAST— PAST THE WATER HOLE!

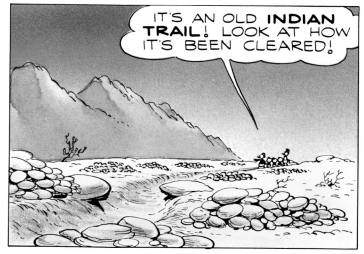

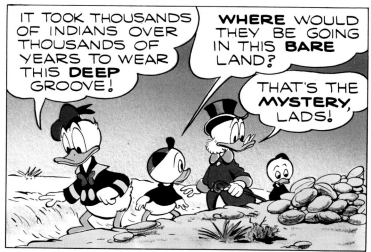

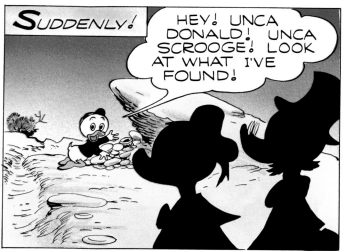

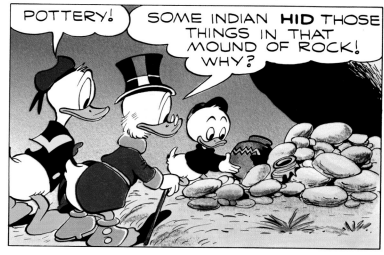

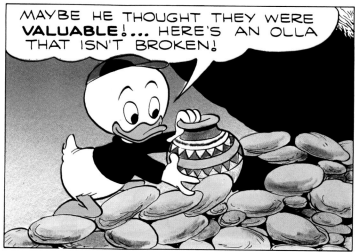

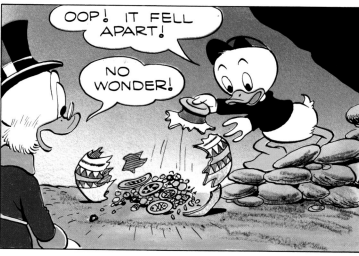

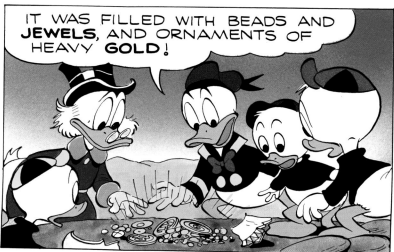

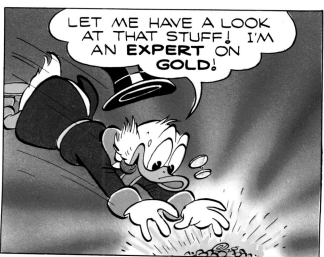

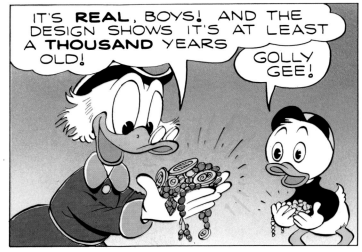

IT'S **REAL**, BOYS! AND THE DESIGN SHOWS IT'S AT LEAST A **THOUSAND** YEARS OLD!

GOLLY GEE!

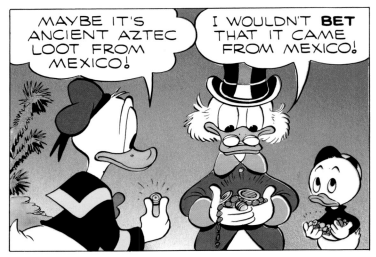

MAYBE IT'S ANCIENT AZTEC LOOT FROM MEXICO!

I WOULDN'T **BET** THAT IT CAME FROM MEXICO!

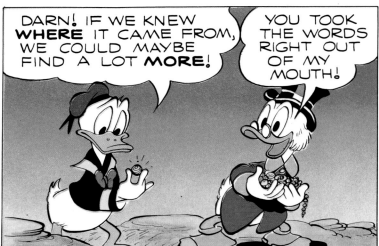

DARN! IF WE KNEW **WHERE** IT CAME FROM, WE COULD MAYBE FIND A LOT **MORE**!

YOU TOOK THE WORDS RIGHT OUT OF MY MOUTH!

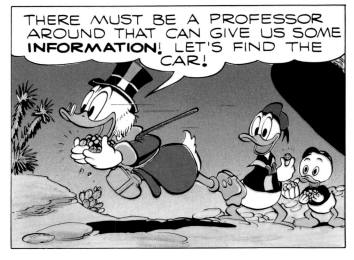

THERE MUST BE A PROFESSOR AROUND THAT CAN GIVE US SOME **INFORMATION**! LET'S FIND THE CAR!

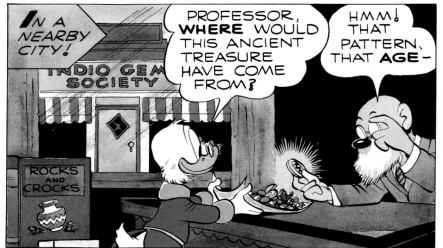

IN A NEARBY CITY!

INDIO GEM SOCIETY

ROCKS AND CROCKS

PROFESSOR, **WHERE** WOULD THIS ANCIENT TREASURE HAVE COME FROM?

HMM! THAT PATTERN, THAT **AGE** —

IT COULD HAVE COME FROM ONLY **ONE** PLACE! ---- I KNOW YOU WON'T BELIEVE ME —

BUT THIS IS TREASURE FROM THE ORIGINAL **SEVEN CITIES OF CIBOLA**!

HAVE YOU GOT SOME ICE WATER, PROFESSOR? THERE'S A CASH REGISTER RINGING IN UNCA SCROOGE'S HEAD!

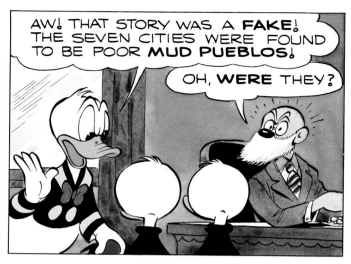

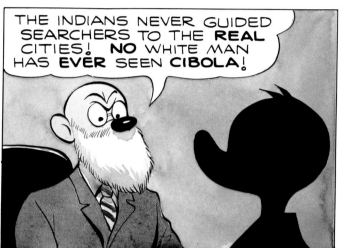

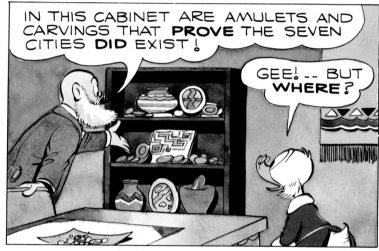

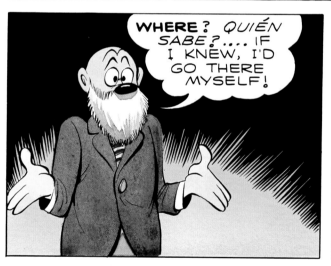

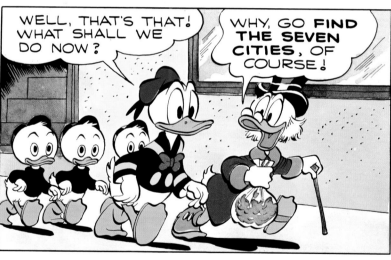

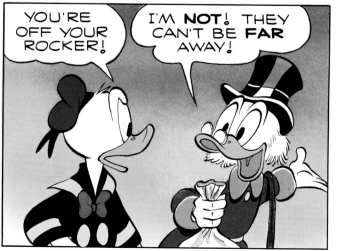

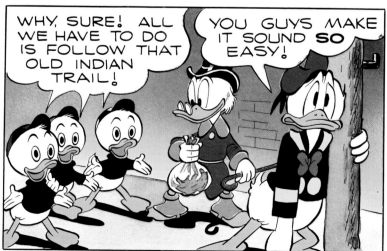

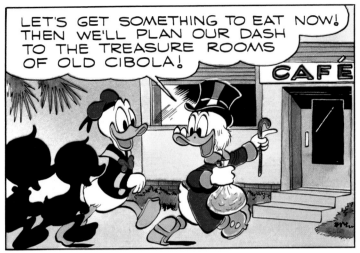

LET'S GET SOMETHING TO EAT NOW! THEN WE'LL PLAN OUR DASH TO THE TREASURE ROOMS OF OLD CIBOLA!

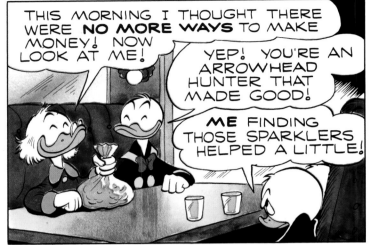

THIS MORNING I THOUGHT THERE WERE **NO MORE WAYS** TO MAKE MONEY! NOW LOOK AT ME!

YEP! YOU'RE AN ARROWHEAD HUNTER THAT MADE GOOD!

ME FINDING THOSE SPARKLERS HELPED A LITTLE!

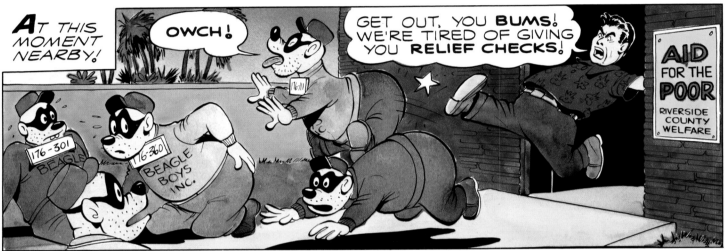

*A*T THIS MOMENT NEARBY!

OWCH!

GET OUT, YOU **BUMS!** WE'RE TIRED OF GIVING YOU **RELIEF CHECKS!**

AID FOR THE POOR

RIVERSIDE COUNTY WELFARE

WE BEAGLE BOYS ARE **NEEDY** CASES!

YOU CAN'T KICK US OUT TO **STARVE!**

YES! HOW ARE WE GOING TO **EAT?**

SINCE BANKS PUT IN BURGLAR ALARMS WE'VE HAD A HARD TIME MAKING ENDS MEET!

YEAH! AN' WE'RE **TIRED** OF JAIL COOKING!

LAY OFF THE SOB STUFF! YOU'RE ABLE TO **WORK!** GET YOURSELVES **JOBS!**

AID FOR THE POOR

OH, HOW CRUEL AND HEARTLESS THE WORLD HAS BECOME TO US BEAGLE BOYS! ...(SOB! SOB!)

WUP!..... DRY YOUR TEARS, BOYS! LOOK AT THE **BONANZA** I SEE!

OLD **SCROOGE McDUCK!** THE **RICHEST** FANTASTICATRILLIONAIRE IN THE WORLD!

THERE'S ALWAYS **BIG DEALS** BREWING WHEN HE'S AROUND!

HE'S PROBABLY BREWING ONE RIGHT NOW!

LET'S LISTEN IN ON HIS DIAMOND-STUDDED WORDS!

HE MAY DROP A HINT THAT WILL KEEP US IN **MINK** FOR YEARS!

So-

WE START OUT TOMORROW TO FIND THE SEVEN CITIES!

AND WE'LL BE RIGHT BEHIND YOU! HEH! HEH!

ONCE WE'VE FOUND THE SEVEN CITIES, WE CAN GO BACK WITH FLEETS OF TRUCKS AND HAUL OUT THE **GOLD!**

OH, BOY! OH, BOY!

I PROPOSE A **TOAST** TO THE **SUCCESS** OF OUR EXPEDITION!

CLICK!

CLICK!

MORNING ON THE MESA!

NOW, HAVE WE GOT EVERYTHING WE NEED? WATER? GRUB? BLANKETS?

YES!
YES!
YES!

AND WE'VE BROUGHT OUR **JUNIOR WOODCHUCKS' GUIDEBOOK!** JUST IN CASE WE NEED TO KNOW SOME **VITAL INFORMATION!**

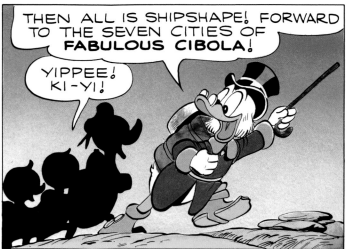

THEN ALL IS SHIPSHAPE! FORWARD TO THE SEVEN CITIES OF **FABULOUS CIBOLA!**

YIPPEE! KI-YI!

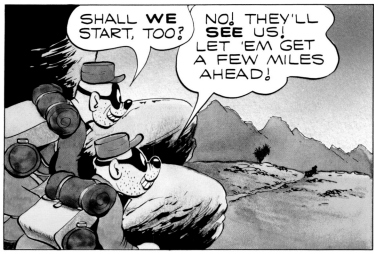

SHALL **WE** START, TOO?

NO! THEY'LL **SEE** US! LET 'EM GET A FEW MILES AHEAD!

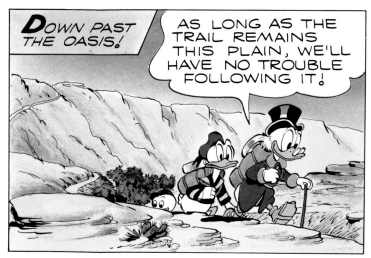

DOWN PAST THE OASIS!

AS LONG AS THE TRAIL REMAINS THIS PLAIN, WE'LL HAVE NO TROUBLE FOLLOWING IT!

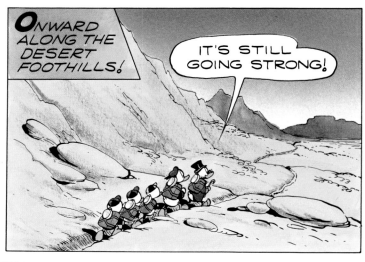

ONWARD ALONG THE DESERT FOOTHILLS!

IT'S STILL GOING STRONG!

SUDDENLY!

WHUP! **END** OF THE LINE!

SAND HAS COVERED THE TRAIL!

WHERE DOES IT GO FROM HERE — UP **THAT** WAY OR ACROSS **THIS** WAY?

WE'LL KNOW IN A JIFFY!

"TRAVELERS AFOOT IN HOT DESERTS SHOULD SET THEIR COURSE TOWARD SHADE!"

WHERE IS THE **NEAREST** SHADE?

IT'S THAT BIG BLUFF AWAY OVER THERE TO THE LEFT!

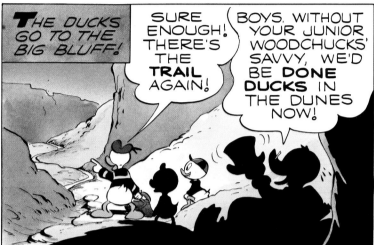

THE DUCKS GO TO THE BIG BLUFF!

SURE ENOUGH! THERE'S THE **TRAIL** AGAIN!

BOYS, WITHOUT YOUR JUNIOR WOODCHUCKS' SAVVY, WE'D BE **DONE DUCKS** IN THE DUNES NOW!

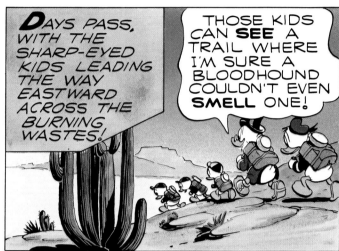

DAYS PASS, WITH THE SHARP-EYED KIDS LEADING THE WAY EASTWARD ACROSS THE BURNING WASTES!

THOSE KIDS CAN **SEE** A TRAIL WHERE I'M SURE A BLOODHOUND COULDN'T EVEN **SMELL** ONE!

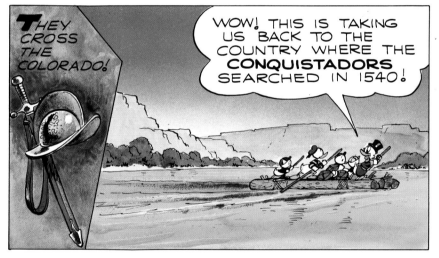

THEY CROSS THE COLORADO!

WOW! THIS IS TAKING US BACK TO THE COUNTRY WHERE THE **CONQUISTADORS** SEARCHED IN 1540!

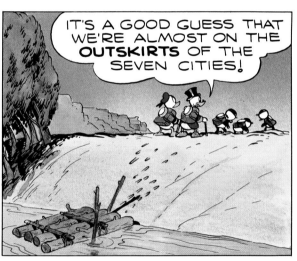

IT'S A GOOD GUESS THAT WE'RE ALMOST ON THE **OUTSKIRTS** OF THE SEVEN CITIES!

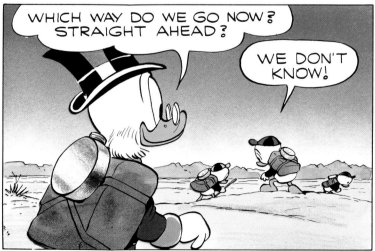

WHICH WAY DO WE GO NOW? STRAIGHT AHEAD?

WE DON'T KNOW!

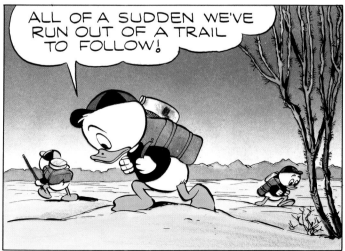

ALL OF A SUDDEN WE'VE RUN OUT OF A TRAIL TO FOLLOW!

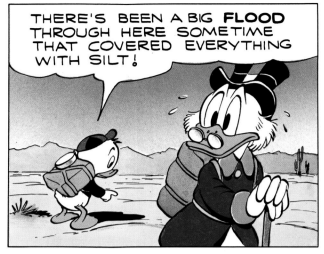

THERE'S BEEN A BIG **FLOOD** THROUGH HERE SOMETIME THAT COVERED EVERYTHING WITH SILT!

WE'LL JUST HAVE TO HIKE ACROSS TO THAT DISTANT RANGE AND TRY TO PICK UP THE TRAIL AGAIN!

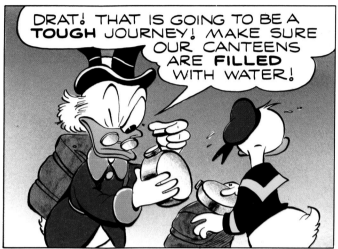

DRAT! THAT IS GOING TO BE A **TOUGH** JOURNEY! MAKE SURE OUR CANTEENS ARE **FILLED** WITH WATER!

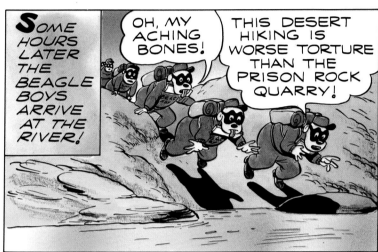

SOME HOURS LATER THE BEAGLE BOYS ARRIVE AT THE RIVER!

OH, MY ACHING BONES!

THIS DESERT HIKING IS WORSE TORTURE THAN THE PRISON ROCK QUARRY!

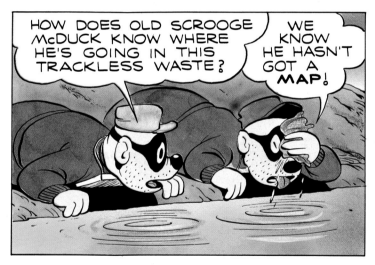

HOW DOES OLD SCROOGE McDUCK KNOW WHERE HE'S GOING IN THIS TRACKLESS WASTE?

WE KNOW HE HASN'T GOT A **MAP!**

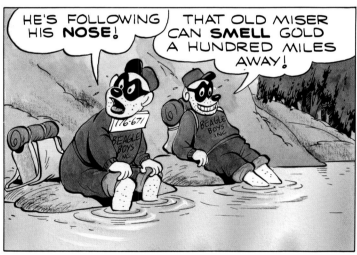

HE'S FOLLOWING HIS **NOSE!**

THAT OLD MISER CAN **SMELL** GOLD A HUNDRED MILES AWAY!

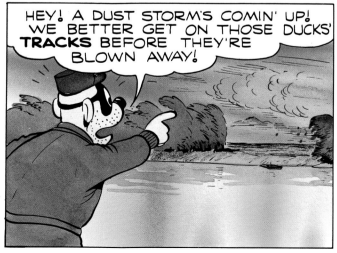

HEY! A DUST STORM'S COMIN' UP! WE BETTER GET ON THOSE DUCKS' **TRACKS** BEFORE THEY'RE BLOWN AWAY!

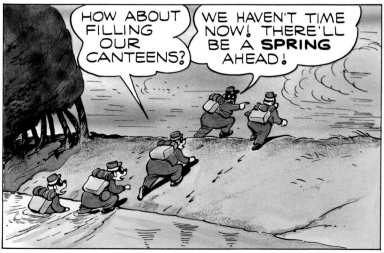

HOW ABOUT FILLING OUR CANTEENS?

WE HAVEN'T TIME NOW! THERE'LL BE A **SPRING** AHEAD!

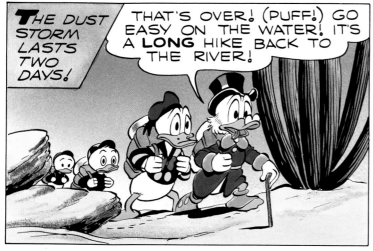

THE DUST STORM LASTS TWO DAYS!

THAT'S OVER! (PUFF!) GO EASY ON THE WATER! IT'S A **LONG** HIKE BACK TO THE RIVER!

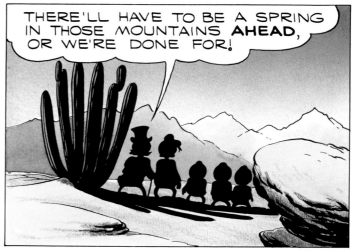

THERE'LL HAVE TO BE A SPRING IN THOSE MOUNTAINS **AHEAD**, OR WE'RE DONE FOR!

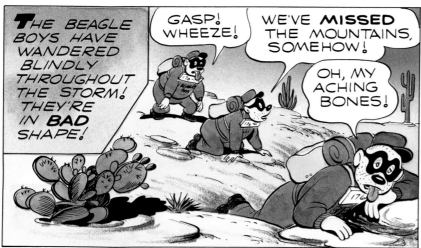

THE BEAGLE BOYS HAVE WANDERED BLINDLY THROUGHOUT THE STORM! THEY'RE IN **BAD** SHAPE!

GASP! WHEEZE!

WE'VE **MISSED** THE MOUNTAINS, SOMEHOW!

OH, MY ACHING BONES!

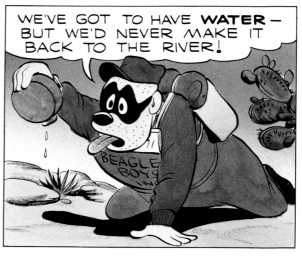

WE'VE GOT TO HAVE **WATER** — BUT WE'D NEVER MAKE IT BACK TO THE RIVER!

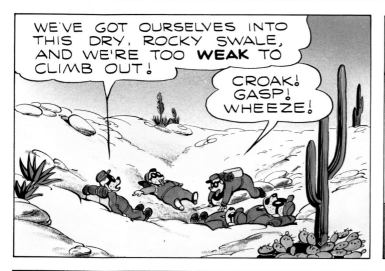

WE'VE GOT OURSELVES INTO THIS DRY, ROCKY SWALE, AND WE'RE TOO **WEAK** TO CLIMB OUT!

CROAK! GASP! WHEEZE!

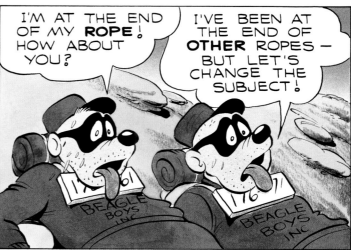

I'M AT THE END OF MY **ROPE**! HOW ABOUT YOU?

I'VE BEEN AT THE END OF **OTHER** ROPES — BUT LET'S CHANGE THE SUBJECT!

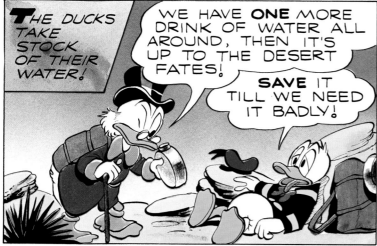

THE DUCKS TAKE STOCK OF THEIR WATER!

WE HAVE **ONE** MORE DRINK OF WATER ALL AROUND, THEN IT'S UP TO THE DESERT FATES!

SAVE IT TILL WE NEED IT BADLY!

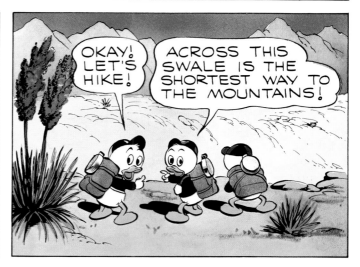

OKAY! LET'S HIKE!

ACROSS THIS SWALE IS THE SHORTEST WAY TO THE MOUNTAINS!

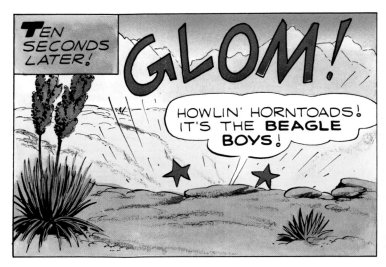

TEN SECONDS LATER!

GLOM!

HOWLIN' HORNTOADS! IT'S THE **BEAGLE BOYS!**

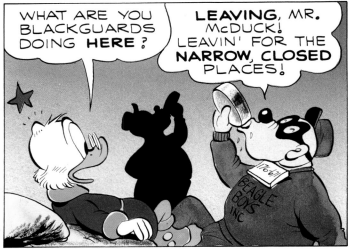

WHAT ARE YOU **BLACKGUARDS** DOING **HERE?**

LEAVING, MR. McDUCK! LEAVIN' FOR THE **NARROW, CLOSED PLACES!**

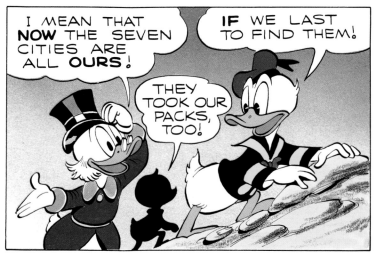

WE GIVE THE **WIDE OPEN** SPACES BACK TO THE DESERT RATS!

THE OLD PRISON ROCK PILE WILL LOOK **GOOD** TO US NOW!

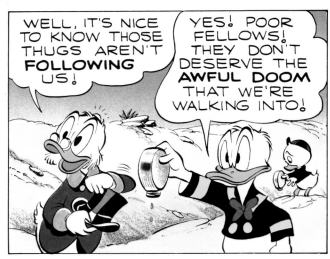

WELL, IT'S NICE TO KNOW THOSE THUGS AREN'T **FOLLOWING** US!

YES! POOR FELLOWS! THEY DON'T DESERVE THE **AWFUL DOOM** THAT WE'RE WALKING INTO!

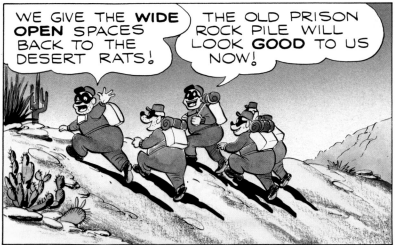

I MEAN THAT **NOW** THE SEVEN CITIES ARE ALL **OURS!**

IF WE LAST TO FIND THEM!

THEY TOOK OUR PACKS, TOO!

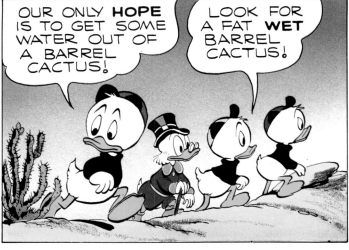

OUR ONLY **HOPE** IS TO GET SOME WATER OUT OF A BARREL CACTUS!

LOOK FOR A FAT **WET** BARREL CACTUS!

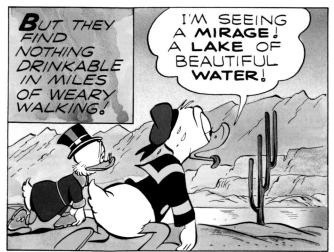

BUT THEY FIND NOTHING DRINKABLE IN MILES OF WEARY WALKING!

I'M SEEING A **MIRAGE!** A **LAKE** OF BEAUTIFUL **WATER!**

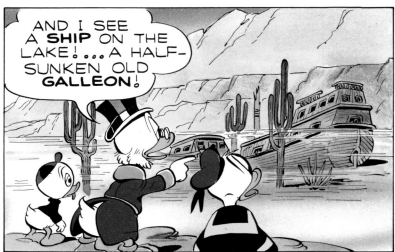

AND I SEE A **SHIP** ON THE LAKE!...A HALF-SUNKEN OLD **GALLEON!**

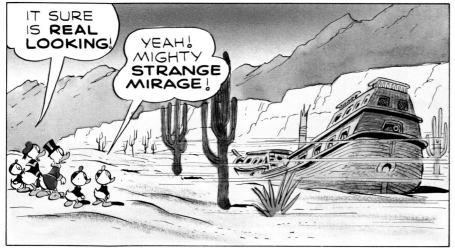

IT SURE IS **REAL** LOOKING!

YEAH! MIGHTY **STRANGE** MIRAGE!

ACCORDING TO OUR GUIDE-BOOK IT MIGHT BE THE "**LOST SHIP OF THE DESERT**," WHICH HAS BEEN SEEN SEVERAL TIMES IN THE LAST FOUR CENTURIES!

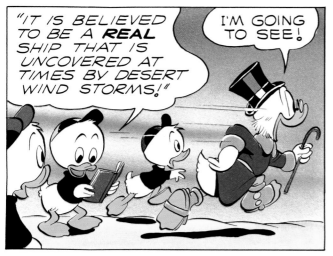

"IT IS BELIEVED TO BE A **REAL** SHIP THAT IS UNCOVERED AT TIMES BY DESERT WIND STORMS!"

I'M GOING TO SEE!

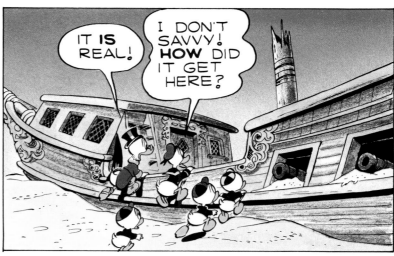

IT **IS** REAL!

I DON'T SAVVY! **HOW** DID IT GET HERE?

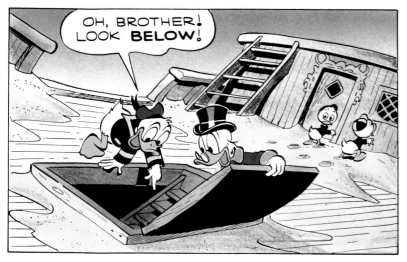

OH, BROTHER! LOOK **BELOW**!

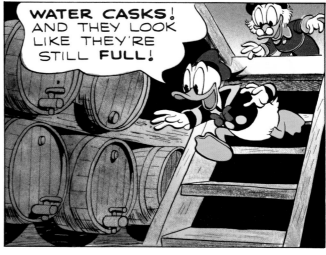

WATER CASKS! AND THEY LOOK LIKE THEY'RE STILL **FULL**!

WELL, NOT **QUITE** FULL, BUT THERE'S ENOUGH TO WET OUR WHISTLES!

BOYS, WE'VE MADE THE **SECOND BIGGEST** FIND IN THE DESERT— NEXT TO THE SEVEN CITIES THEMSELVES!

THERE MUST BE SOME **RECORDS** SOMEPLACE!

THE LOGBOOK, FOR INSTANCE!

I'VE FOUND IT — I'M GLAD UNCA SCROOGE CAN READ **SPANISH**!

THE OLD SHIP'S LOG SUPPLIES A MISSING PAGE OF HISTORY!

IT'S THE STORY OF CAPTAIN FRANCISCO DE ULLOA*, WHO SAILED WEST FROM LOWER CALIFORNIA IN 1539 AND WAS NEVER SEEN AGAIN!

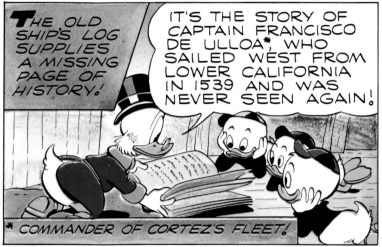

* COMMANDER OF CORTEZ'S FLEET!

IT SEEMS HE'D BEEN EXPLORING THE MOUTH OF THE COLORADO RIVER, SEEKING A ROUTE TO THE SEVEN CITIES! HE GAVE UP AND SAILED AWAY, BUT LATER DECIDED TO RETURN TO THE RIVER FOR ONE MORE TRY!

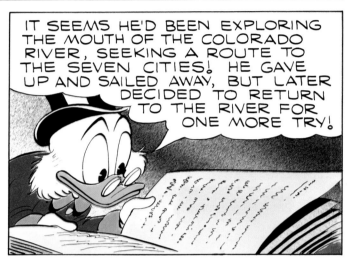

"AT THE BAR WE WERE CAUGHT IN A GREAT **TIDE**, WHICH SWEPT US UP THE RIVER FORTY LEAGUES OR MORE!

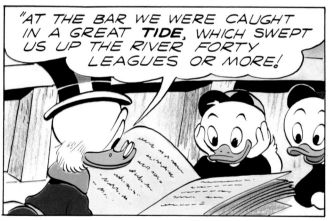

"**T**HEREUPON A GREAT EARTHQUAKE LIFTED THE RIVER AND HURLED ITS WATERS FAR EASTWARD!....

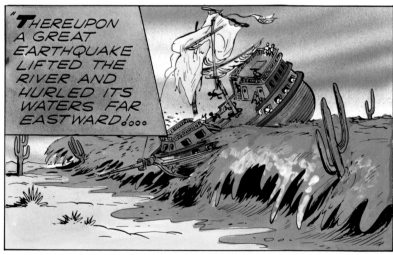

"**W**HERE THE WATERS SANK INTO THE GROUND, AND OUR PROUD SHIP CAME TO REST ON A LOW DUNE, SURROUNDED BY SPINY PLANTS!

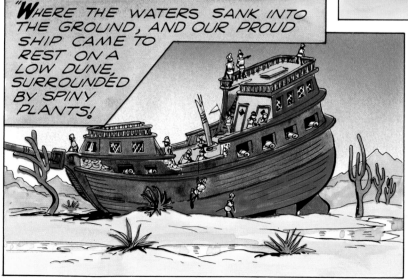

SOME STORY!

UH-HUH! BUT YOU HAVEN'T HEARD THE **BEST** PART YET!

HE SAYS THAT THEY LOOKED OVER THE BOW AND SAW A GREAT HOST OF INDIANS COMING FROM A CLEFT IN THE CLIFFS, AND THAT THEY WERE DRESSED IN **GOLD**!

INDIANS FROM **CIBOLA**!

WHAT ELSE DOES HE SAY?

NOTHING! THAT IS THE **LAST** ENTRY IN THE BOOK!

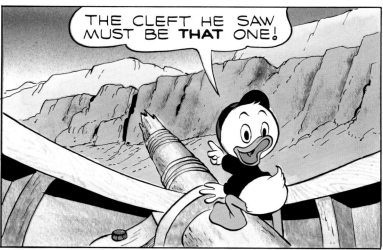

THE CLEFT HE SAW MUST BE **THAT** ONE!

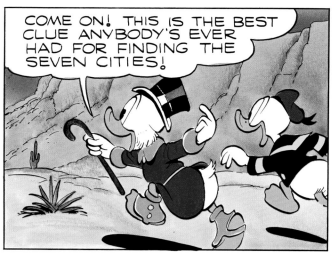

COME ON! THIS IS THE BEST CLUE ANYBODY'S EVER HAD FOR FINDING THE SEVEN CITIES!

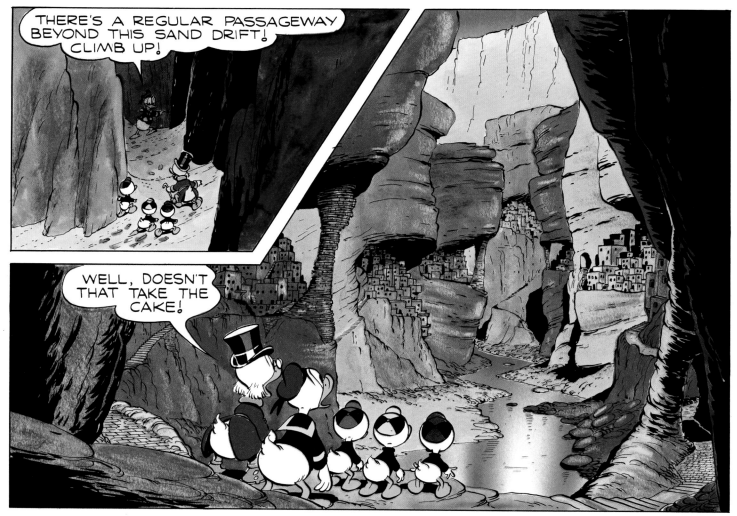

THERE'S A REGULAR PASSAGEWAY BEYOND THIS SAND DRIFT! CLIMB UP!

WELL, DOESN'T THAT TAKE THE CAKE!

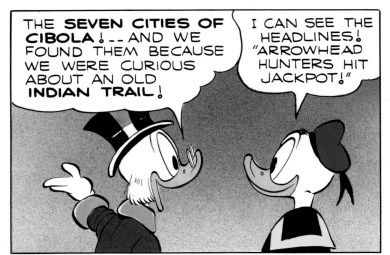

THE **SEVEN CITIES OF CIBOLA** !--AND WE FOUND THEM BECAUSE WE WERE CURIOUS ABOUT AN OLD **INDIAN TRAIL** !

I CAN SEE THE HEADLINES! "ARROWHEAD HUNTERS HIT JACKPOT!"

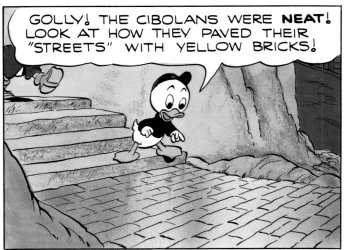

GOLLY! THE CIBOLANS WERE **NEAT**! LOOK AT HOW THEY PAVED THEIR "STREETS" WITH YELLOW BRICKS!

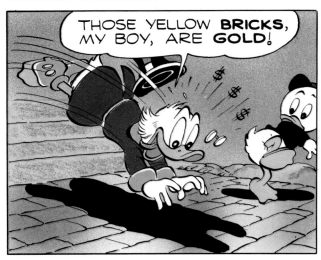

THOSE YELLOW **BRICKS**, MY BOY, ARE **GOLD**!

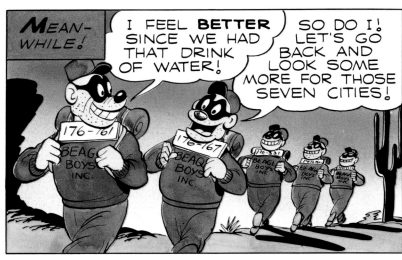

MEAN- WHILE!

I FEEL **BETTER** SINCE WE HAD THAT DRINK OF WATER!

SO DO I! LET'S GO BACK AND LOOK SOME MORE FOR THOSE SEVEN CITIES!

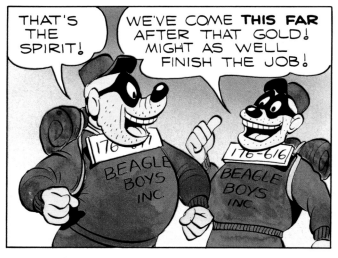

THAT'S THE SPIRIT!

WE'VE COME **THIS FAR** AFTER THAT GOLD! MIGHT AS WELL FINISH THE JOB!

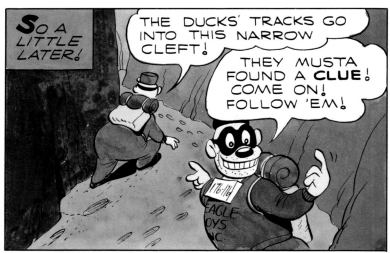

So A LITTLE LATER!

THE DUCKS' TRACKS GO INTO THIS NARROW CLEFT!

THEY MUSTA FOUND A **CLUE**! COME ON! FOLLOW 'EM!

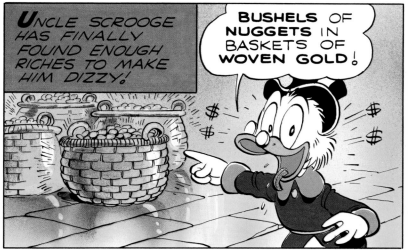

UNCLE SCROOGE HAS FINALLY FOUND ENOUGH RICHES TO MAKE HIM DIZZY!

BUSHELS OF **NUGGETS** IN BASKETS OF **WOVEN GOLD**!

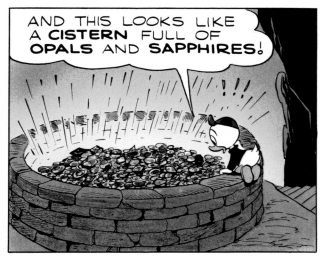

AND THIS LOOKS LIKE A **CISTERN** FULL OF **OPALS** AND **SAPPHIRES**!

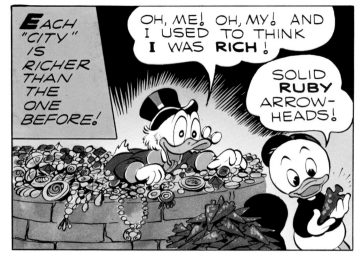

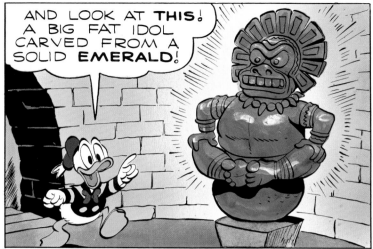

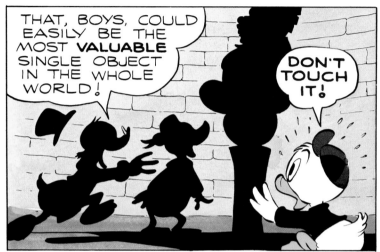

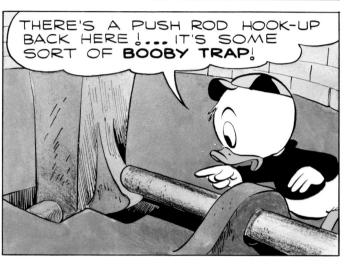

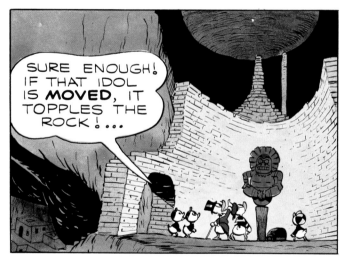

LET'S **MAP** THIS PLACE, THEN BUILD A RAILROAD INTO HERE TO HAUL THE TREASURE OUT!

OKAY! BUT RIGHT NOW I'M WONDERING WHAT BECAME OF THE **PEOPLE** THAT USED TO LIVE HERE!

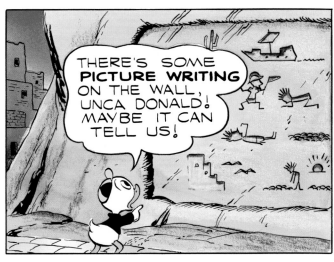

THERE'S SOME **PICTURE WRITING** ON THE WALL, UNCA DONALD! MAYBE IT CAN TELL US!

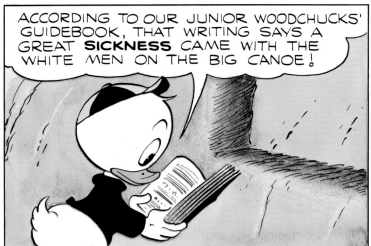

ACCORDING TO OUR JUNIOR WOODCHUCKS' GUIDEBOOK, THAT WRITING SAYS A GREAT **SICKNESS** CAME WITH THE WHITE MEN ON THE BIG CANOE!

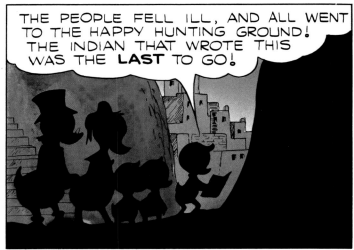

THE PEOPLE FELL ILL, AND ALL WENT TO THE HAPPY HUNTING GROUND! THE INDIAN THAT WROTE THIS WAS THE **LAST** TO GO!

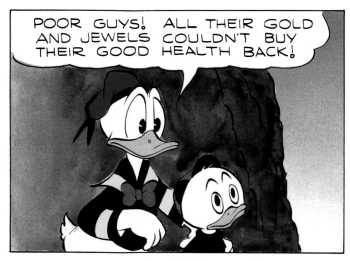

POOR GUYS! ALL THEIR GOLD AND JEWELS COULDN'T BUY THEIR GOOD HEALTH BACK!

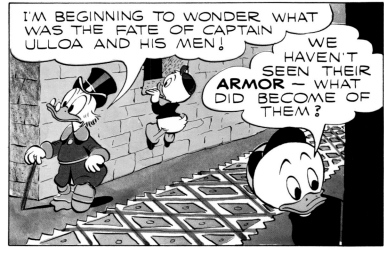

I'M BEGINNING TO WONDER WHAT WAS THE FATE OF CAPTAIN ULLOA AND HIS MEN!

WE HAVEN'T SEEN THEIR **ARMOR** — WHAT DID BECOME OF THEM?

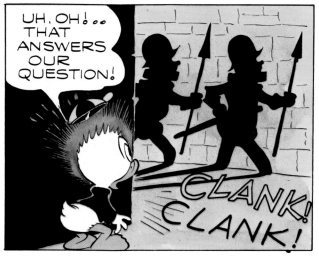

UH, OH!.. THAT ANSWERS OUR QUESTION!

CLANK! CLANK!

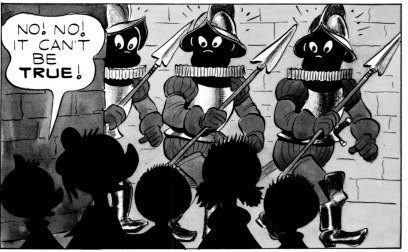

NO! NO! IT CAN'T BE **TRUE!**

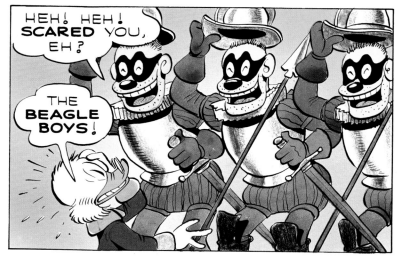

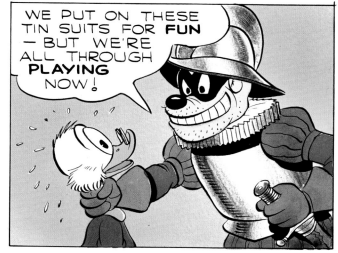

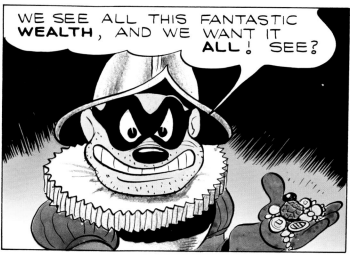

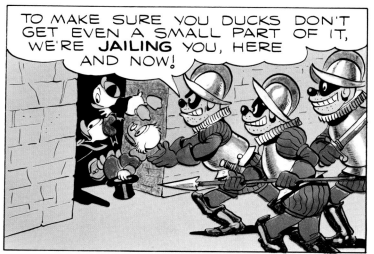

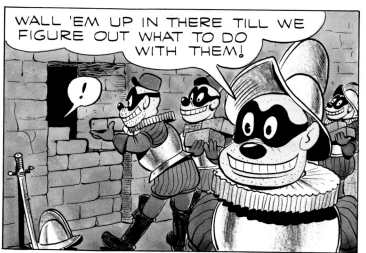

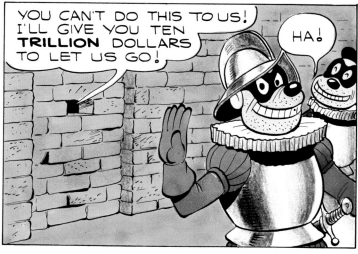

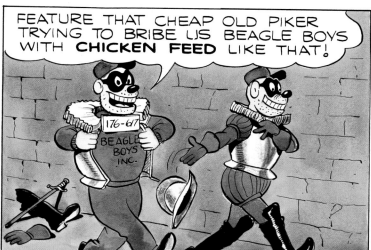

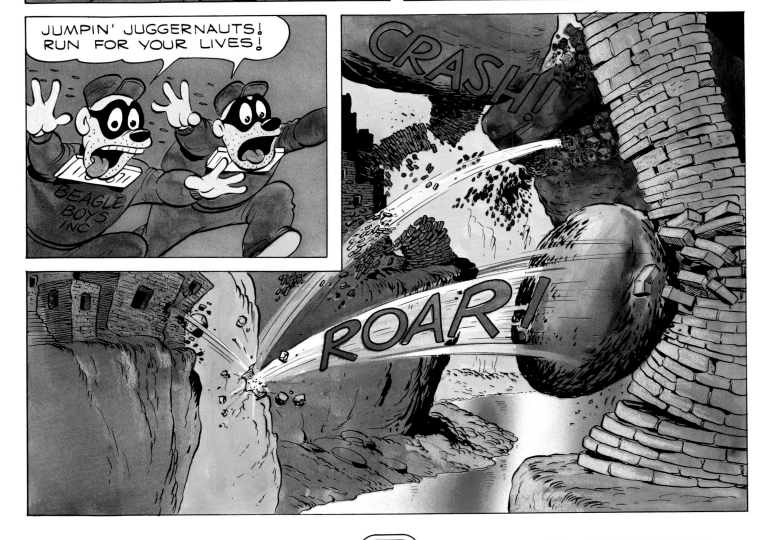

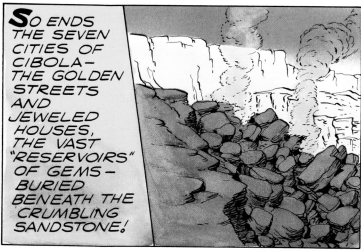

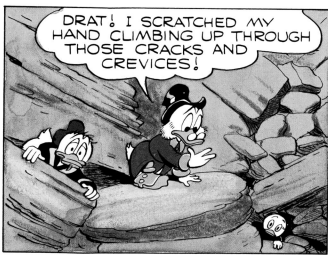

I'VE GOT A BAD BUMP ON THE HEAD! HOW ABOUT YOU LADS?

YES! I DON'T REMEMBER HOW I GOT IT!

LAST I REMEMBER WE WERE UP ON A MESA LOOKING FOR ARROW-HEADS!

YEAH! ME, TOO!

HEY! THERE'S SOME **BEAGLE BOYS**! WONDER WHAT **THEY'RE** DOING HERE?

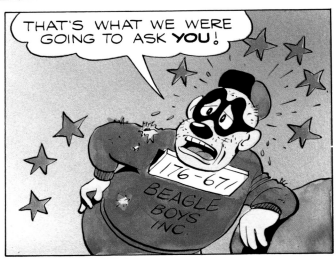

THAT'S WHAT WE WERE GOING TO ASK **YOU**!

176-671

BEAGLE BOYS INC.

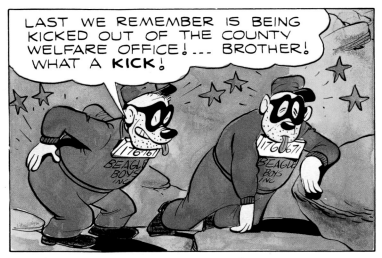

LAST WE REMEMBER IS BEING KICKED OUT OF THE COUNTY WELFARE OFFICE! ... BROTHER! WHAT A **KICK**!

WAIT! **I** REMEMBER SOMETHING!

YOU DO? WHAT?

I HAD **FOUR** ARROWHEADS, WORTH **FIFTY CENTS** APIECE! I MUSTA LOST 'EM IN THAT LANDSLIDE!

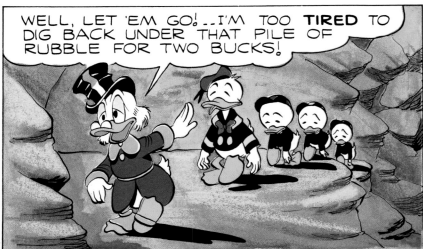

WELL, LET 'EM GO! ...I'M TOO **TIRED** TO DIG BACK UNDER THAT PILE OF RUBBLE FOR TWO BUCKS!

❝I polished and polished on the scripts and drawings until I had done the best I could in the time available.❞

The plot of "Seven Cities of Cibola" actually came from local contacts. My wife, Garé, and I went down to Indio, California, to see Al Koch, the manager of the Riverside County welfare office. He was quite an authority on Indian tribes that have lived around here for generations: their history, the tribal names, the things they did. He said he would take us to an old Indian trail that went over the top of a mesa out by Thousand Palms. He thought that the Arizona tribes and the tribes on the West Coast had used it as a trade route. There was one type of seashell that made beautiful necklaces. The California Indians would carry these shells all the way across the desert, over the Colorado River, and into Arizona, possibly even to Cibola, where these fabled seven cities were. They would trade them there for turquoise and the beautiful things that the Arizona Indians made, then come back. The traffic went on for thousands of years. Al said, "When you see that trail, you'll know that it must have been traveled for thousands of years because you can see the trail in that hard desert soil on top of the mesa, and the Indians had worn it that deep wearing only soft moccasins."

So we went up there and looked at the old Indian trail. Every fifty or a hundred feet there was a little circle of rocks where the Indians had had a campfire or a cremation. Whenever one of them died on the trail, they built a little brush fire and cremated him right there. Years earlier, people used to find shards of pottery where these sites were. Out in the eastern part of Riverside County, out toward the Colorado River, there were places where the trail would crop up again on a particular stretch of hillside that hadn't been buried under the drifting sands. Al was pretty sure this was the authentic thing.

Later, he and I had several martinis and got to talking about all the possibilities. The ducks could follow the trail and find the Seven Cities of Cibola. The more we drank, the more grandiose the idea seemed. When Garé and I came home that night, I thought of it for a while, and it still seemed very good. But the next morning when I thought it over, I felt I had only enough for a ten-page story. Just the ducks following an old trail across the desert, and what did they get into? Lizards? I decided I couldn't use rattlesnakes very well. The ducks could get cactus thorns in their feet, they

could get thirsty—I was trying to think of things they could do. They could come to the Colorado River and maybe get half-drowned trying to get across. Then they could go into the mountains on the other side and find the Seven Cities of Cibola. Well, so what? It's a bunch of treasure, and it's just a simple little one-way story. I thought there had to be something more to go in there to fill up the spaces and make it more interesting.

It happened that I was in a restaurant a couple of days later having a hamburger. There was an old hillbilly type of rancher in there. He had a big spread of land off to the south of Hemet, where he raised goats and that sort of stuff, and he was a notorious spinner of big stories. He was telling some guy about the Lost Ship of the Desert, a wild legend I'd heard of before. He had been on a prospecting trip east of the Colorado, and on his way back with his pack mules, he saw a spar sticking up out of the sand. He went to it and darned if it wasn't an old Spanish galleon, this old ship that had been lost in the desert for hundreds of years. I was really cupping my weak ears to try to hear everything he had to say. I knew by hearsay that he was a hokum spreader, so I couldn't depend on his story very much, but I thought that his dubious ship fitted nicely into my Cibola story. So I kept listening. He told of deck railings that were still sticking up. The wood was very well preserved from having been out in the desert with no rain to rot it and from having been covered with sand. He said it wasn't a very big ship, just a small galleon that could have sailed up the Colorado River. He thought perhaps a tidal wave had washed it so far in from the sea and that in the four hundred years since then, the river might have changed its course. He couldn't account for it, but he knew he could go right back to it. And I

thought, "Well, why in the hell haven't you?!"

It seemed worthwhile to go to the library and see what I could find on that Lost Ship of the Desert. Little accounts had cropped up in the paper every once in a while of people who were delirious from thirst who saw the ship. I found that at one time it was believed to have been a ship lost from a survey party going up the Colorado, and at another time that it was believed to be a flat-bottomed barge that got picked up by a tidal wave generated by an earthquake. There was an earthquake in the very early 1800's that might have accounted for that one. But nobody could prove that they'd seen such a lost ship.

I figured I could go to town on that idea because nobody could say I was wrong. There was evidence that a Spanish expedition did lose a ship up the Colorado and evidence that a great tidal wave had once roared up the river. It was a nice gimmick to have the ducks find this ship and tie it in with the Seven Cities of Cibola by having the bowsprit point right to the cleft in the rocks.

But even with all the material I had assembled up to that time, I still needed something. I needed a menace. Something that would bring the whole thing to some kind of terrific climax. The Beagle Boys being in there constantly created suspense and danger. Their finally pulling over the booby trap was just the thing I had to have. So all these elements were the result of walking along an old Indian path and later hearing a long-winded old guy talking in a restaurant. And since Al Koch had suggested the whole idea, I drew him into the twelfth page of the story, booting the Beagle Boys out of his office.

THE LEMMING
WITH THE
LOCKET

The Lemming with the Locket
Uncle Scrooge #9 March 1955

Lemmings are mysterious little creatures. At times there are almost as many of them as there are dollars in Uncle Scrooge's money bin. At such times they stage mass migrations to the sea. Millions and millions of lemmings all going the same direction at the same time, every lemming looking exactly like every other lemming. In this nightmarish story Uncle Scrooge has the task of finding *one* lemming among all those millions, which wears around its neck a tiny, but very valuable, locket.

Nobody but Uncle Scrooge could get himself into such a predicament, and nobody but a great lover of fine Norwegian cheese could ever get him out.

The moral of this story is never put all of your eggs in one basket or lock all of your secrets in one locket. *C.B. 1981*

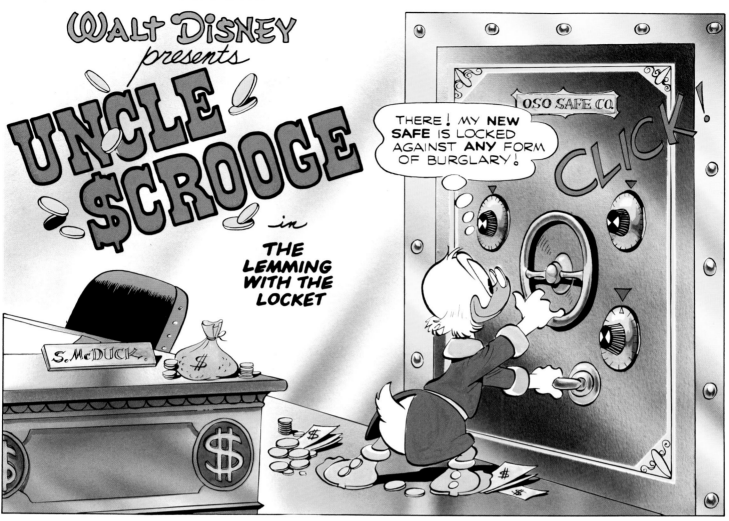

WALT DISNEY presents UNCLE $CROOGE in THE LEMMING WITH THE LOCKET

THERE! MY **NEW** SAFE IS LOCKED AGAINST **ANY** FORM OF BURGLARY!

CLICK!

THIS MIGHTY BOX OF IMPERVIUM METAL COST ME ONE-HALF OF MY ENTIRE FORTUNE, BUT IT IS WORTH IT!

ITS TEN-FOOT THICK WALLS CAN NEVER BE CUT OR CRACKED OR BURNED THROUGH! THE ONLY WAY TO GET INSIDE IS THROUGH THIS MIGHTY DOOR!

AND THE ONLY WAY TO OPEN THE DOOR IS BY WORKING THE COMBINATION OF **SEVEN** LOCKS!

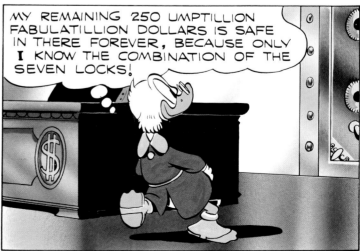

MY REMAINING 250 UMPTILLION FABULATILLION DOLLARS IS SAFE IN THERE FOREVER, BECAUSE ONLY **I** KNOW THE COMBINATION OF THE SEVEN LOCKS!

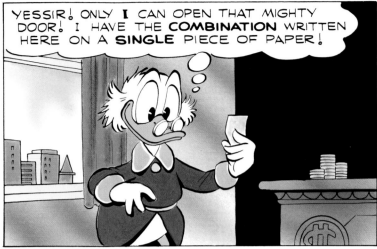

YESSIR! ONLY **I** CAN OPEN THAT MIGHTY DOOR! I HAVE THE **COMBINATION** WRITTEN HERE ON A **SINGLE** PIECE OF PAPER!

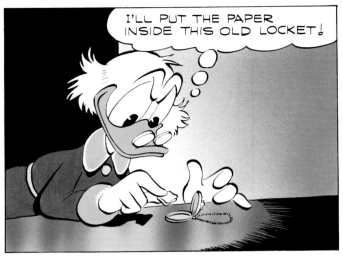

I'LL PUT THE PAPER INSIDE THIS OLD LOCKET!

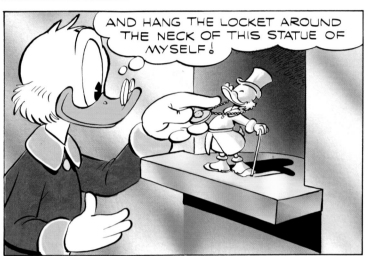

AND HANG THE LOCKET AROUND THE NECK OF THIS STATUE OF MYSELF!

NOBODY WOULD EVER DREAM THAT THE COMBINATION OF THE SAFE IS HIDDEN IN SUCH A PROMINENT PLACE!

FOR THE FIRST TIME IN MY LIFE, I CAN FEEL **SAFE** ABOUT MY MONEY! WHAT A GRAND AND GLORIOUS FEELING!

DOWN BY THE WHARVES, UNCLE SCROOGE'S NEPHEWS ARE FISHING!

I'M GETTING HUNGRY! SHALL WE EAT?

YES! WE'RE HUNGRY, TOO, UNCA DONALD!

I BROUGHT BREAD AND SAUSAGE AND SOME OF THAT **IMPORTED** CHEESE WE LIKE SO WELL!

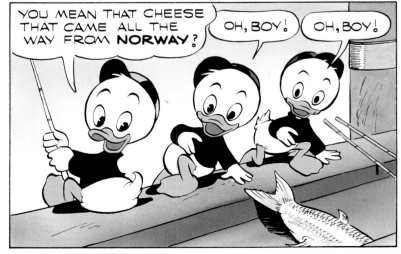

YOU MEAN THAT CHEESE THAT CAME ALL THE WAY FROM **NORWAY**?

OH, BOY!

OH, BOY!

GEE! THE SACK FEELS **HEAVY**!

WELL, WHAT DO YOU KNOW—A THIEVING **RAT** HAS BEEN IN OUR LUNCH BAG!

URP!

HE ATE **ALL** OF THE CHEESE!

HE **SHOWS** IT! THE **OVERSTUFFED** PIG!

ARK! YAP!

THAT'S A STRANGE-- LOOKING **RAT**, UNCA DONALD!

HE HAS A SHORT TAIL AND REDDISH COLOR!

AND TINY EARS!

GRR! SPUT! SPIT!

LET'S TAKE HIM UPTOWN AND SEE IF UNCLE SCROOGE KNOWS WHAT KIND OF RAT HE IS!

SO—

UNCLE SCROOGE, YOU'RE A MAN OF THE WORLD! WHAT SPECIES OF VARMINT IS THIS?

A **RAT**! A HORRIBLE, **MONEY-CHEWING** RAT!

GET HIM OUT OF HERE BEFORE HE GNAWS INTO MY SAFE AND EATS UP A BILLION DOLLARS OF MY MONEY!

ARF! SPUT!

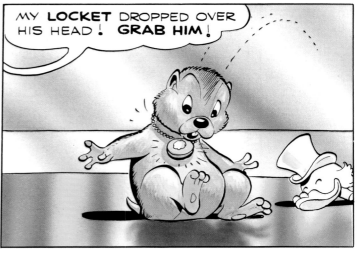

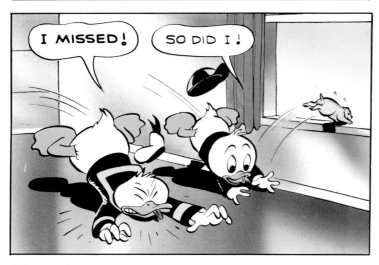

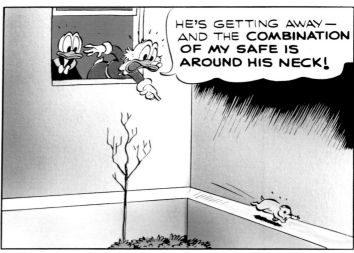

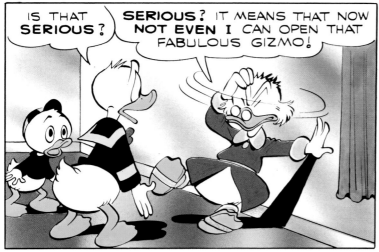

LATER! I'M SORRY I BROUGHT THE RAT TO YOU AND CAUSED ALL THIS TROUBLE, UNCLE SCROOGE!

WHERE DID YOU FIND THE BEAST, IN THE FIRST PLACE?

DOWN BY THE WATERFRONT, WHERE THE SHIPS COME IN!

WELL, **THAT'S** WHERE WE'LL FIND HIM!

HE'S PROBABLY GONE BACK THERE, ALREADY — **WAK!**

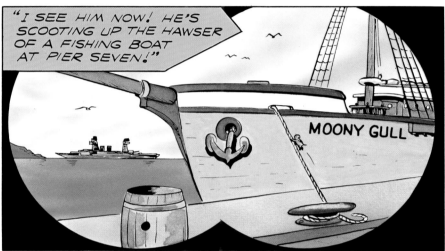

"I SEE HIM NOW! HE'S SCOOTING UP THE HAWSER OF A FISHING BOAT AT PIER SEVEN!"

MOONY GULL

COME ON, BOYS! WE'VE GOT HIM CORNERED!

BUT— WUP! WE'RE **TOO LATE!**

THE SCHOONER'S **GONE!**

HEY, SAILOR! WHERE'S THAT SCHOONER GOING?

WHO KNOWS? FISHING SCHOONERS GO **EVERYWHERE!**

BUT THE CAPTAIN MUST HAVE A **NEXT** PORT OF CALL!

HE GOES WHERE HE FINDS FISH — HIS NEXT PORT OF CALL MAY BE TOKYO — OR CASABLANCA!

WE'VE GOT TO CATCH THAT BOAT BEFORE IT GETS OUT OF SIGHT! FIND US A TAXI TO THE AIRPORT!

A FEW MINUTES LATER!

THIS HELICOPTER WILL OVERHAUL THAT WIND-JAMMER IN NOTHING FLAT!

I SEE A SCHOONER, ALREADY!

THAT'S **IT**! THE MOONY GULL!

GO DOWN! I WANT TO LAND ON THAT SHIP!

WHAT SHIP?

I'LL BE DOGGONED! IT'S LOST IN A **FOG BANK**!

AND WHAT **THICK** FOG!

WE'LL HAVE TO GO BACK TO SHORE, SIR, WHILE WE STILL KNOW HOW TO GET THERE!

WOE IS ME!

*T*HE FOG REMAINS FOR DAYS!

THERE'S **NO** WAY TO TRACE THE SCHOONER NOW! IT'S MAYBE IN MID-OCEAN!

WE'VE GOT AN IDEA!

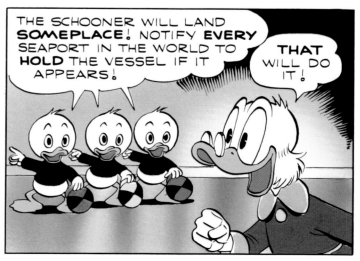

THE SCHOONER WILL LAND **SOMEPLACE**! NOTIFY **EVERY** SEAPORT IN THE WORLD TO **HOLD** THE VESSEL IF IT APPEARS!

THAT WILL DO IT!

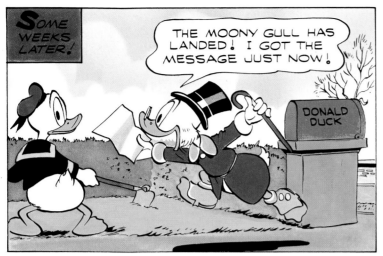

SOME WEEKS LATER!

THE MOONY GULL HAS LANDED! I GOT THE MESSAGE JUST NOW!

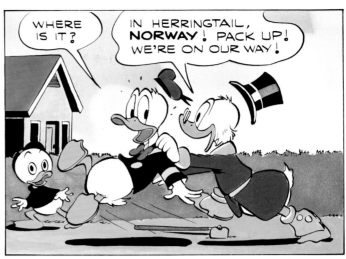

WHERE IS IT?

IN HERRINGTAIL, **NORWAY**! PACK UP! WE'RE ON OUR WAY!

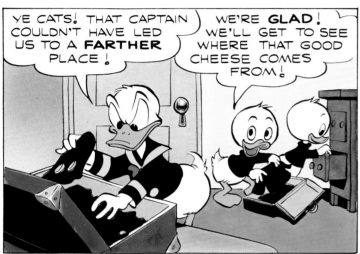

YE CATS! THAT CAPTAIN COULDN'T HAVE LED US TO A **FARTHER** PLACE!

WE'RE **GLAD**! WE'LL GET TO SEE WHERE THAT GOOD CHEESE COMES FROM!

SO—

THEY'RE HOLDING THE SHIP IN THE FJORD! WE'LL BOARD HER AND FIND THE RAT!

IF HE'S STILL ABOARD!

HE IS! THE CREWMEN HAVE SEEN HIM!

YOUR TROUBLES WILL SOON BE OVER, UNCA SCROOGE!

NEXT DAY— THE RUGGED COAST OF NORWAY!

BRACE FOR A LANDING! THERE'S HERRINGTAIL, IN THE FJORD!

AND THERE'S THE SCHOONER, JUST WAITING FOR ME TO PICK UP THAT CONFOUNDED **RAT**!

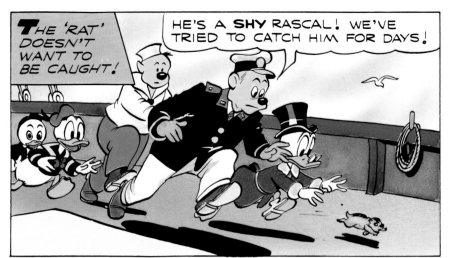

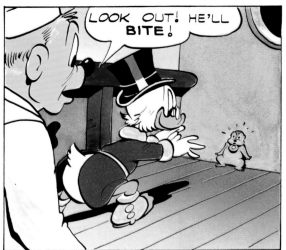

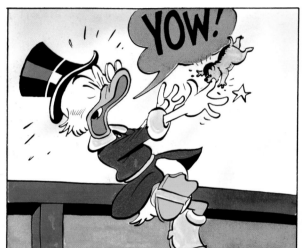

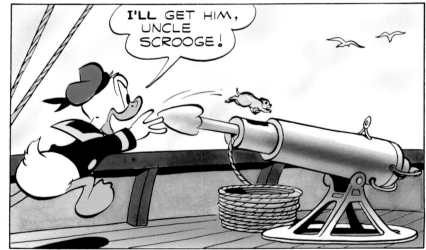

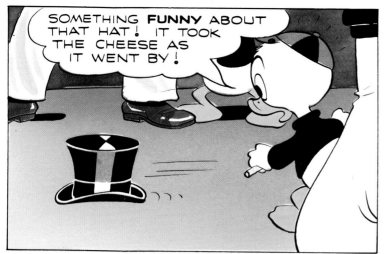

SOMETHING **FUNNY** ABOUT THAT HAT! IT TOOK THE CHEESE AS IT WENT BY!

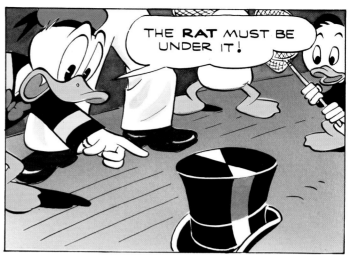

THE **RAT** MUST BE UNDER IT!

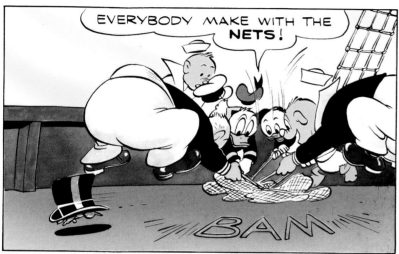

EVERYBODY MAKE WITH THE **NETS**!

BAM

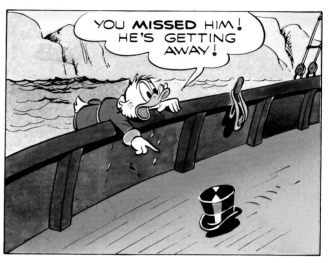

YOU **MISSED** HIM! HE'S GETTING AWAY!

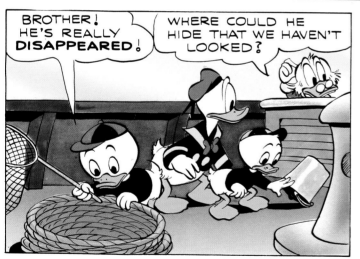

BROTHER! HE'S REALLY **DISAPPEARED**!

WHERE COULD HE HIDE THAT WE HAVEN'T LOOKED?

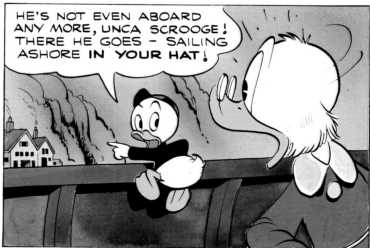

HE'S NOT EVEN ABOARD ANY MORE, UNCA SCROOGE! THERE HE GOES — SAILING ASHORE **IN YOUR HAT**!

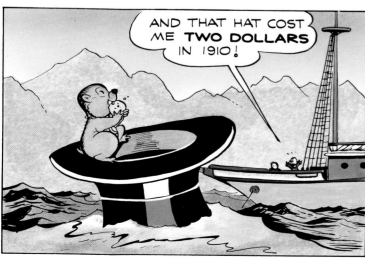

AND THAT HAT COST ME **TWO DOLLARS** IN 1910!

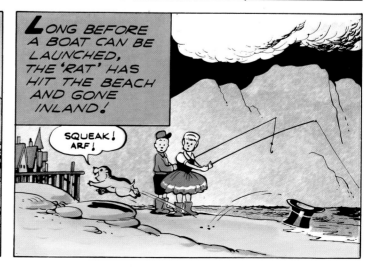

LONG BEFORE A BOAT CAN BE LAUNCHED, THE 'RAT' HAS HIT THE BEACH AND GONE INLAND!

SQUEAK! ARF!

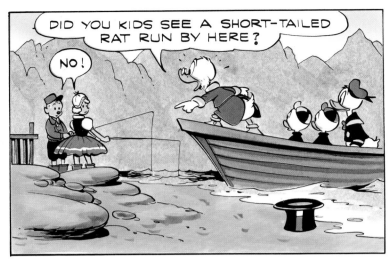

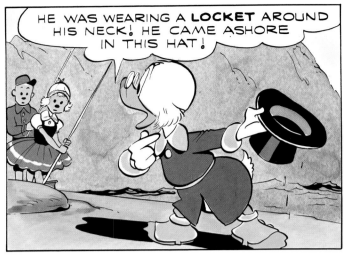

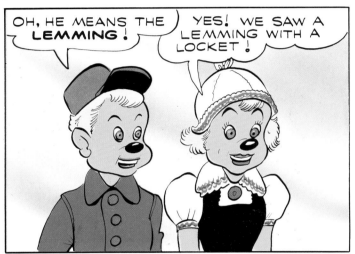

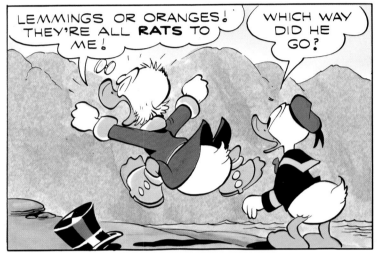

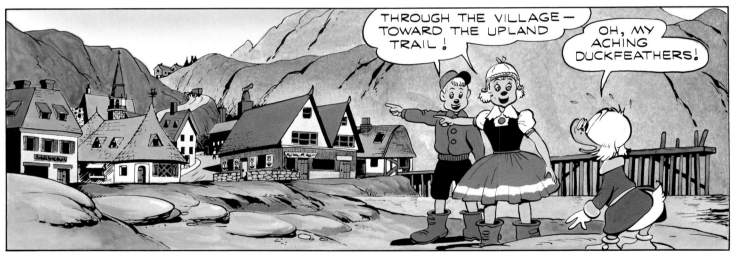

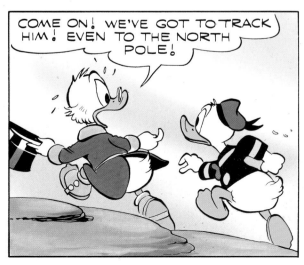

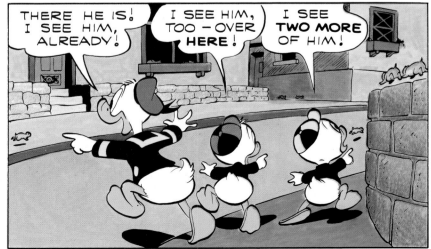

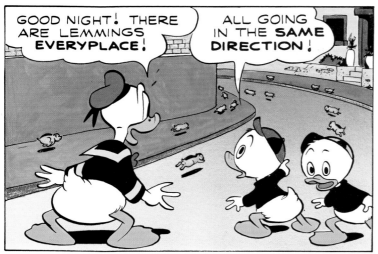

GOOD NIGHT! THERE ARE LEMMINGS EVERYPLACE!

ALL GOING IN THE SAME DIRECTION!

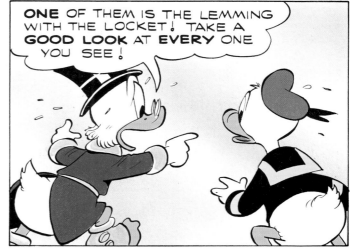

ONE OF THEM IS THE LEMMING WITH THE LOCKET! TAKE A GOOD LOOK AT EVERY ONE YOU SEE!

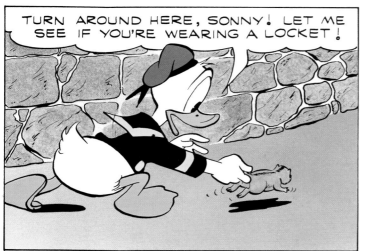

TURN AROUND HERE, SONNY! LET ME SEE IF YOU'RE WEARING A LOCKET!

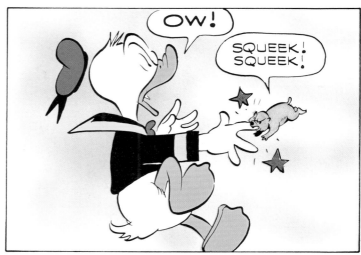

OW!

SQUEEK! SQUEEK!

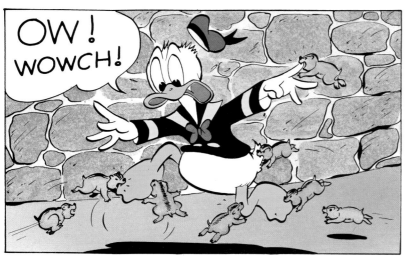

OW! WOWCH!

CLANNISH LITTLE RASCALS, AREN'T THEY?

THIS SEARCH IS GOING TO BE LONG AND TOUGH!

LET'S FIND A STORE WHERE WE CAN BUY SOME OF THAT GOOD CHEESE!

THERE'S ONE NOW!

WE'LL GET SOME FOR OUR LUNCH AND SOME TO TAKE BACK HOME!

LARSEN'S ST

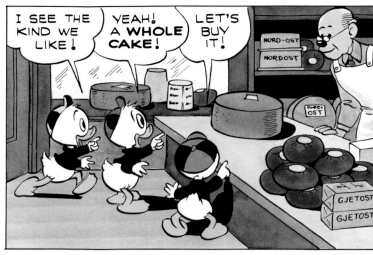

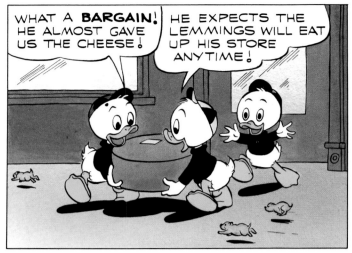

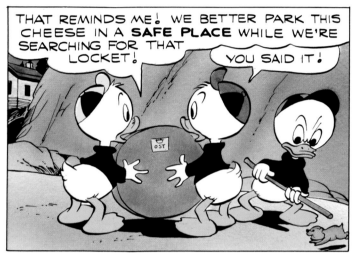

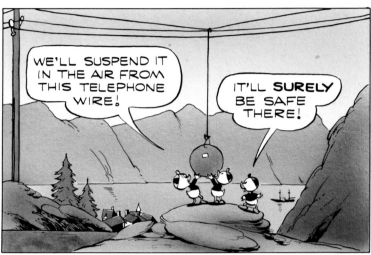

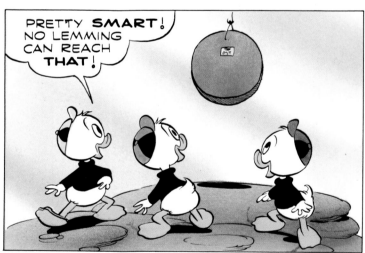

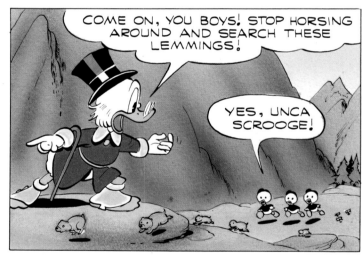

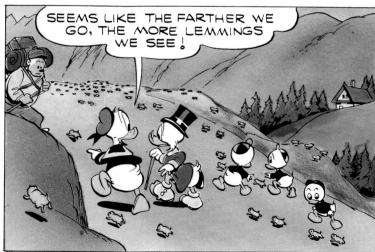

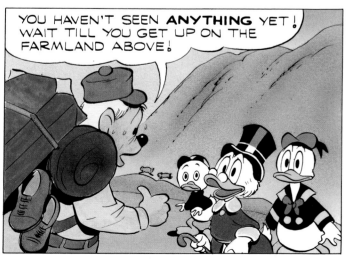

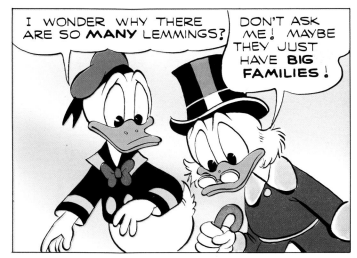

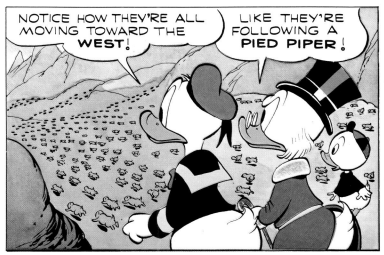

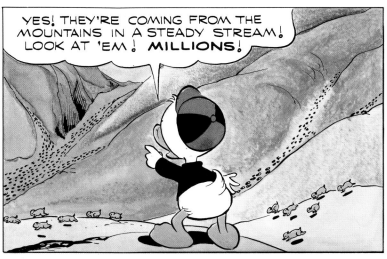

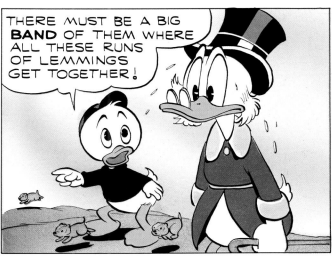

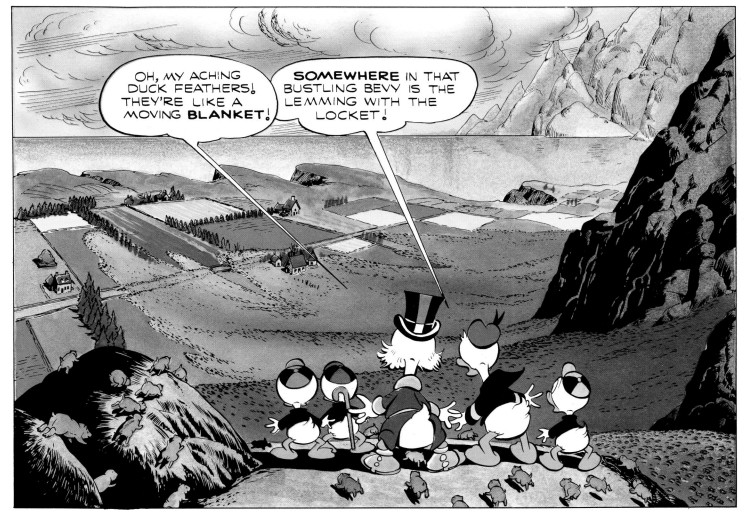

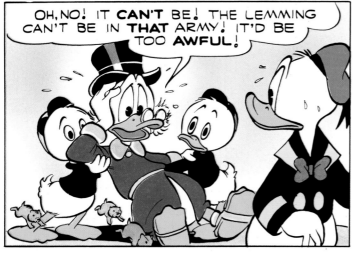

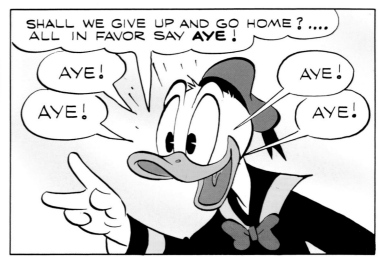

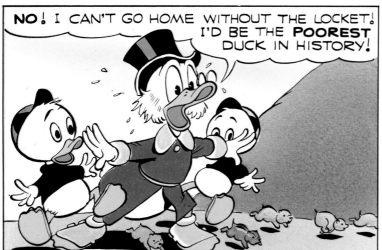

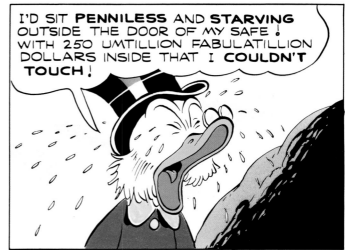

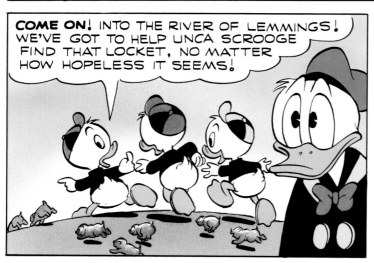

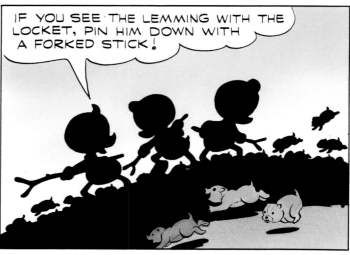

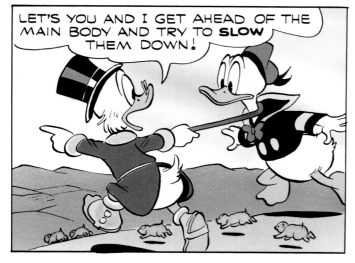

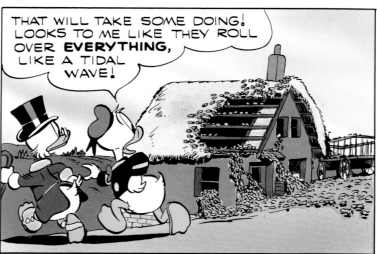

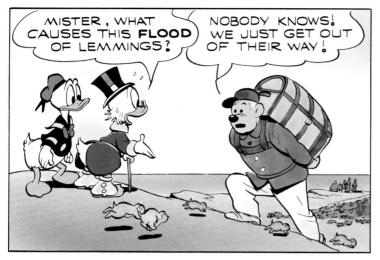

MISTER, WHAT CAUSES THIS **FLOOD** OF LEMMINGS?

NOBODY KNOWS! WE JUST GET OUT OF THEIR WAY!

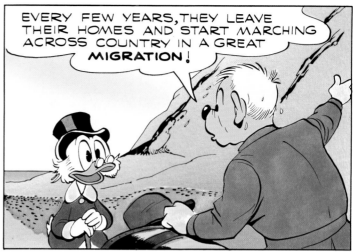

EVERY FEW YEARS, THEY LEAVE THEIR HOMES AND START MARCHING ACROSS COUNTRY IN A GREAT **MIGRATION**!

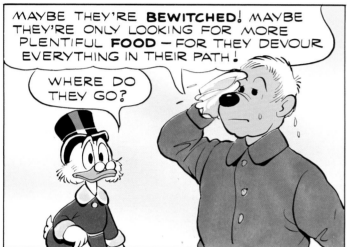

MAYBE THEY'RE **BEWITCHED**! MAYBE THEY'RE ONLY LOOKING FOR MORE PLENTIFUL **FOOD** — FOR THEY DEVOUR EVERYTHING IN THEIR PATH!

WHERE DO THEY GO?

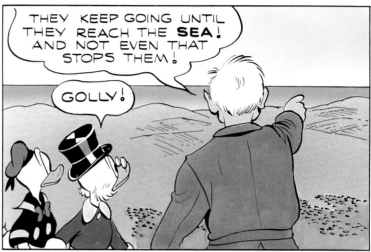

THEY KEEP GOING UNTIL THEY REACH THE **SEA**! AND NOT EVEN THAT STOPS THEM!

GOLLY!

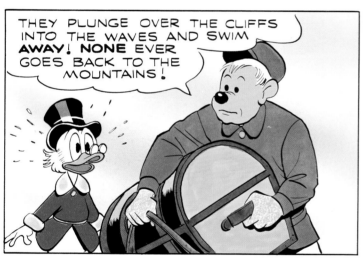

THEY PLUNGE OVER THE CLIFFS INTO THE WAVES AND SWIM **AWAY**! **NONE** EVER GOES BACK TO THE MOUNTAINS!

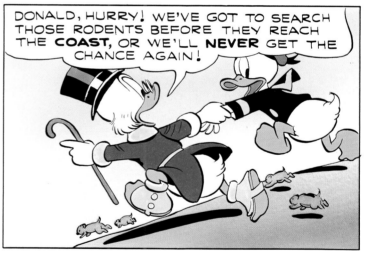

DONALD, HURRY! WE'VE GOT TO SEARCH THOSE RODENTS BEFORE THEY REACH THE **COAST**, OR WE'LL **NEVER** GET THE CHANCE AGAIN!

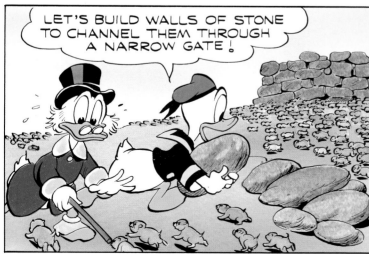

LET'S BUILD WALLS OF STONE TO CHANNEL THEM THROUGH A NARROW GATE!

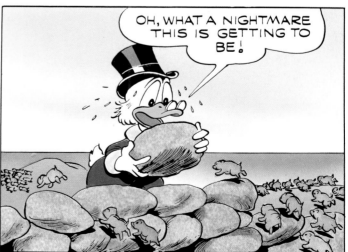

OH, WHAT A NIGHTMARE THIS IS GETTING TO BE!

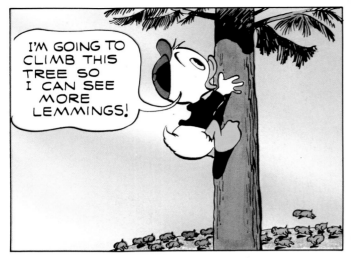

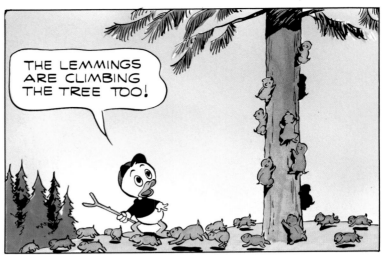

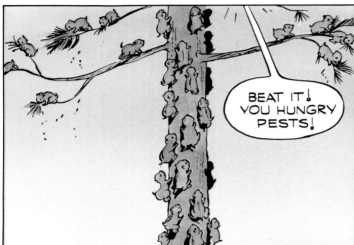

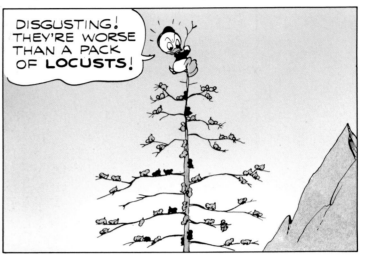

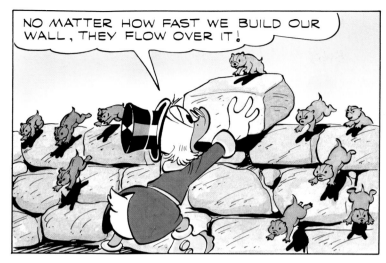

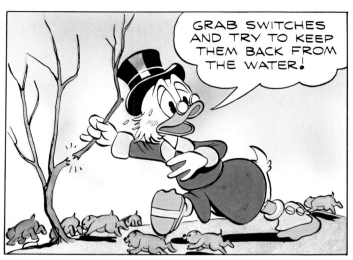

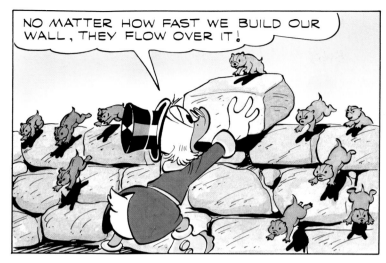

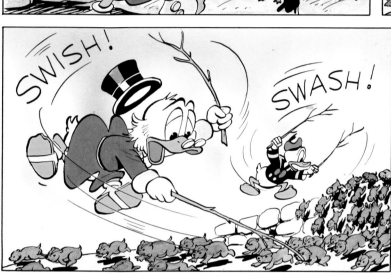

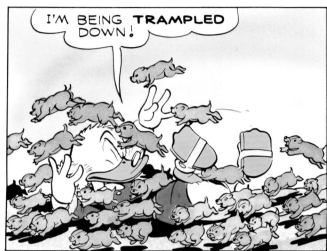

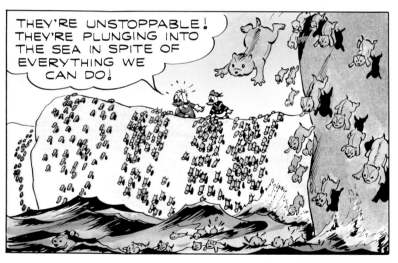

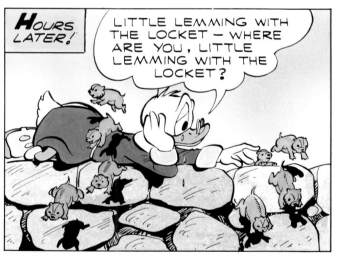

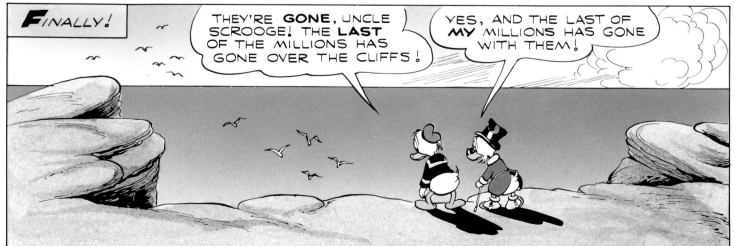

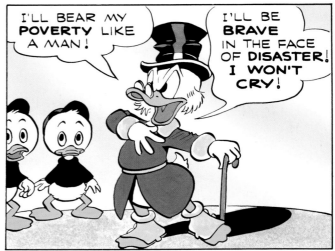

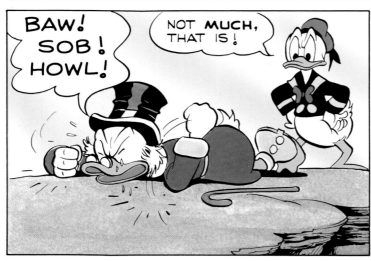

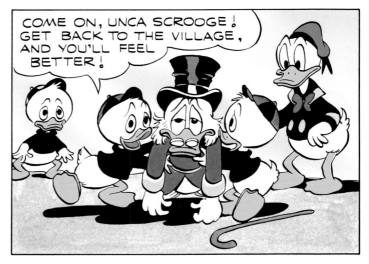

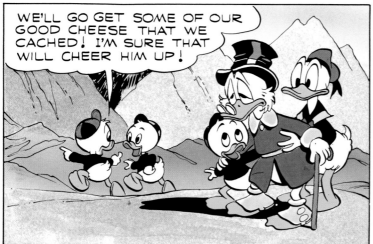

THAT HOLE'S ABOUT THE SIZE OF A **LEMMING!**

YES! A **LEMMING!**

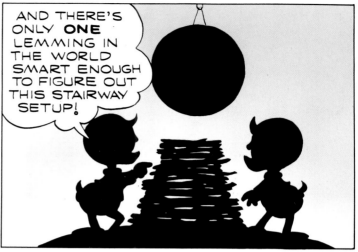

AND THERE'S ONLY **ONE** LEMMING IN THE WORLD SMART ENOUGH TO FIGURE OUT THIS STAIRWAY SETUP!

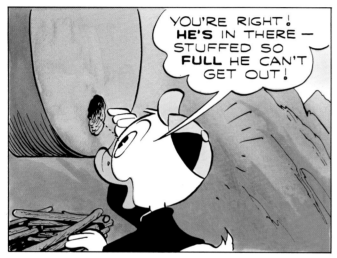

YOU'RE RIGHT! **HE'S** IN THERE — STUFFED SO **FULL** HE CAN'T GET OUT!

UNCA SCROOGE!

STOP! **WAIT!** LET'S NOT TELL HIM JUST YET!

IF WE WORK THIS RIGHT, WE MAY BE ABLE TO GET A **RICH** REWARD FOR **FINDING** THE LOCKET!

WE'RE ONLY **DUCKS,** NOT **MAGICIANS** — BUT I'M WITH YOU!

So—

CHEER UP, UNCLE SCROOGE! EVERY-THING WILL TURN OUT ALL RIGHT!

YES! IN A HUNDRED YEARS, I WON'T CARE MORE OR LESS!

❝Sitz baths in Lethargy are not recommended as cures for lead deposits on the *gluteus maximus*. ❞

It happened that there had been a big migration of lemmings a short time before I started the story. I read about it in the paper, and that got me to thinking of lemmings. I read more about them in *National Geographic* and other places, so I felt they would be a good prop as a menace. From that, I hit upon the idea for a big climax situation of having Uncle Scrooge's safe combination being on the neck of one lemming in a migration of millions of lemmings. I built backward to a beginning and then moved forward with the panel breakdowns.

I called the boat the *Mooney Gull* so that the reader could remember it if they saw it again. There is a little trick in the naming of things like ships. If you're going to have a ship in a scene early in a story and then not see it again until quite awhile later, the name of that ship or some feature of it has got to stick in the reader's memory so that they recognize it instantly when they see it again. It's a good thing to have a lot of impact in the name of something. Many of my names had little puns in them—like the villain "Chisel McSue"—so that people would relate to them quickly.

Not long ago, I got a letter from some guys in Norway who were fascinated by the fact that I had made the lemmings so authentic and that I knew about the cheese and things made in Norway. The lemmings and cheese were so authentic that they thought I had surely been to Norway. When they found out that I'd never been there and had only read about them in geographic magazines, it seemed that I disappointed them a great deal. They sent me some Gjetost cheese by airmail. It was soft when it got here but was real tasty stuff. It had a picture of a reindeer on the wrapper, so I thought, "I bet it's reindeer cheese!" But it wasn't.

Some of the main people who influenced my drawing style were Winsor McCay, Opper, and Hal Foster. Roy Crane, who drew *Buzz Sawyer*, also had a direct, simple style. There were a number of real good artists who didn't use much crosshatching or managed to put their story over with good clean lines and just blacks and whites. I knew that I couldn't handle much crosshatching and pen shading or the benday process they used in comic-book work. There used to be a lithographic process that wasn't exactly like the old origi-

nal benday. A number of guys used processed paper for putting in dots and shading. I knew if I ever got into that, I would just be making myself a mess of trouble and a lot of extra work, so I acted as if I never even knew about it.

Another influence was a book called *Creative Illustration* by Andrew Loomis. It was an art book, a constructive book with some good pointers in it on illustrating. It explained color balance, drawing and perspective, the handling of groups of people, and drawing individual persons: muscles, hands, heads, and expressions. It was a good book.

Western Publishing used very large sheets of drawing paper. I don't know how the other artists could draw detailed stuff on those big sheets. I cut them in half so that I could reach the top panels and still keep my paper flat. Otherwise, you've got to tuck the lower end down under the edge of the drawing board and work on the upper half. That paper always had a flex to it, so it was hard to bend.

Sometimes there was a difficulty in keeping the ducks consistent when there was a time lag between publication of the stories. One time Western Publishing changed the drawing paper on me. I had been drawing on a real good quality of Strathmore drawing paper. Whenever I made my pencil drawing, the pencil didn't dig into the paper and leave a trench. When I inked, it was over the top of nice, smooth paper. They changed to cheap paper with a kind of chalk face on it. I discovered that whenever I made a drawing of a duck, my pencil made a little groove in this stuff, and when I started to ink it, the pen would follow this groove, even though I had erased and redrawn it and cut another groove. I was making my ducks so that they were too tall for several months before

Barks researched the facts and locales of his stories with great care. The extent of his basic reference library is evident in this 1962 photo taken in his studio on Poppy Drive in Hemet, California.

I suddenly realized that I had gotten away from the way I used to draw the ducks on the old paper. Maybe it's because I'm tall, but I wanted to draw them taller than they were in the model sheet. Also, the model sheet for the newspaper duck had him standing up more straight than my duck, which was the animation duck that I'd drawn in the story department. I would sort of subconsciously try to make my duck look a little bit more like the animation ducks. I would draw the ducks in roughly and then I'd erase them and draw them over again to shorten them up. I drew every duck twice before I got him right. But on this paper I would draw them over and still wouldn't get them right because my pencil would be inclined to go back into the old grooves again. The company that made this new paper was in West Germany. They themselves discovered that the paper was too soft on the surface and started turning out a good product. So all of a sudden my paper was nice and firm again, and I was able to draw like I wanted to.

LAND
BENEATH THE
GROUND!

Land Beneath the Ground!
Uncle Scrooge #13 March 1956

What is down under the surface of the earth? Geologists say a strong layer of rocky stuff and, below that, hot soup. Uncle Scrooge got to worrying about how strong that layer of rocky stuff might be, and he set about digging a hole down through it. He never got deep enough to find the hot soup, but he got into some hot soup of another kind.

In this science-fiction adventure Uncle Scrooge and his helpful nephews find the cause of earthquakes, and they unwittingly trigger one that would jolt Richter right off his scale. *C.B. 1981*

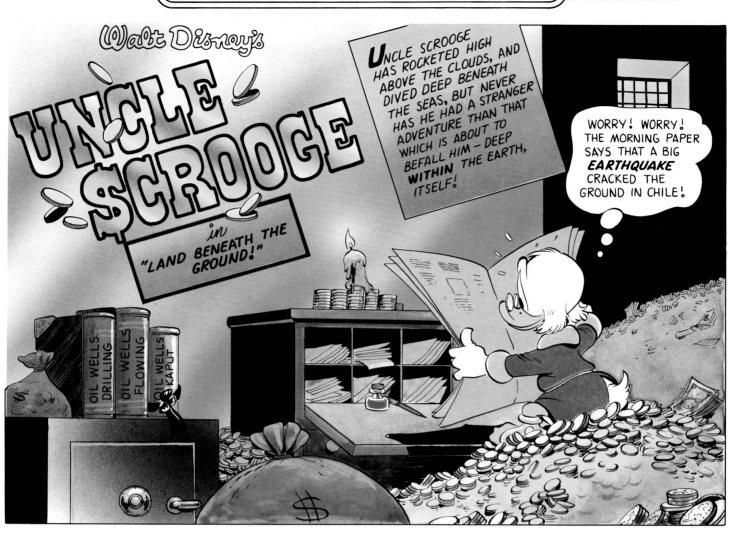

HI, UNCLE SCROOGE! WHERE ARE YOU GOING?

TO FIND AN *EXPERT* ON EARTHQUAKES!

YOU MEAN LITTLE DISH-RATTLING EARTHQUAKES, OR *BIG* QUAKES THAT CRACK MOUNTAINS IN TWO?

I MEAN *BIG* ONES!

I'M AFRAID ONE MIGHT OPEN A *CRACK* BENEATH MY MONEY BIN AND SWALLOW THE WHOLE THING INTO THE GROUND!

THAT WOULDN'T BE A *CRACK*, IT'D BE A *CANYON*!

I HOPED THE PROFESSORS AT THE UNIVERSITY COULD TELL ME IF THERE'S ANY DANGER OF SUCH A QUAKE HAPPENING *HERE*!

THE PROFESSORS COULD ONLY MAKE *GUESSES*!

THAT'S RIGHT! AND WITH MY MILLION *TONS* OF MONEY AT STAKE, I NEED MORE THAN GUESSES — I NEED *FACTS*!

THERE IS ONLY *ONE* WAY TO FIND THE FACTS!

THAT IS TO DIG A *SHAFT* DOWN THROUGH THE EARTH'S CRUST BENEATH YOUR BIN AND SEE FOR YOURSELF IF THERE ARE ANY WEAK PLACES WHERE THE ROCKS COULD CRACK!

SAY! THAT'S A *SWELL* IDEA!

IF THE DIGGERS FIND ANY DEEP FISSURES OR *HOLLOW PLACES* DOWN THERE, I CAN MOVE MY BIN TO MORE SOLID GROUND!

RIGHT AS RAIN!

I'LL PUT A CREW OF DIGGERS TO WORK ON THE JOB RIGHT AWAY! THERE COULD BE AN EARTHQUAKE ON ITS WAY HERE TO HAPPEN RIGHT NOW!

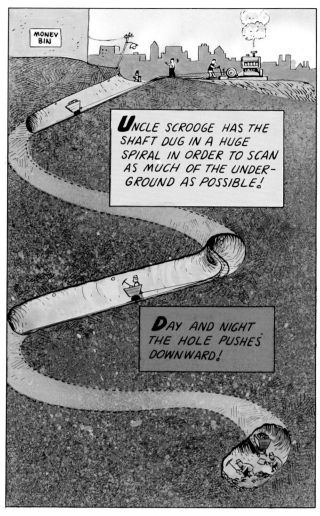

UNCLE SCROOGE HAS THE SHAFT DUG IN A HUGE SPIRAL IN ORDER TO SCAN AS MUCH OF THE UNDERGROUND AS POSSIBLE!

DAY AND NIGHT THE HOLE PUSHES DOWNWARD!

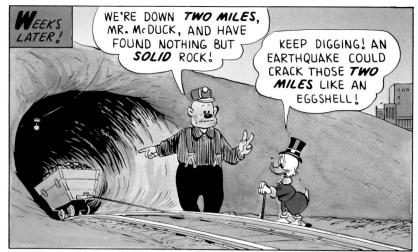

WEEKS LATER!

WE'RE DOWN TWO MILES, MR. McDUCK, AND HAVE FOUND NOTHING BUT SOLID ROCK!

KEEP DIGGING! AN EARTHQUAKE COULD CRACK THOSE TWO MILES LIKE AN EGGSHELL!

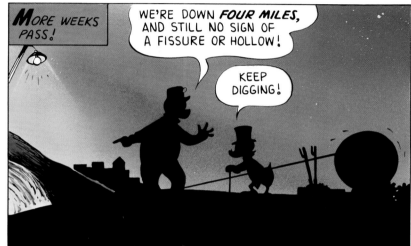

MORE WEEKS PASS!

WE'RE DOWN FOUR MILES, AND STILL NO SIGN OF A FISSURE OR HOLLOW!

KEEP DIGGING!

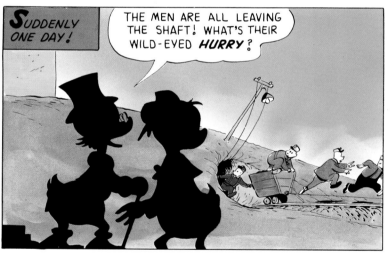

SUDDENLY ONE DAY!

THE MEN ARE ALL LEAVING THE SHAFT! WHAT'S THEIR WILD-EYED HURRY?

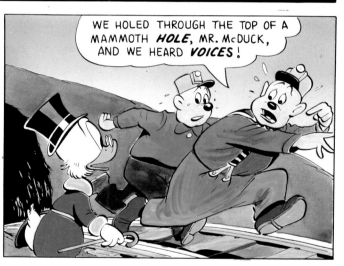

WE HOLED THROUGH THE TOP OF A MAMMOTH HOLE, MR. McDUCK, AND WE HEARD VOICES!

VOICES!.... MILES DOWN INSIDE THE EARTH! IT COULDN'T BE POSSIBLE!

AW! THOSE GOOFS WERE ONLY HEARING ECHOES!

HOW BIG WAS THE HOLE?

MAYBE AS BIG AS THE WHOLE INSIDE OF THE WORLD! WE DIDN'T TAKE TIME TO LOOK!

AND WE'RE NOT GOING BACK!

THE KIDS OUTFIT ANOTHER CAR WITH ALL THE GEAR NEEDED FOR A SPEEDY RESCUE!

WE'LL EVEN TAKE ALONG A *TELEPHONE* SET, IN CASE WE NEED TO CALL FOR HELP!

I'LL SET THE WINDING DRUM ON *AUTOMATIC RELEASE*, AND WE'LL BE ROLLING!

OH, ME! OH, MY! WHAT IF THE WORLD IS *HOLLOW* INSIDE, LIKE A TENNIS BALL?

LET'S NOT EVEN *THINK* ABOUT IT!

YEEK! NOW *OUR* CAR IS RUNNING WILD!

NO WONDER! *SOME JOKER* HAS PULLED THE *SAME* CABLE PIN TRICK ON *US!*

BUT WE WERE *SMART!* WE BROUGHT ALONG POLES TO *JAM* THE WHEELS IN CASE *ANYTHING* WENT WRONG!

PUT *THAT* IN YOUR *INVISIBLE* PIPES AND SMOKE IT, YOU *INVISIBLE* JOKERS!

SKREE

THE KIDS BRING THEIR CAR SAFELY TO THE BOTTOM OF THE SHAFT!

WELL, WE'RE HERE!

AND *NO SIGN* OF UNCA SCROOGE, OR UNCA DONALD!

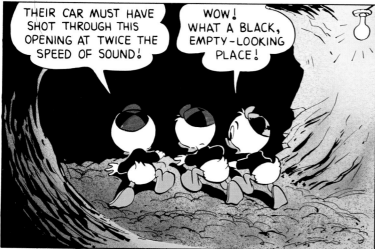

THEIR CAR MUST HAVE SHOT THROUGH THIS OPENING AT TWICE THE SPEED OF SOUND!

WOW! WHAT A BLACK, EMPTY-LOOKING PLACE!

GULP!

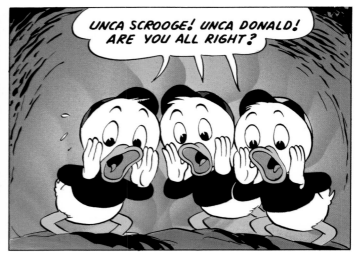

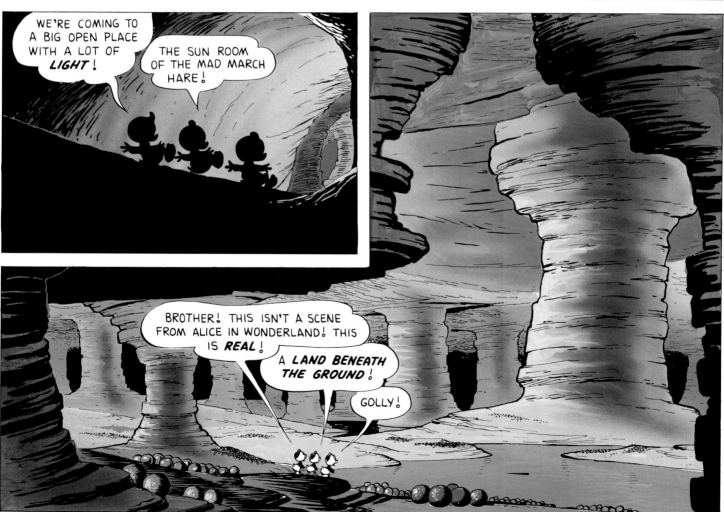

IT HAS EVEN GOT SOME KIND OF *PHOSPHORUS* LIGHT!

HEY! LISTEN! I HEAR *UNCA DONALD* AND *UNCA SCROOGE!*

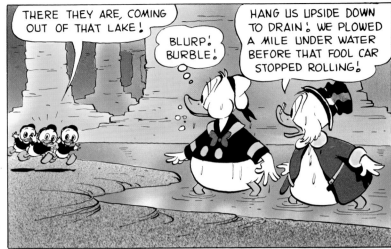

THERE THEY ARE, COMING OUT OF THAT LAKE!

BLURP! BURBLE!

HANG US UPSIDE DOWN TO DRAIN! WE PLOWED A MILE UNDER WATER BEFORE THAT FOOL CAR STOPPED ROLLING!

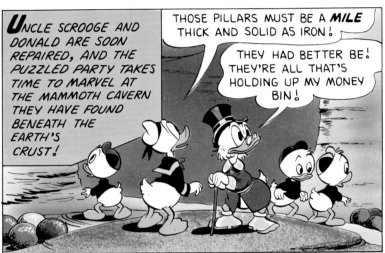

*U*NCLE SCROOGE AND DONALD ARE SOON REPAIRED, AND THE PUZZLED PARTY TAKES TIME TO MARVEL AT THE MAMMOTH CAVERN THEY HAVE FOUND BENEATH THE EARTH'S CRUST!

THOSE PILLARS MUST BE A *MILE* THICK AND SOLID AS IRON!

THEY HAD BETTER BE! THEY'RE ALL THAT'S HOLDING UP MY MONEY BIN!

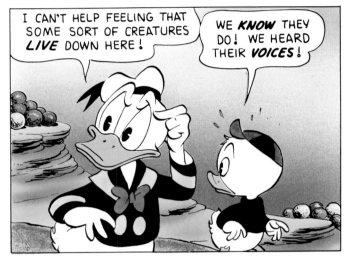

I CAN'T HELP FEELING THAT SOME SORT OF CREATURES *LIVE* DOWN HERE!

WE *KNOW* THEY DO! WE HEARD THEIR *VOICES!*

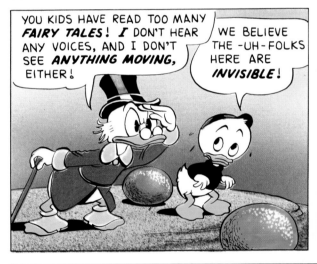

YOU KIDS HAVE READ TOO MANY *FAIRY TALES!* *I* DON'T HEAR ANY VOICES, AND I DON'T SEE *ANYTHING MOVING,* EITHER!

WE BELIEVE THE -UH-FOLKS HERE ARE *INVISIBLE!*

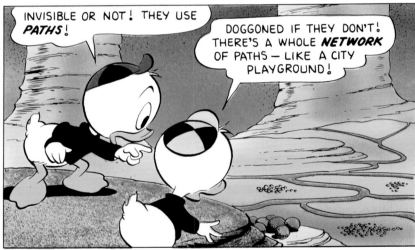

INVISIBLE OR NOT! THEY USE *PATHS!*

DOGGONED IF THEY DON'T! THERE'S A WHOLE *NETWORK* OF PATHS — LIKE A CITY PLAYGROUND!

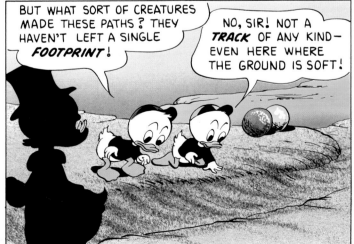

BUT WHAT SORT OF CREATURES MADE THESE PATHS? THEY HAVEN'T LEFT A SINGLE *FOOTPRINT!*

NO, SIR! NOT A *TRACK* OF ANY KIND — EVEN HERE WHERE THE GROUND IS SOFT!

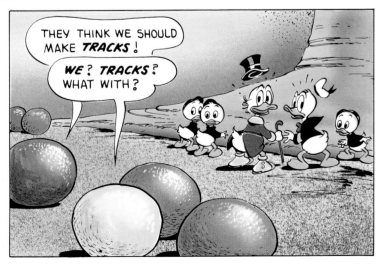

THEY THINK WE SHOULD MAKE *TRACKS!*

WE? TRACKS? WHAT WITH?

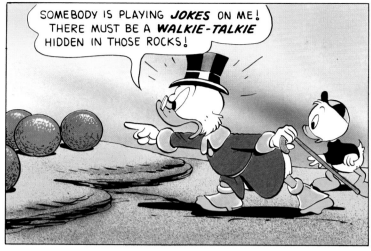

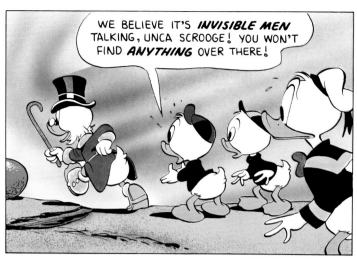

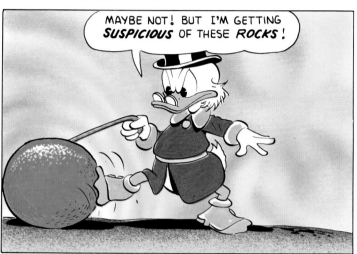

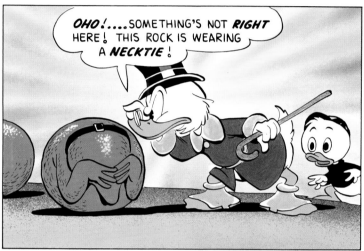

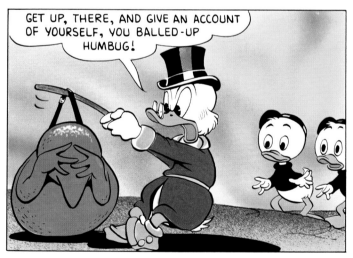

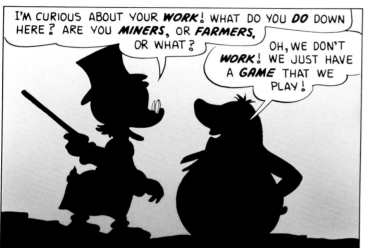

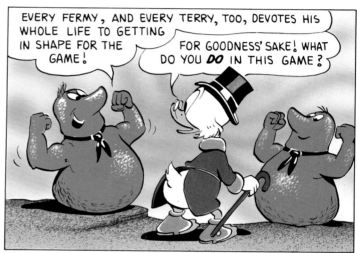

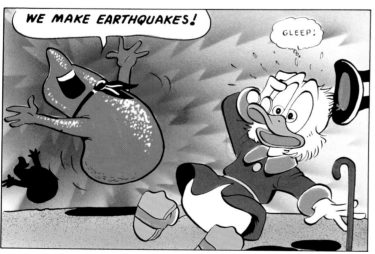

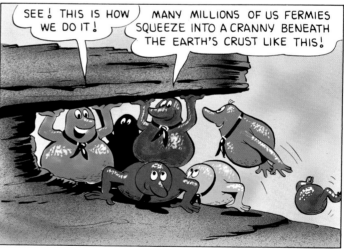

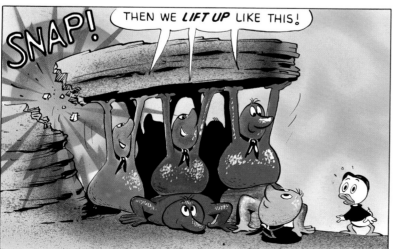

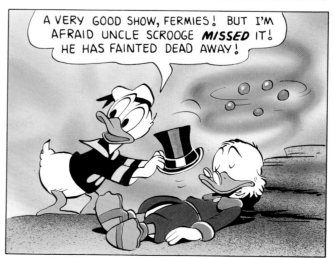

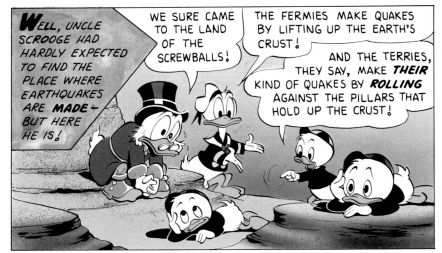

WELL, UNCLE SCROOGE HAD HARDLY EXPECTED TO FIND THE PLACE WHERE EARTHQUAKES ARE **MADE**— BUT HERE HE IS!

WE SURE CAME TO THE LAND OF THE SCREWBALLS!

THE FERMIES MAKE QUAKES BY LIFTING UP THE EARTH'S CRUST!

AND THE TERRIES, THEY SAY, MAKE **THEIR** KIND OF QUAKES BY **ROLLING** AGAINST THE PILLARS THAT HOLD UP THE CRUST!

YE CATS! THERE'S AN **EARTHQUAKE** NOW!

THAT SEEMED TO COME FROM CLOSE BY! LET'S GO SEE WHAT CAUSED IT?

YOU MEAN SEE **WHO** CAUSED IT!

IT'S A CLASS OF **BABY TERRIES** TAKING LESSONS AT EARTHQUAKE **SCHOOL**!

THERE THEY GO, LEARNING HOW TO MAKE QUAKES BY ROLLING LIKE BOWLING BALLS AGAINST THAT SMALL PILLAR!

THUD!

OH, BOY! THAT WAS A REAL **SMACKER**! LET'S LISTEN TO WHAT THE RADIO NEWSMEN HAVE TO SAY ABOUT IT!

A **SLIGHT** QUAKE HAS JUST JOLTED A SMALL SECTION OF DUCKBURG!

SLIGHT, HE CALLS IT! AND WE ALMOST JARRED OUR TEETH OUT!

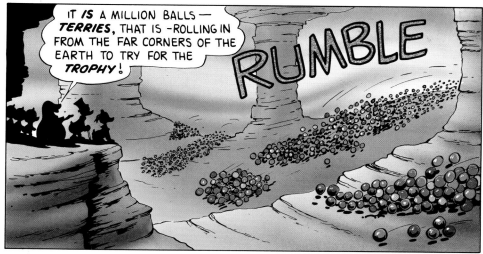

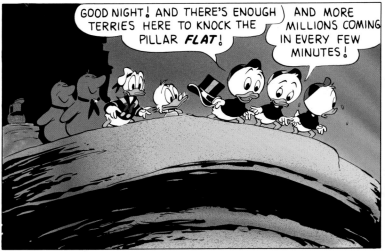

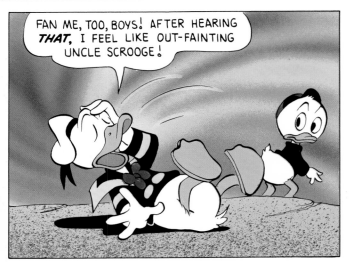

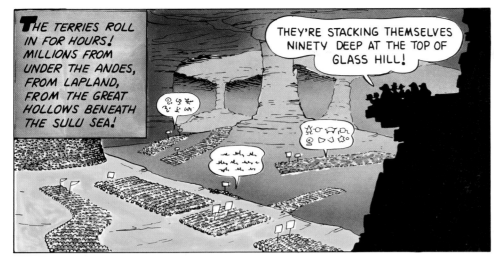

THE TERRIES ROLL IN FOR HOURS! MILLIONS FROM UNDER THE ANDES, FROM LAPLAND, FROM THE GREAT HOLLOWS BENEATH THE SULU SEA!

THEY'RE STACKING THEMSELVES NINETY DEEP AT THE TOP OF GLASS HILL!

BY MIDNIGHT, DUCKBURG TIME, THEY'LL BE READY TO ROLL!

UNCA SCROOGE, WE'VE ONLY A LITTLE WHILE LEFT IN WHICH TO GET BACK UP THE SHAFT AND WARN THE PEOPLE TO FLEE!

IT WOULD DO NO GOOD! PEOPLE WOULDN'T BELIEVE US!

MAYBE NOT, BUT WE CAN SAVE OURSELVES! COME ON!

DO YOU SUPPOSE OUR VISITORS COULD BRING TROUBLE DOWN HERE TO TERRY FERMY BY ROUSING THEIR PEOPLE AGAINST US?

HAW! THEIR PEOPLE WILL NEVER BELIEVE THEIR STORIES ABOUT US! AND, BESIDES —

THEIR SHAFT IS AT THE TOP END OF MOSS SLIDE! THEY CAN NEVER CLIMB UP TO IT WITHOUT THE HELP OF THOUSANDS OF FERMIES BOOSTING THEM FROM BEHIND!

THEY'RE STUCK HERE UNTIL WE FIND TIME TO BARGAIN WITH THEM FOR THEIR SILENCE!

IN THE MEANTIME THEY MIGHT AS WELL ENJOY THE EARTHQUAKE, HEY?

CALM DOWN OUT OF YOUR PANIC, YOU STAMPEDING DUCKS! I'VE JUST FIGURED OUT TWO WAYS TO PREVENT THIS EARTHQUAKE FROM HAPPENING!

YOU HAVE?

ONE OF THE WAYS IS TO APPEAL TO THEIR *SPORTING* FANCY! AND, THERE, DONALD IS WHERE *YOU* CAN BE A BIG HELP!

SHOW ME WHERE TO FIND THE *LEADER* OF THE TERRIES! I HAVE A BIG *DEAL* TO MAKE!

HE'S UP THE HILL ON THE FLAG PLATFORM!

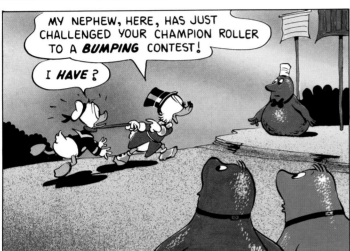

MY NEPHEW, HERE, HAS JUST CHALLENGED YOUR CHAMPION ROLLER TO A *BUMPING* CONTEST!

I *HAVE*?

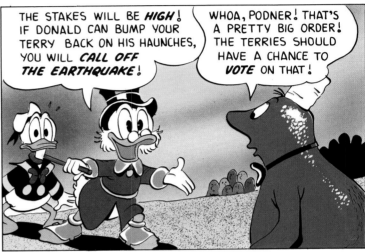

THE STAKES WILL BE *HIGH*! IF DONALD CAN BUMP YOUR TERRY BACK ON HIS HAUNCHES, YOU WILL *CALL OFF THE EARTHQUAKE*!

WHOA, PODNER! THAT'S A PRETTY BIG ORDER! THE TERRIES SHOULD HAVE A CHANCE TO *VOTE* ON THAT!

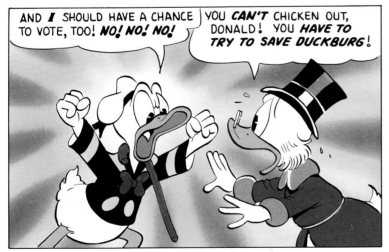

AND *I* SHOULD HAVE A CHANCE TO VOTE, TOO! NO! NO! NO!

YOU *CAN'T* CHICKEN OUT, DONALD! YOU *HAVE TO TRY TO SAVE DUCKBURG*!

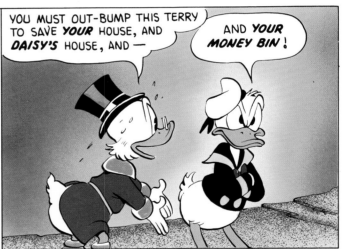

YOU MUST OUT-BUMP THIS TERRY TO SAVE *YOUR* HOUSE, AND *DAISY'S* HOUSE, AND —

AND *YOUR MONEY BIN*!

THE TERRIES VOTE *"YES"*! BRING YOUR NEPHEW OUT ONTO THE ROLLWAY!

IT'S *ON*!

WELL, ALL RIGHT! I'LL DO IT TO SAVE *MY* HOUSE!

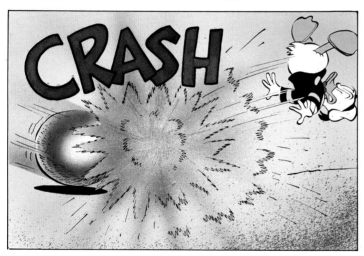

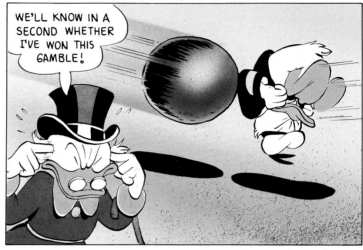

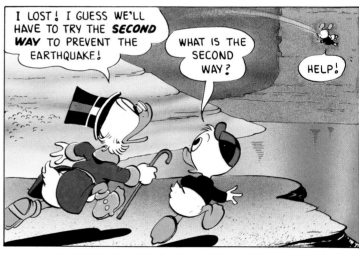

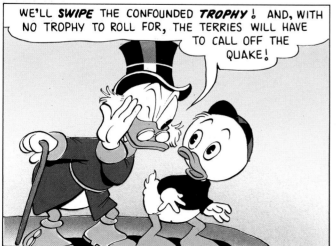

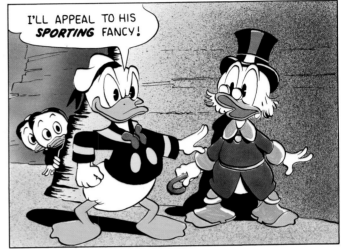

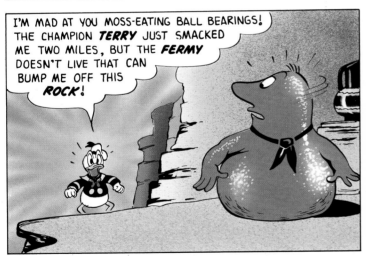

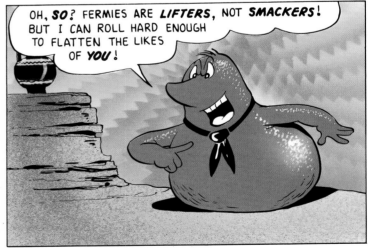

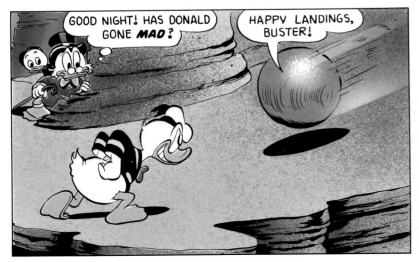

HE WON'T BE GIVING AN *ALARM* VERY *SOON*! HE'S GOING TO ROLL CLEAR OVER INTO THAT *THIRD* VALLEY!

I'VE GOT THE *TROPHY*! COME ON! FULL SPEED FOR THE *SHAFT*!

*D*ONALD'S TRICK IS ONLY PARTLY SUCCESSFUL! THE TERRY FERMIANS HAVE A WAY OF *SENDING* MESSAGES!

I'VE SHORE BEEN FLIM-FLAMMED! THOSE DUCKS WERE FIXIN' TO SWIPE THE *TROPHY*!

I'LL HAVE TO *TELEBOOM* AN ALARM TO HEADQUARTERS!

BUM BOOM BUM

BUM BOOM BUM

A *MESSAGE* FROM THE *GUARD*! THE DUCKS HAVE STOLEN THE TROPHY, AND THEY'RE RACING FOR THEIR SHAFT!

AFTER THEM, *EVERYBODY*!

UH, OH! HERE COMES *TROUBLE*!

TERRIES AND FERMIES BY THE MILLION ROLLING UP BEHIND US!

RUMBLE

AND THAT'S ONLY THE *START* OF OUR TROUBLE!

HOW ARE WE GOING TO CLIMB THIS SLICK *MOSS SLIDE*?

I CAN'T PULL MYSELF UP BY HAND, FOOT, OR FINGERNAIL!

WE SLIDE DOWN FASTER THAN WE CLIMB UP!

THERE DOESN'T SEEM TO BE ANY *ROUGH* PLACES THAT WE COULD USE FOR HANDHOLDS!

WE'VE *GOT TO* GET UP *SOMEWAY!* THOSE ROLLING BULB MEN ARE RIGHT BEHIND US!

I'LL SEE IF THE JUNIOR WOODCHUCKS' GUIDE BOOK HAS AN ANSWER TO THIS PROBLEM!

LOOK IN THE CHAPTER ON VEGETABLE FORMS!

NO! IT'LL BE IN THE INSTRUCTIONS FOR GRASPING *SLICK* OBJECTS!

THERE'S A WHOLE PAGE ON CATCHING GREASED PIGS BUT —

DO SOMETHING! DO SOMETHING!

AH! HERE IT IS UNDER "DESPERATE DILEMMAS"! IT SAYS, "WHEN YOU CAN'T CLIMB *OVER* AN OBSTACLE, GO *UNDER* IT!"

I'LL BE DOGGONED! THIS MOSS *LIFTS UP* LIKE A BLANKET, AND THE GROUND BENEATH IS *ROUGH GRAVEL!*

WE CAN CRAWL UP THE SLIDE *UNDER* THE MOSS LIKE *MOLES!* COME ON!

RUMBLE

WE'RE ON OUR WAY!

AND NOT A SECOND TOO SOON!

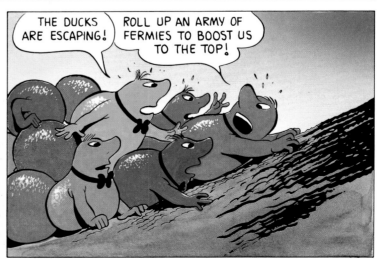

THE DUCKS ARE ESCAPING!

ROLL UP AN ARMY OF FERMIES TO BOOST US TO THE TOP!

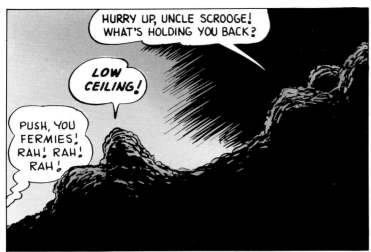

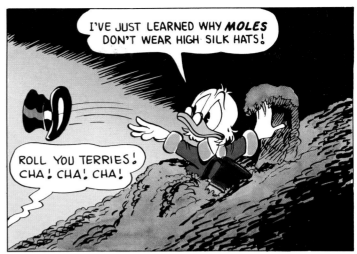

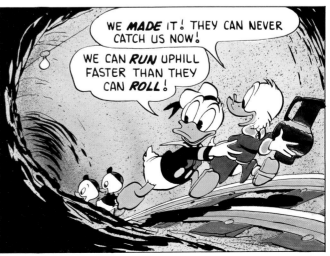

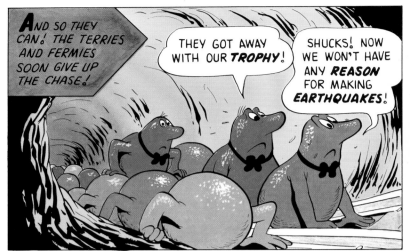

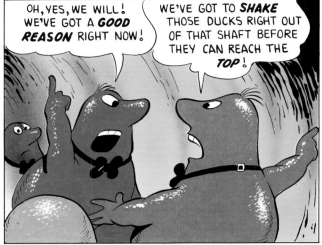

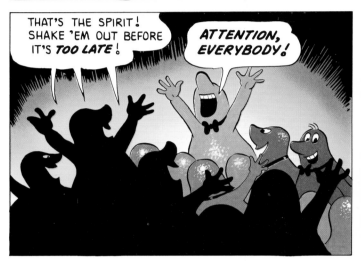

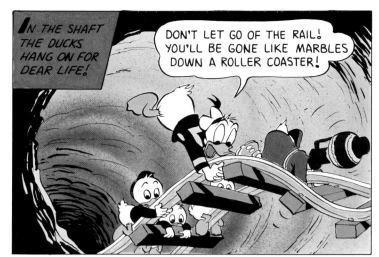

IN THE SHAFT THE DUCKS HANG ON FOR DEAR LIFE!

DON'T LET GO OF THE RAIL! YOU'LL BE GONE LIKE MARBLES DOWN A ROLLER COASTER!

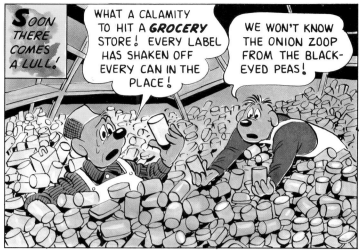

SOON THERE COMES A LULL!

WHAT A CALAMITY TO HIT A *GROCERY* STORE! EVERY LABEL HAS SHAKEN OFF EVERY CAN IN THE PLACE!

WE WON'T KNOW THE ONION ZOOP FROM THE BLACK-EYED PEAS!

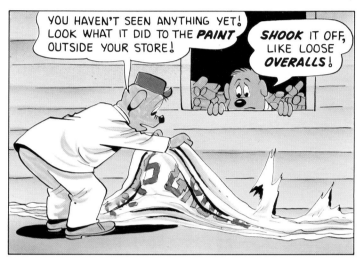

YOU HAVEN'T SEEN ANYTHING YET! LOOK WHAT IT DID TO THE *PAINT* OUTSIDE YOUR STORE!

SHOOK IT OFF, LIKE LOOSE *OVERALLS*!

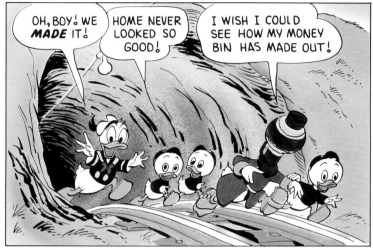

OH, BOY! WE *MADE* IT!

HOME NEVER LOOKED SO GOOD!

I WISH I COULD SEE HOW MY MONEY BIN HAS MADE OUT!

DID THE DUCKS SHAKE OUT OF THE SHAFT?

NO!

THEN, LET'S GIVE IT TO THEM AGAIN!

YOW! WE'RE GETTING *ANOTHER* SHAKING!

THIS ONE IS WORSE THAN THE FIRST ONE!

MY SCHEME *FAILED!* I'VE BEEN AN AWFUL *JUGHEAD!*

PFOP

LOOKOUT ABOVE!

MY MONEY BIN IS BOUNCING DOWN TOWARD THE SHAFT!

IT HAS STOPPED OVER THE HOLE, AND I CAN HEAR THE FLOOR CRACKING OPEN!

$

McDUCKS MONEY BIN

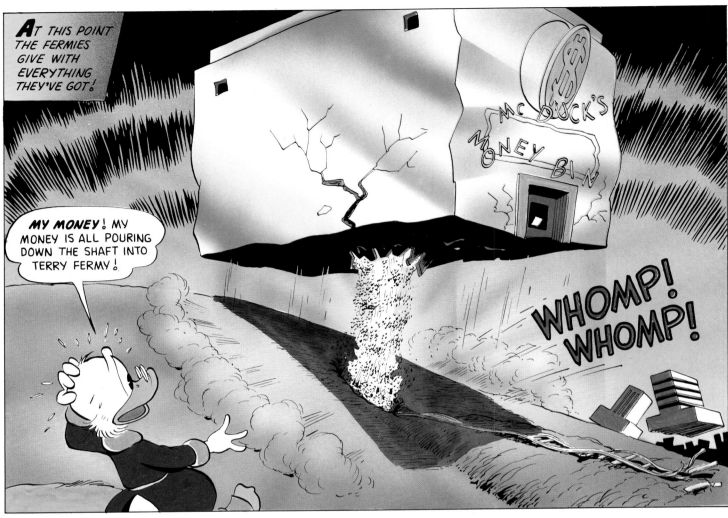

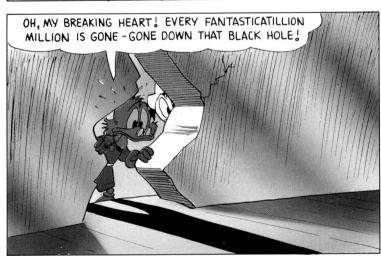

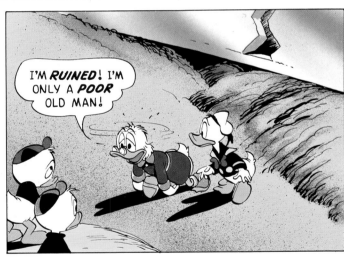

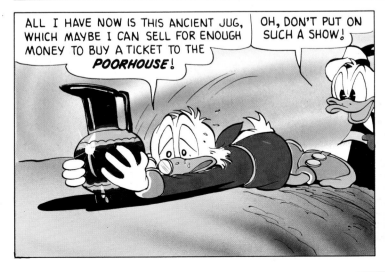

AND I WOULDN'T GO THROUGH ANOTHER OF THEIR ALL-OUT EARTHQUAKES FOR **ANYTHING**!

NOT EVEN FOR MY FIVE BILLION QUINTUPLATILLION UMPTUPLATILLION MULTUPLATILLION IMPOSSIBIDILLION AND SO FORTH DOLLARS AND EXTRA ODD CENTS! **I'VE HAD IT!**

DOWN BELOW THE TERRY FERMIANS ARE PUZZLED!

WHAT IS **THIS** STUFF THAT CAME POURING DOWN THE SHAFT?

MAYBE IT'S SOMETHING THAT OLD McDUCK SENT DOWN IN **EXCHANGE** FOR OUR TROPHY!

IF IT IS, IT MUST BE **MONEY**! I'VE HEARD BROADCASTS SAYING HE HAS **TONS** OF THE STUFF!

MONEY, HUH? THAT OLD TROPHY SNATCHER HAS HIS **NERVE**!

WE ALL KNOW HOW **MUCH** MONEY IS WORTH!

THEY TRY TO **GIVE IT AWAY** ON THEIR RADIO PROGRAMS!

WE'VE BEEN **INSULTED**!

AND WHAT'S WORSE, AS LONG AS THAT **SHAFT IS OPEN**, WE'RE GOING TO GET **MORE** OF THIS KIND OF **TRASH** DUMPED ON US!

THEN, LET'S **CLOSE** THE SHAFT!

YES! **SEAL IT UP**! AND GET RID OF THAT MESSY **MONEY**, TOO!

IT'S GOING TO BE A LOT OF **HARD WORK**, BUT COME ON, EVERYBODY!

WAIT! THIS NEEDN'T BE A **JOB OF WORK**! THERE'S A WAY WE CAN DO IT THAT'LL MAKE IT **FUN**!

WE'LL CHOOSE A **NEW TROPHY**, AND THE FIRST TO TRY FOR IT WILL BE THE OLD CHAMPS, THE **FERMIES**!

FERMIES! FERMIES! RAH! RAH! RAH!

TO **WIN** THE TROPHY, THE FERMIES WILL HAVE TO PUSH ALL THIS UNWELCOME MONEY **BACK UP** THE SHAFT — AND **PLUG** THE HOLE WITH **SOLID ROCK**!

WE CAN DO IT! CHA! CHA! CHA!

NOW FOR A **NEW TROPHY**, I PROPOSE THIS **HAT**!

THE OLD DUCK'S HAT!

IT'D BREAK HIS HEART IF HE KNEW WE WERE GOING TO MAKE IT OUR NEW **TROPHY**!

WE CAN BE **SHORE** THAT HE WON'T LIKE THIS, SO SHALL WE MAKE THIS **HAT** OUR NEW **TROPHY**?

YES!

UP ABOVE UNCLE SCROOGE IS BEING LED GENTLY AWAY!

OH, ME! OH, MY! I HOPE THE DUCKBURG SAFETY COUNCIL DOESN'T MAKE ME **PLUG** THAT SHAFT! IT'D COST MILLIONS!

WHAT'S THAT **NOISE**?

ANOTHER **RUMBLE** COMING UP THE SHAFT!

IT'S **MONEY**! I CAN HEAR THE **JINGLE**!

KA-CHOONK

IT'S MY **MONEY**! MY MONEY'S COME BACK FROM THE DEPTHS!

THE TERRY FERMIANS MUST NOT HAVE **LIKED** THE STUFF!

CHONK

WOW! AND THEY MUST NOT HAVE LIKED **US**, EITHER!

So UNCLE SCROOGE GETS ALL OF HIS MONEY BACK, AND THINGS ARE AGAIN AS THEY WERE!

THERE'S A PROFESSOR FROM THE UNIVERSITY HERE TO SEE YOU, UNCA SCROOGE!

SEND HIM IN!

I JUST WANT TO ASSURE YOU, MR. McDUCK, THAT THERE WILL BE NO MORE EARTHQUAKES FOR MANY, MANY YEARS! THE **PRESSURE** IS OFF!

WHAT DO YOU SUPPOSE **CAUSES** EARTHQUAKES, PROFESSOR?

WHY, UH — **GAS** THAT BUILDS UP IN FISSURES AS THE EARTH SHRINKS!

HE SHORE AIN'T **BEEN AROUND**, HAS HE, PODNERS?

The Deleted Panels

Over the years, there were a few instances in which Carl Barks decided to tighten up and improve the telling of his story even after he had completed the final artwork. He removed a panel here and a page there in order to make the action move faster and with greater clarity. Just such editing occurred during the drawing of *Land Beneath the Ground!* A small portion of the story may also have been excised to make the page count conform to a revision in postal mailing standards. Mr. Barks retained some of the cut panels and made them available for this book.

Although it is believed that the equivalent of a full page is still missing from this sequence (it probably fit between pages 3 and 4 of the published story), the following pages represent an almost complete restoration of the original version of the story. To orient the reader, the pages or portions of pages which have been previously published are reproduced in black and white. The newly inserted pieces are in color.

Unfortunately, the exact nature of the still missing fragments has not been ascertained. Nonetheless, the sequence which you are about to read presents a rare glimpse into the artist's creative process.

"At least one full page was cut . . . before this section which follows page 181 of the current edition." CB

GEE! FLARES AND LIGHTS, AND EVEN A CAMERA!

EVERYTHING BUT AN *OBSERVER*! WHO IS *GOING DOWN* FOR YOU, UNCLE SCROOGE?

I HAVEN'T DECIDED YET, DONALD! HAVE YOU GOT *$500*?

FIVE HUNDRED — *ME*? OF COURSE NOT!

THEN, *YOU* ARE GOING TO BE THE *OBSERVER*!

I DON'T GET YOU!

I HAVE HERE YOUR I.O.U. FOR *FIFTY CENTS* YOU BORROWED IN 1950! AT COMPOUND INTEREST THAT NOW AMOUNTS TO *$500*!

UH, OH! I CAN GUESS THE REST OF THIS DEAL!

Below: The caption starting "So, in order . . ." was added, as was Donald's head, to make up for the above panels of cut material.

*S*O, IN ORDER TO FIND OUT MORE ABOUT THE BIG HOLE, UNCLE SCROOGE ASKS DONALD TO GO DOWN AND LOOK THE PLACE OVER!

OH, ME!

HAS ANYBODY NOTICED THESE FUNNY, ROUND *ROCKS*? I DIDN'T SEE THEM HERE *YESTERDAY*!

COME TO THINK OF IT, I DIDN'T SEE THEM, EITHER! BUT I GUESS IT'S NOT IMPORTANT!

BOOST ME UP, BOYS! I MUST SHOW DONALD HOW TO HANDLE THE FLARES AND THINGS!

NOW START THE HOISTING MOTOR, AND BE READY TO LOWER THE CAR WHEN DONALD IS READY TO GO DOWN!

YES, UNCA SCROOGE!

The dialogue, "But we were smart!" was added to make up for the cut half page above.

The top right panel on page 186 ended the edited version of the mine car sequence.

IT HAS EVEN GOT SOME KIND OF **PHOSPHORUS** LIGHT!

HEY! LISTEN! I HEAR **UNCA DONALD** AND **UNCA SCROOGE!**

THEIR VOICES ARE COMING FROM BEYOND THAT CROOKED PILLAR!

HELP! HELP!

WELL, WOULDN'T **THAT** TAKE A PRIZE?

HELP! HELP! STOP THIS LOOPING CRATE BEFORE WE GET CAR-SICK!

THANK GOODNESS! YOU'RE NOT IN **SERIOUS** TROUBLE!

YOU DON'T CALL **THIS** SERIOUS?

WE HIT THIS ROCK ARCH LIKE A RUNAWAY ROCKET, AND WE'VE BEEN LOOPING THE LOOP HERE FORTY MINUTES SLOWING DOWN!

I FIGURE WE'LL STOP ABOUT NOON THURSDAY!

YANK ONE OF THE SIDE BOARDS OFF THE CAR AND USE IT TO **JAM** THE WHEELS!

YOU'LL STOP IN NO TIME!

HOW COME **WE** DON'T GET IDEAS LIKE THIS?

DON'T ASK ME! I ONLY KNOW HOW TO MAKE MONEY!

SKREE

UH, OH!

SOMETHING WRONG HERE!

YOU KIDS AND YOUR **BRIGHT** IDEAS!

WELL, HOW COULD WE KNOW THAT YOU WOULD STOP THE CAR AT THE **TOP** OF THE LOOP?

UNCLE SCROOGE AND DONALD ARE SOON REPAIRED, AND THE PUZZLED PARTY TAKES TIME TO MARVEL AT THE MAMMOTH CAVERN THEY HAVE FOUND BENEATH THE EARTH'S CRUST!

THOSE PILLARS MUST BE A **MILE** THICK AND SOLID AS IRON!

THEY HAD BETTER BE! THEY'RE ALL THAT'S HOLDING UP MY MONEY BIN!

I CAN'T HELP FEELING THAT SOME SORT OF CREATURES **LIVE** DOWN HERE!

WE **KNOW** THEY DO! WE HEARD THEIR **VOICES**!

YOU KIDS HAVE READ TOO MANY **FAIRY TALES**! **I** DON'T HEAR ANY VOICES, AND I DON'T SEE **ANYTHING MOVING**, EITHER!

WE BELIEVE THE -UH- FOLKS HERE ARE **INVISIBLE**!

INVISIBLE OR NOT! THEY USE **PATHS**!

DOGGONED IF THEY DON'T! THERE'S A WHOLE **NETWORK** OF PATHS — LIKE A CITY PLAYGROUND!

BUT WHAT SORT OF CREATURES MADE THESE PATHS? THEY HAVEN'T LEFT A SINGLE **FOOTPRINT**!

NO, SIR! NOT A **TRACK** OF ANY KIND — EVEN HERE WHERE THE GROUND IS SOFT!

THEY THINK WE SHOULD MAKE **TRACKS**!

WE? TRACKS? WHAT WITH?

The story resumes on page 187 of the current edition.

This is an alternative version of page 199.

These two panels are ". . . all that is known to remain from a page or two of cuts." CB

"My age is eighty and I don't look a day over 79½."

This story must have come from outer space somewhere and hit me on the head, because I can't think of how I happened to come up with that idea. I suppose I was always figuring on poor old Uncle Scrooge and his problems with his money. I couldn't have the Beagle Boys always being the guys who were trying to bore into it. There had to be other menaces.

One menace that came up naturally was an earthquake. It's about the only thing that could affect that tremendous bin with its walls so many feet thick: A cyclone or rain or lightning couldn't hurt it. It must have been with that thought in mind that I got to working on the idea of having Scrooge drill a hole down into the ground to see what was under there, how solid the foundation was. Would they find a big geyser of molten metal or lava, or would it be something else completely unexpected?

I took the idea that it must be the completely unexpected. They find a hole filled with queer creatures that live down there. I thought of lizards and all sorts of dragons before I came up with these comical little round-bodied guys. After I invented them, I decided they could be the guys who made earthquakes. The story was then built from the problem of how Scrooge could combat an earthquake, moved to his ex-

ploring to see how vulnerable he was, then to the guys who actually cause earthquakes.

There were a number of panels taken out and redrawn. The whole sequence where Scrooge and Donald came down in a mine car: It went up a wall and around the ceiling, then fell down. I thought it didn't move the story ahead and was too much like a bunch of animation gags. I already had panels drawn and inked, but I cut them out. It makes the story much tighter and it reads faster. I thought I could make the story stronger by taking out all the incidental stuff.

At the time I wrote the story, the popular radio stations around San Jacinto were the ones that played western music, cowboy music. That's all I ever listened to on the radio. I didn't have a television—in fact, televisions were not very common in that early time. I would listen to that cowboy music. It became part of my nature to think in terms of a lot of people listening to it. Out here in the West and in Texas, Oklahoma, and Arkansas, western expressions like "So long, pardner" and "They went that-a-way" were just part of the way people thought. So I was thinking the same way, and I had the Terries and Fermies talk that way because it sounded a

little funny. One of them says, "You should hear the fellows talk that live under a place called 'Boston.'" The ones that lived underneath Duckberg talked this western lingo. The ones from Asia talked Siamese or Hindi or whatever it was that the radio stations over their heads broadcast through the rocks and shale slabs.

I got Donald into the head-butting contest to give him something to do. With Scrooge being the main protagonist and the three kids and their *Junior Woodchuck Guide Book* being the brains that always saved him, Donald needed some lines. So he had to be shoved into a situation like that in order to justify paying him any salary—thirty cents an hour, he got!

Writing was a mental strain. Once I had gotten the general idea, then that was a moment of joy. I'd think, "Oh, boy! I've got the essence of a plot here! All I need to do now is break it down into panels, and then I can start drawing."

A climax gag is really a sequence of jokes or pantomime. In animation it was sometimes an excuse for animators to really do their stuff. I could never have been an animator. I became bored with thinking up animation gags in which the characters just moved endlessly. I wanted to keep things moving on to some new situation. I didn't want to stay for seven hundred drawings on one spot. I might have felt differently about it if I had worked on the animation itself. There may have been charm in taking a character like Pluto, for example, and putting a plumber's helper on his back end and working him into about seven minutes of contortions or having him stuck on fly paper for seven more

minutes. The animator might have had a good time doing it, but it wasn't for me.

Breaking a story down into the panels was quite a bit of drudgery. But that's where all these little gags would come in—during the business of breaking it down: Little sight gags and little dialogue gags come at that time. So when I got my plot all broken down into eight-panel pages and the whole thing written out and sprinkled with gags, the *real* pleasure came—sitting down to draw. I liked the roughing out fairly well, but when I really relaxed was on the inking. I could have three or four pages all drawn in blue pencil, and then I'd have it easy for a while! I would start to ink it. That's where I really put the polish into it. Sometimes I would see still another thing that I could do in the way of a gag. I'd just erase or maybe throw away half a page and draw it over again in order to do a new gag.

When I do dialogue, I know what dialogue is going into the balloon, but not exactly. I always tried to tell all of my ideas in the fewest words possible, but sometimes I had to put in what seemed to me too many words and just crush the characters clear down to the bottom of the panel. I notice in modern comics they will put one balloon up at the top and another at the bottom of the panel and have some of the charcters above their own dialogue and others below it. I always tried to keep it up at the top because you can see the characters at the same time you're reading the dialogue. But when there's one balloon off down here and another one up there, it divides it all up to where you can't grasp the whole picture at once. It's hard for me to read recent comics, and I believe that's one of the reasons.

THE SECOND
RICHEST
DUCK

The Second-Richest Duck
Uncle Scrooge #15 September 1956

In the rough world of commerce, financial tycoons are always winning or losing monopolies on oil or rubber or something. Some even win monopolies on monopolies, and such tycoons become very, very rich. For many years Uncle Scrooge thought he had a permanent monopoly on the title "World's Richest." He got that way by being outrageously stingy, overbearingly aggressive, and undignifiedly greedy. He never dreamed that another person in all the world would develop similar mastery of such an array of unsavory characteristics.

He meets such a person in this accounting of a titanic showdown in which he matches monopoly for monopoly with a master tightwad who has all of Uncle Scrooge's talents plus a little bit more.

This guy is meaner, and that helps make the difference when the second richest duck is crowned in a ruthless matchathon that dirties a strip of Africa from the Limpopo halfway to the Blue Nile. *C.B. 1981*

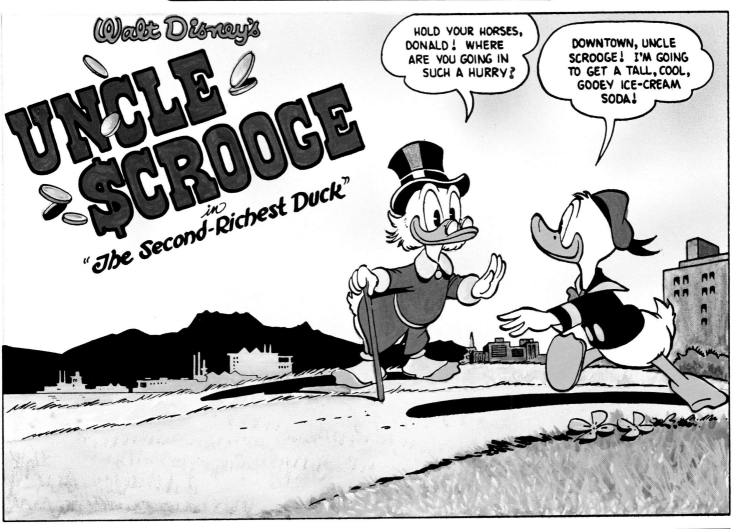

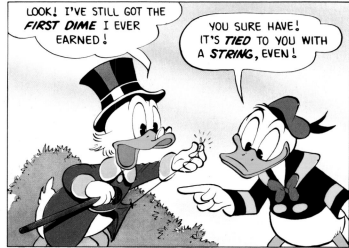

I'M THE *RICHEST* DUCK IN THE WORLD, AND JUST KNOWING THAT, MAKES UP FOR ALL THE TALL, COOL, FIZZY SODAS I'VE MISSED WHILE GETTING THAT WAY!

PAPER! PAPER! BUY A MORNING PAPER!

TAKE IT AWAY! I NEVER BUY NEWSPAPERS! THEY COST *TEN CENTS!*

I'VE SAVED MANY A DOLLAR BY *FINDING* MY NEWSPAPERS IN THE PARK WHERE MORE *EXTRAVAGANT* PEOPLE HAVE THROWN THEM AWAY!

AH! HERE'S ONE THAT'S ONLY TWO DAYS OLD! THAT'S BETTER THAN THE ONE I FOUND YESTERDAY, WHICH WAS FULL OF NEWS ABOUT THE 1906 EARTHQUAKE!

WAK! NO! NO! THIS *CAN'T* BE! IT'S TOO *AWFUL!*

"FLINTHEART GLOMGOLD, THE FABULOUS SOUTH AFRICAN MINE OWNER, IS NOW THE *RICHEST* DUCK IN THE WORLD!

"HIS DISCOVERY OF A VEIN OF PURE GOLD IN HIS NEWEST MINE HAS PUSHED HIS FORTUNE PAST THE ONE MULTIPLUJILLION NINE OBSQUATUMATILLION MARK!"

THAT UPSTART! THAT JOHNNY-COME-LATELY! HE CAN'T DO THIS TO ME! OH, ME! OH, MY!

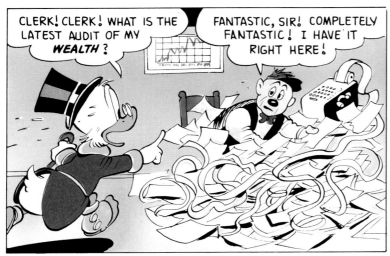

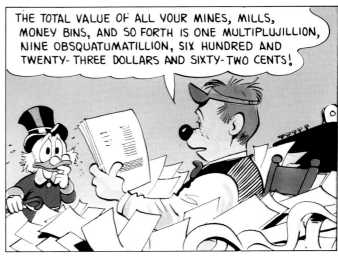

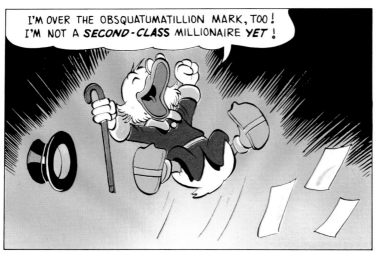

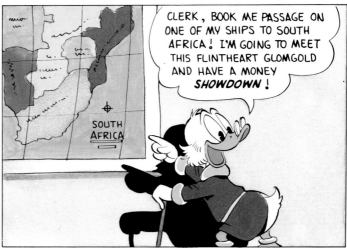

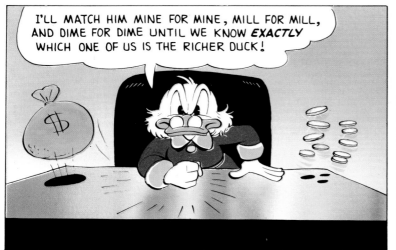

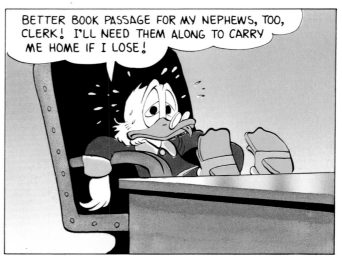

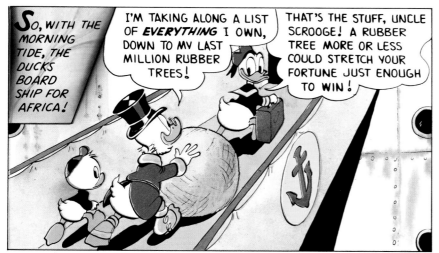

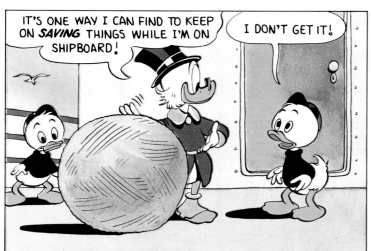

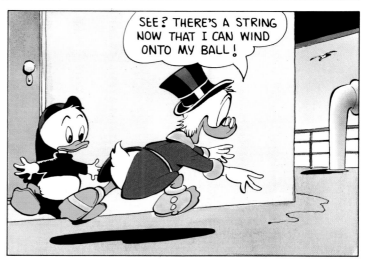

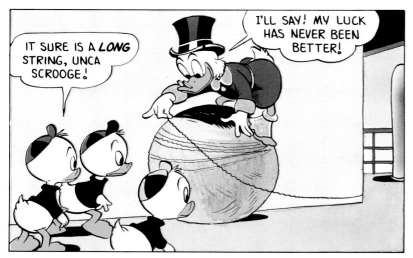

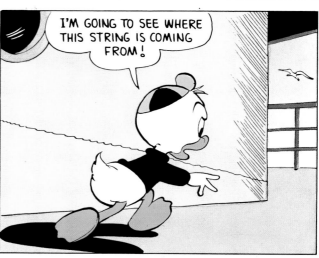

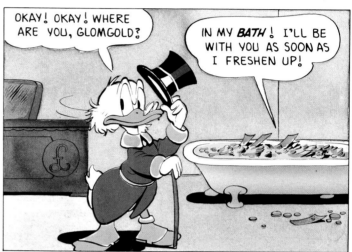

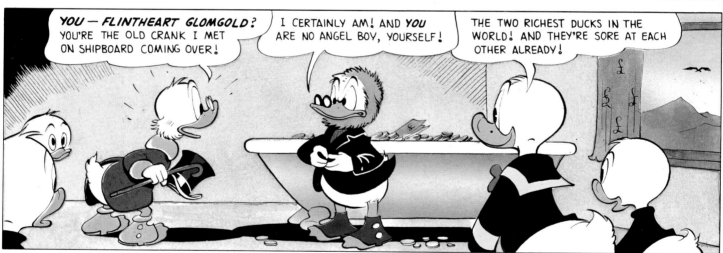

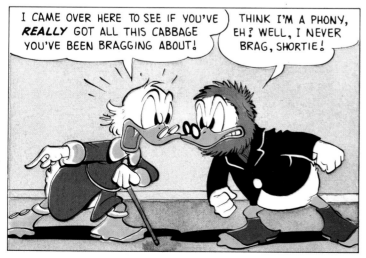

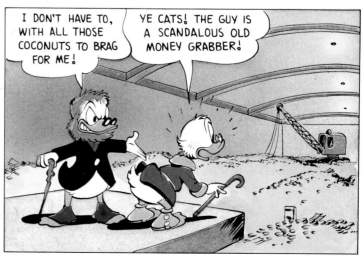

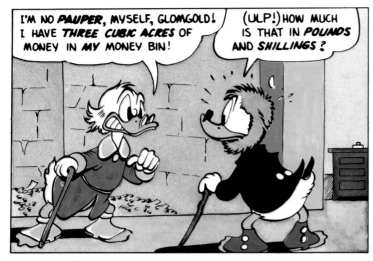

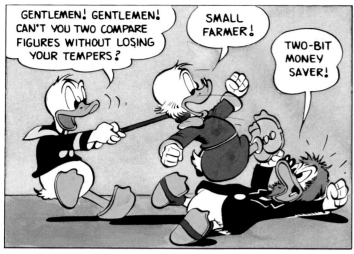

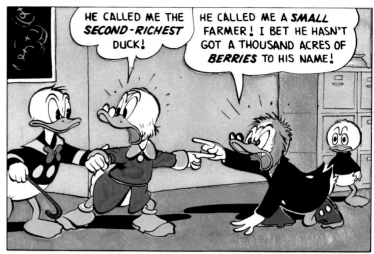

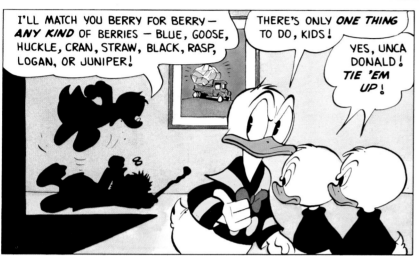

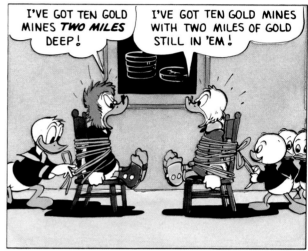

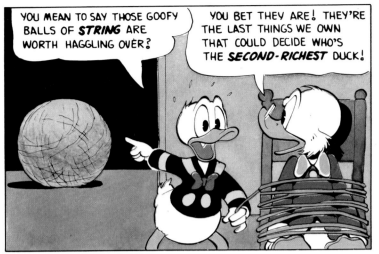

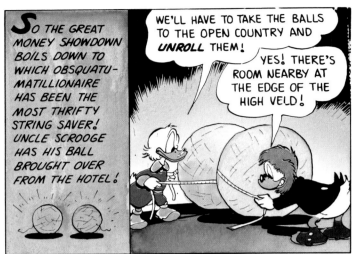

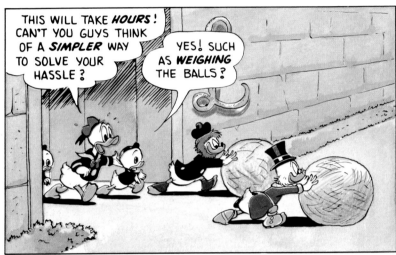

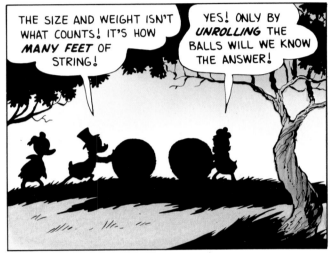

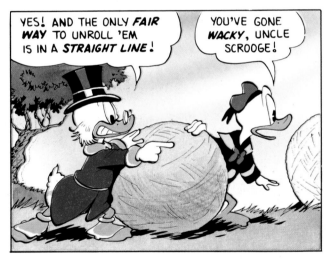

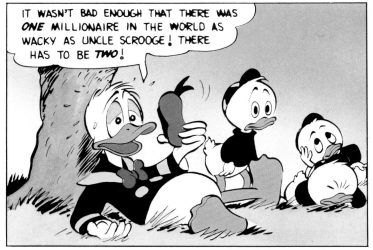

IT WASN'T BAD ENOUGH THAT THERE WAS *ONE* MILLIONAIRE IN THE WORLD AS WACKY AS UNCLE SCROOGE! THERE HAS TO BE *TWO*!

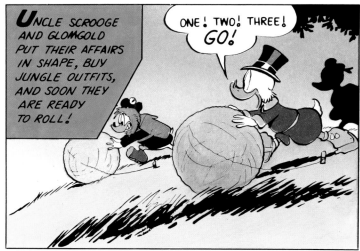

*U*NCLE SCROOGE AND GLOMGOLD PUT THEIR AFFAIRS IN SHAPE, BUY JUNGLE OUTFITS, AND SOON THEY ARE READY TO ROLL!

ONE! TWO! THREE! *GO*!

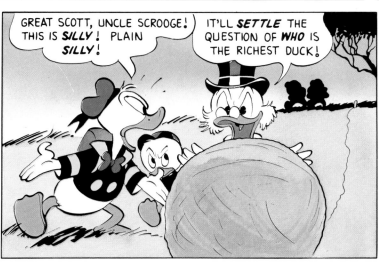

GREAT SCOTT, UNCLE SCROOGE! THIS IS *SILLY*! PLAIN *SILLY*!

IT'LL *SETTLE* THE QUESTION OF *WHO* IS THE RICHEST DUCK!

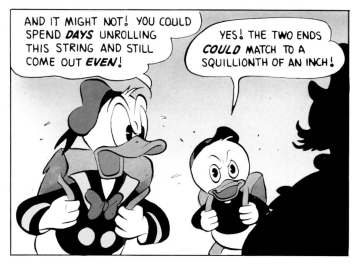

AND IT MIGHT NOT! YOU COULD SPEND *DAYS* UNROLLING THIS STRING AND STILL COME OUT *EVEN*!

YES! THE TWO ENDS *COULD* MATCH TO A SQUILLIONTH OF AN INCH!

(SNORT!) THEY *COULD*, BUT THEY *WON'T*! WHY DO YOU SUPPOSE I SUGGESTED THIS CROSS-COUNTRY ROLLING DERBY?

I WANTED TO GET INTO *ROUGH COUNTRY*, WHERE THINGS COULD *HAPPEN* TO THAT PRECIOUS STRING OF OLD FLINTY'S!

HEH! HEH! HEH!

THERE ARE *FIVE OF US* TO PROTECT *MY* STRING FROM FLOODS AND GRASS FIRES, BUT OLD FLINTY IS ALL ALONE! HEH! HEH!

HEH! HEH! HEH! WAIT TILL WE GET TO THE *ANT COUNTRY* AND THE *THORN BRAMBLES*! AFRICA WILL TAKE CARE OF OLD SCROOGIE'S STRING!

ACROSS THE DRY PLAINS OF BECHUANALAND THE ROLLING IS FAST AND FURIOUS!

OLD FLINTY IS HARD PUT TO KEEP UP! IF WE ROLL IN *RELAYS* WE'LL MAKE HIM SO TIRED HE'LL *FOLD UP*!

YOU'LL FOLD UP, TOO, IF YOU DON'T STOP DOING THAT *VICTORY DANCE* EVERY FEW FEET!

YES! WIN THE VICTORY FIRST! THEN DANCE!

FIRST NIGHT CAMP IS FAR OUT IN THE GRASSLANDS!

OH, MY BUNIONS! THOSE BALLS HAVEN'T *SHRUNK* AN INCH!

THERE'S ENOUGH STRING LEFT TO ROLL TO *TRIPOLI*!

OH, WOE IS US!

HEH! HEH! ANOTHER DAY LIKE THIS ONE, AND OLD FLINTY WON'T CARE WHETHER HE WINS OR NOT!

POOR OLD GUY! HE'S *SO TIRED*!

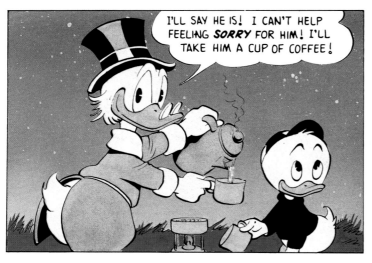

I'LL SAY HE IS! I CAN'T HELP FEELING *SORRY* FOR HIM! I'LL TAKE HIM A CUP OF COFFEE!

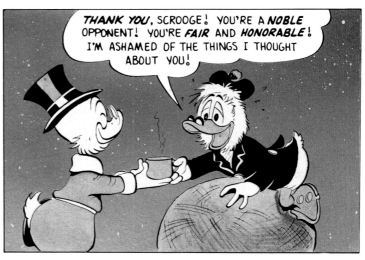

THANK YOU, SCROOGE! YOU'RE A *NOBLE* OPPONENT! YOU'RE *FAIR* AND *HONORABLE*! I'M ASHAMED OF THE THINGS I THOUGHT ABOUT YOU!

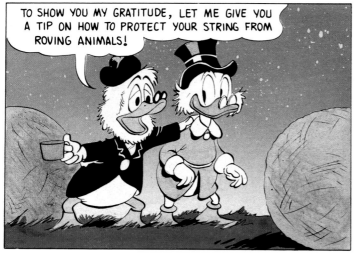

TO SHOW YOU MY GRATITUDE, LET ME GIVE YOU A TIP ON HOW TO PROTECT YOUR STRING FROM ROVING ANIMALS!

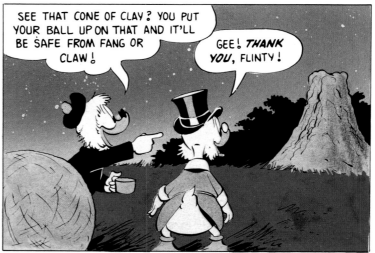

SEE THAT CONE OF CLAY? YOU PUT YOUR BALL UP ON THAT AND IT'LL BE SAFE FROM FANG OR CLAW!

GEE! *THANK YOU*, FLINTY!

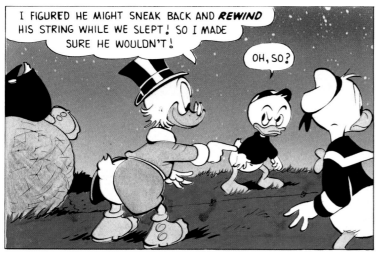

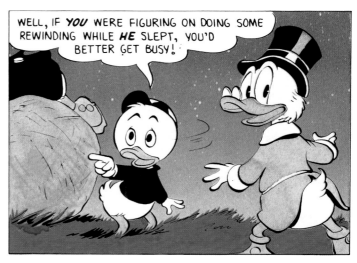

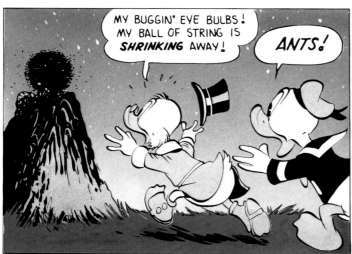

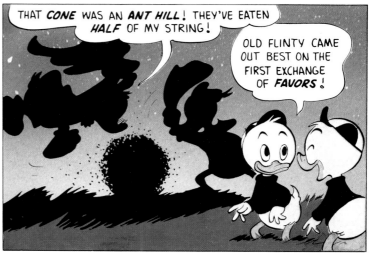

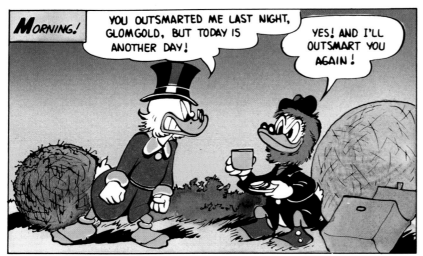

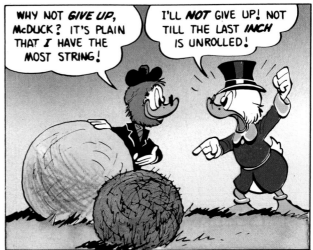

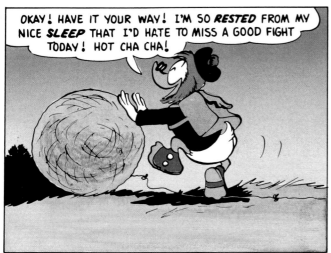

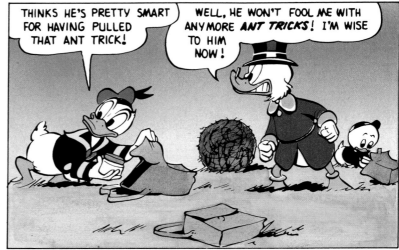

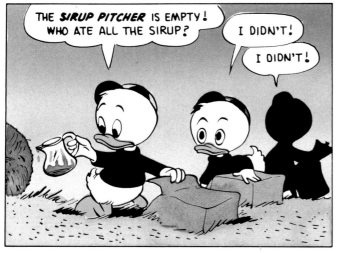

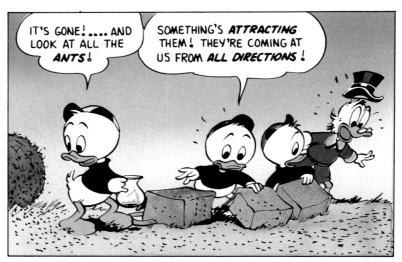

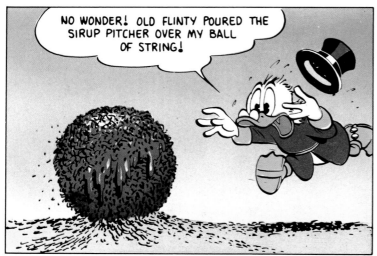

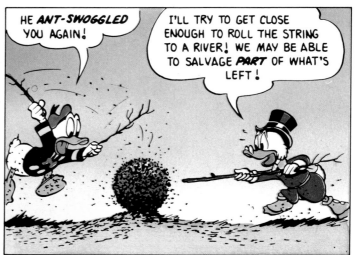

THAT NIGHT COMES PROOF THAT UNCLE SCROOGE IS RIGHT! AFRICA IS *NOBODY'S* FRIEND!

WHAT'S THAT *ROAR* OFF TO THE NORTH?

IT ISN'T *THUNDER*, OR WE'D SEE LIGHTNING!

IT SOUNDS MENACING, AND IT'S COMING *CLOSER*!

I'M *SCARED*! I WISH I HAD A *SAFE* PLACE TO STASH MY BALL OF STRING!

THERE'S A SAFE PLACE, FLINTY! PARK IT ON TOP OF THAT *CONE* OF CLAY!

YOU'RE NOT BEING FUNNY, McDUCK!

HEH! HEH! I'VE GOT A SAFE PLACE TO PARK *MY BALL* — IN MY *HAT*!

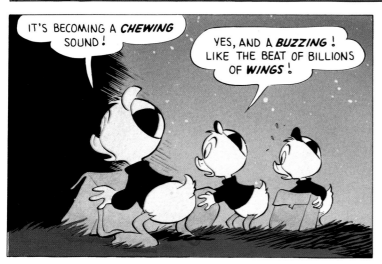

IT'S BECOMING A *CHEWING* SOUND!

YES, AND A *BUZZING*! LIKE THE BEAT OF BILLIONS OF *WINGS*!

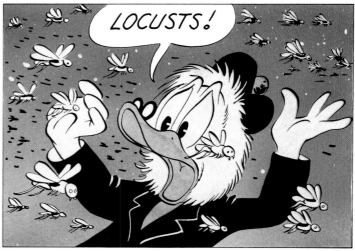

LOCUSTS!

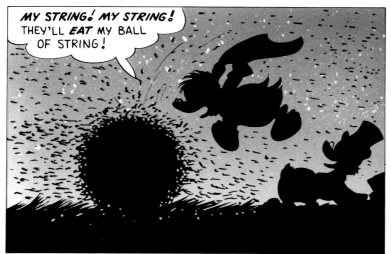

MY STRING! MY STRING! THEY'LL *EAT* MY BALL OF STRING!

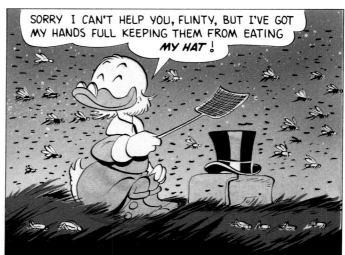

SORRY I CAN'T HELP YOU, FLINTY, BUT I'VE GOT MY HANDS FULL KEEPING THEM FROM EATING *MY HAT*!

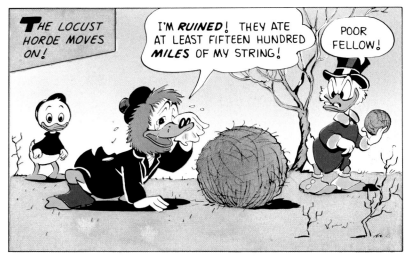

THE LOCUST HORDE MOVES ON!

I'M *RUINED*! THEY ATE AT LEAST FIFTEEN HUNDRED *MILES* OF MY STRING!

POOR FELLOW!

YOU HAVEN'T OVER A *THOUSAND MILES* LEFT! YOU'VE STILL GOT A LOT OF *CALAMITIES* COMING TO YOU!

WAK! NOW THERE'S A CHAIN OF *FIRES* STARTING UP OFF TO THE SOUTH AND WEST!

GRASS FIRES! THE NATIVES ARE BURNING THE VELD TO STOP THE LOCUSTS! RUN FOR YOUR LIVES!

?

WHY RUN? THERE'S NOT A BLADE OF GRASS HERE TO BURN!

THE *FIRE* ISN'T OUR DANGER! IT'S *ANIMALS*!

THERE'LL BE A *STAMPEDE* PAST HERE IN THE NEXT FEW MINUTES! CLIMB THE STRONGEST TREE YOU CAN FIND!

SOON!

I'LL BE A DOGGONED SITTING DUCK! THOSE GUYS WOULD *STEP ON YOU*!

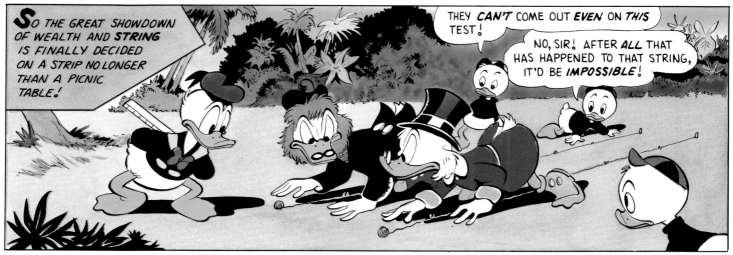

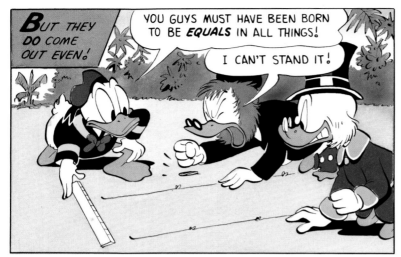

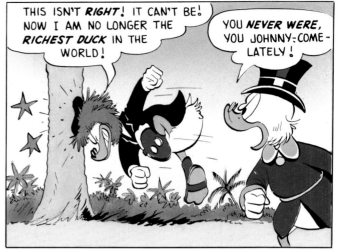

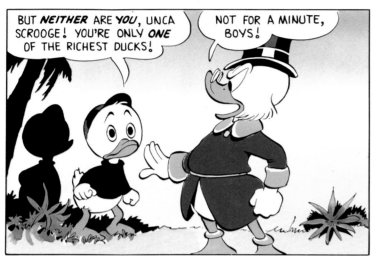

❝I finally decided to do a water color to show that I'm really a hairy-chinned rebel at heart.❞

Striving to find a duplicate for Uncle Scrooge, to show that there were other people just as ornery as he is, I invented Flintheart Glomgold, who is even more ornery than Scrooge. He takes unfair advantage of Scrooge to such an extent that Scrooge comes out being the sympathetic one. Some funny things in the story are the stinginess of those guys and the dirty things that they do to one another to save a penny. Also funny is rolling the balls of string through the heart of Africa to see which one had the most string. I don't know at what point I thought of that, but it must have been quite early in the formation of the synopsis, because I wouldn't have started out with that string-saving gag unless I had planned to use the unrolling scene: that led into action gags and comic menaces in Africa.

Years ago, saving tinfoil and string used to be quite a thing. The only tinfoil you ever came across was around chewing gum or inside of cigarette packages. It wasn't as common as it is now. People who saved tinfoil would get a ball maybe six inches across and feel quite rich. I don't know what they ever did with it,

whether they really thought it had value, but it was something heavy.

People saved string back then because it was a good idea to save it. When I was a kid, you didn't get stuff in a paper bag. When you bought potatoes, the wrapping paper was folded around and tied with a string. So we always accumulated string around the house. We didn't have Scotch tape, so we used string for holding things together. Some people carried it to the point of seeing how big a ball of string they could accumulate. One old photographer had a ball over a foot across. He had been at it for years to get one that big. He couldn't explain any other reason for it except that he got satisfaction seeing how much bigger it had gotten. That's no crazier than collecting comic books.

There have been times when I felt nervous about taking a chance with a plot, but it wasn't enough to stop me. I'd compromise a bit if I felt I was getting too wild. I've got a conservative head; it never went off completely wild. I've approached every subject with my teeth chattering and knees knocking. Getting new ideas was the big nerve-wracker. Often I'd feel I'd pumped the

well dry and hadn't another idea in my system: I'd get real scared. I can remember times when I got so scared that when I did come up with an idea, I almost cried with relief at having gotten over that hump again. There were times when I would have dead periods in which nothing would crank out for days. I'd watch that old calendar going by, and it was beginning to look like the coming of the noose! I was a terrible pessimist.

I think I worked better under pressure. I had to! I'm lazy by nature and postpone work as long as I can. I'd fool away a week, then get into absolute terror when I only had three weeks left to do everything. When I had to work, I could do it.

Those periods happened more and more over the years, but toward the end of my writing career, I ceased to worry about them. If I had a dead period, I'd relax a bit and think, "Oh, well, it will pass." Sometimes I'd cudgel my brain to forcefully create a plot. But plots that I forced never seemed to gel. They were the ones that I would take a second look at after I'd drawn a page or two, put them on the shelf and go to a whole new idea. Just getting that false start out of my system would clear the tracks so that the good ideas could come along.

I had never done painting or sketching on my own until about 1955, when suddenly I was ahead of my deadlines. So I tried to paint some watercolors. But it didn't take me long to find that I was beginning to lose interest in my duck work; I had to go back to concentrating on those ducks again. The watercolors were too much fun. That's a reason why I never developed my own comic strips. When I got to thinking up material for a strip, I soon realized that it would take months, even years, before I'd get enough polished

material to have three weeks of continuity to show to a syndicate. In the meantime, I would have had to have something to buy groceries with. I couldn't leave the ducks for that long, so I decided I'd stick with those ducks and figure that sometime something's going to make the decision for me. I thought, "It will either be that I go on to the end of my time with the ducks or the ducks lose their publisher or something happens so that there are no longer any duck comic books for me to do." So I just let fate make the decision for me like old Gladstone Gander.

I spent a lot of time learning from other people's writings, but after I had begun producing stories for comic-books, I stopped reading other people's work, especially comic-book writing. I had only Donald and the nephews to work with and had found a good formula for using them, so I didn't want to unconsciously absorb foreign methods of working. I might get mixed up. I was fascinated by heros like Superman, and a little afraid of what it might do to me. I'd wind up writing for Marvel instead of for the ducks.

Actually I was expressing myself more freely because I was anonymous than if I had had a lot of fame and a lot of people trying to influence my thinking. Guys like Walt Kelly were surrounded by swarms of people. Of course, he loved it, but it would have stagnated me. I needed privacy and my own little old hole in the earth where I could work in order to be productive and inspired.

I think I was like a hack horse in a way. I had a bunch of duck characters, and I'd get one story done and go right into doing another. Every story was a challenge as to whether I was going to be able to bring it off. So I dug a little deeper each time.

LAND OF THE
PYGMY
INDIANS

Land of the Pygmy Indians
Uncle $crooge #18　June 1957

Clean air, clean water, clean, quiet environment. We think of those things as part of our birthright. They once were long ago, before we overran them with our brand of civilization. Now what have we got?

Air so polluted we have to grind it before it will filter through our gas masks. Water so undrinkable it is safer to die of thirst. An environment so littered we cannot see the ground, and ground so caustic with chemical spills it eats the soles off our shoes. And quiet—who knows what that is, anymore?

So we dream that somewhere in the boondocks we can find a place that is still clean and quiet, as nature intended it to be. But if we find such a place, would it be safe to move in?

Uncle Scrooge tries it in this tale of the oxygen belt and finds that his kind and our kind are mighty darned unwelcome.　*C.B. 1981*

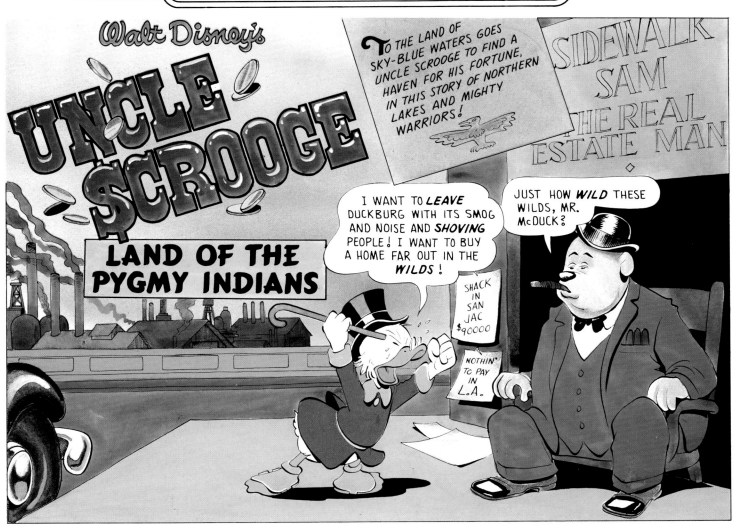

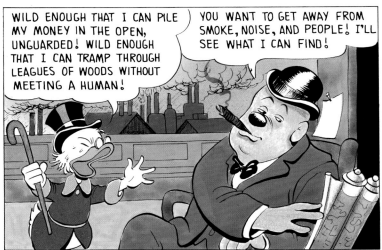

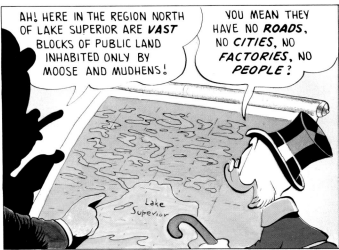

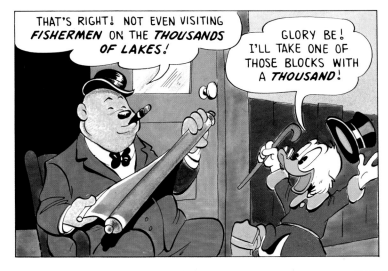

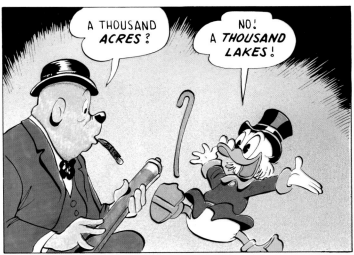

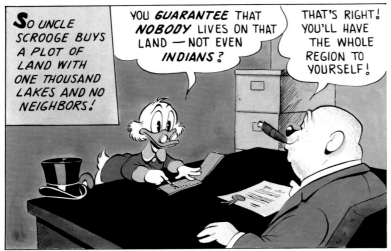

So Uncle Scrooge buys a plot of land with one thousand lakes and no neighbors!

YOU *GUARANTEE* THAT *NOBODY* LIVES ON THAT LAND — NOT EVEN *INDIANS?*

THAT'S RIGHT! YOU'LL HAVE THE WHOLE REGION TO YOURSELF!

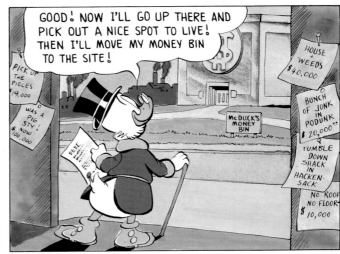

GOOD! NOW I'LL GO UP THERE AND PICK OUT A NICE SPOT TO LIVE! THEN I'LL MOVE MY MONEY BIN TO THE SITE!

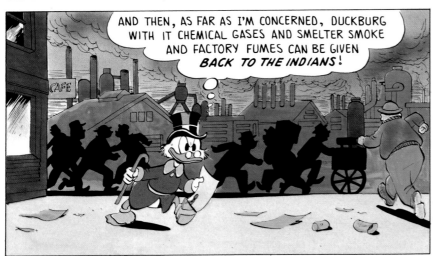

AND THEN, AS FAR AS I'M CONCERNED, DUCKBURG WITH IT CHEMICAL GASES AND SMELTER SMOKE AND FACTORY FUMES CAN BE GIVEN *BACK TO THE INDIANS!*

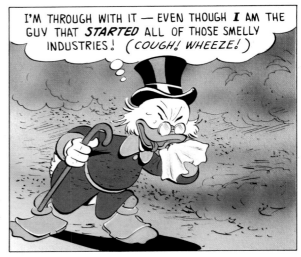

I'M THROUGH WITH IT — EVEN THOUGH *I* AM THE GUY THAT *STARTED* ALL OF THOSE SMELLY INDUSTRIES! *(COUGH! WHEEZE!)*

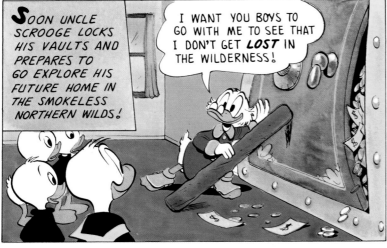

Soon Uncle Scrooge locks his vaults and prepares to go explore his future home in the smokeless northern wilds!

I WANT YOU BOYS TO GO WITH ME TO SEE THAT I DON'T GET *LOST* IN THE WILDERNESS!

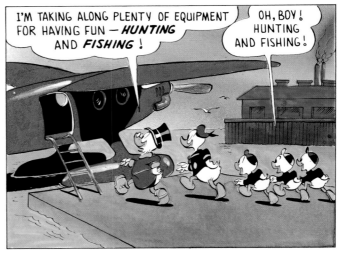

I'M TAKING ALONG PLENTY OF EQUIPMENT FOR HAVING FUN — *HUNTING* AND *FISHING!*

OH, BOY! HUNTING AND FISHING!

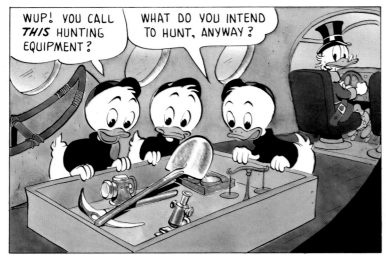

WUP! YOU CALL *THIS* HUNTING EQUIPMENT?

WHAT DO YOU INTEND TO HUNT, ANYWAY?

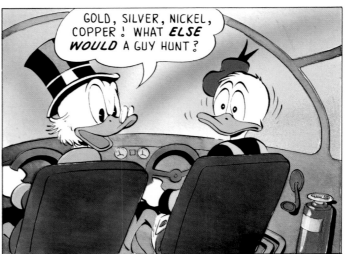

GOLD, SILVER, NICKEL, COPPER! WHAT *ELSE* *WOULD* A GUY HUNT?

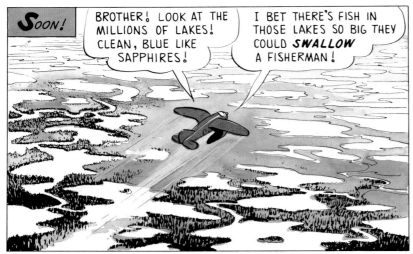

SOON! BROTHER! LOOK AT THE MILLIONS OF LAKES! CLEAN, BLUE LIKE SAPPHIRES!

I BET THERE'S FISH IN THOSE LAKES SO BIG THEY COULD *SWALLOW* A FISHERMAN!

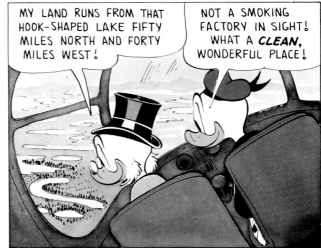

MY LAND RUNS FROM THAT HOOK-SHAPED LAKE FIFTY MILES NORTH AND FORTY MILES WEST!

NOT A SMOKING FACTORY IN SIGHT! WHAT A *CLEAN,* WONDERFUL PLACE!

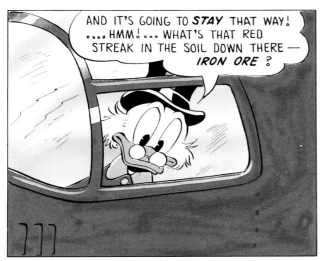

AND IT'S GOING TO *STAY* THAT WAY!HMM!... WHAT'S THAT RED STREAK IN THE SOIL DOWN THERE — *IRON ORE*?

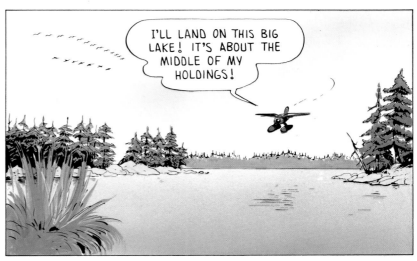

I'LL LAND ON THIS BIG LAKE! IT'S ABOUT THE MIDDLE OF MY HOLDINGS!

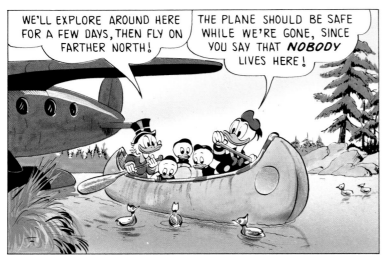

WE'LL EXPLORE AROUND HERE FOR A FEW DAYS, THEN FLY ON FARTHER NORTH!

THE PLANE SHOULD BE SAFE WHILE WE'RE GONE, SINCE YOU SAY THAT *NOBODY* LIVES HERE!

MY! MY! WHAT A SPARKLING *HEALTHINESS* TO THE AIR! I COULD BOTTLE IT, I BET, AND *SELL* IT IN DUCKBURG!

AND LOOK AT THE *TIMBER* THAT COULD BE TURNED INTO *PAPER*!

YOU FORGET ABOUT *PAPER,* UNCA SCROOGE! YOU CAME UP HERE TO GET *AWAY* FROM PAPER AND PAPER MILLS AND SUCH THINGS!

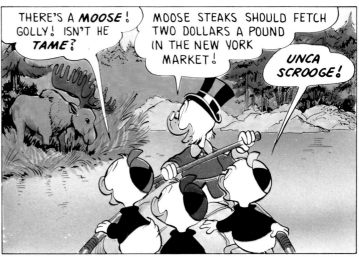

THERE'S A *MOOSE*! GOLLY! ISN'T HE *TAME*?

MOOSE STEAKS SHOULD FETCH TWO DOLLARS A POUND IN THE NEW YORK MARKET!

UNCA SCROOGE!

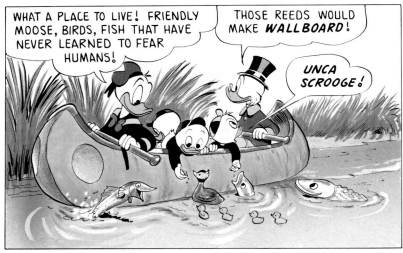

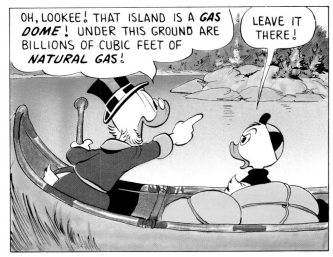

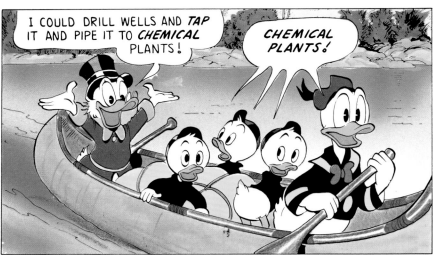

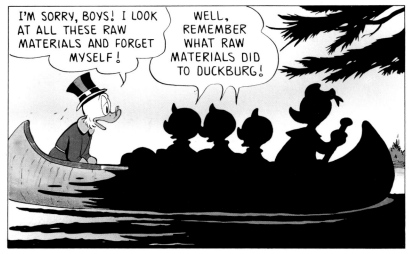

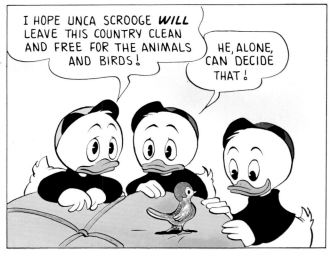

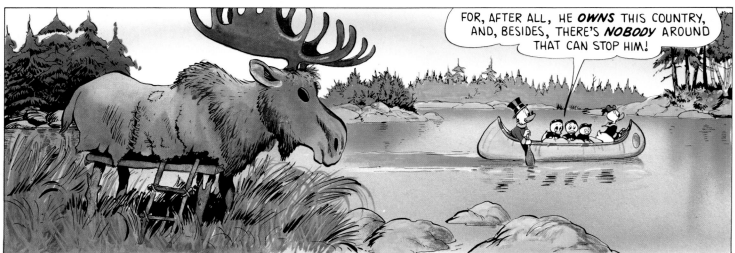

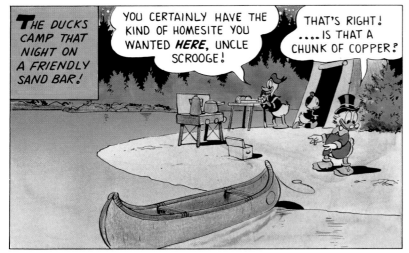

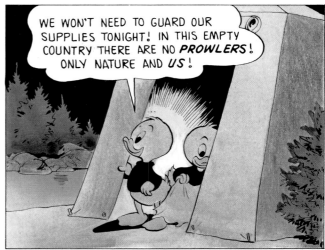

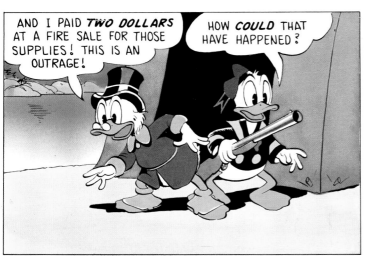

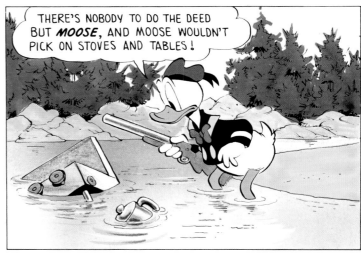

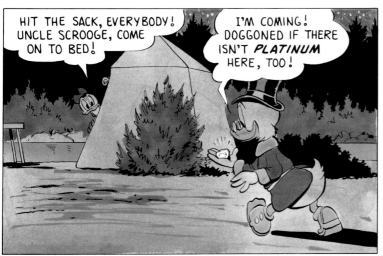

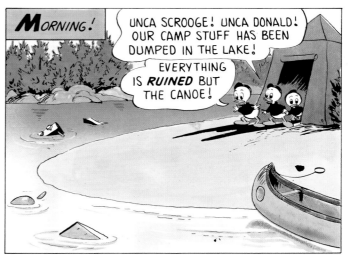

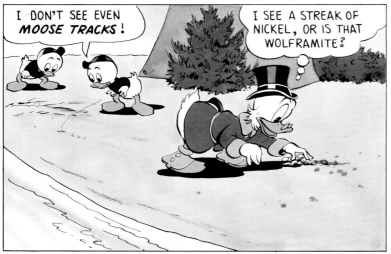

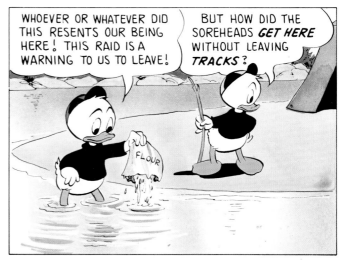

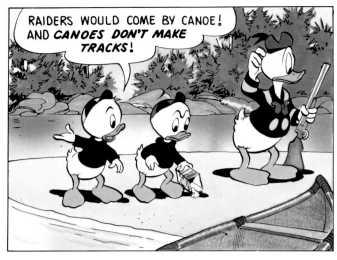

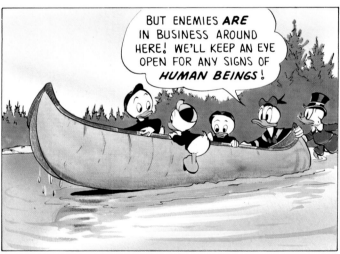

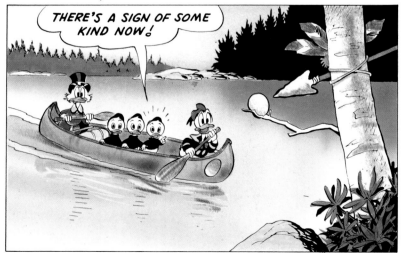

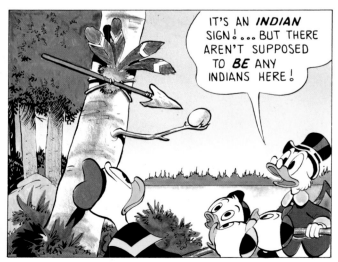

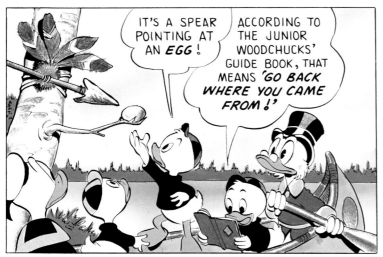

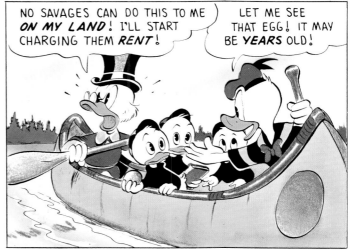

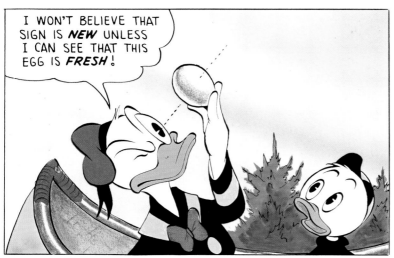

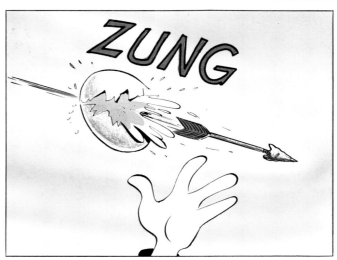

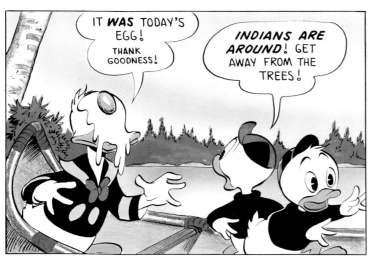

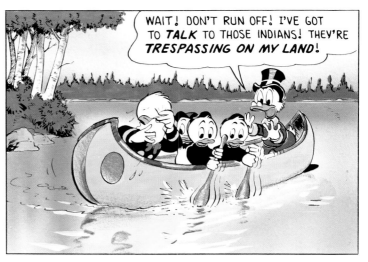

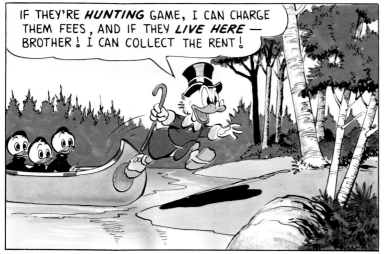

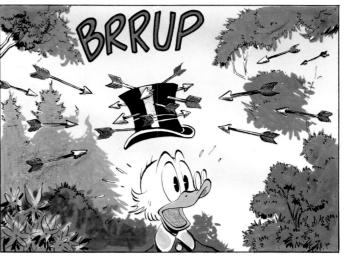

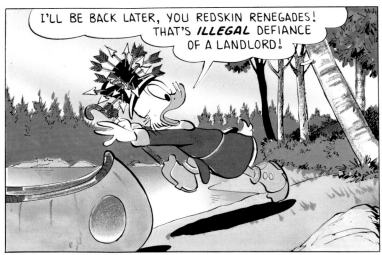

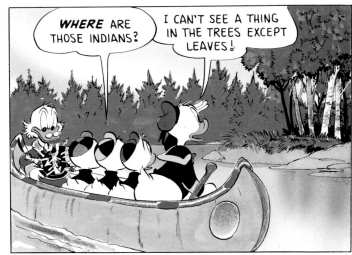

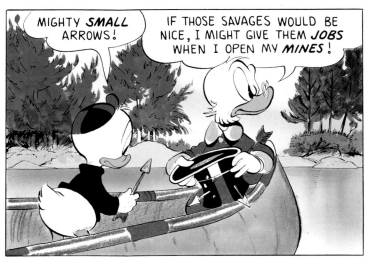

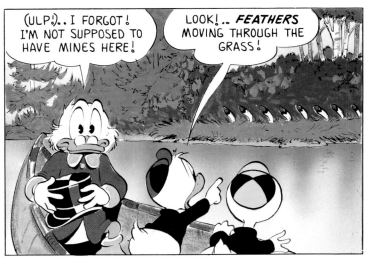

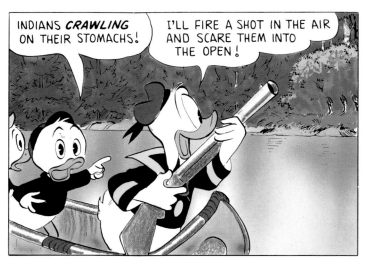

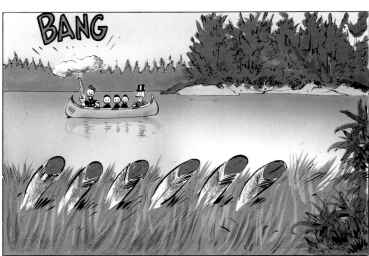

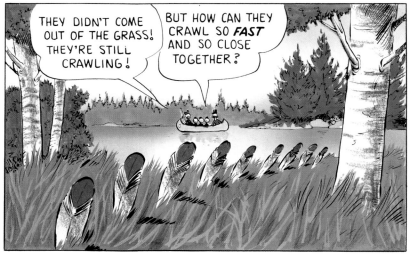

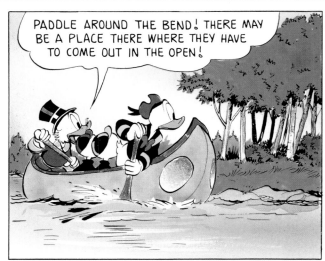

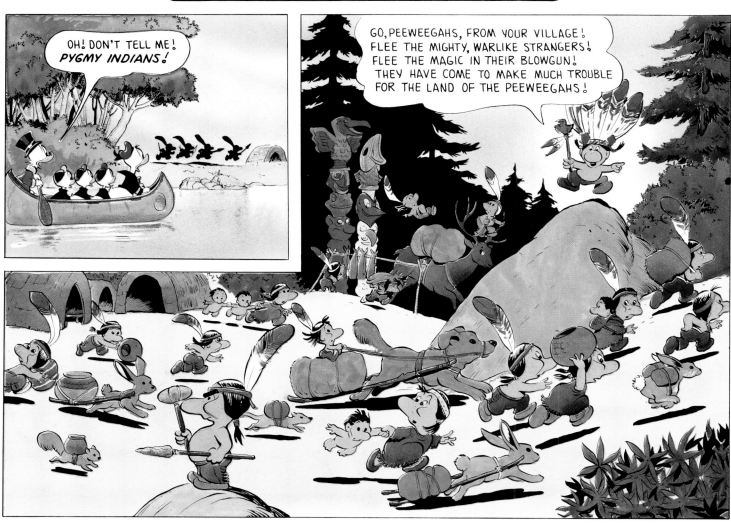

OH! DON'T TELL ME! *PYGMY INDIANS!*

GO, PEEWEEGAHS, FROM YOUR VILLAGE! FLEE THE MIGHTY, WARLIKE STRANGERS! FLEE THE MAGIC IN THEIR BLOWGUN! THEY HAVE COME TO MAKE MUCH TROUBLE FOR THE LAND OF THE PEEWEEGAHS!

PYGMY INDIANS THAT TALK IN RHYTHM LIKE LONG-FELLOW'S *"SONG OF HIAWATHA"!*

IT MAY BE A GAG, BUT HIAWATHA *DID* FISH AND HUNT HERE YEARS AGO!

GO, PEEWEEGAHS TO THE FOREST, TO THE HIDE-OUT OF THE RED DEER, TO THE BURROWS OF THE BADGER, TO THE SPOTS WHERE MEN CAN'T FIND YOU!

STOP THEM! LET THEM KNOW WE'RE NOT HERE TO HURT THEM!

WAIT! I ONLY WANT A *LEGAL* POWWOW!

LOOKOUT, UNCA SCROOGE! THEY LEFT A *REAR GUARD* IN THE TREES!

AN ARROW GOES DOWN UNCLE SCROOGE'S GUN BARREL!

YEEK!

ZIP

BWOM

JUST FOR THAT, YOU REDSKINS' RENT GOES UP TO A DOLLAR A MONTH!

WELL, WHAT DO WE DO NOW?

I *COULD* GO BACK TO THAT LAND DEALER AND GET MY MONEY BACK!

HE *GUARANTEED* THAT *NOBODY* LIVED IN THIS AREA! BUT I'M KIND OF *TAKEN* WITH THE POSSIBILITIES HERE!

BESIDES, IF I COULD *TAME* THOSE LITTLE SAVAGES, THEY'D MAKE THE BEST DOGGONED *PIPE LINE CLEANERS* THAT EVER—

UNCA SCROOGE!

WE *COULD* TRY TO CAPTURE ONE OF THE LITTLE GUYS AND GET OUR MESSAGE ACROSS TO HIM!

YES! THEN SEND HIM BACK TO THE TRIBE TO TELL THEM NOT TO *FEAR* US!

THAT'S THE TICKET! TELL THEM I'LL BE EASY ON THE *RENT*, AND THAT I'LL LET THEM HAVE ONE WHOLE LAKE TO FISH ON!

THEY'LL *LOVE* YOU, UNCA SCROOGE!

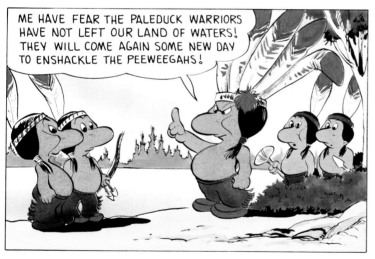

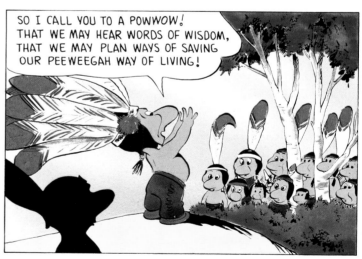

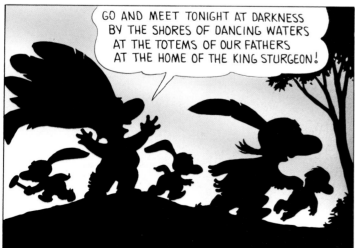

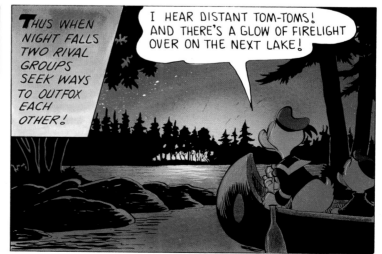

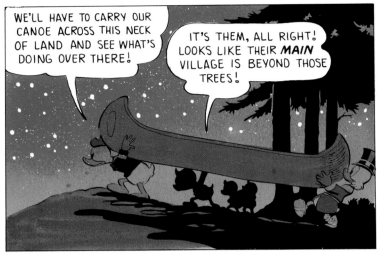

WE'LL HAVE TO CARRY OUR CANOE ACROSS THIS NECK OF LAND AND SEE WHAT'S DOING OVER THERE!

IT'S THEM, ALL RIGHT! LOOKS LIKE THEIR *MAIN* VILLAGE IS BEYOND THOSE TREES!

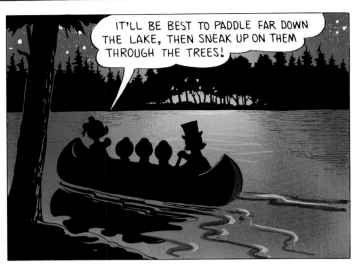

IT'LL BE BEST TO PADDLE FAR DOWN THE LAKE, THEN SNEAK UP ON THEM THROUGH THE TREES!

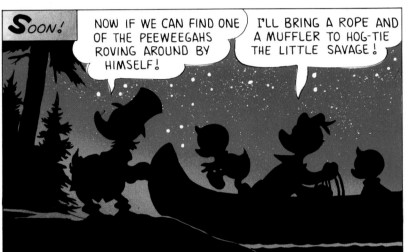

SOON!

NOW IF WE CAN FIND ONE OF THE PEEWEEGAHS ROVING AROUND BY HIMSELF!

I'LL BRING A ROPE AND A MUFFLER TO HOG-TIE THE LITTLE SAVAGE!

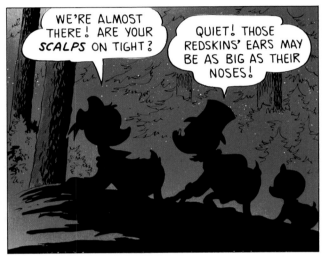

WE'RE ALMOST THERE! ARE YOUR *SCALPS* ON TIGHT?

QUIET! THOSE REDSKINS' EARS MAY BE AS BIG AS THEIR NOSES!

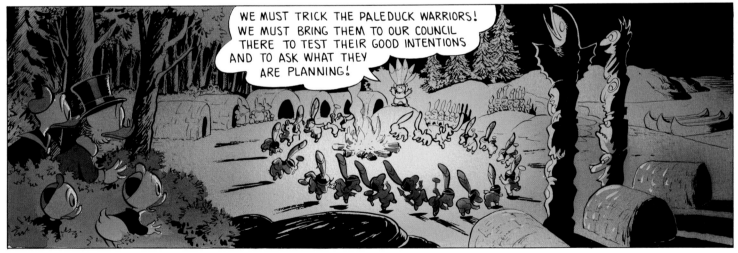

WE MUST TRICK THE PALEDUCK WARRIORS! WE MUST BRING THEM TO OUR COUNCIL THERE TO TEST THEIR GOOD INTENTIONS AND TO ASK WHAT THEY ARE PLANNING!

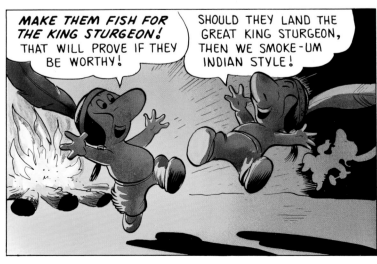

MAKE THEM FISH FOR THE KING STURGEON! THAT WILL PROVE IF THEY BE WORTHY!

SHOULD THEY LAND THE GREAT KING STURGEON, THEN WE SMOKE-UM INDIAN STYLE!

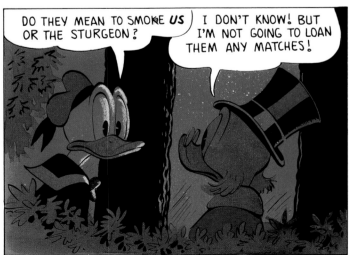

DO THEY MEAN TO SMOKE *US* OR THE STURGEON?

I DON'T KNOW! BUT I'M NOT GOING TO LOAN THEM ANY MATCHES!

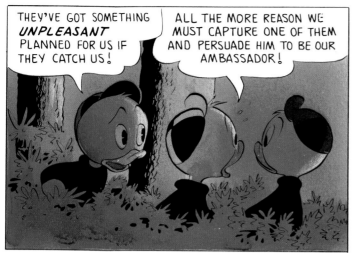

THEY'VE GOT SOMETHING *UNPLEASANT* PLANNED FOR US IF THEY CATCH US!

ALL THE MORE REASON WE MUST CAPTURE ONE OF THEM AND PERSUADE HIM TO BE OUR AMBASSADOR!

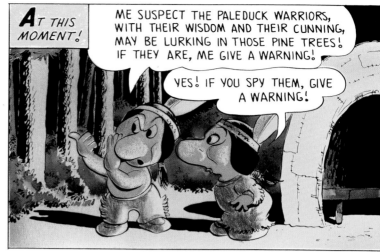

AT THIS MOMENT!

ME SUSPECT THE PALEDUCK WARRIORS, WITH THEIR WISDOM AND THEIR CUNNING, MAY BE LURKING IN THOSE PINE TREES! IF THEY ARE, ME GIVE A WARNING!

YES! IF YOU SPY THEM, GIVE A WARNING!

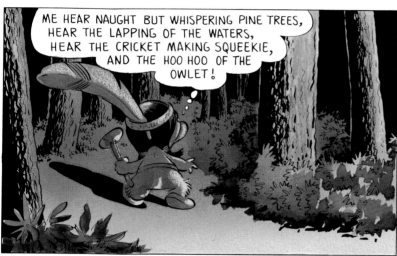

ME HEAR NAUGHT BUT WHISPERING PINE TREES, HEAR THE LAPPING OF THE WATERS, HEAR THE CRICKET MAKING SQUEEKIE, AND THE HOO HOO OF THE OWLET!

GLOM

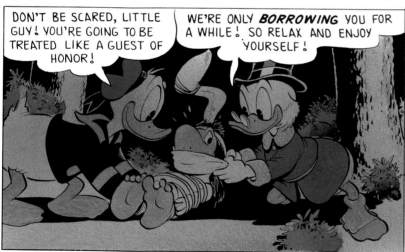

DON'T BE SCARED, LITTLE GUY! YOU'RE GOING TO BE TREATED LIKE A GUEST OF HONOR!

WE'RE ONLY *BORROWING* YOU FOR A WHILE! SO RELAX AND ENJOY YOURSELF!

COME ON! WE'VE GOT TO GET GOING BEFORE THIS GUY IS *MISSED*!

YES! LAM OUT OF HERE!

LUCKY FOR US, THE TRIBE IS MAKING TOO MUCH NOISE TO HEAR US!

HURRY!

DAWN!

WE'VE MADE A CLEAN GETAWAY!

OUR PLANE IS WAITING AROUND THE NEXT BEND IF MY MAP IS RIGHT!

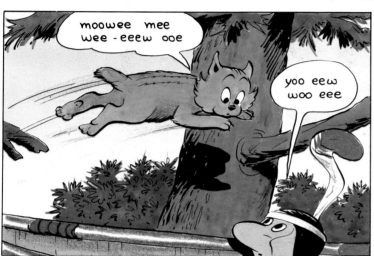

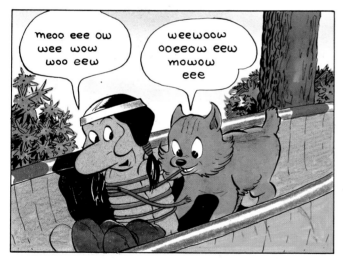

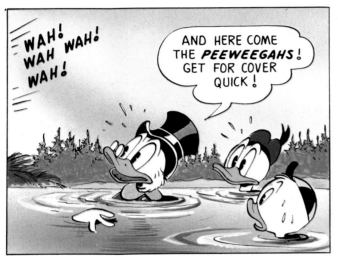

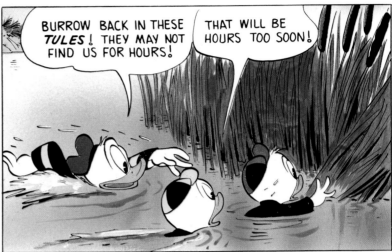

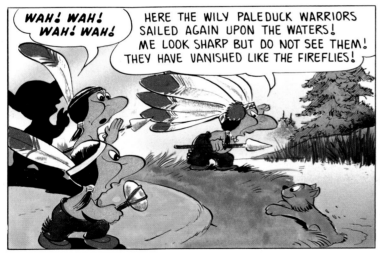

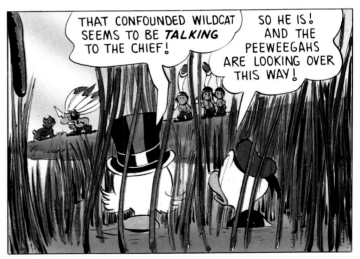

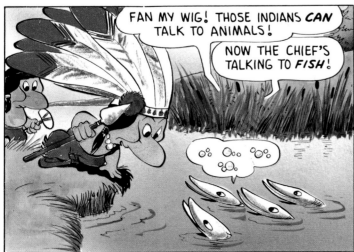

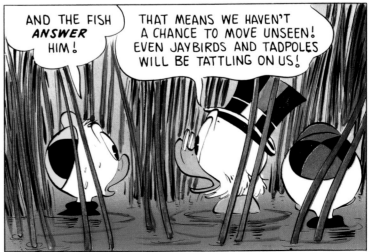

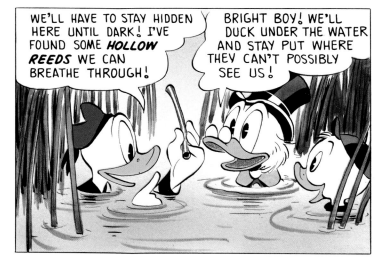

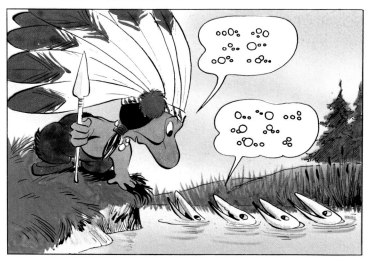

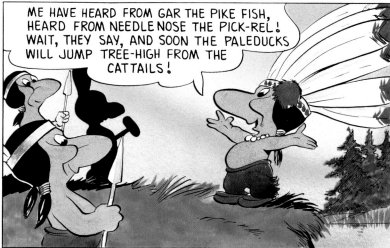

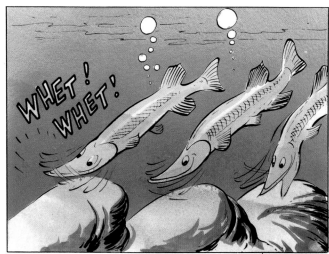

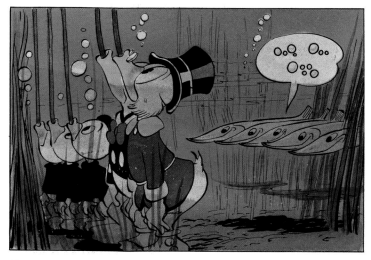

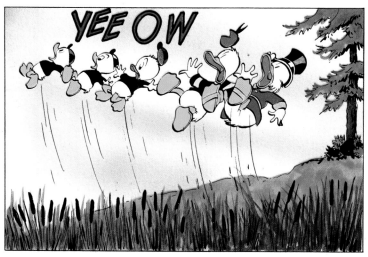

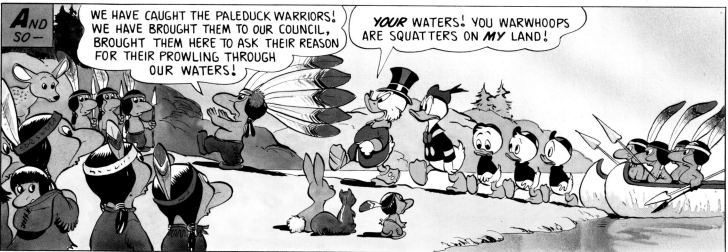

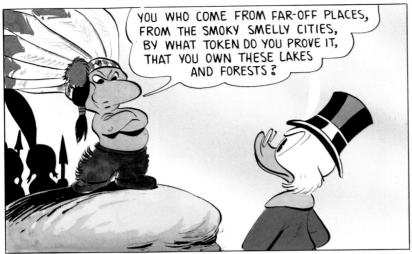

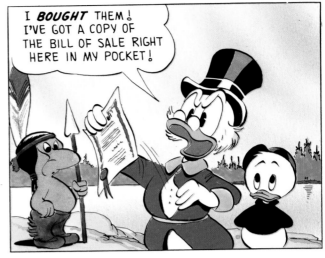

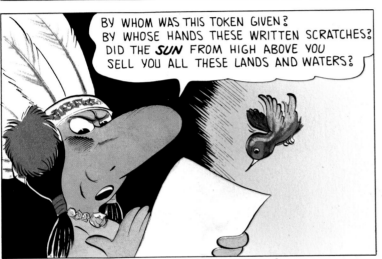

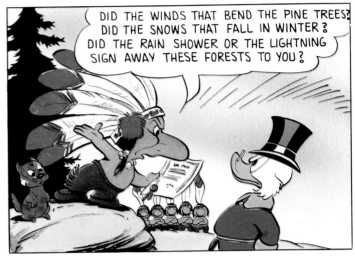

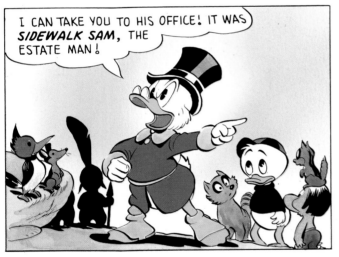

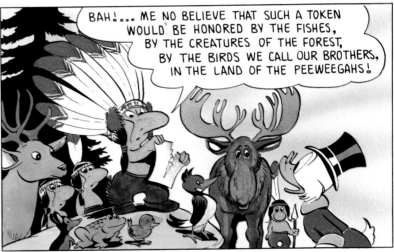

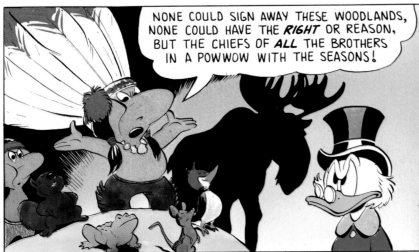

CHIEF, I INTEND TO DO JUST THAT! I BOUGHT THIS LAND SO I COULD *SAVE IT* — AND ME — FROM BEING SMOTHERED BY FACTORIES AND SHOVING PEOPLE!

YOU WOULD NOT COME TO BURN OR PLUNDER? WOULD NOT COME WITH SMOKING MONSTERS, SMASHING DOWN THE SINGING PINE TREES, DROWNING OUT THE BEAVER LODGES!

OH, *NO*!

I'D COME LIKE *DANIEL BOONE* — WITH ONLY THE SHIRT ON MY BACK — AND WITH MY MONEY BIN, OF COURSE!

HEY! THAT'S A LUMP OF PURE *NICKEL* AROUND YOUR NECK! WHERE DID YOU FIND IT?

UNCA SCROOGE!

WE THINK PALEDUCKS' WORDS ARE FLIM FLAM! THAT THEY'RE SPOKEN TO DECEIVE US! ONLY *DEEDS* CAN PROVE DUCKS WORTHY TO BE BROTHERS TO PEEWEEGAHS!

SEND THE STRONGEST OF THEIR WARRIORS TO THE LAKE TO CATCH THE STURGEON! THAT WILL PROVE IF THEY BE WORTHY IF HE LAND THE GREAT *KING STURGEON*!

WAH! WAH! WAH! LET HIM CATCH THE GREAT KING STURGEON!

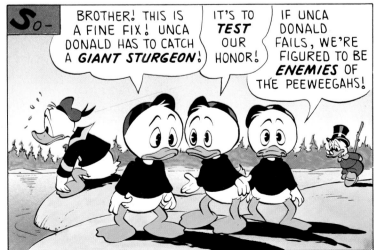

SO—

BROTHER! THIS IS A FINE FIX! UNCA DONALD HAS TO CATCH A *GIANT STURGEON*!

IT'S TO *TEST* OUR HONOR!

IF UNCA DONALD FAILS, WE'RE FIGURED TO BE *ENEMIES* OF THE PEEWEEGAHS!

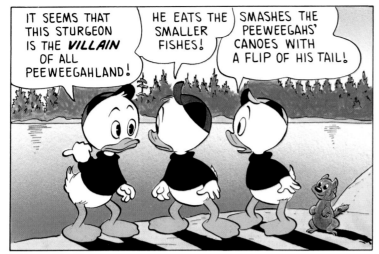

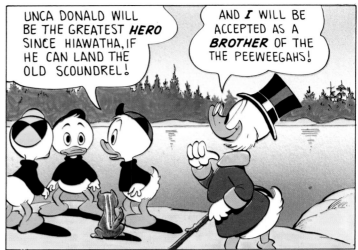

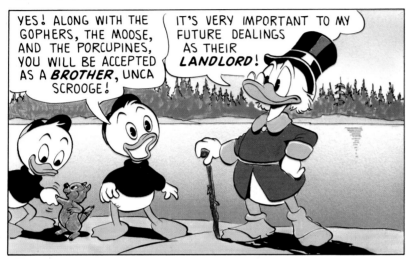

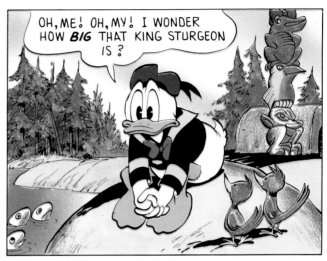

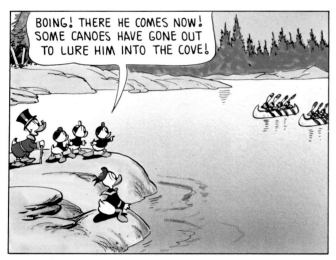

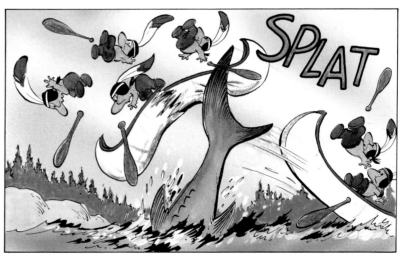

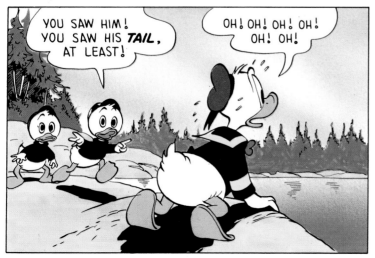

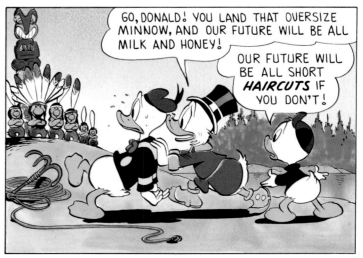

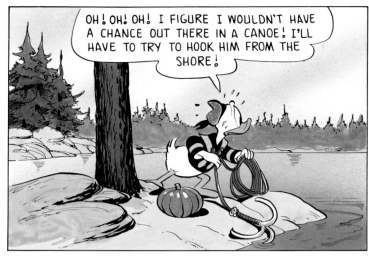

OH! OH! OH! I FIGURE I WOULDN'T HAVE A CHANCE OUT THERE IN A CANOE! I'LL HAVE TO TRY TO HOOK HIM FROM THE SHORE!

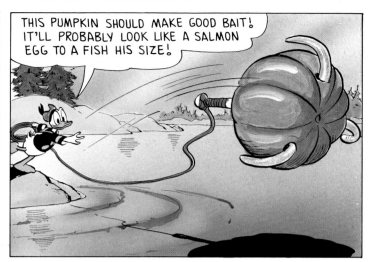

THIS PUMPKIN SHOULD MAKE GOOD BAIT! IT'LL PROBABLY LOOK LIKE A SALMON EGG TO A FISH HIS SIZE!

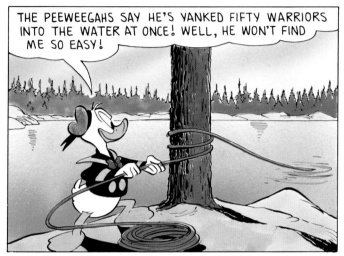

THE PEEWEEGAHS SAY HE'S YANKED FIFTY WARRIORS INTO THE WATER AT ONCE! WELL, HE WON'T FIND ME SO EASY!

OH, HO! I'VE GOT A *NIBBLE*!

IT'S THE *STURGEON*! HE'S OFF TO THE RACES!

SPANG

THAT'S HOLDING HIM, UNCA DONALD!

THAT'S JOLTING HIS GASKETS LOOSE!

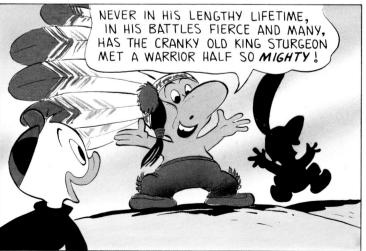

NEVER IN HIS LENGTHY LIFETIME, IN HIS BATTLES FIERCE AND MANY, HAS THE CRANKY OLD KING STURGEON MET A WARRIOR HALF SO *MIGHTY*!

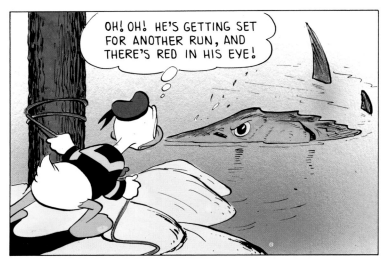

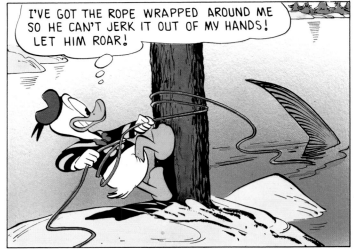

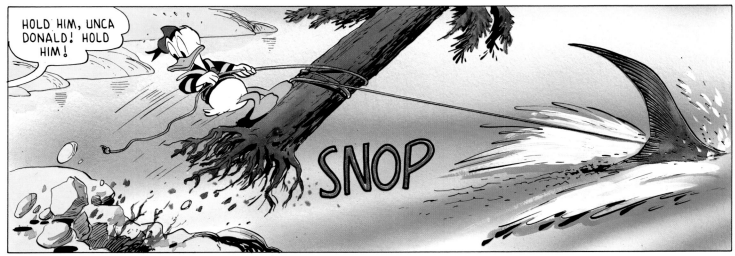

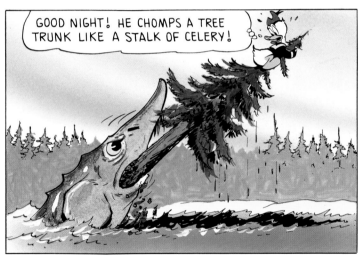

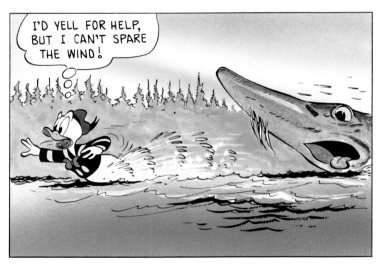

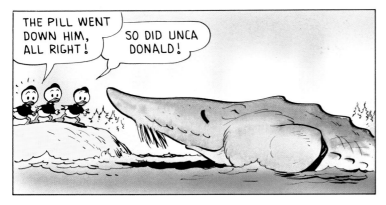

MAKE THEM WELCOME TO OUR TEPEES, WELCOME AT OUR COUNCIL FIRES! THEY HAVE BOPPED THE GREAT KING STURGEON! NOW WE SMOKE-UM INDIAN STYLE!

WHAT IS THIS SMOKE-UM BUSINESS THEY SEEM SO KEEN ABOUT?

SEARCH ME!

OH! I GET IT! IT'S SOME SORT OF *PEACE PIPE* CEREMONY!

SURE! AND INDIAN STYLE MEANS THEY PASS THE PIPE AROUND!

YOU WHO CAME TO CLAIM OUR HOMELAND, CAME WITH MANY PLANS AND WISHES, SMOKE THIS PIPE, AND WE WILL LISTEN, LISTEN TO YOUR BIG AMBITIONS!

MY HOPES ARE TO KEEP THESE LAKES CLEAN AND THE AIR PURE AND THE FORESTS GREEN!

I WON'T PUT UP ANY *FACTORIES* OR *SMELTERS* — AT LEAST, I THINK I CAN KEEP MYSELF FROM DOING THAT!

FOR A WHILE, I HOPE!

AK! HAK! COFF SPUT

WHAF FOOF!

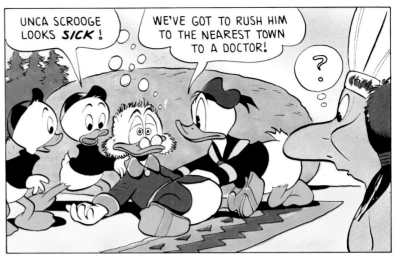

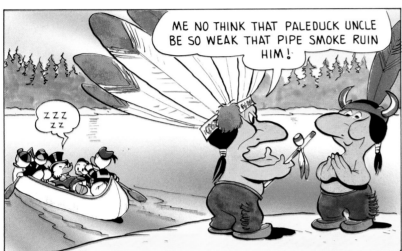

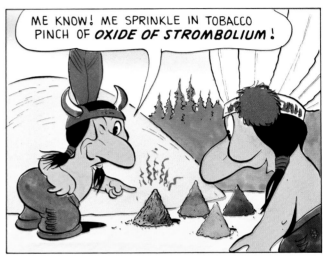

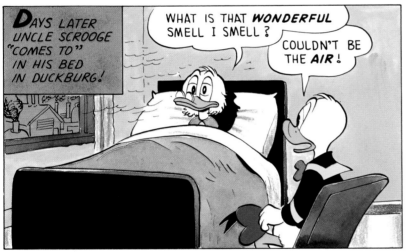

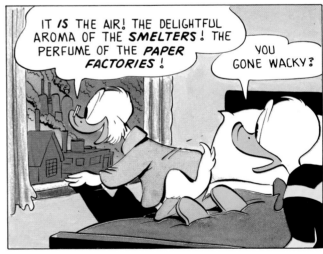

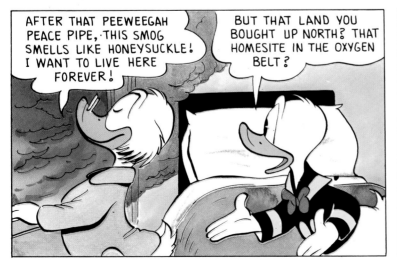

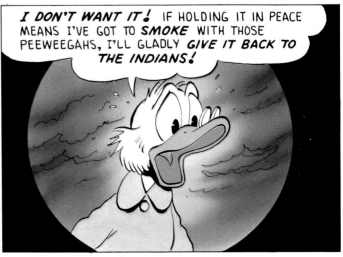

> **❝I've always looked at the ducks as caricatures of human beings.❞**

"Land of the Pygmy Indians" is a story that I got started on from the environmentalists who were rattling on about the foul air of the cities. And Uncle Scrooge had factories with their pollution. So I had *him* get affected by the smoke and noise, just like the other people. He decided to go out into areas of clean air, where there was clear water and everything was pure, simple and quiet. To get him out there was only the first step. There had to be funny business resulting from his move. The fact that the old guy can't go anywhere without getting involved in finding gold or silver, that was a good gimmick for causing comic problems. Uncle Scrooge takes his problems with him wherever he goes, so when he got there, he just about messed up paradise.

Then I had to have something for the other ducks to do when they got there: that's where I got the idea of Donald having to catch a king sturgeon. I figured on that being my climax. I went back from that to building up to how Donald got into the problem of having to catch that fish. I began coming up with the idea of Pygmy Indians out in the brush and grass. I suddenly realized that I was duplicating a plot line I had used years' ago: the Gneezles in "Mystery of the Swamp." That gave me pause for a while, but I realized that only the plot line was similar; all other elements were breaking new ground. Besides, the

Pygmy Indians were more believable and interesting than the Gneezles, so I went ahead with the story and let the gags fall where they might.

Then I came up with having the pygmies talk in the language of Longfellow's "Song of Hiawatha." About the eighth grade, I had to read and recite it in school: I thought it was a very tiresome way of telling a story back then, but the meter lends itself very well to the conversations of the pygmies when they talk about what they're going to do. It gives the story a special flavor. The dialogue took longer to write than normal; it practically had to be timed with a metronome. I'd come up with the gist of what they wanted to say, then try to figure out a way to express it in Longfellow's meter.

I recalled that Hiawatha was able to talk with animals, so that was good for the pygmies'. They could even talk to fishes in little bubbles. It gave a good reason for Donald to have to catch that big sturgeon, which he was going to have to do regardless of what the rest of the story was about, because that was about the only big climax action gag I had.

The fat real-estate shark was like real ones that I wanted to take a poke at. You get up on the edges of the beautiful forests, and their offices are all over, wanting to sell you a patch of paradise.

ISLAND IN THE SKY

Island in the Sky
Uncle Scrooge #29 March 1960

Ever since that distant day when man saw his first star, men have dreamed of exploring space. Curiously, those dreams have usually turned into highly imaginative nightmares, which populate the unknowns of space with dreadful creatures and mad scientists and so on and on.

Could not there be other types of creatures up there? Uncle Scrooge didn't do any speculating on the type of creatures he might find before he set out on this trip into the dark void, he just wanted to find no creatures at all!

He finds, instead, a system of life that closely resembles our own, and he finds, too, that emotions exist out there—hunger, fear, frustration, pity, and, finally, a great joy, which is all the sweeter because he bought it at a frightfully high price. *C.B. 1981*

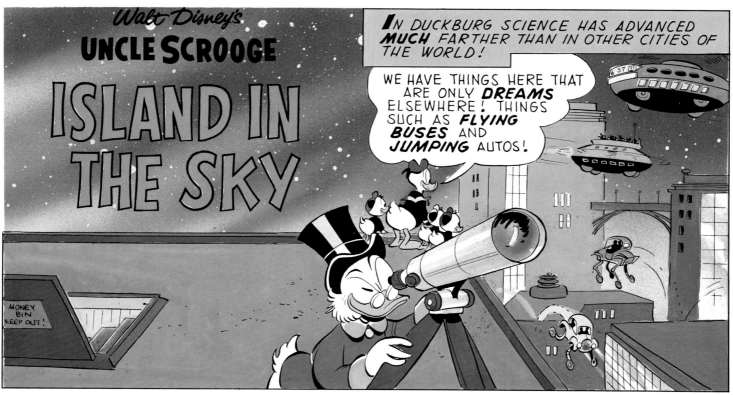

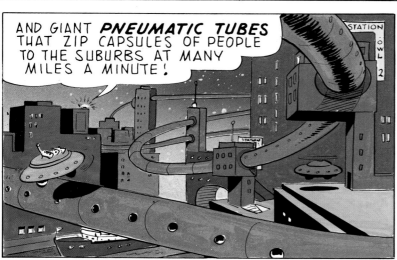

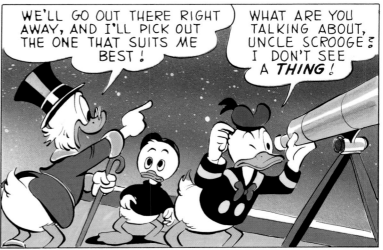

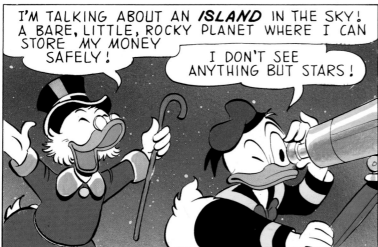

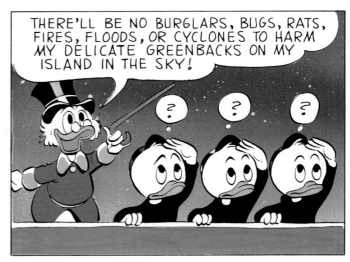

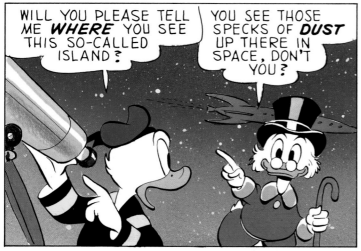

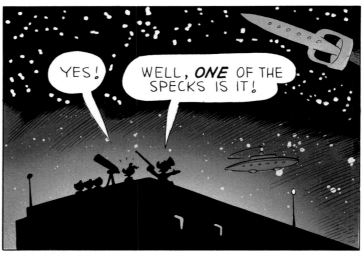

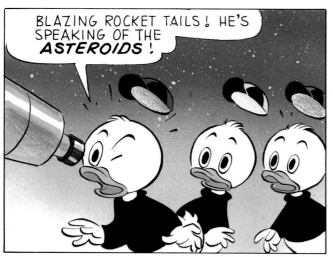

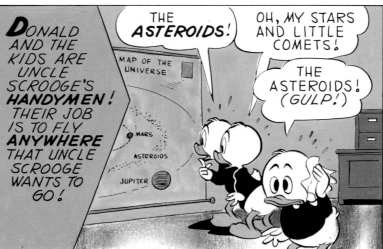

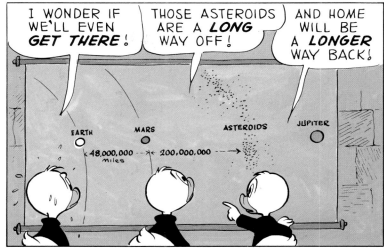

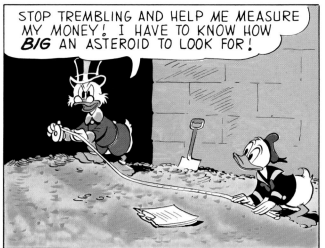

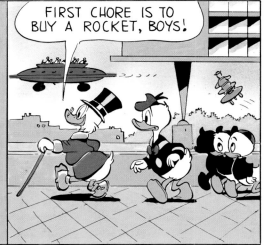

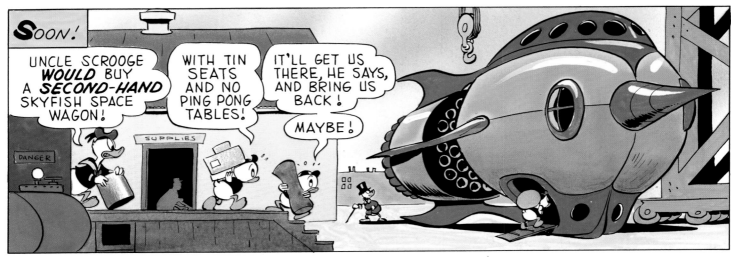

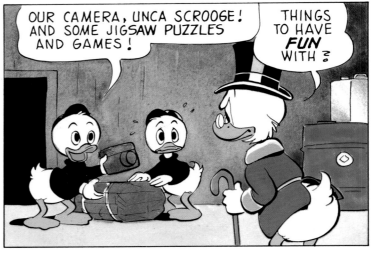

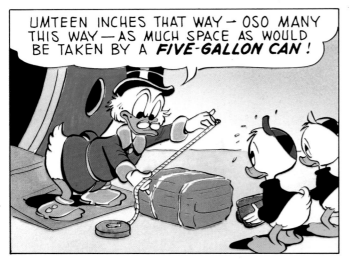

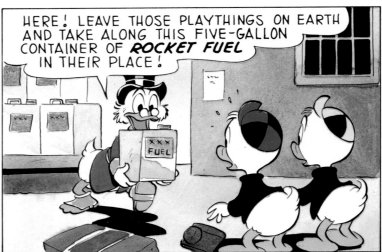

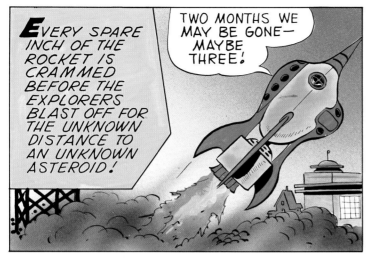

*E*VERY SPARE INCH OF THE ROCKET IS CRAMMED BEFORE THE EXPLORERS BLAST OFF FOR THE UNKNOWN DISTANCE TO AN UNKNOWN ASTEROID!

TWO MONTHS WE MAY BE GONE— MAYBE THREE!

A GREAT MANY NIGHTS TO SPEND ON A BED AS *HARD* AS THIS ONE!

WHAT'S *IN* THIS MATTRESS, ANYWAY?

ROCKET FUEL, BOY! *CANS* OF ROCKET FUEL!

YE CATS! ANY OTHER EXPLORER WOULD HAVE HIRED A *TANKER* ROCKET TO GO ALONG IF HE WERE SO SCARED OF RUNNING OUT OF GAS!

BUT NOT UNCA SCROOGE! HE IS MORE SCARED OF RUNNING OUT OF MONEY!

I'M HUNGRY! SHALL WE HAVE SOME CRACKERS AND ORANGE JUICE?

YES! GOOD IDEA!

HEY! WHAT'S IN THIS CAN, ANYWAY?

ROCKET FUEL!

GRADE A JUICE

WELL, THE *DUCK FUEL* ON THIS WAGON IS GOING TO BE MOST *UNFANCY!*

YES! HAVE SOME MORE CRACKERS AND *WATER*, MATES!

MAGNETIC SHOES

*D*AYS LATER THE EXPEDITION NEARS SPACE WHEEL FIVE!

OUR LAST GLIMPSE OF CIVILIZATION, BOYS!

WHAT A BEAUTIFUL SIGHT! LIKE FORT LARAMIE MUST HAVE LOOKED TO THE PIONEER WAGON TRAINS!

WE'LL GET A *HOT DOG* AND A SHOWER WHILE UNCA SCROOGE —

SORRY, BOYS! WE'RE NOT STOPPING!

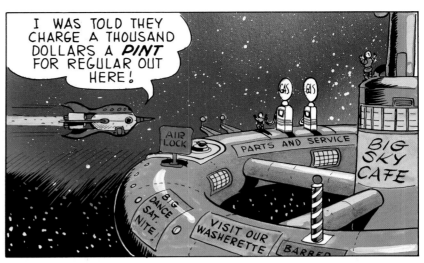

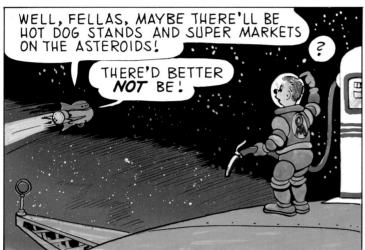

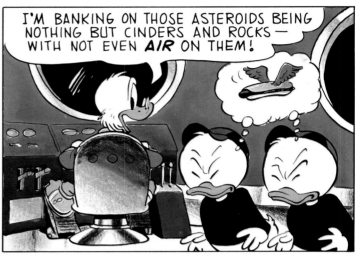

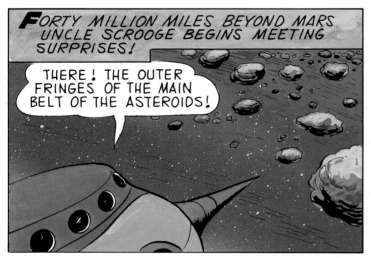

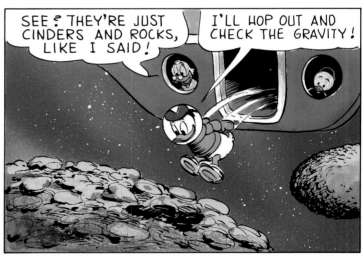

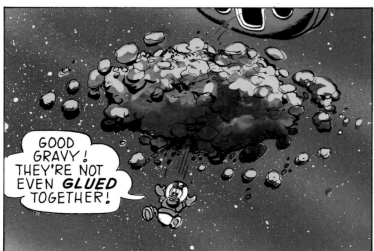

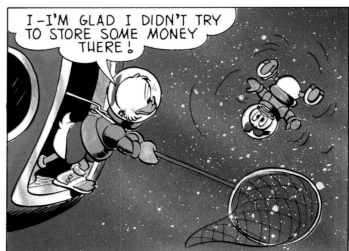

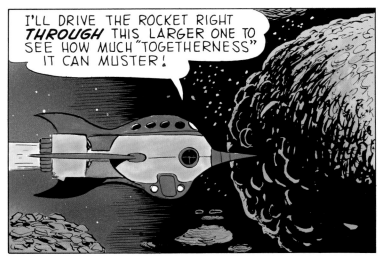

I'LL DRIVE THE ROCKET RIGHT *THROUGH* THIS LARGER ONE TO SEE HOW MUCH "TOGETHERNESS" IT CAN MUSTER!

OH, FOR PETE'S SAKE! IT'S LIKE A *FOAM RUBBER PILLOW!*

I THINK A SQUEEZE BOTTLE FULL OF USED *CHEWING GUM* IS A MORE APT DESCRIPTION!

PFOP

DRAT! ALL THIS STOPPING AND STARTING USES UP *ROCKET FUEL*, AND I'M LEARNING NOTHING!

NO? I THOUGHT WE'D JUST BEEN TAUGHT A TERRIFIC LESSON!

*S*OON!

MANY OF THESE ASTEROIDS ARE NO LARGER THAN HOUSES!

AND THE *ODDEST* SHAPES!

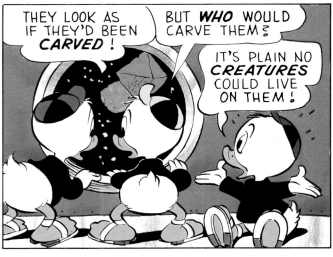

THEY LOOK AS IF THEY'D BEEN *CARVED!*

BUT *WHO* WOULD CARVE THEM?

IT'S PLAIN NO *CREATURES* COULD LIVE ON THEM!

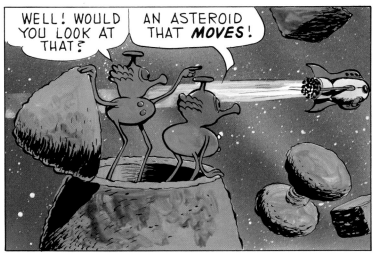

WELL! WOULD YOU LOOK AT THAT?

AN ASTEROID THAT *MOVES!*

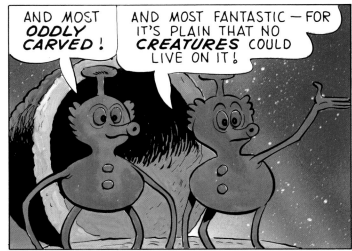

AND MOST *ODDLY CARVED!*

AND MOST FANTASTIC — FOR IT'S PLAIN THAT NO *CREATURES* COULD LIVE ON IT!

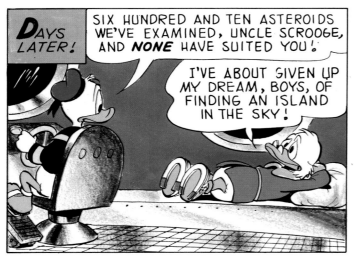

DAYS LATER!

SIX HUNDRED AND TEN ASTEROIDS WE'VE EXAMINED, UNCLE SCROOGE, AND **NONE** HAVE SUITED YOU!

I'VE ABOUT GIVEN UP MY DREAM, BOYS, OF FINDING AN ISLAND IN THE SKY!

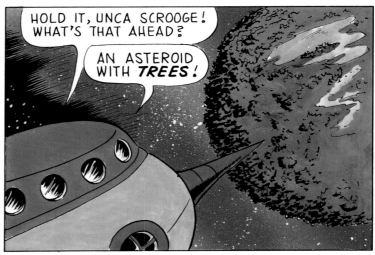

HOLD IT, UNCA SCROOGE! WHAT'S THAT AHEAD?

AN ASTEROID WITH **TREES**!

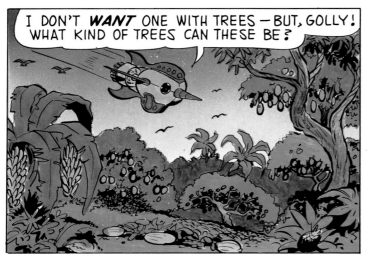

I DON'T **WANT** ONE WITH TREES — BUT, GOLLY! WHAT KIND OF TREES CAN THESE BE?

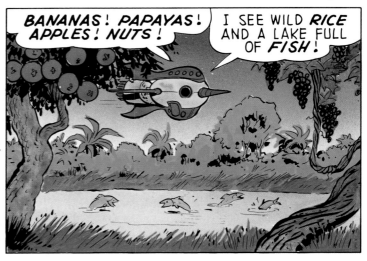

BANANAS! PAPAYAS! APPLES! NUTS!

I SEE WILD **RICE** AND A LAKE FULL OF **FISH**!

BUT I DON'T SEE ANY **PEOPLE**!

WHO **WANTS** TO?

UNCA SCROOGE, IT LOOKS **SAFE**! CAN WE LAND AND FILL UP THE **PANTRY**?

PLEASE! THERE'S LOTS OF ROOM FOR GROCERIES IN HERE NOW!

I DON'T KNOW, BOYS! THERE'S **AIR** AND **GRAVITY** ON THIS ASTEROID, WHICH MEANS WE'D USE A WHALE OF A BLAST OF **FUEL** TO GET BACK IN SPACE AGAIN!

THE "BRAIN" FIGURES YOU CAN LAND **TWICE** AND STILL HAVE ENOUGH FUEL TO GET BACK TO DUCKBURG!

WELL, IN THAT CASE — WE'LL LAND!

BUT FIRST *FEEL* THAT GROUND WITH A LONG STICK, DEWEY! I WANT TO BE SURE IT ISN'T ANOTHER SOFT-SHELL DEAL!

JAB JAB

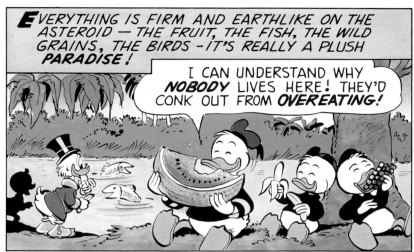

*E*VERYTHING IS FIRM AND EARTHLIKE ON THE ASTEROID — THE FRUIT, THE FISH, THE WILD GRAINS, THE BIRDS — IT'S REALLY A PLUSH *PARADISE*!

I CAN UNDERSTAND WHY *NOBODY* LIVES HERE! THEY'D CONK OUT FROM *OVEREATING*!

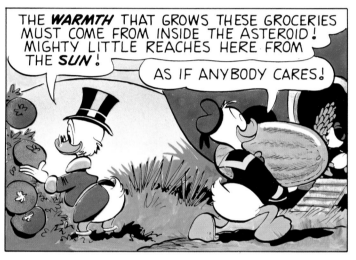

THE *WARMTH* THAT GROWS THESE GROCERIES MUST COME FROM INSIDE THE ASTEROID! MIGHTY LITTLE REACHES HERE FROM THE *SUN*!

AS IF ANYBODY CARES!

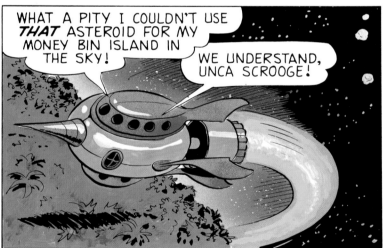

WELL, BOYS, IF WE AND THE ROCKET ARE ALL CRAMMED FULL, WE'LL BLAST OFF!

OKAY, UNCA SCROOGE! IT'S HOME TO DUCKBURG!

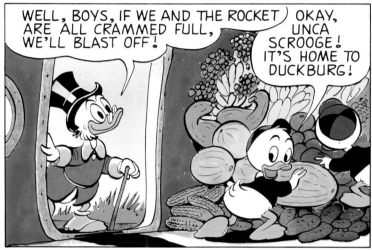

WHAT A PITY I COULDN'T USE *THAT* ASTEROID FOR MY MONEY BIN ISLAND IN THE SKY!

WE UNDERSTAND, UNCA SCROOGE!

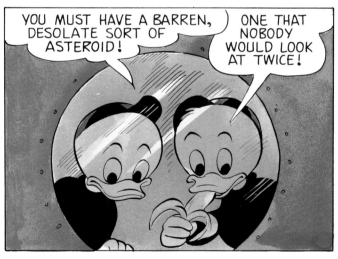

YOU MUST HAVE A BARREN, DESOLATE SORT OF ASTEROID!

ONE THAT NOBODY WOULD LOOK AT TWICE!

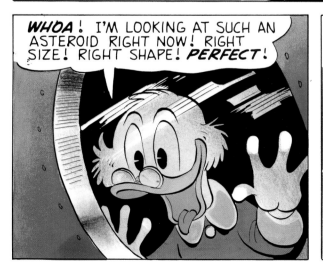

WHOA! I'M LOOKING AT SUCH AN ASTEROID RIGHT NOW! RIGHT SIZE! RIGHT SHAPE! *PERFECT*!

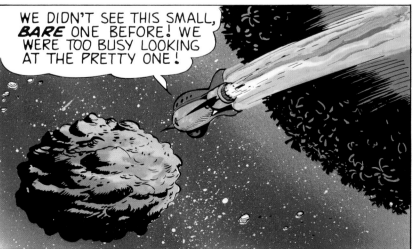

WE DIDN'T SEE THIS SMALL, *BARE* ONE BEFORE! WE WERE TOO BUSY LOOKING AT THE PRETTY ONE!

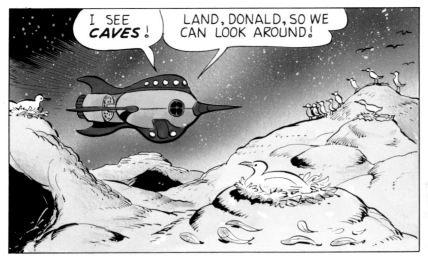

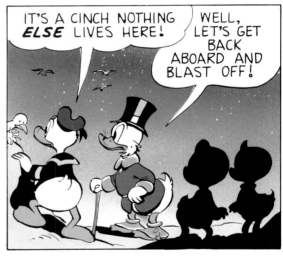

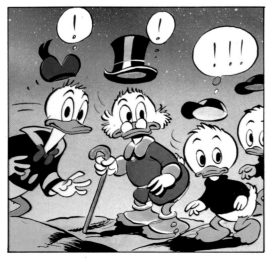

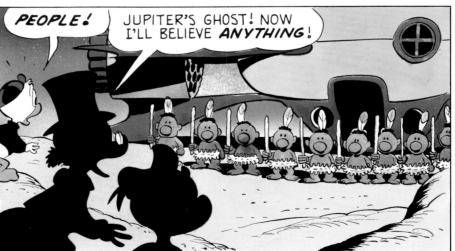

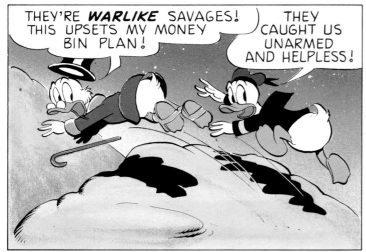

THEY'RE **WARLIKE** SAVAGES! THIS UPSETS MY MONEY BIN PLAN!

THEY CAUGHT US UNARMED AND HELPLESS!

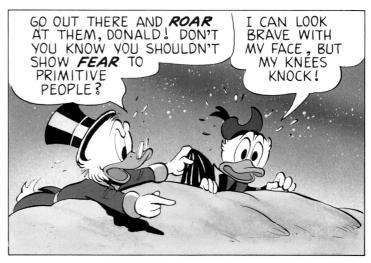

GO OUT THERE AND **ROAR** AT THEM, DONALD! DON'T YOU KNOW YOU SHOULDN'T SHOW **FEAR** TO PRIMITIVE PEOPLE?

I CAN LOOK BRAVE WITH MY FACE, BUT MY KNEES KNOCK!

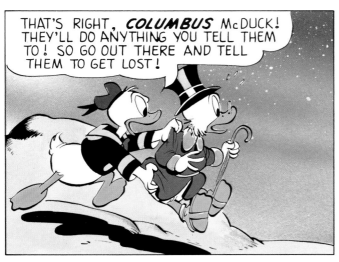

HOW!

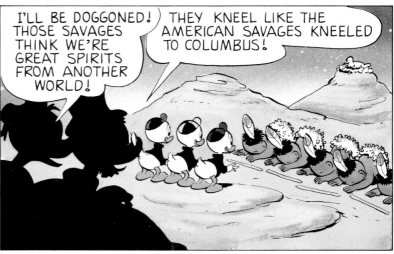

I'LL BE DOGGONED! THOSE SAVAGES THINK WE'RE GREAT SPIRITS FROM ANOTHER WORLD!

THEY KNEEL LIKE THE AMERICAN SAVAGES KNEELED TO COLUMBUS!

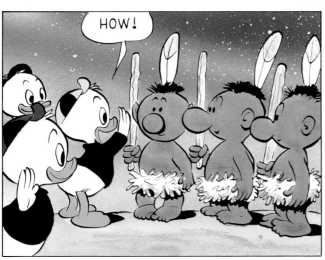

THAT'S RIGHT, **COLUMBUS** McDUCK! THEY'LL DO ANYTHING YOU TELL THEM TO! SO GO OUT THERE AND TELL THEM TO GET LOST!

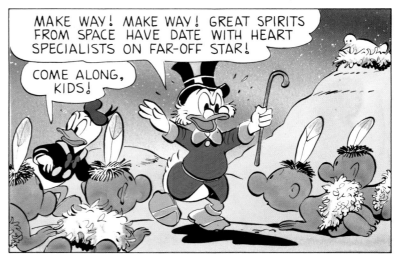

MAKE WAY! MAKE WAY! GREAT SPIRITS FROM SPACE HAVE DATE WITH HEART SPECIALISTS ON FAR-OFF STAR!

COME ALONG, KIDS!

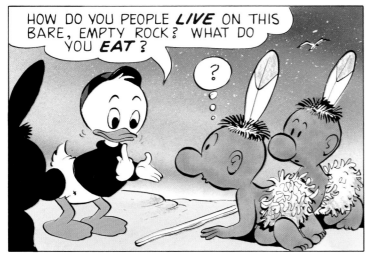

HOW DO YOU PEOPLE **LIVE** ON THIS BARE, EMPTY ROCK? WHAT DO YOU **EAT**?

?

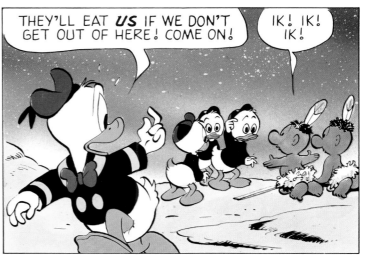

THEY'LL EAT **US** IF WE DON'T GET OUT OF HERE! COME ON!

IK! IK! IK!

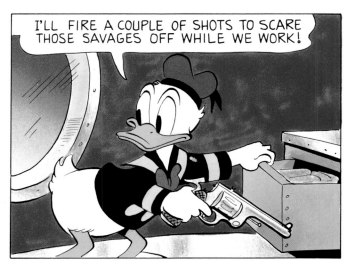

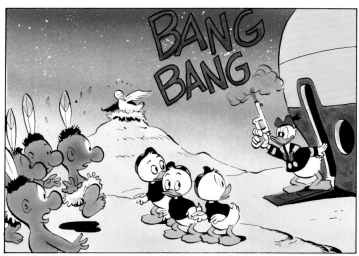

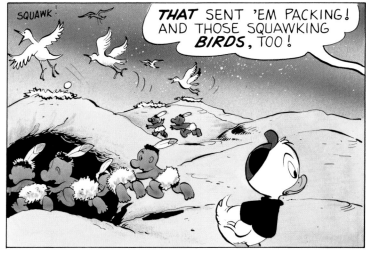

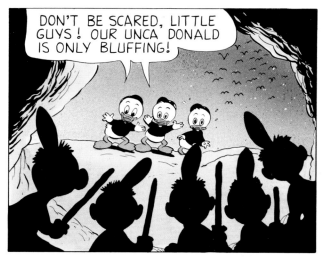

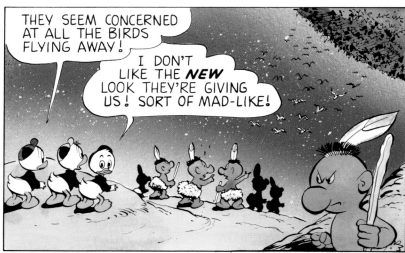

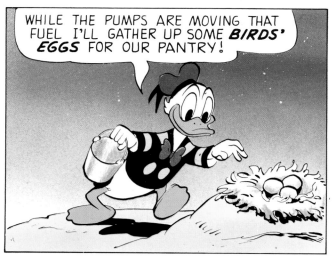

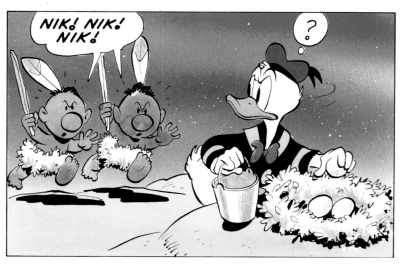

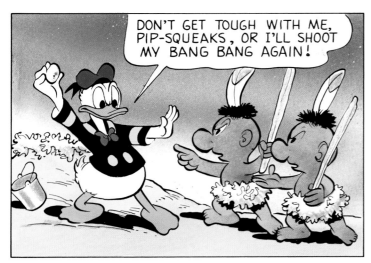

THEY'RE COMING FOR *ME* NOW!

BANG BANG BANG

THEY'RE NOT *SCARED* ANYMORE! THEY'VE GOTTEN *MAD* ABOUT SOMETHING!

SLAM

YIK, YIK NOK WIK WAK WU ZIK ZOK!

WHAT ARE THESE ASTEROID APACHES JABBERING ABOUT?

SEE IF WE CAN *TRANSLATE* IT WITH OUR JUNIOR WOODCHUCKS' GUIDE BOOK!

KEY TO FOREIGN LINGOES - CHAPTER 3, PAGE 78!

YIK, NOK, WIK— THEY'RE TALKING ABOUT *FOOD*!

I KNEW IT! I KNEW IT —*US*!

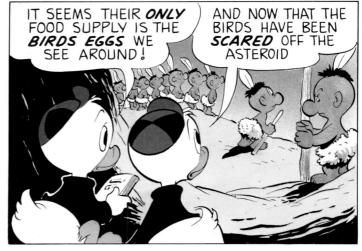

IT SEEMS THEIR *ONLY* FOOD SUPPLY IS THE *BIRDS EGGS* WE SEE AROUND!

AND NOW THAT THE BIRDS HAVE BEEN *SCARED* OFF THE ASTEROID

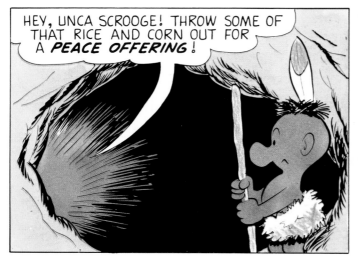

HEY, UNCA SCROOGE! THROW SOME OF THAT RICE AND CORN OUT FOR A *PEACE OFFERING*!

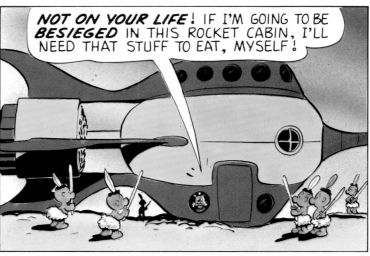

NOT ON YOUR LIFE! IF I'M GOING TO BE *BESIEGED* IN THIS ROCKET CABIN, I'LL NEED THAT STUFF TO EAT, MYSELF!

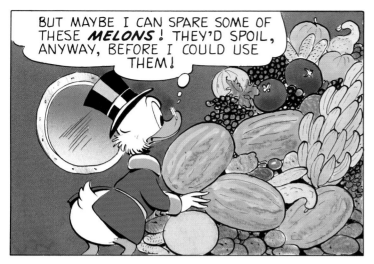

BUT MAYBE I CAN SPARE SOME OF THESE **MELONS**! THEY'D SPOIL, ANYWAY, BEFORE I COULD USE THEM!

I'LL LET THE CHIEF MOHAWK HAVE THIS BIG WATERMELON!

RIGHT IN THE BREADBASKET!

IK, IK! WIK, YIK! YAHOO!

THE NATIVES ARE SCRAMBLING FOR THE BROKEN PIECES OF MELON!

OUR GUARDS ARE SCRAMBLING, TOO!

THE COAST IS CLEAR! LET'S SCRAM!

LOOK AT 'EM EAT! I HAVEN'T SEEN SUCH TABLE MANNERS SINCE GUS GOOSE'S LAST FAMILY PICNIC!

POOR, **HUNGRY**, LITTLE SIWASHES!

YUM! YUM! SMACK! CHOMP!

GET ABOARD QUICK, BOYS, AND WE'LL BLAST OFF!

NO, WE **WON'T**! WE'RE NOT BLASTING OFF UNTIL WE'VE GIVEN EVERY **BITE** OF THIS FOOD TO THESE PANTRYLESS PEOPLE!

NOW, WAIT A MINUTE! DOGGONE IT! WHAT ARE **WE** GOING TO EAT ON OUR WAY HOME?

SPACE BISCUITS AND WATER, LIKE WE ATE COMING OUT!

THESE PEOPLE HAVE BUT A ONE-DAY SUPPLY OF FOOD SINCE UNCA DONALD SCARED THEIR EGG-LAYING BIRDS AWAY!

WE *HAVE TO* GIVE THEM THESE GROCERIES!

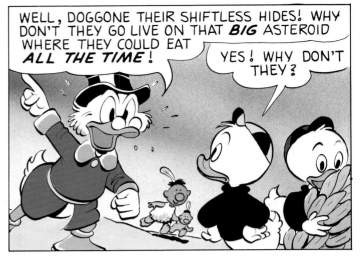

WELL, DOGGONE THEIR SHIFTLESS HIDES! WHY DON'T THEY GO LIVE ON THAT *BIG* ASTEROID WHERE THEY COULD EAT *ALL THE TIME*!

YES! WHY DON'T THEY?

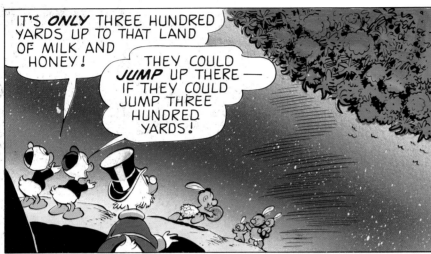

IT'S *ONLY* THREE HUNDRED YARDS UP TO THAT LAND OF MILK AND HONEY!

THEY COULD *JUMP* UP THERE— IF THEY COULD JUMP THREE HUNDRED YARDS!

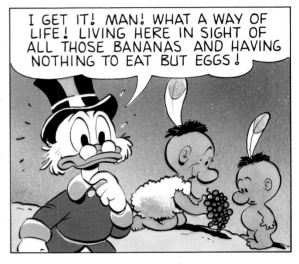

I GET IT! MAN! WHAT A WAY OF LIFE! LIVING HERE IN SIGHT OF ALL THOSE BANANAS AND HAVING NOTHING TO EAT BUT EGGS!

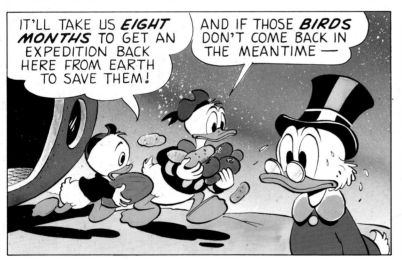

IT'LL TAKE US *EIGHT MONTHS* TO GET AN EXPEDITION BACK HERE FROM EARTH TO SAVE THEM!

AND IF THOSE *BIRDS* DON'T COME BACK IN THE MEANTIME—

THE BIRDS WILL *HAVE TO* COME BACK! THERE'S NO WAY WE CAN *FERRY* THE PEOPLE TO THE OTHER ASTEROID! WE HAVE ONLY ENOUGH FUEL TO BLAST OFF *ONCE*!

DONALD! YOU AND THE BOYS GET INTO LAUNCHING HARNESS! I'M GOING TO REFIGURE OUR FUEL PROBLEM ONCE MORE ON THE ELECTRONIC BRAIN!

WE'VE ALREADY FIGURED IT, UNCA SCROOGE!

THERE ARE NO *TWO* WAYS ABOUT IT! WE HAVE TO *ABANDON* THESE LITTLE APACHES TO THEIR ROTTEN LUCK!

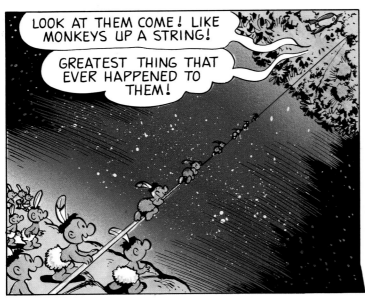

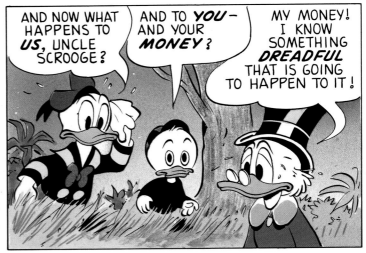

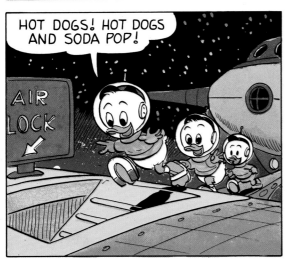

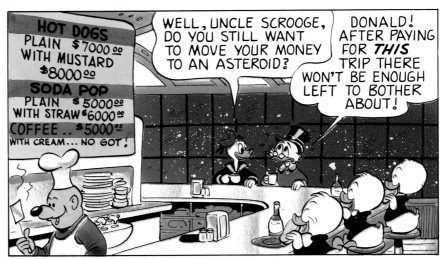

❝One of the greatest difficulties in handling characters is in figuring out how each character is going to react to a certain situation. In that respect, Uncle Scrooge is fairly easy to keep in line. He will always choose the cheapest way to meet an emergency.❞

"Island in the Sky" was published in 1960, so I must have done it in the fall of 1959. I went back to the Buck Rogers style of spaceships because I thought they looked more picturesque. They had a cartoony quality about them that the regular rockets of today don't have. Of course, in 1959 we didn't have very much in the way of rockets. They were just cigar-shaped things, and they didn't seem to have any potential for glamour as they were flying through the sky. The Buck Rogers type, however, reminded me of old cars: They had a classic look about them like the old Mercers, Stutzes, and Kissel cars. Oh, they were beautiful things! Of course, that's a generation long ago, and practically nobody remembers them but old-timers like me.

The story shows what earth people will do one day when they get into outer space and meet up with people who live in other worlds. I'm afraid that the earth people will make a mighty bad impression on whoever they meet. Certainly Uncle Scrooge and Donald carried their earth ways up there

to this little planet. They had their fears and greeds, and they imposed them on these poor little people who lived on this barren island in the asteroids—very much like regular earth people would if they got there. It also gave me a chance to have Uncle Scrooge finally relent and do something good to repay the damage he and his nephews had done. The way he rewarded those little Indian fellows was nice. It was a situation that is very much duplicated in real life, where the people who have nothing are always in sight of plenty but are unable to reach it. That is one of the things that causes many of our social problems: The people who have nothing have such a difficult time getting anything. It can all be passing by in big Cadillacs in front of them, but they can't have any of it because of some barrier between them and it. In that respect, this story's got a little sociological inference, but it's purely a physical problem. The little guys were there in sight of this beautiful planet full of food, and they were starving. The fact that Uncle Scrooge was able to bridge the gap for them with

nothing more complicated than a rope made a nice little touch for the story.

The first idea I had for the story was that Scrooge was going to outer space to find an asteroid where he could hide his money. And, of course, I had to think up something interesting he could find on those asteroids. So I just kept turning over ideas one after another, and I came up with this business of there being two asteroids: One

BORN
500
YEARS
TOO
SOON

As a break from gag writing, the storymen in the Disney Duck Unit often did caricatures of each other. Carl Barks had a reputation for concocting inventions as seen in the top drawing by Ken Hultgren from about 1940. The bottom sketch is by Nick George.

is bare, the other is all covered with vegetables. People live on the bare one and starve. Everything grows lush on the other one. It added an element to the story that made the plot worthwhile.

I managed to get a little humor into this by having old Scrooge's stinginess cause the ducks to practically starve to death on the way there to the asteroids because he was hauling rocket fuel so he wouldn't have to buy it at Space Wheel 5. Then when he finally had to buy it on the way back, it was out of his own goodness of heart that he had gotten himself into the situation. I could just visualize old Uncle Scrooge hurting inside as he looked at the prices!

Sometimes I look back at my stories and it feels like looking at the work of a total stranger. I think, "Good God, I could never have thought of those gags! I never had them in me!" That information that comes to a writer must come out of a bunch of computers he's got in his head that he doesn't even know about. They all get to meshing their gears, and pretty soon he comes up with an idea, something entirely strange to his own nature. Sometimes I think the head is full of a whole bunch of little wheels, like little movie reels. The best thoughts you've stored away, experiences you've had, things you've read about, are memory scenes buzzing around with little flashes passing through your mind. At any moment, some of them get going in conjuncton with others, and pretty soon a whole new gag has formed, something you wouldn't have ever come up with if you hadn't had that help from the subconscious buzzing in the wheels up there.

THE MANY FACES OF MAGICA DE SPELL

The Many Faces of Magica De Spell
Uncle Scrooge #48 March 1964

The tricky world of villainy is peopled with many sorts of rapscallions: burglars, bamboozlers, sneak thieves, legal loophole law-twisters, dynamiters, and organized gangs like the terrible Beagle Boys. But topping all of these types in sheer cussedness are witches.

One dreadful day in 1961 the slithery, slinky Magica De Spell entered Uncle Scrooge's office and announced that she was a sorceress. Uncle Scrooge thought that was very funny, and he laughed and laughed.

He hasn't laughed since; he has been too busy saving his fortune and his deified old Number-One Dime from the supernatural clutches of that sure-enough, honest-to-god, unspurious, professional hex-throwing sorceress. In 1964 he barely saved his face in the fantastic battle chronicled here. Be warned before reading this; it shows witchcraft at its perfidious, spell-casting worst. *C.B. 1981*

Walt Disney **UNCLE SCROOGE**

THE MANY FACES OF MAGICA DE SPELL

DUCKBURG IS SHAKEN BY A MIGHTY EARTHQUAKE!

MAN! THE TOWN IS ROCKING LIKE A TIN CANOE! WON'T THIS SHAKING *DAMAGE* YOUR MONEY BIN, UNCLE SCROOGE?

NOT A BIT, NEPHEW!

LIGHTNING STRIKES WITH THE POWER OF A BILLION AXES!

DOESN'T THIS *LIGHTNING* WORRY YOU, UNCLE SCROOGE?

IT CAN'T HURT A THING, DONALD!

CRASHHH

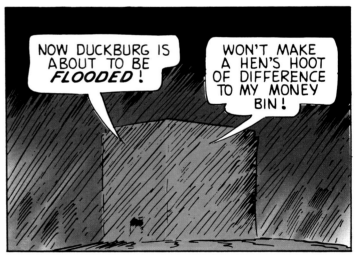

NOW DUCKBURG IS ABOUT TO BE *FLOODED*!

WON'T MAKE A HEN'S HOOT OF DIFFERENCE TO MY MONEY BIN!

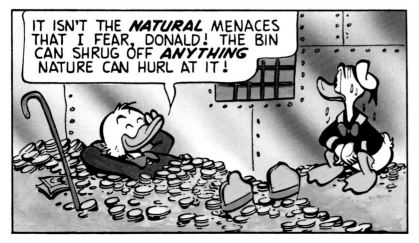

IT ISN'T THE *NATURAL* MENACES THAT I FEAR, DONALD! THE BIN CAN SHRUG OFF *ANYTHING* NATURE CAN HURL AT IT!

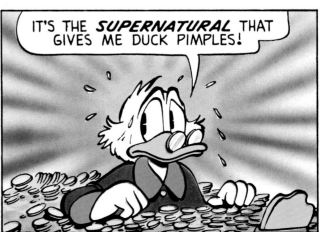

IT'S THE *SUPERNATURAL* THAT GIVES ME DUCK PIMPLES!

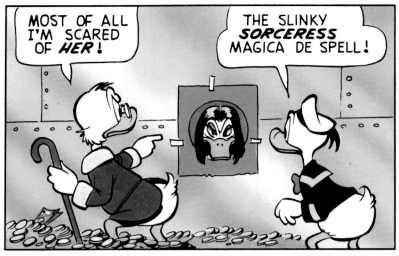

MOST OF ALL I'M SCARED OF *HER*!

THE SLINKY *SORCERESS* MAGICA DE SPELL!

I AGREE, UNCLE SCROOGE! WHEN IT COMES TO TOSSING AROUND SUPERNATURAL POWERS, THAT GAL OUT-TOSSES EVERYBODY! (SHUDDER!)

SHE CAN USE HER POWERS OF *TRICKERY* TO GET *INSIDE* THESE MIGHTY WALLS!

SHE'S DONE IT BEFORE, BUT YOU'VE ALWAYS MANAGED TO KEEP HER FROM TAKING ANYTHING!

THAT'S BECAUSE I WAS *LUCKY*, NEPHEW! SHE STILL HAS HOPES, THOUGH, OF GETTING MY OLD *NUMBER ONE* DIME, HERE!

YOU KNOW WHERE SHE IS?

AT THIS MOMENT? I SURE DO! I HAVE SQUADS OF SLEUTHS WATCHING HER *ALL THE TIME*!

WELL, THEY'LL GIVE YOU WARNING *EARLY* IF SHE STARTS ANOTHER RAID ON YOUR OLD KEEPSAKE!

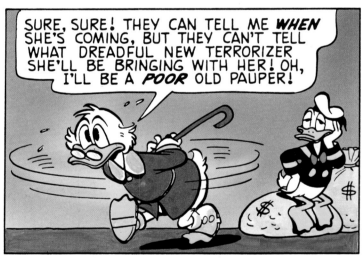

SURE, SURE! THEY CAN TELL ME *WHEN* SHE'S COMING, BUT THEY CAN'T TELL WHAT DREADFUL NEW TERRORIZER SHE'LL BE BRINGING WITH HER! OH, I'LL BE A *POOR* OLD PAUPER!

*U*NCLE SCROOGE HAS GOOD REASON TO WORRY! IN HER SORCERY SHOP ON MT. VESUVIUS, MAGICA DE SPELL IS COOKING UP A GIMMICK THAT WILL MAKE HIS WILDEST NIGHTMARES COME TRUE!

I'LL GET HIS OLD DIME THIS TIME! I'LL GET THAT OLD NUMBER ONE COIN WHICH IS THE SPARK PLUG OF ALL OF McDUCK'S VAST FORTUNE!

HEE, HEE! THEN *YOU'LL* BE THE *RICHEST* DUCK IN THE WORLD, BOSS LADY, AND McDUCK WILL BE THE *POOREST*! HEE, HEE, HEEEE!

WITH THAT OLD DIME TO BRING ME LUCK I'LL BE ABLE TO QUIT THE SORCERY BUSINESS AND LIVE LIKE KING MIDAS' WIDOW!

SEVEN-YEAR PLAGUES

THIS FORMULA I FOUND IN THE CAVE OF CIRCE WILL MAKE OLD McDUCK DANCE TO MY MUSIC!

HEE, HEE! POWDERED DRAGONS' TEETH, FAT FROM A ROYAL FATHEAD, DINGBAT FUZZ, A CROSS-EYED CAT'S WHISKERS!

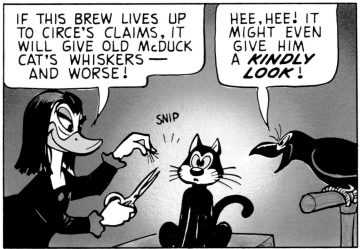

IF THIS BREW LIVES UP TO CIRCE'S CLAIMS, IT WILL GIVE OLD McDUCK CAT'S WHISKERS — AND WORSE!

HEE, HEE! IT MIGHT EVEN GIVE HIM A *KINDLY LOOK*!

SNIP

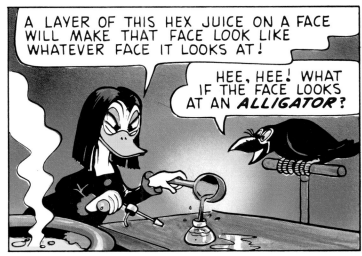

A LAYER OF THIS HEX JUICE ON A FACE WILL MAKE THAT FACE LOOK LIKE WHATEVER FACE IT LOOKS AT!

HEE, HEE! WHAT IF THE FACE LOOKS AT AN *ALLIGATOR*?

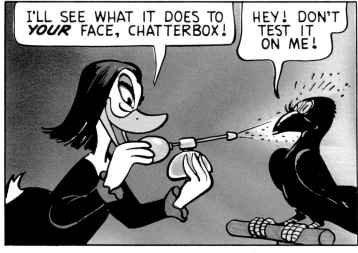

I'LL SEE WHAT IT DOES TO *YOUR* FACE, CHATTERBOX!

HEY! DON'T TEST IT ON ME!

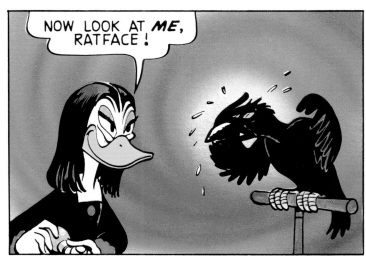

NOW LOOK AT *ME*, RATFACE!

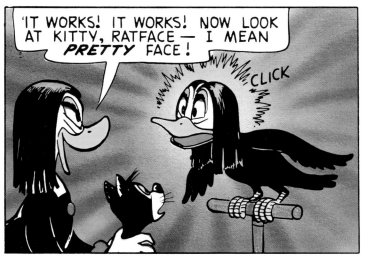

'IT WORKS! IT WORKS! NOW LOOK AT KITTY, RATFACE — I MEAN *PRETTY* FACE!

CLICK

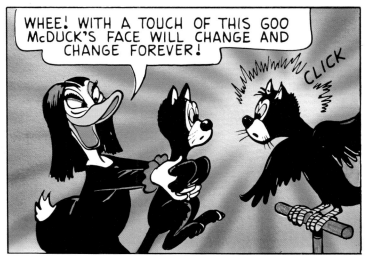

WHEE! WITH A TOUCH OF THIS GOO McDUCK'S FACE WILL CHANGE AND CHANGE FOREVER!

CLICK

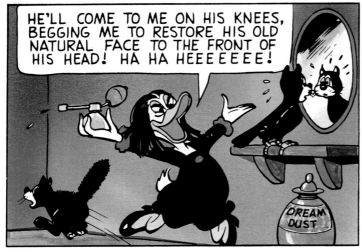

HE'LL COME TO ME ON HIS KNEES, BEGGING ME TO RESTORE HIS OLD NATURAL FACE TO THE FRONT OF HIS HEAD! HA HA HEEEEEEE!

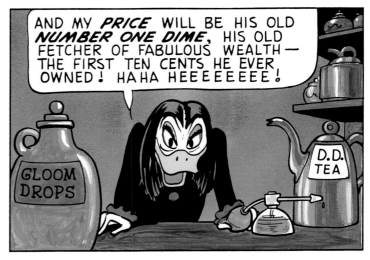

AND MY *PRICE* WILL BE HIS OLD *NUMBER ONE DIME*, HIS OLD FETCHER OF FABULOUS WEALTH — THE FIRST TEN CENTS HE EVER OWNED! HAHA HEEEEEEE!

GLOOM DROPS

DREAM DUST

D.D. TEA

HEY, BOSS LADY! HOW ABOUT RESTORING *MY* FACE TO ITS OLD *RAVENOUS* LOOK?

I — I — ER!

CLICK

THERE DOESN'T SEEM TO BE ANY FORMULA FOR *UNHEXING* THAT HEX JUICE!

(GULP!) THEN, I'M *STUCK* WITH THIS FACE!

I'M AFRAID SO! AND McDUCK WILL BE STUCK WITH *HIS* UNSTABLE FACE, TOO!

OH, WELL! AFTER I GET McDUCK'S OLD NUMBER ONE DIME I WON'T CARE IF HE *EVER* GETS HIS REAL FACE BACK!

SIGH!

OUTSIDE!

FROM ALL THE CACKLING AND SQUEALING INSIDE THERE, I'D SAY MAGICA IS ABOUT TO TAKE OFF ON A SORCERY SAFARI!

BE READY TO RADIO A WARNING!

HEE, HEEEE! WHEE!

DRAT! McDUCK'S *DETECTIVES* ARE WATCHING MY DOOR, AS USUAL! I PREFER TO GET PAST THEM *UNSEEN*!

MY SCHEME DEPENDS SO MUCH ON TAKING McDUCK BY *SURPRISE*! HMMM!

YOUR BODY AND *MY* FACE ARE GOING TO COME IN *USEFUL*, RAVEN, OL' CRAVEN!

McDUCK, McDUCK! MAGICA IS ABOUT TO *LEAVE*!... SHE'S OPENING HER DOOR!... SHE'S *COMING OUT*!

DOES SHE LOOK ANY *DIFFERENT* THAN USUAL, MEN?

$ FAST BUCK

WE'LL SAY! SHE'S TURNED INTO A *WITCH*!

AND SHE'S *FLYING* AWAY WITHOUT A BROOM!

FOLLOW HER! DON'T LET HER GET OUT OF YOUR SIGHT!

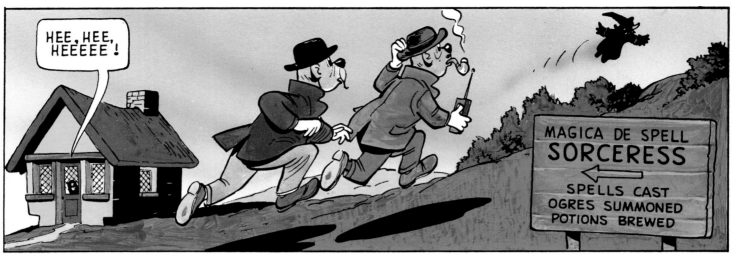

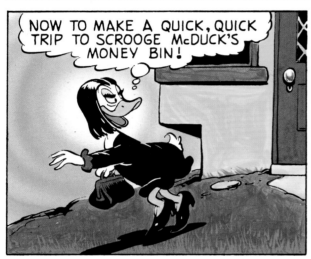

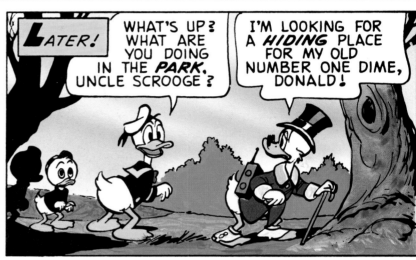

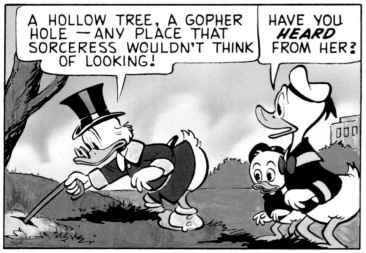

AT THE AIRPORT!

AH! DUCKBURG, AND NOT A DETECTIVE IN SIGHT! I'M GOING TO CATCH OLD McDUCK WITH HIS GUARD DOWN!

CONFOUNDED *DOGS*! THEY ALWAYS BARK AT ME, NO MATTER WHERE I GO!

YOUR *UGLY FACE* ANNOYS ME, BEAST! LET ME CHANGE IT TO SOMETHING *PRETTY*!

BRAAAAAK!

CLICK

THAT WAS A MISTAKE!

HEE, HEE, HEE! CIRCE'S FORMULA IS SUCH AN AMUSING TOY TO PLAY WITH!

NEARBY!

IF MAGICA IS STILL ON MOUNT VESUVIUS, YOU'VE NO REASON TO BE JITTERY, UNCLE SCROOGE!

I KNOW, BUT HER NEW *FLYING* TECHNIQUE BUGS ME!

SHE'S NOW ABLE TO APPEAR ALMOST *ANYWHERE* ANYTIME!

UNCLE SCROOGE, YOU'RE BEING UNREASONABLE!

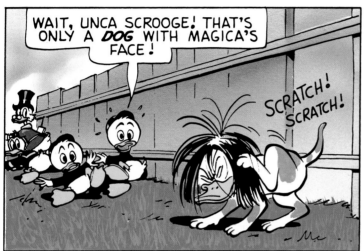

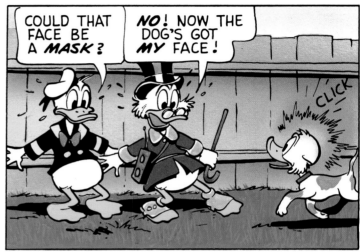

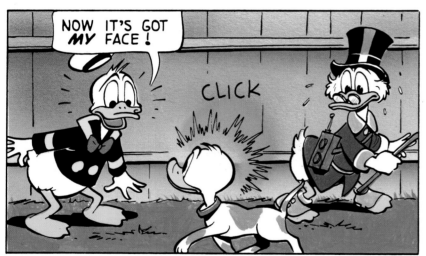

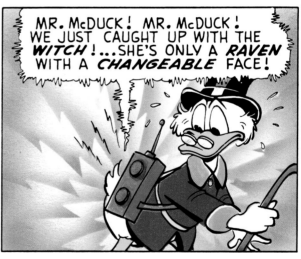

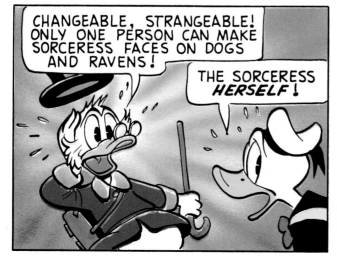

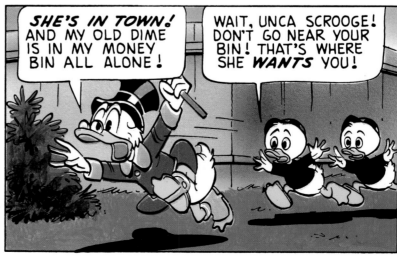

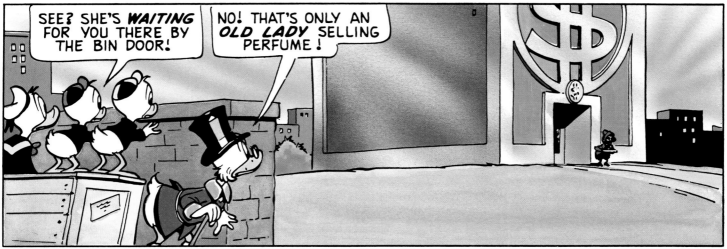

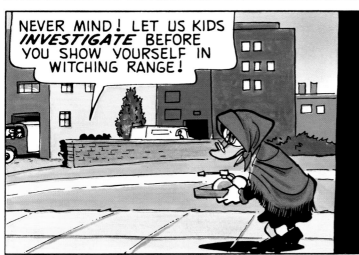

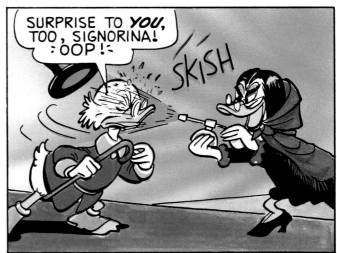

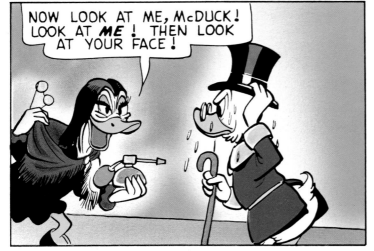

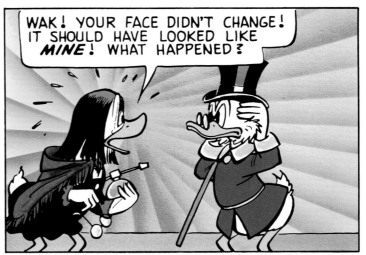

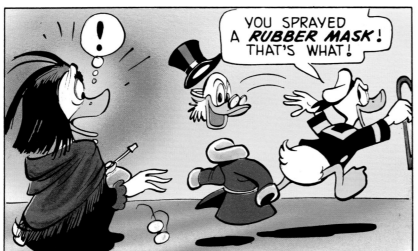

UNCLE SCROOGE PARACHUTES DOWN AT THE AIRPORT!

I TOLD DONALD AND THE KIDS TO MEET ME HERE WITH SUPPLIES FOR A LONG TRIP!

AND SOON!

WHERE ARE WE FLYING TO, UNCA SCROOGE?

I DON'T KNOW MYSELF, LADS!

I'LL JUST PLAY THIS TRIP BY EAR AS WE GO ALONG!

(SSST! SPUT!) I MISSED AGAIN!

OH, WELL! OF THE HUNDRED AND NINETY-SEVEN MILLION *SQUARE MILES* ON THIS EARTH, McDUCK WILL HAVE TO HIDE IN *ONE* OF THEM! I'LL FIND HIM!

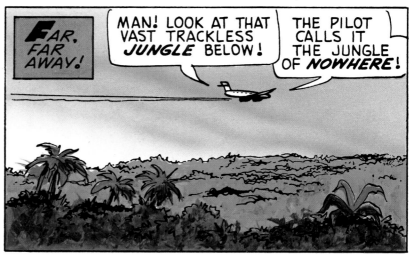

FAR, FAR AWAY!

MAN! LOOK AT THAT VAST TRACKLESS *JUNGLE* BELOW!

THE PILOT CALLS IT THE JUNGLE OF *NOWHERE*!

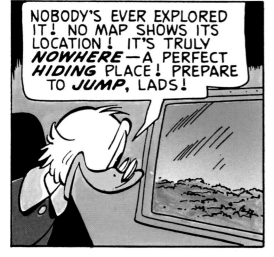

NOBODY'S EVER EXPLORED IT! NO MAP SHOWS ITS LOCATION! IT'S TRULY *NOWHERE*—A PERFECT *HIDING* PLACE! PREPARE TO *JUMP*, LADS!

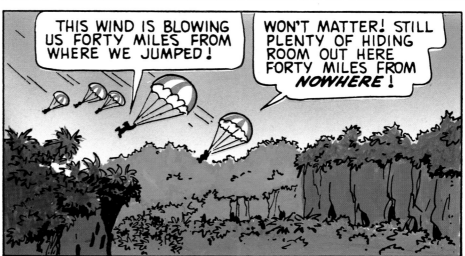

THIS WIND IS BLOWING US FORTY MILES FROM WHERE WE JUMPED!

WON'T MATTER! STILL PLENTY OF HIDING ROOM OUT HERE FORTY MILES FROM *NOWHERE*!

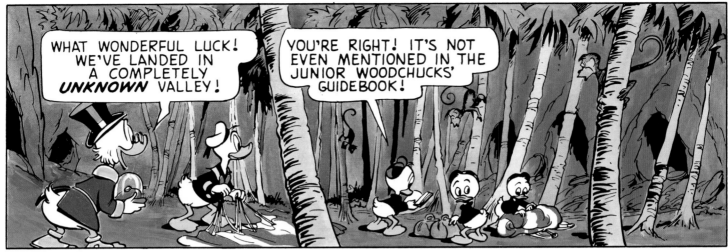

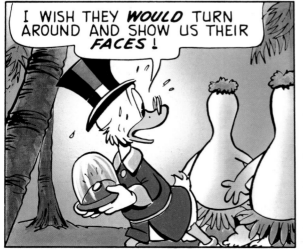

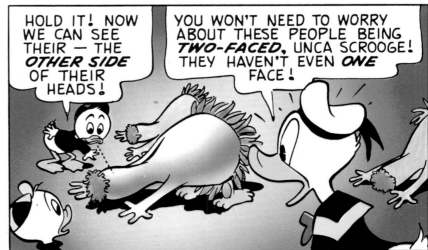

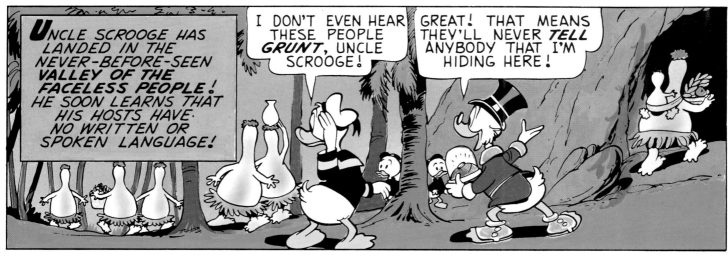

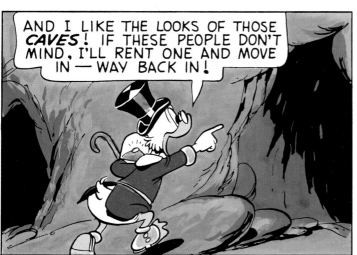

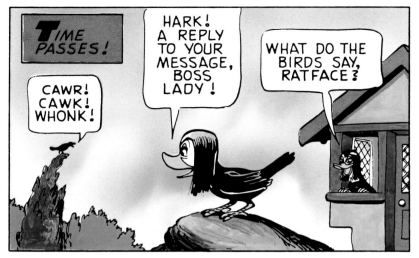

TIME PASSES!

CAWR! CAWK! WHONK!

HARK! A REPLY TO YOUR MESSAGE, BOSS LADY!

WHAT DO THE BIRDS SAY, RATFACE?

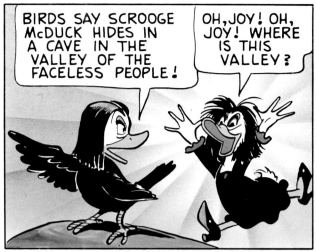

BIRDS SAY SCROOGE McDUCK HIDES IN A CAVE IN THE VALLEY OF THE FACELESS PEOPLE!

OH, JOY! OH, JOY! WHERE IS THIS VALLEY?

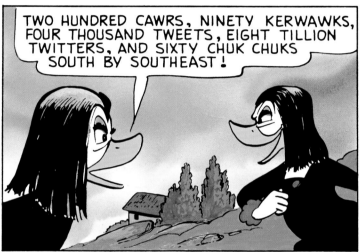

TWO HUNDRED CAWRS, NINETY KERWAWKS, FOUR THOUSAND TWEETS, EIGHT TILLION TWITTERS, AND SIXTY CHUK CHUKS SOUTH BY SOUTHEAST!

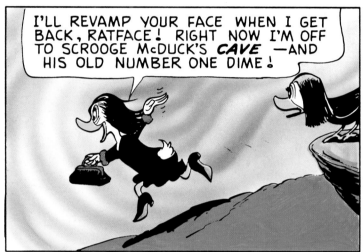

I'LL REVAMP YOUR FACE WHEN I GET BACK, RATFACE! RIGHT NOW I'M OFF TO SCROOGE McDUCK'S *CAVE* —AND HIS OLD NUMBER ONE DIME!

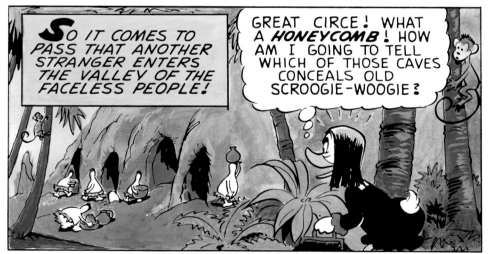

So IT COMES TO PASS THAT ANOTHER STRANGER ENTERS THE VALLEY OF THE FACELESS PEOPLE!

GREAT CIRCE! WHAT A *HONEYCOMB*! HOW AM I GOING TO TELL WHICH OF THOSE CAVES CONCEALS OLD SCROOGIE-WOOGIE?

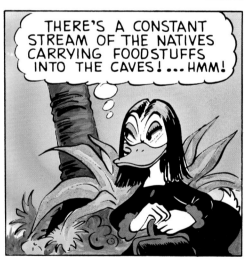

THERE'S A CONSTANT STREAM OF THE NATIVES CARRYING FOODSTUFFS INTO THE CAVES! ...HMM!

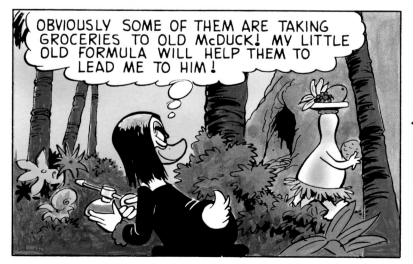

OBVIOUSLY SOME OF THEM ARE TAKING GROCERIES TO OLD McDUCK! MY LITTLE OLD FORMULA WILL HELP THEM TO LEAD ME TO HIM!

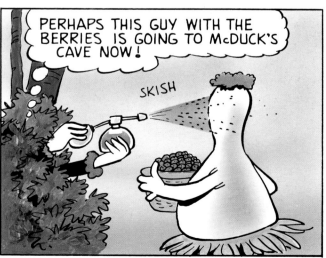

PERHAPS THIS GUY WITH THE BERRIES IS GOING TO McDUCK'S CAVE NOW!

SKISH

HEE, HEE! IF THAT GUY COMES FACE TO FACE WITH OLD SCROOGE, HE'LL GET A McDUCK FACE!

AND ALL I HAVE TO DO IS NOTE WHICH CAVE HE LEAVES!

SOON

YUM YUM! THESE NATIVES SURE KEEP ME EATING WELL!

CLICK

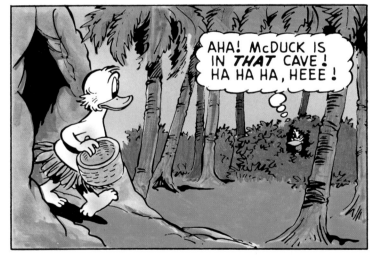

AHA! McDUCK IS IN *THAT* CAVE! HA HA HA, HEEE!

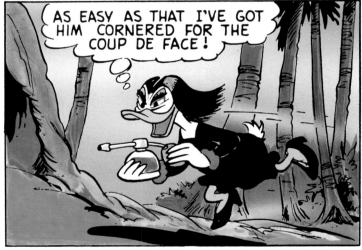

AS EASY AS THAT I'VE GOT HIM CORNERED FOR THE COUP DE FACE!

HAVE SOME BERRIES, DONALD!.... WHAT ARE YOU STARING AT?

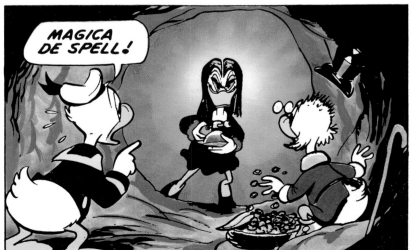

MAGICA DE SPELL!

NOW WE'LL START TALKING, McDUCK, ABOUT A *TRADE* YOU'LL BE MOST ANXIOUS TO MAKE!

I WOULDN'T DARE TALK RIGHT NOW, LADY!

THERE AREN'T WORDS *HOT* ENOUGH TO SAY WHAT I'M THINKING!

*O*UTSIDE!

HEY, LOOK! THERE'S *UNCA SCROOGE* WALKING AROUND TAKING THE SUN!

NO! NO! NOT WITH *THAT* FIGURE!

A NO-FACER COULDN'T GET UNCA SCROOGE'S FACE *UNLESS* ——!

YEAH, *UNLESS*!

GET THIS GUY UNDERCOVER AND *BLINDFOLDED* BEFORE HE SEES ANY OTHER FACES! WE'RE GOING TO *NEED* HIM!

KIDS! KIDS! THE *SORCERESS* HAS *FOUND* UNCLE SCROOGE!

SO WE GUESSED, UNCA DONALD! FOLLOW US! WE'RE PLANNING TO THROW A SWITCH ON THAT WITCH!

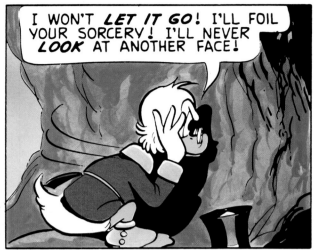

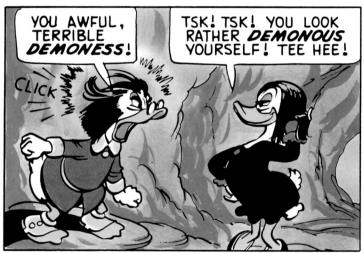

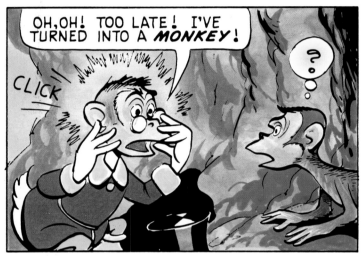

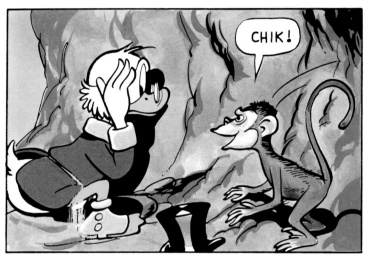

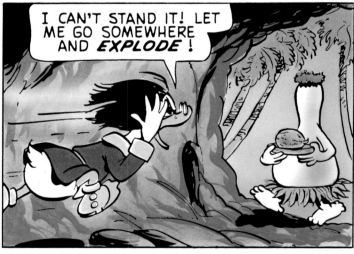

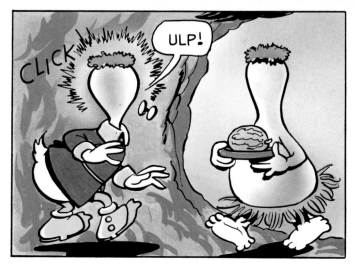

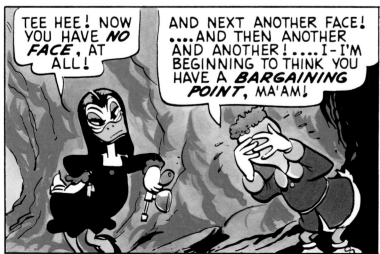

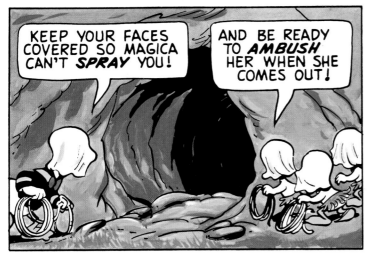

KEEP YOUR FACES COVERED SO MAGICA CAN'T *SPRAY* YOU!

AND BE READY TO *AMBUSH* HER WHEN SHE COMES OUT!

NOW IT'S AGREED THAT IF I GIVE YOU MY OLD DIME, YOU'LL *REMOVE* THIS CURSE FROM MY FACE?

OH, YES! YES, *INDEED*, McDUCK! TEE, HEE!

OKAY! LET ME HAVE MY OLD FACE BACK!

HA HA, HEEEE! *SOMETIME*, McDUCK! ... SOMETIME!

CLICK

RIGHT NOW I DON'T EVEN KNOW IF THERE *IS* A WAY TO RESTORE YOUR FACE! *GOODBYE*!

MY GIRLISH INSTINCT TELLS ME I MIGHT BE *AMBUSHED* OUTSIDE THAT DOORWAY!

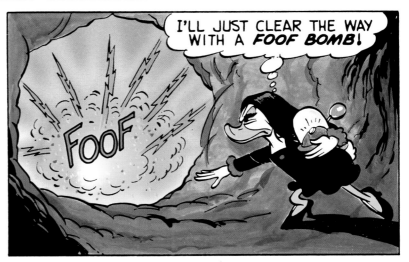

I'LL JUST CLEAR THE WAY WITH A *FOOF* BOMB!

FOOF

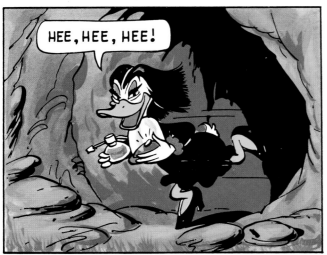

HEE, HEE, HEE!

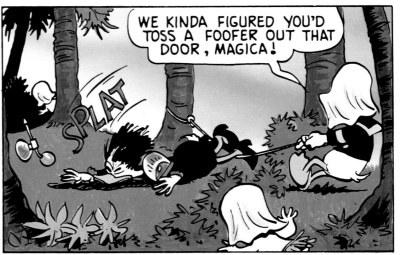

WE KINDA FIGURED YOU'D TOSS A FOOFER OUT THAT DOOR, MAGICA!

SPLAT

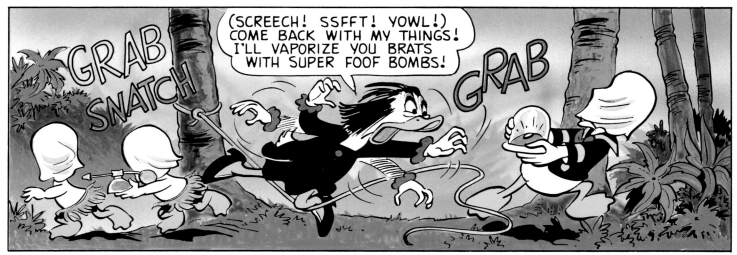

CLICK

NOW YOU'RE *SCROOGE McDUCK* AGAIN!

IT JUST TOOK US *FAST-THINKING FIXERS* TO DO *THAT* RESTORING JOB!

WE'RE *TOPS*, MEN!

LOOK AT ME, DONALD! IS MY FACE THE SAME AS IT USED TO BE?

YES, YES! BUT BE *CAREFUL*!

CLICK

I WAS GOING TO REMIND YOU TO NEVER *LOOK AT ANYBODY*! WELL, NEVER MIND!

THE DUCKS ARE STUMPED!

NOW WE'RE RIGHT BACK WHERE WE STARTED!

MY FACE! MY FACE!...I'LL NEVER SEE LOVABLE, OLD, WHISKERY *ME* AGAIN!

IF IT'S ANY CONSOLATION, UNCLE SCROOGE, MAGICA IS NO BETTER OFF THAN YOU ARE!

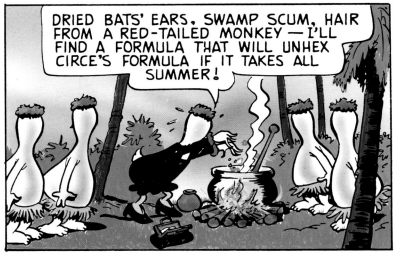

DRIED BATS' EARS, SWAMP SCUM, HAIR FROM A RED-TAILED MONKEY — I'LL FIND A FORMULA THAT WILL UNHEX CIRCE'S FORMULA IF IT TAKES ALL SUMMER!

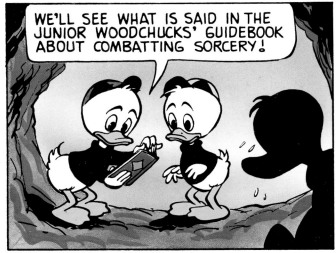

WE'LL SEE WHAT IS SAID IN THE JUNIOR WOODCHUCKS' GUIDEBOOK ABOUT COMBATTING SORCERY!

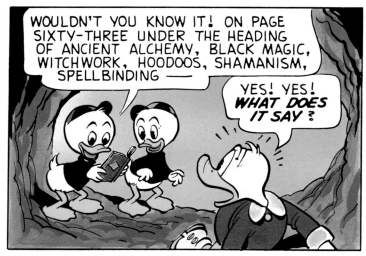

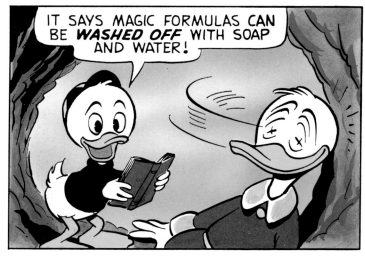

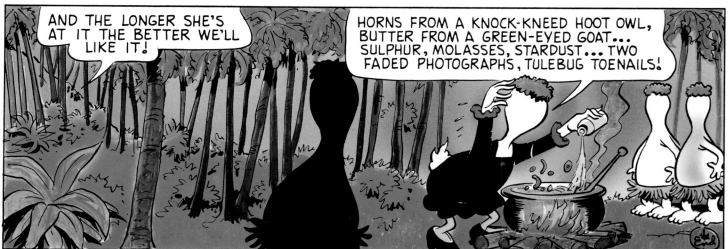

❝I have no cartoonists in my ancestral tree whatsoever, no artists that I know of, no writers that I know of. I was just sort of a mutant that came along.❞

"Magica De Spell" is outright fantasy: old-time sorcery jazzed up with a little bit of humor. She was another menace that I developed because I couldn't be using the Beagle Boys all the time. Disney had witches in just about every movie they made, at least it seemed that way to me. So I thought, why not invent a witch? If I made her look kind of glamorous, with long sleek black hair and slanty eyes, instead of one of those fat, hook-nosed old witches, she could be an attractive witch. Magica herself was modeled on the dark-haired witch from the Charles Addams family cartoons in *The New Yorker*, which I liked very much. And that seemed to pay off all right in Italy because they just went nuts over her: Over there she was one of the most popular characters. In fact, she lived on Mount Vesuvius.

When she first came to see Scrooge, she had a gimmick she was working on. She was trying to get a dime from each of the rich men in the world. She thought if she got a coin from each one and melted them all into one amulet, that would make her just as rich and lucky as these millionaires. When she came to ask Uncle Scrooge for a dime, old Scrooge had a bunch of dimes out on the top of his desk, and one of them was the old number-one dime—

the first dime Scrooge had ever made. So when Magica asked him for a dime—because she thought it would be nice to have "something" he had touched so many times that she could use for making an amulet—Scrooge thought it was kind of amusing. He said "Well, sure" and gave her a dime, but the one he gave her was the old number-one dime. So Magica had no more than gotten out of the door when he discovered that he'd given her the wrong dime. All hell broke loose. Aided by the kids, Uncle Scrooge took off after her. They caught up with her just as she was about to get on the plane to go back to Vesuvius. Scrooge asked to have the dime back and offered to give her another dime for it. Magica said, "Why do you want *that* dime back?" And Scrooge said, "That was the first dime I ever owned," and she said, "Oh, it was? The first dime you ever owned? Then you must have touched it many, many times. It would be much more powerful than any other dime that you might have had." She determined that she was going to keep it. And that led to a lot of trickery and sorcery by which she escaped to Vesuvius with the old number-one dime. Uncle Scrooge and the ducks had to follow her all the way to the volcano—where she was going to melt it—in

A group of sketches of Magica-de Spell done by Barks for his own reference in about 1963. Since, at that time, none of his fellow artists were using Magica in their stories, Barks never did a formal model sheet.

order to save the dime.

And from then on Magica has been after that number-one dime. That's the one object she wants more than anything else. She knows that if she took a barrel of Scrooge's money, why, in a little while it would be gone, but if she had that old number-one dime and made it into this very lucky amulet, she would have many barrels of her own money and would be the most powerful person in the world. She'd also be the richest. She could even give up sorcery, which is a dangerous occupation. That is why she keeps trying time and again.

This story features just another of her many gimmicks for trying to get that dime. It's a story that uses a lot of her sorcery and her props, like her black raven and the fact that in the end she's gotten into the land of these faceless creatures, and she's become faceless herself as a result of the kids' smartness. She can't think of anything simple for removing her magical gook from her face. She tries all kinds of potions she's put together, and the kids meanwhile have looked in their *Junior Woodchuck Guide Book* and found that soap and water would take it off. It shows that sorcery is a superficial kind of thing in that respect.

I don't actually know how I got the idea of the formula that would transfer faces. Those kind of things just pop into my head. Like thinking up crazy names, they just come falling out of the sky.

MICRO-DUCKS FROM OUTER SPACE

Micro-Ducks from Outer Space
Uncle Scrooge #65 September 1966

The author of this story offers no apologies for its "flying saucer" theme. He believes its bizarre sequence of happenings is within the realm of possibility. Certainly UFOs have been seen by human eyes, and there is evidence that their crews are able to juggle molecular structures, else how come our radar beams go right through them?

Too often people think of UFO visitors as being menacing monsters. Might it not be just as logical that the visitors view us as the menacing monsters? Must their spaceships be huge, glowing leviathans? Can't their crews be vegetarians rather than voracious people-eaters?

This story attempts to meet such questions head on. We hope you will like Captain Micron and Princess Teentsy Teen. They show that they kind of like us. *C.B. 1981*

Walt Disney UNCLE SCROOGE
MICRO-DUCKS FROM OUTER SPACE

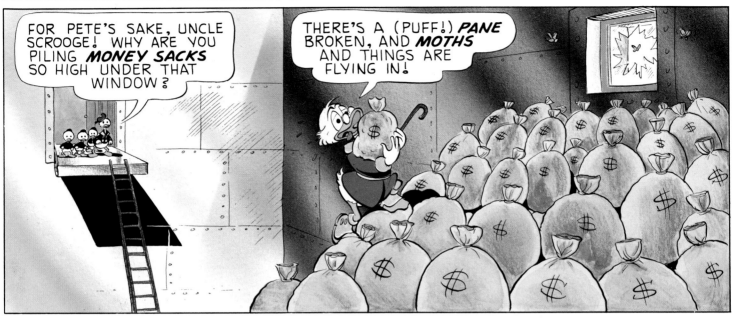

FOR PETE'S SAKE, UNCLE SCROOGE! WHY ARE YOU PILING *MONEY SACKS* SO HIGH UNDER THAT WINDOW?

THERE'S A (PUFF!) *PANE* BROKEN, AND *MOTHS* AND THINGS ARE FLYING IN!

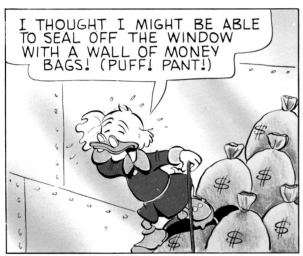

I THOUGHT I MIGHT BE ABLE TO SEAL OFF THE WINDOW WITH A WALL OF MONEY BAGS! (PUFF! PANT!)

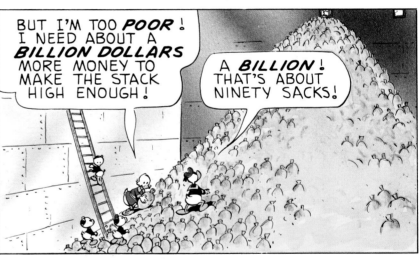

BUT I'M TOO *POOR*! I NEED ABOUT A *BILLION DOLLARS* MORE MONEY TO MAKE THE STACK HIGH ENOUGH!

A *BILLION*! THAT'S ABOUT NINETY SACKS!

SEEMS TO US A NEW PANE OF GLASS WOULD COST ABOUT A DOLLAR, AND WOULD SEAL THE HOLE MORE SENSIBLY!

IT'D SEAL THE HOLE ALL RIGHT, LADS, BUT THEN I'D BE A DOLLAR *POORER*!

WHEREAS, DOING IT MY WAY, I'D NOT ONLY SEAL THE HOLE, BUT BE A BILLION DOLLARS *RICHER*!

WELL, WE CAN'T THINK OF ANY *FAST* WAYS YOU CAN MAKE A BILLION DOLLARS, UNCA SCROOGE!

OR ANY SLOW WAYS, EITHER!

I GUESS I'LL JUST HAVE TO SWAT MOTHS AS BEST I CAN UNTIL SOMETHING LUCRATIVE TURNS UP!

*A*T THAT MOMENT!

MAKE A *BILLION DOLLARS*! READ ALL ABOUT IT IN THE MORNING NEWS!

KEEP OUT

McDUCK MONEY BIN. GO AWAY

PAPER! PAPER!

ZOW

IT'S FOR *REAL*!

SKEPTICS CLUB OFFERS VAST PRIZE TO ANYONE WHO CAN PRODUCE A *LIVE FLYING SAUCER*!

BAH! THAT OFFER HAS MORE STRINGS ATTACHED THAN A STARVING SPIDER!

SEEMS TO ME *YOU* WERE MIGHTY SLOW GETTIN' OUT HERE TO BUY A PAPER, UNCLE SCROOGE!

HASTE MAKES WASTE, DONALD! I KNEW I COULD BORROW *YOURS*!

SAUCER MUST BE FROM *ANOTHER WORLD* AND MUST BE PRODUCED AT THE SKEPTICS BANQUET TONIGHT!.... *TONIGHT*! GET THAT!

AND GET THIS — THERE MUST BE **LIVE CREATURES** IN THE SAUCER! LITTLE GREEN MEN, THEY MEAN!

PHOOEY! THOSE SKEPTICS KNOW IT'D BE IMPOSSIBLE TO **FIND** SUCH A SAUCER, LET ALONE HAUL IT SNARLING AND ZAPPING TO THEIR BANQUET!

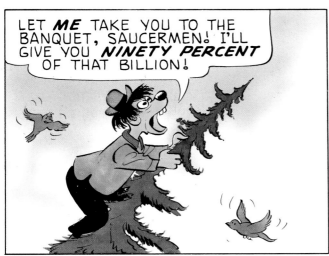

THEY'RE ONLY DANGLING THEIR BILLION DOLLARS TO MAKE PEOPLE ACT FOOLISH! I'M GOING BACK TO SWATTING MOTHS!

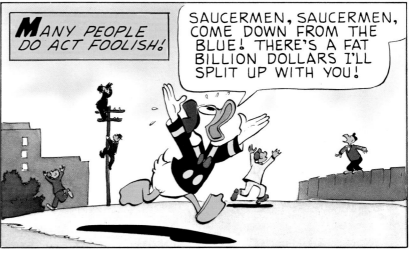

MANY PEOPLE DO ACT FOOLISH!

SAUCERMEN, SAUCERMEN, COME DOWN FROM THE BLUE! THERE'S A FAT BILLION DOLLARS I'LL SPLIT UP WITH YOU!

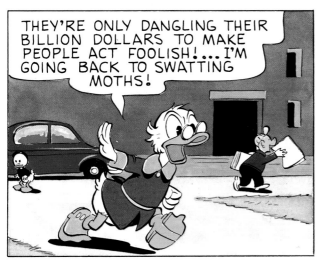

LET **ME** TAKE YOU TO THE BANQUET, SAUCERMEN! I'LL GIVE YOU **NINETY PERCENT** OF THAT BILLION!

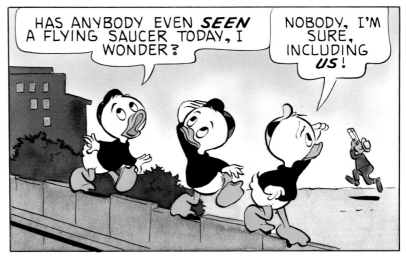

HAS ANYBODY EVEN **SEEN** A FLYING SAUCER TODAY, I WONDER?

NOBODY, I'M SURE, INCLUDING **US**!

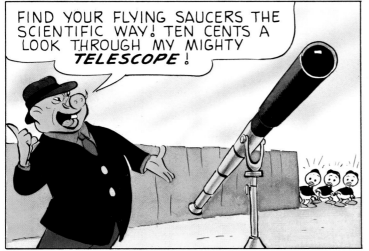

FIND YOUR FLYING SAUCERS THE SCIENTIFIC WAY! TEN CENTS A LOOK THROUGH MY MIGHTY **TELESCOPE**!

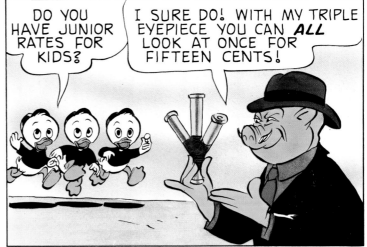

DO YOU HAVE JUNIOR RATES FOR KIDS?

I SURE DO! WITH MY TRIPLE EYEPIECE YOU CAN **ALL** LOOK AT ONCE FOR FIFTEEN CENTS!

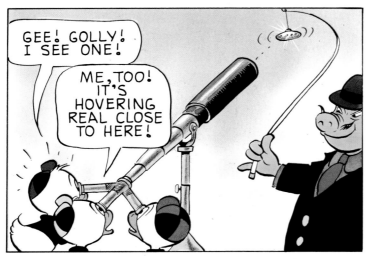

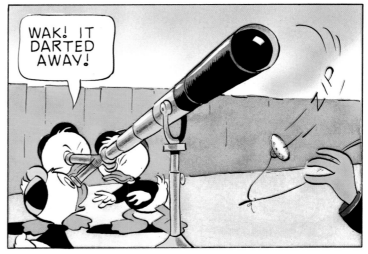

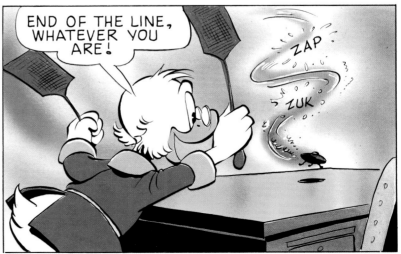

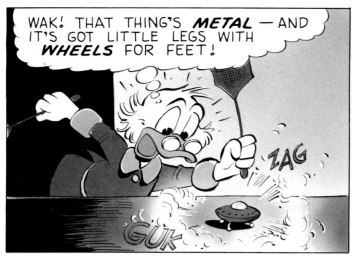

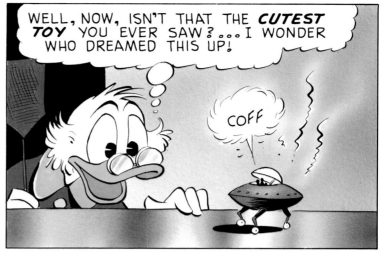

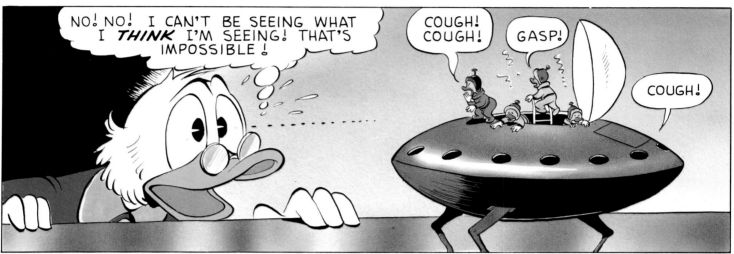

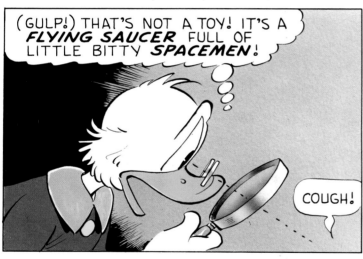

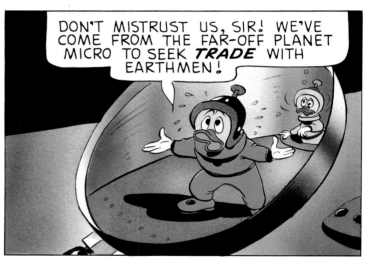

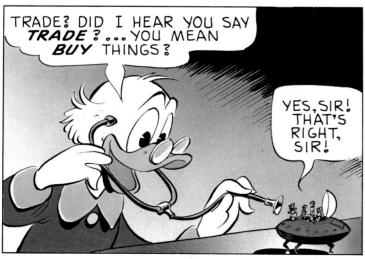

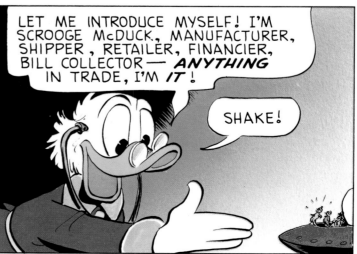

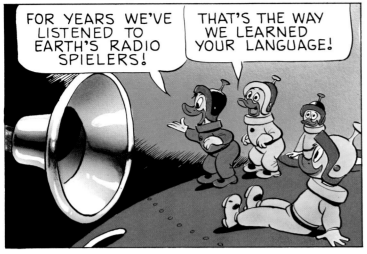

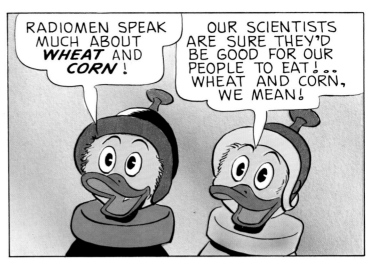

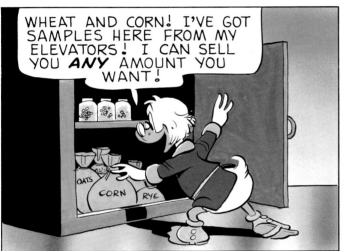

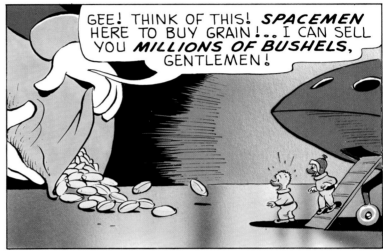

GOLD! WE HOPE THERE'S ENOUGH IN THIS SACK!

NOW, ISN'T THAT THE CUTEST STUFF! GOLD COINS NO BIGGER THAN A SCOTCHMAN'S TIP!

TWO OF THESE COINS WILL PAY FOR YOUR GRAIN, GENTS! YOU GET THE REST OF THE SACK BACK IN CHANGE!

WELL, THIS IS A PLEASANT SURPRISE, CAPTAIN!

WE'D THOUGHT FROM LISTENING TO RADIOS AND TV THAT ALL EARTHMEN WERE CROOKS AND MONSTERS!

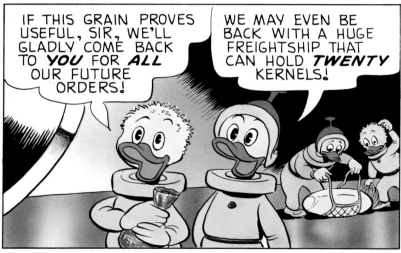

IF THIS GRAIN PROVES USEFUL, SIR, WE'LL GLADLY COME BACK TO YOU FOR ALL OUR FUTURE ORDERS!

WE MAY EVEN BE BACK WITH A HUGE FREIGHTSHIP THAT CAN HOLD TWENTY KERNELS!

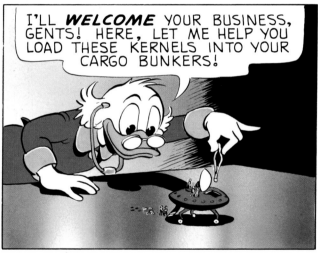

I'LL WELCOME YOUR BUSINESS, GENTS! HERE, LET ME HELP YOU LOAD THESE KERNELS INTO YOUR CARGO BUNKERS!

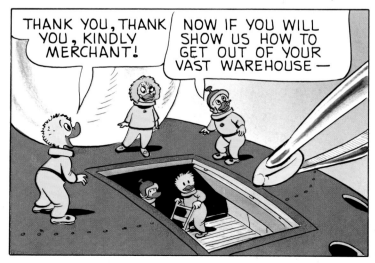

THANK YOU, THANK YOU, KINDLY MERCHANT!

NOW IF YOU WILL SHOW US HOW TO GET OUT OF YOUR VAST WAREHOUSE —

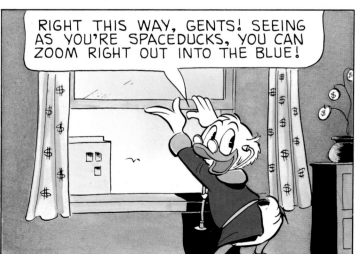

RIGHT THIS WAY, GENTS! SEEING AS YOU'RE SPACEDUCKS, YOU CAN ZOOM RIGHT OUT INTO THE BLUE!

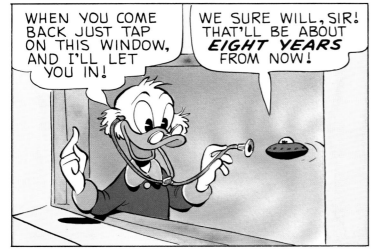

WHEN YOU COME BACK JUST TAP ON THIS WINDOW, AND I'LL LET YOU IN!

WE SURE WILL, SIR! THAT'LL BE ABOUT *EIGHT YEARS* FROM NOW!

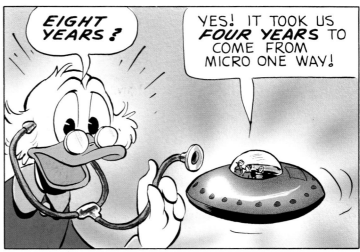

EIGHT YEARS?

YES! IT TOOK US *FOUR YEARS* TO COME FROM MICRO ONE WAY!

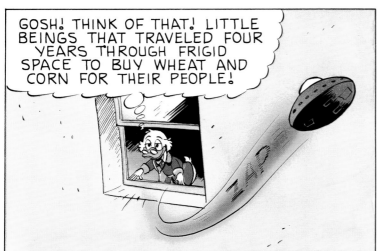

GOSH! THINK OF THAT! LITTLE BEINGS THAT TRAVELED FOUR YEARS THROUGH FRIGID SPACE TO BUY WHEAT AND CORN FOR THEIR PEOPLE!

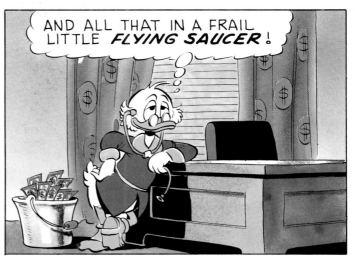

AND ALL THAT IN A FRAIL LITTLE *FLYING SAUCER!*

(ULP!)... *FLYING SAUCER!*

THERE'S THIS *BANQUET* TONIGHT, AND I HAD A FLYING SAUCER THAT I COULD HAVE CAPTURED IN MY *HAT!*

I WAS SO GREEDILY SELLING WHEAT AND CORN FOR TWO ONE-HUNDREDTHS OF A CENT I MISSED OUT ON A *BILLION DOLLARS!*

ROOF →

MICRO-DUCKS! MICRO-DUCKS! COME BACK! I JUST *REMEMBERED* SOMETHING!

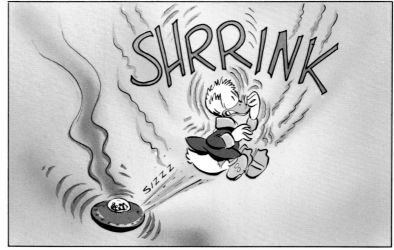

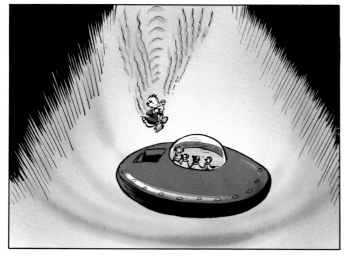

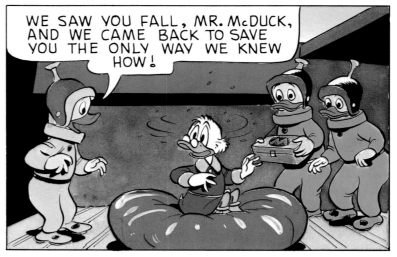

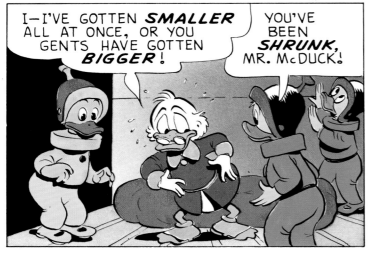

I—I'VE GOTTEN **SMALLER** ALL AT ONCE, OR YOU GENTS HAVE GOTTEN **BIGGER**!

YOU'VE BEEN **SHRUNK**, MR. McDUCK!

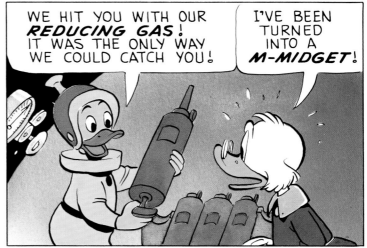

WE HIT YOU WITH OUR **REDUCING GAS**! IT WAS THE ONLY WAY WE COULD CATCH YOU!

I'VE BEEN TURNED INTO A **M-MIDGET**!

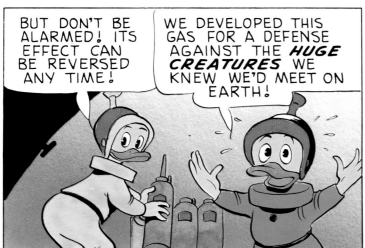

BUT DON'T BE ALARMED! ITS EFFECT CAN BE REVERSED ANY TIME!

WE DEVELOPED THIS GAS FOR A DEFENSE AGAINST THE **HUGE CREATURES** WE KNEW WE'D MEET ON EARTH!

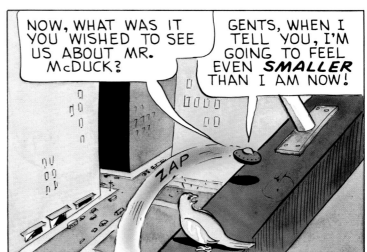

NOW, WHAT WAS IT YOU WISHED TO SEE US ABOUT MR. McDUCK?

GENTS, WHEN I TELL YOU, I'M GOING TO FEEL EVEN **SMALLER** THAN I AM NOW!

ZAP

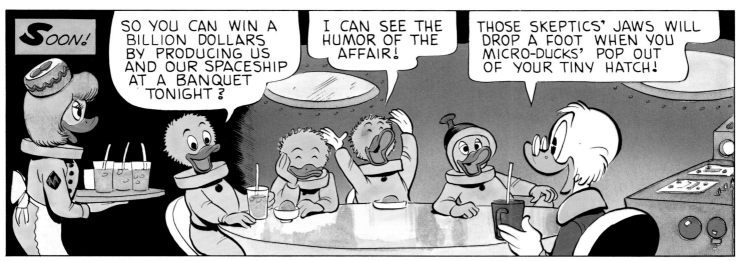

SOON!

SO YOU CAN WIN A BILLION DOLLARS BY PRODUCING US AND OUR SPACESHIP AT A BANQUET TONIGHT?

I CAN SEE THE HUMOR OF THE AFFAIR!

THOSE SKEPTICS' JAWS WILL DROP A FOOT WHEN YOU MICRO-DUCKS' POP OUT OF YOUR TINY HATCH!

I THINK I HEAR UNCLE SCROOGE'S VOICE TALKING SOMEWHERE IN THIS ROOM!

HE SOUNDS FAR OFF, AND SO DO THE OTHER VOICES!

I GET IT! HIS VOICE IS COMING OUT OF THIS TINY **RADIO**, OR WHATEVER IT IS!

AND, GENTS, WHAT SEEING **YOU** WILL DO TO MY NEPHEW, DONALD!....HE'LL KEEL OVER!

OH, HELLO, DONALD! I DIDN'T KNOW YOU WERE HERE!

UNCA SCROOGE, WHERE DID YOU **COME FROM** SO SUDDENLY?

I JUST POPPED OUT OF MY FRIENDS' FLYING SAUCER!

SAUCER? YOU'RE KIDDING!

NO HE ISN'T! I SEE LITTLE **SPACEMEN** COMING OUT OF IT!

HELLO, HUEY! HI, DEWEY! HI, LOUIE!

DONALD! DONALD! COME TO! I DIDN'T THINK YOU'D **REALLY** KEEL OVER!

SOON!

SO THE MICRO-DUCKS AND I FIGURE IT'D BE BIG DRAMA FOR ME TO POP OUT OF THE SPACESHIP AT THE BANQUET!

THAT WOULD **FLOOR** THOSE SKEPTICS!

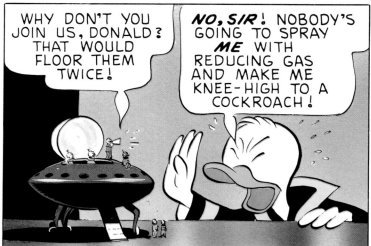

WHY DON'T YOU JOIN US, DONALD? THAT WOULD FLOOR THEM TWICE!

NO, SIR! NOBODY'S GOING TO SPRAY **ME** WITH REDUCING GAS AND MAKE ME KNEE-HIGH TO A COCKROACH!

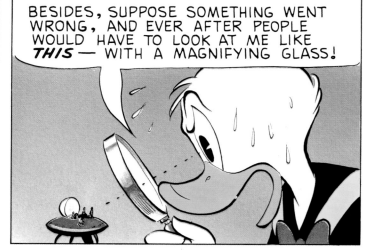

BESIDES, SUPPOSE SOMETHING WENT WRONG, AND EVER AFTER PEOPLE WOULD HAVE TO LOOK AT ME LIKE **THIS** — WITH A MAGNIFYING GLASS!

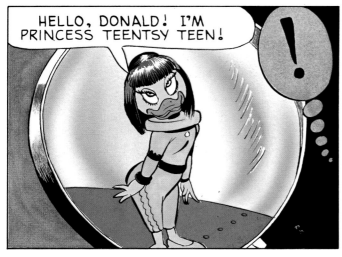

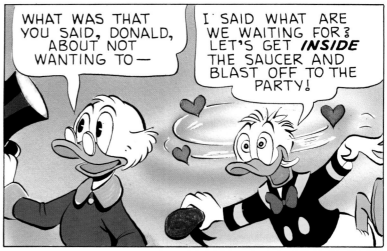

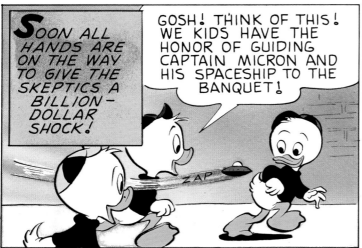

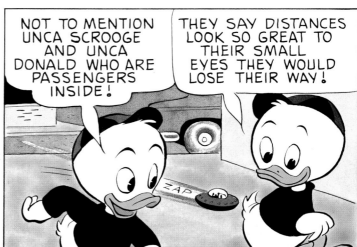

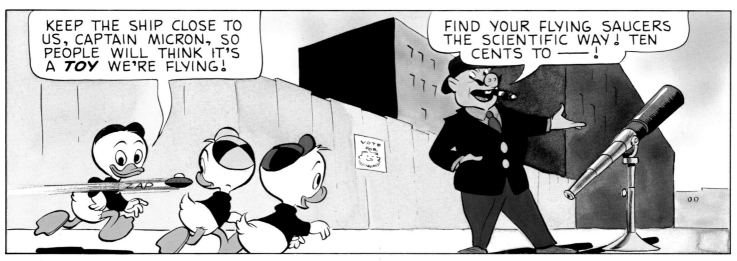

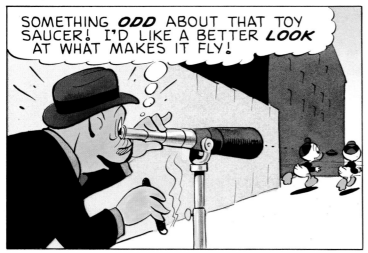

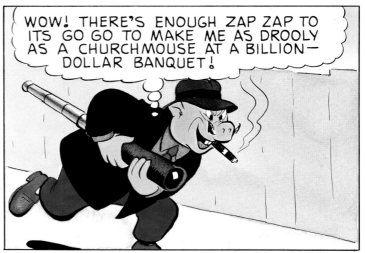

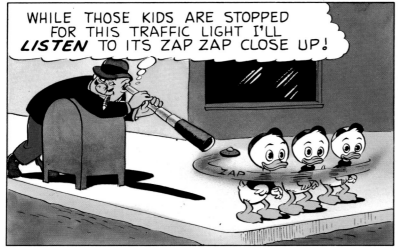

WHILE THOSE KIDS ARE STOPPED FOR THIS TRAFFIC LIGHT I'LL *LISTEN* TO ITS ZAP ZAP CLOSE UP!

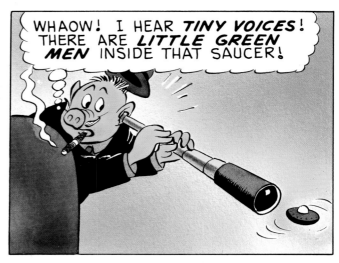

WHAOW! I HEAR *TINY VOICES*! THERE ARE *LITTLE GREEN MEN* INSIDE THAT SAUCER!

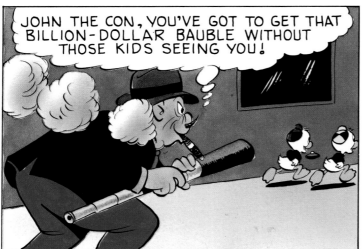

JOHN THE CON, YOU'VE GOT TO GET THAT BILLION-DOLLAR BAUBLE WITHOUT THOSE KIDS SEEING YOU!

BEST WAY IS TO *SEPARATE* THEM BY *BLINDING* THE SAUCER PILOT!

PHOOP

GUK KAFF GAK

I'LL BE A NIKE ZEUS! ... I DIDN'T EXPECT MY *SMOKE SCREEN* TO BRING 'EM DOWN LIKE A LEAD BRICK!

SPLUK

YOU CAN ZAP AROUND A LITTLE NOW, CAPTAIN MICRON! WE'RE NEARLY THERE!

CAPTAIN MICRON!

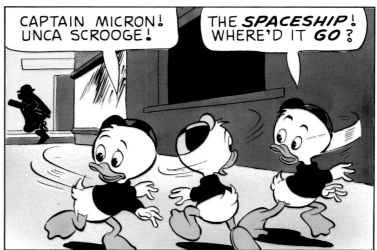

CAPTAIN MICRON! UNCA SCROOGE!

THE *SPACESHIP*! WHERE'D IT *GO*?

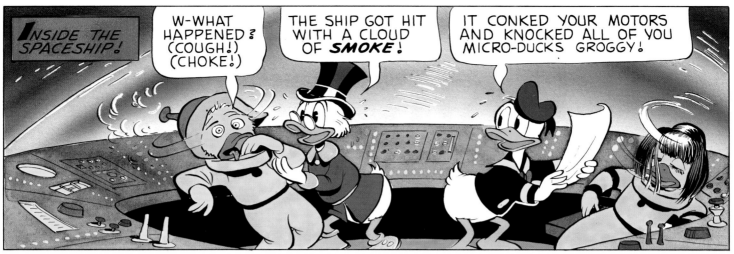

INSIDE THE SPACESHIP!

W-WHAT HAPPENED? (COUGH!) (CHOKE!)

THE SHIP GOT HIT WITH A CLOUD OF **SMOKE**!

IT CONKED YOUR MOTORS AND KNOCKED ALL OF YOU MICRO-DUCKS GROGGY!

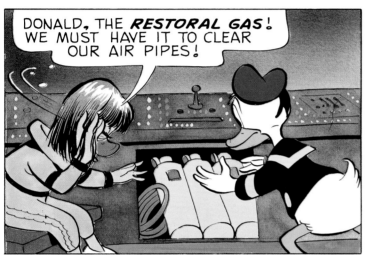

DONALD, THE **RESTORAL GAS**! WE MUST HAVE IT TO CLEAR OUR AIR PIPES!

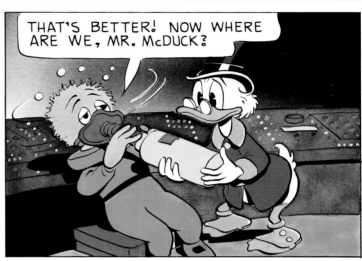

THAT'S BETTER! NOW WHERE ARE WE, MR. McDUCK?

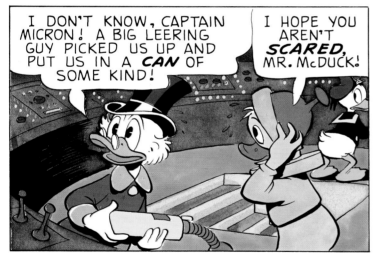

I DON'T KNOW, CAPTAIN MICRON! A BIG LEERING GUY PICKED US UP AND PUT US IN A **CAN** OF SOME KIND!

I HOPE YOU AREN'T **SCARED**, MR. McDUCK!

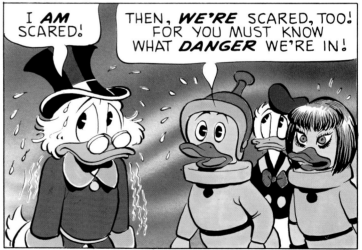

I **AM** SCARED!

THEN, **WE'RE** SCARED, TOO! FOR YOU MUST KNOW WHAT **DANGER** WE'RE IN!

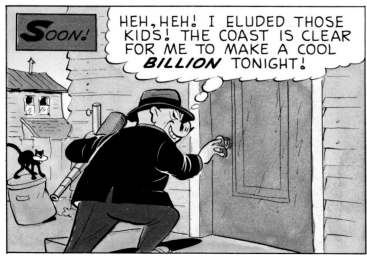

SOON!

HEH, HEH! I ELUDED THOSE KIDS! THE COAST IS CLEAR FOR ME TO MAKE A COOL **BILLION** TONIGHT!

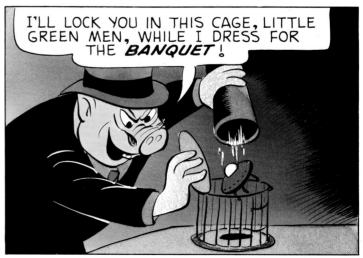

I'LL LOCK YOU IN THIS CAGE, LITTLE GREEN MEN, WHILE I DRESS FOR THE **BANQUET**!

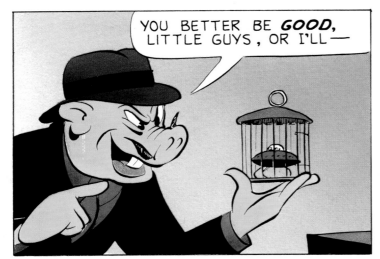

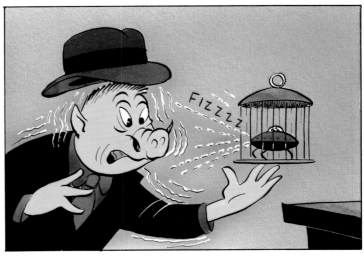

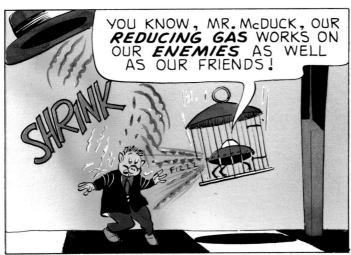

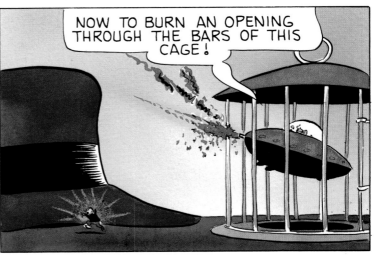

WE BELIEVE IT'S ONE OF YOUR SMALLER *HAWKS*, MR. McDUCK!

ONE OF THEM WAS CHASING US WHEN WE DARTED THROUGH YOUR BROKEN WINDOW EARLIER TODAY!

THANKS TO THE HAWK, WE MET *YOU*, MR. McDUCK!

I'D THANK *THIS* HAWK IF HE'D CHASE US THROUGH THAT SAME WINDOW!

BUT THE TINY VOYAGERS ARE TO HAVE NO SUCH GOOD LUCK!

WHOA! HE CHASED US SMACK INTO A COLUMN OF *SMOKE*!

COUGH COUGH GAK

SPUP

(COUGH! COUGH!)

(SIGH!) I SHOULD GET MAD AT THAT SMOKE, BUT I CAN'T!

DONALD, QUICK! DRAG EVERYBODY OVER TO THE *LEFT SIDE* OF THE SAUCER!

WHY, UNCLE SCROOGE?

THUD

BECAUSE THE RIGHT SIDE IS TEETERING OVER THE RIM OF THE MEANEST *CHIMNEY* I EVER SAW!

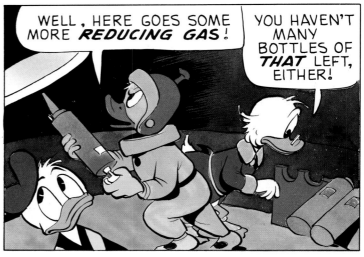

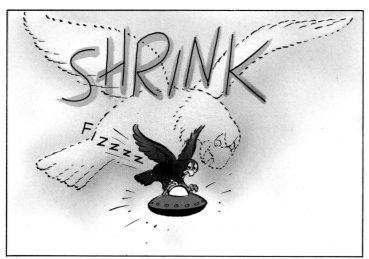

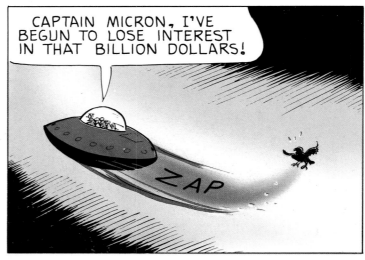

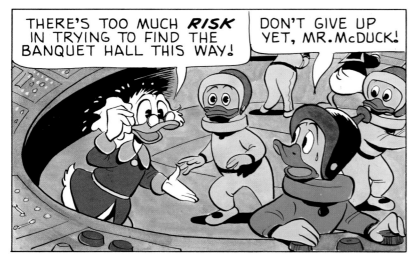

SOMETHING GO WRONG WITH YOUR MAGICAL *TOY*, McDUCK?

YEAH, WHERE ARE THOSE *LIVING BEINGS*? HAR! HAR! HAR!

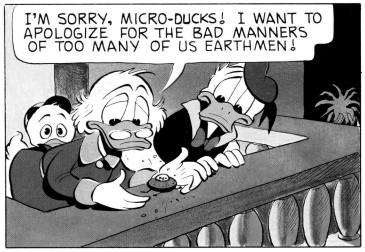

I'M SORRY, MICRO-DUCKS! I WANT TO APOLOGIZE FOR THE BAD MANNERS OF TOO MANY OF US EARTHMEN!

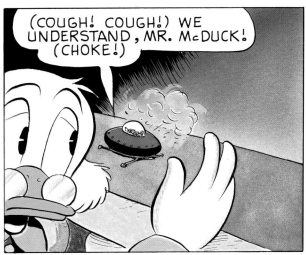

(COUGH! COUGH!) WE UNDERSTAND, MR. McDUCK! (CHOKE!)

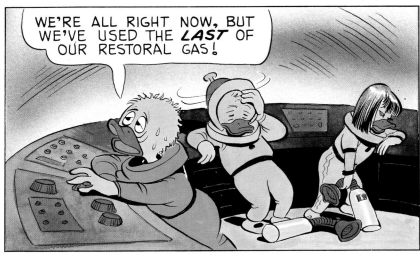

WE'RE ALL RIGHT NOW, BUT WE'VE USED THE *LAST* OF OUR RESTORAL GAS!

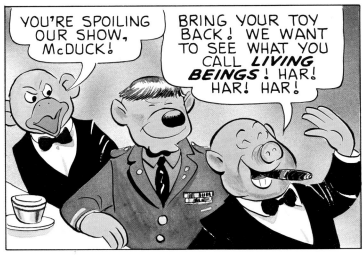

YOU'RE SPOILING OUR SHOW, McDUCK!

BRING YOUR TOY BACK! WE WANT TO SEE WHAT YOU CALL *LIVING BEINGS*! HAR! HAR! HAR!

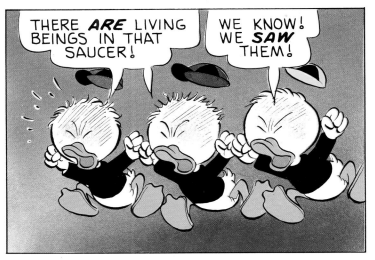

THERE *ARE* LIVING BEINGS IN THAT SAUCER!

WE KNOW! WE *SAW* THEM!

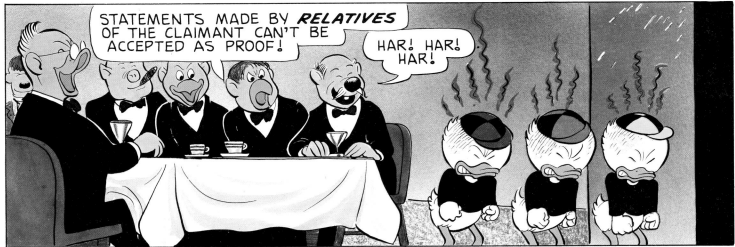

STATEMENTS MADE BY *RELATIVES* OF THE CLAIMANT CAN'T BE ACCEPTED AS PROOF!

HAR! HAR! HAR!

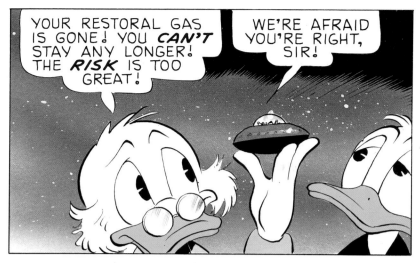

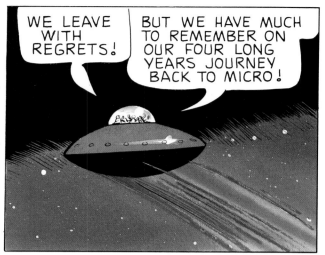

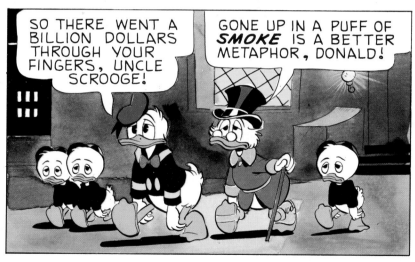

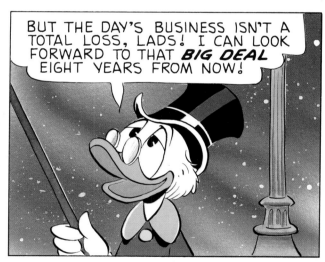

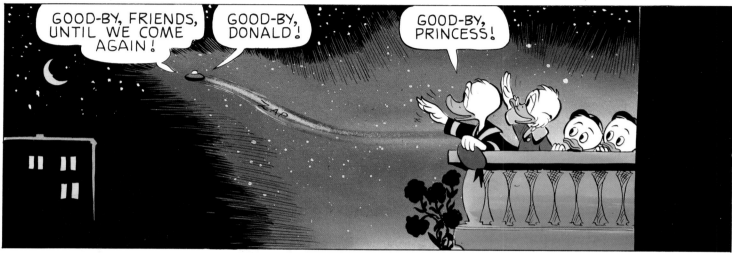

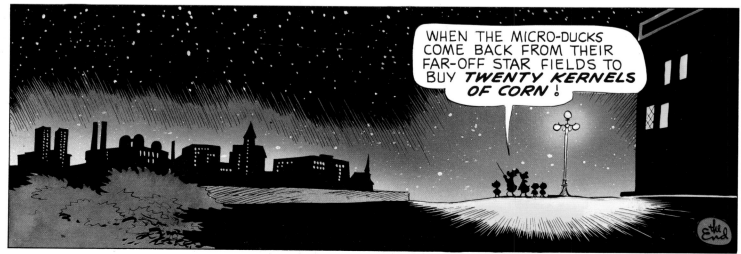

❝Recognition is fine if the rewards are high enough to repay me for loss of privacy and freedom of expression.❞

Why should we imagine that this speck of dust we live on is so important in the world of all those other ones up in the sky? There must be creatures up there far superior to us in their inventions and brains and everything else. We're probably on the mental level of outer space worms. I feel that earth people, with their cynical way of looking down on everybody else, are about the worst beings in the whole sky. If we ever did get to outer space, we'd be the worst hellions ever created. When visitors from out there come to visit, they'd better be on their guard, because we'll hit them over the head, trample them, and pick their pockets.

I felt this story was a good swat at people who are cynical about flying saucers, thinking that only we are intelligent enough to make space voyages. These little guys that came from outer space were far ahead of earth. I decided to make it a tiny spaceship because the gigantic ones are the common way of thinking of them, and I didn't have to do a devil of a lot of drawing.

Scrooge is meticulously moral about selling corn to the micro-ducks. They buy one grain, and he measures out gold dust—under a microscope—to give them change. That makes a great impression on the micro-ducks. They'd been listening to our radios and imagined that we were all crooks who would never give anybody from space or anywhere else a break.

There was a little emotional kick, I thought, when the little guys flew away. Scrooge had been defeated in trying to get his billion dollars, but he swallowed the disappointment and said that he had a big deal coming up in eight years when those little fellows came back to buy kernals of corn.

I've always wanted to promote a broader understanding of life as well as being entertaining. Over the years, many people wrote to say they'd read my stories as children. I was pleased that it looked as if more of them were sitting in Senate chambers than were sitting in gas chambers, so I felt that I had been an influence for good rather than bad.

Perhaps it was because of my basic nature to be honest that I didn't get into crime as a main subject. I structured my stories to be entertaining without espousing criminality. The Beagle Boys were such

goofy morons and fantastic creatures, that I didn't worry much about whether they influenced anybody or not. I heard years later that the editors had a taboo sheet, but they never gave me one. I was by nature chatteringly careful about what I produced. When I made a villain a villain, he was a dirty snake in the grass.

I've always looked at the ducks as charicatured human beings. In rereading the stories, I realized that I had gotten kind of deep in some of them: there was philosophy in there that I hadn't realized I was putting in. It was an added feature that went along with the stories. I think alot of the philosophy in my stories is conservative—conservative in the sense that I feel our civilization reached a peak about 1910. Since then we've been going downhill. Much of the older culture had basic qualities that the new stuff that we keep hatching up can never match.

Look at the magnificient cathedrals and palaces that were built. Nobody can build that kind of thing nowadays. Also, I believe that we should preserve many old ideals and methods of working: honor, honesty, allowing other people to believe their own ideas, not trying to force everyone into one form. The thing I have against the present political system is that it tries to make everybody exactly alike. We should have a million different patterns.

They say that wealthy people like the Vanderbilts and Rockefellers are sinful because they accumulated fortunes by exploiting the poor. I feel that everybody should be able to rise as high as they can or want to, provided they don't kill anybody or actually oppress other people on the way up. A little exploitation is something

you come by in nature. We see it in the pecking order of animals—everybody has to be exploited or to exploit someone else to a certain extent. I don't resent those things.

One year some guys at the Harvard Business school wrote me a letter saying that they had chosen Uncle Scrooge as their mascot. They wondered if I'd make a drawing of Scrooge to put on the wall of the room where they had informal meetings. So I drew them a picture. I even looked up a Latin phrase, *"Fortuna favet fortibus."* It sounded educated, so I lettered it into a ribbon on Scrooge's money bag. It means "Fortune favors the bold."

GO SLOWLY,
SANDS OF
TIME!

Go Slowly Sands of Time
Written 1968, Drawn 1980, First Published 1981

This brand new, never published adventure is presented in "storybook" style, which is a wide departure from the traditional comic book format of paneled drawings full of dialogue balloons. The tale's theme is a departure, too, from the usual moment-by-moment motivations of Uncle Scrooge's frantic emergencies. This is a tale of a great need and a great fear, and of the near hopeless search for solutions.

The time-honored storybook format of brief narrative passages laced with graphic watercolors is well suited for staging the tale's underlying drama, which deals with a kind of time that never marches on. *C.B. 1981*

Ah, spring! Sweet days of love!
Sweet days when men should take the time
a money hill to climb, and there
renew their love affair with their first dime!

—Scrooge McDuck

Uncle Scrooge loves his money. He loves the feel of it and the smell of it, and he loves to dive around in it like a porpoise and to burrow through it like a gopher and to toss it up and let it hit him on the head. He has three cubic acres of the stuff in his vast money bin, and his great joy is to count it and fondle it. He treasures each coin as if it were an irreplaceable keepsake.

One day Uncle Scrooge got to worrying about what might become of all that money when he, its doting owner, must wing off to the great countinghouse in the sky. He considered the horrible prospect of leaving the fortune to his nephews, who would have no better sense than to spend it. The government of Duckburg would do likewise. Uncle Scrooge winced at the thought of even one of his precious coins being spent for milkshakes or baubles.

This money hoard is a collection, he wailed to himself. It must be preserved *en masse*. He perceived that only while he, and he alone, lived and tended the money could the collection be kept intact. Well, he decided he would do the best he could for his poor, defenseless coins and greenbacks—and that was to live as long, as very long, as possible.

He wondered if somewhere in the worlds of food or air or chemistry there might be a rejuvenator that could keep his battery charging and his juices flowing—into infinity.

He summoned his nephews to help him search for a life stretcher.

Donald and Dewey and Huey and Louie helped their Uncle Scrooge delve through scores of books and maps and scientific reports. Nothing of interest was found until one day Huey came upon some glowing accounts of the lengthy life spans of people who lived in the far-off Vale of Khunza.

"That will be the place where I buy the makings of another lifetime!" shouted Uncle Scrooge. "We will go there and find what it is that fires those Khunzans' inner boilers and helps them live such long-winded eternities."

Uncle Scrooge locked the great doors of his money bin. He left behind the zestful pleasures of splashing amongst his beloved coins and set out on the hopeful quest of far-off Khunza. The miles were long and rigorous. Khunza had no airports or taxicabs or even roads. By the time the ducks reached the fabled vale, Uncle Scrooge was tired and chilly and looking much older.

"It certainly is cold in these high mountains," griped Donald.

"Could be that is why the natives live so long," said Dewey. "They are refrigerated."

In spite of his discomfort, Uncle Scrooge's hopes soared. He saw many remarkable specimens of healthy old age: herders in their nineties who could outrun goats and ancient hags who easily carried baskets of yak butter up perpendicular cliffs. The Vale of Khunza certainly showed promise.

The ducks got busy right away on their quest for the oldsters' secrets. They asked uncountable questions and got uncountable answers—all different.

Huey was told that eating lots and lots of dried apricots would add decades to one's life span. Dewey was told that drinking super strong tea would "paralyze" the aging process. Louie was told to eat unhulled rice. Donald was told a dozen other "infallible" recipes. Uncle Scrooge could do no less than try all of the ideas. At the Vale's supermarket he stocked up on every substance that might contain preservative elixirs.

Uncle Scrooge began his perpetuation therapy with the two simplest recipes. He drank the natives' strong tea by the mugful, and he ate dried apricots until they almost came out of his ears, but it was soon obvious that he needed nostrums with higher octane ratings. He was rapidly growing more aged and enfeebled. Besides, the strong tea paralyzed his eyelids in an open position—and the apricots turned his skin a rich, lustrous yellow.

Donald and Dewey and Huey and Louie kept up their efforts to find an age-reversing formula. They popped in and out of the door of Uncle Scrooge's rented hut every few minutes with new recipes for him to try, and each time they let a blast of the frigid outside air gust in. None of the recipes worked any change in the old duck's condition, but the gusts of cold air did have an effect. He started to turn blue, and because of his already yellow color, the hue of his skin became a ghastly green.

It was clear that Uncle Scrooge would have to try recipes that had nothing to do with the world of food. The local natives might keep spry on apricots and tea and unhulled rice and powdered bats' wings and smoked yak knuckles, but Uncle Scrooge couldn't seem to absorb the magic essences.

It was time to try more exotic recipes, and Uncle Scrooge did just that with a "secret formula" involving bees. The kids had heard from one of the ancients that stings of the angry insects would fill the stingee with glowing warmth that could erase wrinkles like magic.

Well, shivering Uncle Scrooge could stand some warmth, and he could stand to lose some wrinkles; he had acquired a great many in the days since he had left his cozy money bin.

He rented the services of a hive of bees and exposed a judicious part of his anatomy to their therapeutic ministrations. When Donald asked him if he could feel the warmth percolating through his veins, Uncle Scrooge could not answer. He had passed out cold—from the heat.

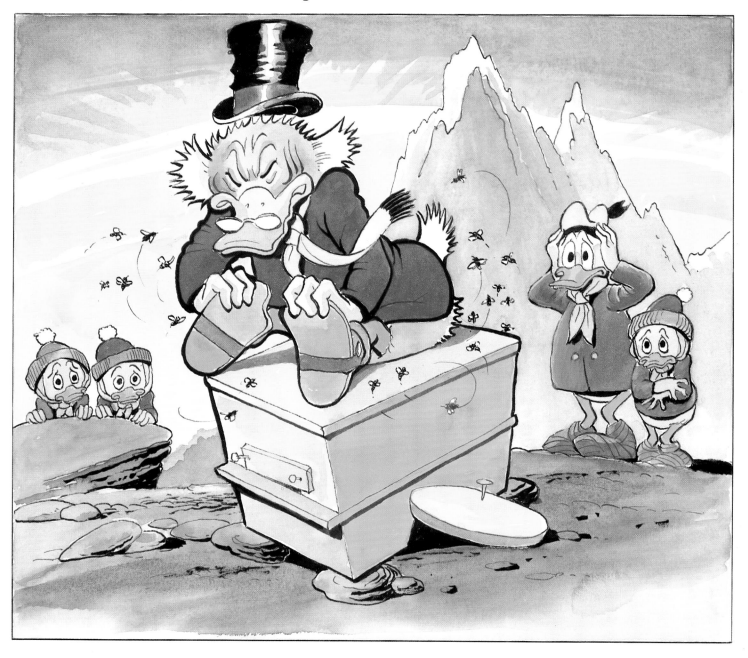

The treatment by the bees may not have added years to Uncle Scrooge's life, but it did fill part of him with such radiant warmth that his nephews thawed their hands for hours by merely standing in his vicinity. Many wrinkles disappeared, too, for a time. However, they were not the ones on his face.

In summing up the results of their search for the Khunzans' secret of elastic life, the ducks could find only one common factor: each and every hoary ancient thoroughly enjoyed whatever rigorous tasks his livelihood involved. The yak herders loved it when frigid winds blew their tents away and delighted in climbing icy mountains with unspeakable burdens on their backs. The ancient beekeeper loved the warm thrust of a bee's bayonet into his horny hide. What each ate or drank seemed to matter very little.

Uncle Scrooge's bones creaked with age, and his hands trembled with palsy as the ducks helped him totter to the royal palace of Khunza, where he felt he must personally interview the most ancient Khunzan of them all—the royal treasurer.

On the way his nephews became curious. "How old *are* you, Uncle Scrooge?" asked one.

"Too old!" yelled the old duck. "But so what? I've always been too busy to keep track of birthdays."

Another asked, "You made your first fortune selling surplus cannons from the Boer War?"

"Humph!" snorted Scrooge. "I was rich before then. I was a Bonanza King on the Comstock Lode! I took millions out of the Klondike!"

"Say no more," said the nephews. "By our figures, you are already as old as these walking fossils of Khunza."

"It isn't how old I *am*," bellowed Scrooge. "It's how old I *have to be* that matters!"

The meeting with the treasurer was short and to the point.

"The secret of long life," the ancient one pontificated, "is to be happy with your work. Your daily toil has to be your whole reason for living. Me, for instance, I love to work with money. I love to count it and to keep all of these ledgers and records up to the minute. I love my work so much it is my greatest amusement."

The nephews nudged each other. No use asking Uncle Scrooge what his greatest amusement was—they already knew.

Uncle Scrooge was only partly satisfied with the hoary treasurer's rationale. It was essentially the same as that of the yak herders. He felt there must be something more—some magical elixir more potent than the snake oil of an abstract philosophy.

He was soon to find it. The treasurer led him to the money jars and with a knowing wink remarked, "That stuffy pitch about enjoying one's work is only wind up the chimney. There is another element in my work that has helped me to live longer than anyone in the Vale, and I think I have found it right *here*!"

He jumped into a money jar and started burrowing among the coins.

"I love money," the old treasurer shouted. "I love the feel of it and the smell of it, and I love to dive around in it like a porpoise and to burrow through it like a gopher and to toss it up and let it hit me on the head!"

Uncle Scrooge reeled as he assimilated the rich juices of the treasurer's words.

"And you want to know something real secrety?" the old treasurer gloated. "There's something in the *metal* of the coins that rubs off on me—"

He didn't get to tell how much the "something" rejuvenated him every day. Uncle Scrooge was already leaving, bound for home.

So the ducks returned to Duckburg, and Uncle Scrooge dove back into the coins in his money bin, and soon the wrinkles disappeared from his aged face, and the aches left his aged bones, and he became as spry as when he was a pushy cannon peddler profiteering from the Boer War.

Donald and the kids weren't sure whether they had seen a miracle.

"Do you think you would like to live forever, Unca Donald?" asked Dewey.

"Doing what Uncle Scrooge is doing?" asked Donald in return. "No. I would prefer to find something different in the worlds of food or air or chemistry that would do for me what money does for Uncle Scrooge."

"Maybe something like tossing off uncountable ice cream sodas, Unca Donald?" asked Louie.

"Right on!" said all the four, and they went out to a soda fountain and experimented on the technology of living forever.

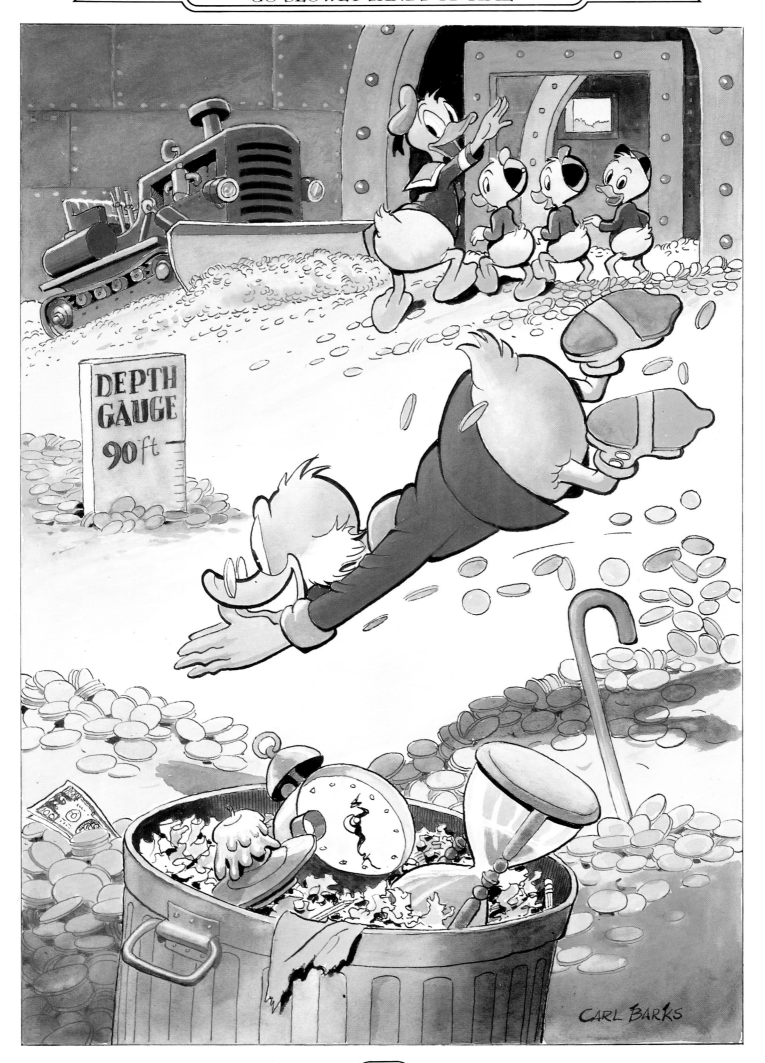

66The publishing company sent me a script one time for a story with Bugs Bunny, Porky and Petunia Pig. Well, I didn't do too badly on Porky and Petunia, but my Bugs was so bad that the staff artist had to draw all new faces on him. Oh, I didn't get any praise out of it, but I was happy that it came out that way because I had no intention of ever being that much of a cartoonist that I could draw Bugs Bunny. It was over my head.99

In the late 1960's, a fellow in Denmark, named Jacobsen who puts out all the Disney books in Denmark and the rest of Scandinavia was running out of stuff to reprint. So he wanted me to do some original stories for them. I said I wouldn't do original stories, I was tired of it. "Well," he said, "could you do just a synopsis?" Just something that his writers could take and break down into story form so that his artist could draw them. So I thought, well, all right, I'll try that. I made a brief synopsis of a Scrooge plot and turned it over to the Disney office to send on to Jacobsen. I don't know whether they ever sent it or whether Jacobsen couldn't see going to that much work to have it broken down into artwork, but nothing ever came of it.

After months went by I thought, "Well, I guess that's the end of it."

In 1975, I was interviewed for a film on comic artists and was asked if I had an original script left from one of my stories. This Scrooge synopsis was the only one I had left. The film's director took the script and showed it to the right people and I ended up drawing it for this book. So now finally something has come of it.

"Go Slowly, Sands of Time" is kind of a spiritual story of Scrooge, which gives him a means of going on and on forever so you don't have to feel that he comes to the end of the line and dies all at once. He's going to just keep on going into eternity. Kids that read about him a hundred years from

now can think of him as still being alive. He has found the fountain of everlasting youth with his money.

I think I put over in the story a little bit of Scrooge's philosophy for living a long time—at least what people think of as a way of living a long time—to enjoy your work and keep busy at it. Supposedly that gives you a longer life. Of course, that's problematical, but I did add that one little thing that not everybody is going to be able to take advantage of: swimming around in this big vat of money. That really gives Uncle Scrooge his extra longevity.

Wouldn't it be something if there were a chain of public money pools? People would be allowed to put on a pair of extremely tight tights with no pockets in them and dive around in money. When they get out they could be x-rayed to see that they haven't swallowed any!

On the farms and the cold, snowy ranch in eastern Oregon where I was raised, all the people lived hard, bitter lives. When I think of them now, I think, my God, every day of their lives was just a hell on earth, but they survived and thrived on the misery that they had to go through. It was just hard work and suffering and loneliness. They had no entertainment other than being able to enjoy their own thoughts, I guess. They slept a lot of long hours away at night when they could. Oh, that was a terrible life when you think of those people out on the homesteads in the west in the old days at the turn of the century. You can read about them coming across the plains and settling in Oklahoma, Nebraska, and along the Colorado River, building their sod houses and living lives of lonely misery. But they must have

enjoyed it or they wouldn't have done it. Of course, my folks were in Oregon, and the sagebrush up there was just a little different version than on the western plains, but it was just as miserable.

My boyhood gave me a different outlook on life than many of the Disney story men had who grew up in cities. I knew how bad life could be, but I never tried to put it into my stories. Life is wretched enough without trying to dredge up constant reminders. I think I found it natural to satirize yearnings and pomposities and frustrations in the ducks because of my earlier contacts with people in woeful ways of life. Those people had the ability to laugh at the most awesome miseries. If they hadn't had humor in their lives, they would have gone crazy.

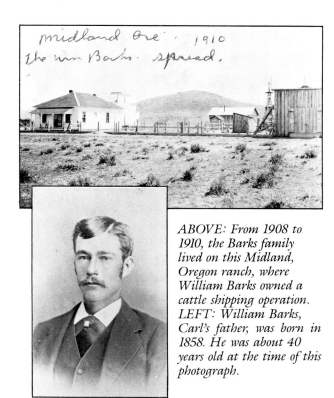

midland Ore. 1910
The wm Barks. spread.

ABOVE: From 1908 to 1910, the Barks family lived on this Midland, Oregon ranch, where William Barks owned a cattle shipping operation. LEFT: William Barks, Carl's father, was born in 1858. He was about 40 years old at the time of this photograph.

A RECOLLECTION

By Garé Barks

I started working with Carl in 1952. The very first thing I did was the top half-page with the masthead on it. It said "DONALD DUCK" in white outline, then had a black shadow around the outside. I was so tense about doing it right that I put it in the wrong place—I put the black on the inside of the letters and it all had to be erased!

Originally, I was working toward being a house-painting contractor and was well on my way, but the second time Carl and I went out together, we were in an automobile accident. My back was injured and I was laid up a number of weeks. It would have been a long time before I could have gone back to house painting. So Carl said that, in the meantime, I could do some work for him, and that was how it started.

For quite a while I just did some of the blacking. I remember one of the first stories I worked on was a Gyro Gearloose in which he caught some mammoth fish. Carl left all the scales for me to put on! I was so nervous because I'd never done anything that thousands and thousands of people would look at. I kept having visions of people opening these books and looking at all these scales on the fish to see if they were in just the right places. The first few months I worked with Carl, I was almost as self-conscious as if I were up on a stage.

Before Carl sat down to do a story, he did lots of thinking and wrote odd bunches of notes. Once he was sure he had enough

Garé Barks, Temecula, California, 1981

material to make a story, he began to do the actual work. He'd write a few pages of script, then draw for a while, then write at it again. When he got tired of writing, he would draw some more. He didn't like to do it all at once and would do anything to break it up. About half or two-thirds of the way through he would stop and finish the script completely to make sure that it came out at the right length. I didn't always read the scripts before they were drawn, but after we'd drawn a few pages of them, I wanted to read it as Carl wrote it. I'd get interested enough so that I wanted to know what was going to happen. Sometimes Carl himself didn't even know how it was going to come out.

Gradually I asked Carl, "What is the worst part for you to do: What do you like least?" He said, "What I'd like to get rid of is the lettering." I didn't like to letter either, but I figured it would help him, so I started

doing the lettering. He would rough it in with a blue pencil, and then I would letter so that it was spaced properly and in the right type of lettering.

Carl used to pull some marvelous faces when he was drawing the expressions on the different duck drawings. He was always trying out the same expression on his own face. He'd pull his eyebrows up and stare. If he was drawing the ducks wide-eyed, he'd open his eyes wide and wider, and suddenly he'd say, "I've got the most awful headache!" It was from pulling his face around.

During the night, Carl would often come up with a bright idea or a solution to something he was puzzled about, and it would wake him up. In the morning he'd get up and say he had the most wonderful idea in the night, but hadn't written it down. He couldn't for the life of him think of what it was: It was gone. So he got to keeping a pencil and paper by the bed. I'd hear this scribble, scribble, scribble in the dark, and I'd say, "Turn the light on so you can see what you're doing!"

I don't think Carl ever missed a deadline. We were working together before we were married and were trying to get far enough ahead so we could take six weeks off for a long vacation. We were trying to hurry, but the two stories that came up right at that time were the story of the lemmings—all these lemmings had to be drawn—and a story in which a bull went through a china dishwear exhibit at a county fair—thousands of pieces of smashed china were flying around in the air in a large splash panel. We had a neighbor that knew we were working to leave at a certain time and that we were working day and night. When we finally got the last darn lemming drawn,

we just let out a "Whoopee!" and she came running to our door and asked, "Are you finished?" And we said, "Yeah, we're finished!" These two stories took about the most drawing, I think, of anything we ever did, and we happened to have them just when we wanted to go away.

About 1956 or '57 we lived in San Jacinto. We had a young newsboy about twelve years old who used to deliver the paper. One day I made the mistake of inviting him in to see what Carl was doing and let him watch Carl drawing on some of the duck pages. He was fascinated. The next day I went out to water the front yard, and there were about fifteen little neighborhood kids all lined up along the sidewalk outside, all buzzing and talking and pointing. I couldn't imagine what was the matter with them. I looked down to see if I had egg on me, or what it was they were looking at. I suddenly realized it was because this was the house in which Donald Duck was drawn. They all wanted to be invited in to watch Carl work. By that experience we learned to keep very quiet wherever we lived and not let the kids know what was being done in the house.

GARÉ BARKS was born Margaret Wynnfred Williams in Hilo, Hawaii. Educated at Punahou Academy, Honolulu, she won four successive scholarships to Vesper George School of Art in Boston, Massachusetts, majoring there in commercial art and stage designing, with post graduate training in portraiture and fine arts. She also studied with Millard Sheets, Madge Tennant, David Vaughn and Ralph Love.

Garé, as she signs her paintings, was early influenced toward realism by her architect father. She first specialized in large tropical florals and had two one-man shows, which gained her mention in the *International Bluebook* and *Dictionary of Notable American Women*, before World War II interrupted her career. By helping her husband depict the far-flung adventures of Donald Duck and Uncle Scrooge, she later discovered that her true *metier* was a combination of landscape and wildlife painting.

Garé paints what she loves—the untouched Western scene which is so fast disappearing. Her subjects are the forests, mountains, rivers and lakes: from the giant redwoods brooding in the foggy valleys of the Pacific Slope to the sparkling aspen groves of the Rockies. Many of Garé's paintings are subjects for fine Christmas cards and other specialties. Her work is represented in private collections throughout the United States, Canada, and Mexico.

UNCLE SCROOGE CHECKLIST

While Uncle Scrooge appeared in many series of comic books including *DONALD DUCK, Walt Disney's Comics and Stories,* and numerous Disney Annuals, this list includes only the issues of the *Uncle Scrooge* series from 1952 to date. Each entry contains the issue number, date of publication, title of story and page count. Most issues also included a four page Gyro Gearloose story and two or more one-page filler stories: these have not been listed. The bulk of material appearing in issues 1 (F.C. #386) through 71 was written, pencilled, inked and lettered by Carl Barks with the assistance of Garé Barks who started work on issue #2(F.C. #456). Issues after #71 contain work by other artists, as well as reprints of Barks's work. Stories which are Barks reprints have the number of the original *Uncle Scrooge* in parentheses following the title. Several issues have reprints from *Walt Disney's Comics and Stories* and are noted: (W.D.C.&S. #...). Many of these stories never had a title, so *descriptive titles* have been created for *reference purposes* only. *Uncle Scrooge #1,2* and 3 were part of the Dell *Four Color* Series (F.C.) and are numbered 386, 456 and 495 respectively. Some issues of the late GOLD KEY period were also published with the WHITMAN logo: the contents are identical, but the WHITMANS were distributed through a different system. In 1983, WHITMAN ceased publication of "Uncle Scrooge" with issue 209. All of the Disney titles lay fallow for three years. Starting with issue 210 in October 1986, a brand new company, GLADSTONE PUBLISHING LIMITED (named after Barks's creation, the infuriatingly lucky Gladstone Gander), revived the entire Disney comic book line. The GLADSTONE comics reprint not only Barks's stories, but also translated versions of material originally produced for foreign language publication in Europe.

Among the writers who work is represented in the non-Barks Scrooge stories are: Del Cannell, Carl Fallberg, Vic Lockman, Nick George, Bob Gregory, Bob Ogle, Cecil Beard, George Crenshaw, Dave Detiege, Don Christiensen, Bob Langhans, Mary Carey, Diana Gabaldon, Dave Angus, Byron Erickson, Geoffrey Blum, and Don Rosa. Artists included: Tony Strobl, Kay Wright, Peter Alvarado,

John Carey, Richard Moores, Jack Bradbury, Paul Murry, Robert Gregory, Phil De Lara, Larry Mayer, Al Hubbard, Roger Armstrong, Vicar, Branca, the Gutenberghus Group (various artists from Denmark, Italy, Chile, Spain), Daan Jippes, and Ben Verhagen. These talented people have ably carried the torch lit by Carl Barks.

DELL COMICS

386 (1)	March 1952	"Only a Poor Old Man"	32
456 (2)	March 1953	"Back to the Klondike"	27
		"Somethin' Fishy Here"	5
495 (3)	Sept. 1953	"The Horseradish Story"	22
		"Trouble from Long Ago" or "The Month of the Golden Goose"	
		"The Water Tank Tryout"	10
4	Dec. 1953	"The Menehune Mystery"	32
5	March 1954	"The Secret of Atlantis"	32
6	June 1954	"Adventure in Tralla La"	22
		"In the Buying Mood"	10
7	Sept. 1954	"The Seven Cities of Cibola"	28
		"$1 Million Dollar Pigeon"	4
8	Dec. 1954	"The Mysterious Unfinished Invention"	28
		"McDuck for Treasurer!"	4
9	March 1955	"The Lemming With the Locket"	22
		"The Tuckered Tiger"	9¾
10	June 1955	"The Fabulous Philosopher's Stone"	24
11	Sept. 1955	"The Great Steamboat Race"	16
		"Riches, Riches, Everywhere!"	16
12	Dec. 1955	"The Golden Fleecing"	31⅞
13	March 1956	"Land Beneath the Ground!"	27
		"Trapped Lightning"	4
14	June 1956	"The Lost Crown of Genghis Khan!"	19
		"The Inch Square Fortune"	7¾
15	Sept. 1956	"The Second-Richest Duck"	20
		"Progress Marches On!"	6¾
16	Dec. 1956	"Back To Long Ago"	21
		"The 'Colossalest Surprise' Quiz Show"	5¾
17	March 1957	"A Cold Bargain"	26¾
18	June 1957	"Land of the Pygmy Indians"	27
19	Sept. 1957	"The Mines of King Solomon"	27
20	Dec. 1957	"City of Golden Roofs"	26
21	March 1958	"The Money Well"	26
22	June 1958	"The Golden River"	26
23	Sept. 1958	"The Strange Shipwrecks"	21
		"The Fabulous Tycoon"	5
24	Dec. 1958	"The Twenty-Four Carat Moon"	20
		"The Magic Ink"	6
25	March 1959	"The Flying Dutchman"	20
		"A Cobbler Should Stick To His Last!"	5¾

WHITMAN COMICS

(Issues 207-209 have no known cover dates, but appeared in 1983)

GLADSTONE

A CARL BARKS BIBLIOGRAPHY

This bibliography covers a small portion of the major articles and books about Carl Barks which were published in the United States. It is not intended to be exhaustive. The many excellent foreign language articles have not been included because of spatial limitations and diffficulty in gaining access to this information.

Ault, Donald, "Comic Art and How to Read It," *California Monthly*, January-February 1976 (Vol. 86, No. 4).

————, "Liborum Comicorum Explicatio," *Occident*, Vol. VII (New Series), No. 1, (1973).

Barks, Carl, "Carl Barks' Prof. Nuts McFuzzy in 'McFuzzy is Safe.'", (reprint from *Calgary Eye Opener*, September (1931), *Ophemera*, (1977).

————, *The Fine Art of Walt Disney's Donald Duck*, Another Rainbow Publishing, Inc., Box 2206, Scottsdale, Arizona. (1981) Note: This limited edition (1875 copies) reproduces virtually all of Carl Barks's oil paintings except the lithograph included in "Uncle Scrooge McDuck: His Life and Times."

————, *Walt Disney's Uncle Scrooge*, New York, Abbeville Press, (1979). Note: This volume contains eighteen Uncle Scrooge stories reprinted from the Mondadori edition originally published in Italy. While the stories have been severely re-edited, re-drawn, re-lettered and re-colored, the book is, nonetheless, a reasonably low cost collection of otherwise expensive Scrooge stories.

Barrier, Michael, Barks Bibliography, *Funnyworld* No. 7 (September 1967) through No. 16, (Winter 1974-1975).

————, "The Duck Man," *The Comic-Book Book* (Don Thompson and Dick Lupoff, editors; New Rochelle, N.Y.: Arlington House, 1974).

————, Interview with Carl Barks, *Comic Art* No. 7 (1968) with Malcolm Willits.

————, "The Lord of Quackly Hall." *Funny-World* No. 6 (June 1967).

————, "Screenwriter for a Duck: Carl Barks at the Disney Studio." *Funnyworld* No. 21, (Fall 1979).

————, "Starting out in the Comics: Carl Barks Becomes the Duck Man." *Funnyworld* No. 22 (1981).

Beaumont, Charles, "The Comic World," *Fortnight* (May 1955). Note: *First known mention of Carl Bark's work in print.*

Boatner, E.B., "Carl Barks–From Burbank to Calisota", 7th Annual Edition of *The Comic Book Price Guide*, Overstreet, (1977).

————, "Comix 101b (half term): Why a Duck?", *The Harvard Magazine* (Vol. 77, No. 9), (1975).

Chalker, Jack, *An Informal Biography of Scrooge McDuck*, Mirage Press (1974).

Ciotti, Paul, "The Man Who Drew Ducks", *California Magazine*, November 1977.

Daniels, Les, *Comix: A History of Comic Books in America*, New York, Outerbridge & Dienstfrey, (1971).

Groth, Gary, "Barks in Boston", *Comics Journal*, No.32, January 1977.

Munsey, Cecil, "The Comic Book King", *Disneyana*, New York, Hawthorn Books (1974).

Schreiner, David, "Carl Barks, The Duck Man", *Yesteryear*, September 1979.

Spicer, Bill, "A Visit with Carl Barks," *Graphic Story World*, No. 2, July 1971.

Summer, Edward, "Of Ducks and Men: Carl Barks Interviewed.", *Panels* No. 2, Spring 1981.

Thompson, Don and Maggie, *Comic Art* No. 5 (1964).

Thompson, Kim, "The Duck Man", *Comics Journal*, No. 63, May 1981.

Wagner, Dave, "An Interview with Donald Duck", *Radical America*, Vol. 7, No. 1, 1973.

There are also two Carl Barks "Fanzines" published several times a year which contain articles on Barks and the Ducks: *The Barks Collector, P.O. Box 1906, Suffolk, VA 23434; The Duckburg Times*, 400 Valleyview, Selah, WA 98942.

In August 1983, ANOTHER RAINBOW PUBLISHING LIMITED (P.O. Box 2206, Scottsdale, AZ 85252) began a 30-volume series entitled *The Carl Barks Library*. When complete in 1989, it will have reprinted virtually all of Carl Barks's comic book work.

PETER LEDGER

began his career in art by accidentally burning down the entire eight story building in which he was working as a photographer's assistant. Born in 1945 in Sydney, Australia, Ledger studied at Orban's Art School, the Julian Ashton School, and the North Sydney Technical School. Somewhat daunted by the fiery beginnings of his artful endeavors, Ledger tried a number of different occupations: he adventured in the South Pacific, worked in a mortuary, drove bulldozers, hunted deer for the New Zealand government, was a surveyor's assistant, a mining engineer and a leatherworker. All these roads lead back to painting, and Ledger has spent nearly twelve years working in advertising and doing posters for motion pictures and rock and roll concerts. He is best known in the United States for his work in *Weirdworld*, a Marvel Comics publication.

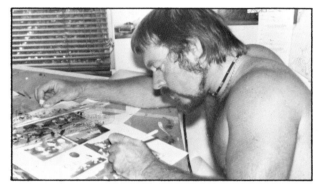

Ledger colored the Barks stories using air brush, watercolor, acrylics, and colored pencil. A slightly different style was chosen to complement the content of each story, ranging from extremely naturalistic to highly fantastic. Working from notes provided by Carl Barks and from personal meetings with Barks, Ledger created backgrounds that echo the style of the 1930s and 1940s animated cartoons from the Disney studios—without obscuring Barks's delicate and expressive pen line. *Land Beneath the Ground* was the most difficult story because it was nearly all air-brushed (a process that requires painstaking, precision masking of every panel on every page). The re-coloring of the 283 story pages in this volume involved painting approximately 2,200 individual panels, over 6,000 tiny duck beaks and more than 12,000 webbed feet. Seven months were required to complete the work.

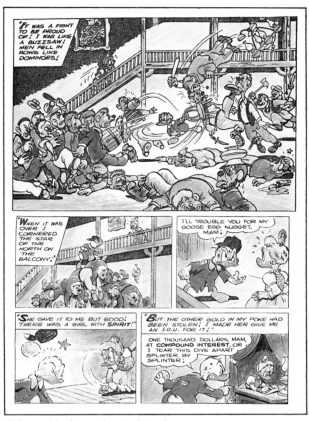

Color guide drawn by Carl Barks.

MICHAEL BARRIER

is the co-editor of *A Smithsonian Book of Comic-Book Comics* and the author of a forthcoming history of Hollywood animated cartoons for Oxford University Press. He has known Carl Barks for more than a dozen years and has interviewed him for articles in a number of magazines and books including *The Comic-Book Book*.

EDWARD SUMMER

has contributed to the screenplays of *Star Wars*, *Little Nemo in Slumberland*, and *Conan the Barbarian*. As a fellow of the National Endowment for the Arts, he produced and directed *The Men Who Made the Comics*, which included a sequence on Carl Barks. He has also written two novels, *Teedie and Me* and *Teefr*, from his own screenplays. Summer has always wanted to be as rich as Uncle Scrooge, but since he still has a long way to go, he says he will settle for being as talented as Carl Barks.

AN AFTERWORD

By Gary Kurtz

This book is the result of a lifelong desire to honor Carl Barks, a masterful storyteller and outstanding graphic artist. As a comic book writer and illustrator, Carl spent his career working anonymously in a field that has never received the serious recognition which it should.

Growing up in the 1940's, I had a long and wondrous association with comic books. For me, certain stories and artwork stood above the rest, and Carl's duck stories were at the very top: they were uniquely full of adventure, imagination and humor.

His graphic images had great visual style and dramatic power. He infused his drawings with energy and movement, almost as if they were frozen frames from a motion picture. This was undoubtedly a major force in sparking my interest in working in a visual storytelling medium.

His characters had such fully developed personalities, that they became real people one could love and hate. Carl's creation of Uncle Scrooge—at once a humanly compelling and satirically witty character— within the context of high adventure stories, was his crowning achievement.

This book is a way of saying thank you to Carl, to preserve a cross section of his work as he intended it to be seen and to present these stories to a new audience, who I hope will be just as inspired and entertained as I was.

Publisher (Limited Edition)
1981

February 4, 1983

Dear Mr. Barks:

Some duck fans in our department have taken the liberty of having an asteroid named after you.

Your tales of adventure on asteroids, the earth, and other exotic places have provided me much enjoyment over the years, and I thought it appropriate that an asteroid should be named "Barks." This turned out to be an easy task: Ted Bowell, who does much asteroid observing, kindly volunteered one of his discoveries.

The asteroid, (2730) Barks, is about 10 kilometers in diameter and orbits the sun every 4 1/2 years from about 350 million km to 400 million km from the sun. Although we don't know much more about this asteroid now, someday we may have more detailed information on this object.

Best wishes,

Peter Thomas
Research Assistant
Center for Radiophysics
and Space Research
Cornell University
Ithaca, New York

Feb 15, 1983

Dear Mr. Thomas:

It was certainly a great pleasure to read that an asteroid has been named after me. I am quite overwhelmed by the significance and scope of such an honor.

I used to look up at the night sky when I was a boy in smogfree eastern Oregon, and I reflected even then on the awesome permanence of those millions of glittering objects. To realize that now one of those objects is named for me boggles my mind. (2730) Barks will still be up there circling the sun eons after the Big Apple and Hollywood's terrazzo "stars" and I have become dust specks blowing in the winds of infinity. I hope that the moral that I gently preached in my story of "Island in the Sky" lives on into that foreverness to help earth people meet their far off neighbors with a handshake instead of a blast with a ray gun.

An Uncle Scrooge with a fortune to hide may even land on (2730) Barks and find a great cave lined with gold leaf an inch thick!

I thank you very, very much. You and your generous colleague, Ted Bowell, have made me feel understandably proud.

Sincerely,

Carl Barks
Cartoonist
Temecula, California

July 30, 1987

Dear Peter:

Here is a print of an image of (2730) Barks. The asteroid is a little faint.

The photograph was taken by Brian A. Skiff on 5 October 1981 using the 13-inch refracting telescope with which Pluto was discovered in 1930. The asteroid is superimposed on a small area of the constellation Pisces at a scale of about 24 arcsec/mm. (On that scale, the Moon would be about 3 inches across.) Two photographic plates were each exposed for 30 minutes about an hour apart, during which time the asteroid moved east to west by about 40 arcsecs with respect to background stars. It was that motion that allowed me to discover the asteroid on 30 August 1981.

With best regards.

Edward Bowell,
Lowell Observatory
Flagstaff, Arizona

1983 Jan. 28
(2730) Barks = 1981 QH
Discovered 1981 Aug. 30 by E. Bowell at the Anderson Mesa
Station of the Lowell Observatory.
Named for Carl Barks, writer and illustrator. His comicbook
stories have emphasized exploration and invention, often featur-
ing space adventure, satellites and minor planets. He touched
on the idea of 'rubble pile asteroids' more than 20 years ago.

Minor Planet Circular 7621

*(On the same day the Minor Planet Circular 7621 also an-
nounced the naming of asteroids for Ops, the Roman goddess
of abundance; James B. Gibson, discoverer of the Amor object
Anteros (one of Earth's nearest neighbors); Arthur Stanley
Eddington, the English astronomer; Sonia Louise Moeller-
Thomas, mother of the discoverer; and Peter the Great. E.S.)*